ARTISTIC BROTHERHOODS IN THE NINETEENTH CENTURY

Artistic Brotherhoods in the Nineteenth Century

Edited by Laura Morowitz and William Vaughan

ASHGATE

Published by
Ashgate Publishing Limited
Gower House
Croft Road
Aldershot
Hants GU11 3HR
England

Ashgate Publishing Company
131 Main Street
Burlington, VT 05401-5600 USA

Ashgate website: http://www.ashgate.com

British Library Cataloguing-in-Publication data

Artistic brotherhoods in the nineteenth century
 1. Art, Modern – 19th century
 I. Morowitz, Laura II. Vaughan, William
 709'.034

Library of Congress Cataloging-in-Publication data

Artistic brotherhoods in the nineteenth century / edited by Laura Morowitz and William Vaughan.
 p. cm.
 Includes bibliographical references and index.
 1. Art – Europe – Societies, etc. 2. Brotherhoods – Europe – History – 19th century.
 I. Title: Artistic brotherhoods in the 19th century. II. Morowitz, Laura. III. Vaughan, William.
 N17.E97 A78 2000
 706'.04–dc21

00–034847

ISBN 0 7546 0014 9

Printed on acid-free paper

Typeset in Palatino by Manton Typesetters, Louth, Lincolnshire, UK and printed in Great Britain by St Edmundsbury Press Ltd, Bury St Edmunds, Suffolk.

Contents

List of figures VII

Notes on contributors XI

Acknowledgements XIII

Introduction 1
Laura Morowitz and William Vaughan

1 The first artistic brotherhood: *fraternité* in the Age of Revolution 32
 William Vaughan

2 The Nazarene *Gemeinschaft*: Overbeck and Cornelius 48
 Mitchell B. Frank

3 The Pre-Raphaelite 'otherhood' and group identity in Victorian
 Britain 67
 Jason Rosenfeld

4 The business of brotherhood: Morris, Marshall, Faulkner &
 Company and the Pre-Raphaelite culture of youth 82
 Amy Bingaman

5 Questions of identity at Abramtsevo 105
 Rosalind Polly Gray

6 Envisioning the Golden Dawn: the Visionists as an artistic
 brotherhood 122
 Sarah Kate Gillespie

7 *Académie* and *fraternité*: constructing masculinities in the
 education of French artists 137
 Susan Waller

8 Girls 'n' the 'hood: female artists in nineteenth-century France 154
 Jane Mayo Roos

9 Anonymity, artistic brotherhoods and the art market in the *fin de
 siècle* 185
 Laura Morowitz

Bibliography 197

Index 201

Figures

Introduction

0.1 Wilhelm von Schadow, *The Artist with his Brother Rudolph and the Sculptor Bertel Thorwaldsen*, oil on canvas, 1816, Nationalgalerie, Berlin

1 Artistic brotherhoods and *fraternité* in the Age of Revolution

1.1 Jacques Louis David, *The Rape of the Sabines*, oil on canvas, 1795–9, Louvre, Paris

1.2 Henri-François Riesener (attrib.), *Portrait of Maurice Quai*, oil on canvas, *c.* 1800, Louvre, Paris

1.3 Jean Broc, *The School of Apelles*, oil on canvas, 1800, Louvre, Paris

1.4 Jean-Pierre Franque, *Allegory on France Before the Return from Egypt*, 1810, Louvre, Paris

2 The Nazarene *Gemeinschaft*: Overbeck and Cornelius

2.1 Friedrich Overbeck's *Lukasbund Diploma*, 30 × 25cm, 1809

2.2 Friedrich Overbeck and Peter Cornelius, *Double Friendship Portrait*, pencil on paper, 1815, private collection

2.3 Friedrich Overbeck, *Joseph Sold by his Brothers*, 335 × 225cm, fresco, 1816, Staatliche Museum, Alte National-galerie, Berlin

2.4 Peter Cornelius, *The Recognition of Joseph by his Brothers*, 1816, Staatliche Museen zu Berlin – Preussischer Kulturbesitz, Nationalgalerie

2.5 Carl Philipp Fohr, *The Café Greco in Rome*, pencil on paper, 1818, Städelsches Kunstinstitut, Frankfurt am Main

3 The Pre-Raphaelite 'otherhood' and group identity in Victorian Britain

3.1 Arthur Hughes after William Holman Hunt, *The Pre-Raphaelite Meeting*, 1848. Reproduction of a sketch from Hunt's *Pre-Raphaelitism and the Pre-Raphaelite Brotherhood* (London: Macmillan, 1905), vol. 1, p. 140

3.2 William Holman Hunt, *Valentine Rescuing Sylvia from Proteus*, oil on canvas arched top, 98.5 × 133.3cm, 1850–1, Birmingham Museums and Art Gallery

4 The business of brotherhood: Morris, Marshall, Faulkner & Company and the Pre-Raphaelite culture of youth

4.1 Dante Gabriel Rossetti and Elizabeth Siddall, Jane Morris's Jewel

Casket, 221 × 213cm, *c.* 1860, Kelmscott Manor, Society of the Antiquaries of London, Lechlade

4.2 Edward Burne-Jones, The Prioress's Tale Wardrobe, 158 × 54.5cm, *c.* 1860, Ashmoleum Museum, Oxford

4.3 William Morris, *La Belle Iseult*, oil on canvas, 71.8 × 50.2cm, 1858, Tate Gallery, London

4.4 Philip Webb and William Morris, St George's Cabinet, 1861, Victoria and Albert Museum, London

4.5 William Morris, *Aphrodite*, oil on canvas, *c.* 1870, Kelmscott Manor, Society of Antiquaries, Lechlede

4.6 William Morris, *A Book of Verse*, 1870, pp. 50–1, L. 131–1953, National Art Library, London

5 Questions of identity at Abramtsevo

5.1 Mikhail Vrubel, *Portrait of Savva Mamontov*, oil on canvas, 187 × 142.5cm, 1897, State Tretyakov Gallery, Moscow

5.2 Valentin Serov, *Winter at Abramtsevo*, oil on canvas, 1886, 20 × 15.5cm, State Tretyakov Gallery, Moscow

5.3 Viktor Vasnetov, *The Chambers of Tsar Berendey*, sketch for the stage design of Act II of the opera *Snow Maiden*, watercolour, 35.5 × 48.8cm, 1885, State Tretyakov Gallery, Moscow

6 Envisioning the Golden Dawn: the Visionists as an artistic brotherhood

6.1 Bertram Grosvenor Goodhue, *The Knight Errant*, frontispiece, 20.3 × 25.4cm, 1892, Brown University Library

6.2 F. Holland Day, *The Vigil*, platinum silver print, *c.* 1899, Metropolitan Museum of Art, Alfred Stieglitz Collection, 5 × 12.7 × 17.8cm (1933), New York

6.3 F. Holland Day, *Crucifixion in Profile, left*, platinum silver print, 15.9 × 8.3cm, 1898, Library of Congress, Prints and Photographs Division no. 142, Washington DC

6.4 Bertram Grosvenor Goodhue, Frontispiece to *Saint Kavin, a Ballad*, by Bliss Carmen, 1894, Queen's University Libraries, Special Collection

7 *Académie* and *fraternité*: constructing masculinities in the education of French artists

7.1 Jean-Henri Cless, *The Studio of David*, drawing, *c.* 1804, Musée Carnavalet, Paris

7.2 Hippolyte Bellangé, *Charges d'Atelier*, 1832, Bibliothèque Nationale de France, Départment des Estampes et de Photographie, Paris

7.3 John Cameron, 'They set about each other … '. From John Shirley Fox, *An Artist's Reminiscences of Paris in the Eighties* (London, 1909), New York Public Library

7.4 Adrien Tournachon, *Horace Vernet*, 24.4 × 18.4cm, 1854, Bibliothèque Nationale de France, Départment des Estampes et de Photographie, Paris

7.5 Nadar, *Eugène Delacroix*, 24.4 × 18.4cm, 1858, Bibliothèque de France, Départment des Estampes et de Photographie, Paris

8 Girls 'n' the 'hood: female artists in nineteenth-century France

8.1 Gavarni [Sulpice-Guillaume Chevalier], 'The Female Artist'. From *La Caricature Provisoire*, 21 March 1839. Photo: author

8.2 After a sketch by M. Ryckebusch, *Painting Jury for the Salon of 1870*, Bibliothèque Nationale de France, Paris

8.3 Anonymous, *The Arts and Decency*, Bibliothèque Nationale de France, Paris

8.4 Rosa Bonheur, *The Horse Fair*, oil on canvas, 244.5 × 506.7cm, 1853/5, Metropolitan Museum of Art, New York. Gift of Cornelius Vanderbilt

8.5 Anonymous, 'Rosa Bonheur at Sixty-Three', 1885. From Anna Klumpke, *Rosa Bonheur, Sa vie, son oeuvre* (Paris: Flammarion, 1908)

8.6 Anna Klumpke, 'The Cigarette' (Portrait of Rosa Bonheur), *c*. 1898. From Anna Klumpke, *Rosa Bonheur, Sa vie, son oeuvre* (Paris: Flammarion, 1908)

8.7 Berthe Morisot, *Reading (Mother and Sister of the Artist)*, oil on canvas, 100 × 81.9cm, 1869/70, National Gallery of Art, Chester Dale Collection, Washington DC

8.8 Berthe Morisot, *Young Woman at Her Window (The Artist's Sister at a Window)*, oil on canvas, 54.9 × 46.4cm, 1870, National Gallery of Art, Alisa Mellon Bruce Collection, Washington DC

8.9 Mary Cassatt, *Portrait of a Lady*, oil on canvas, 164 × 83.8cm, 1878, private collection, Washington, DC

8.10 Mary Cassatt, *In the Garden (Lydia crocheting in the Garden)*, oil, 66 × 94cm, 1880, Metropolitan Museum of Art, New York, Mrs Gardner Cassatt

8.11 Mary Cassatt, *Modern Woman*, oil on canvas, 42.7 × 176.8m, current whereabouts unknown. Photo: from Maud Howe Elliott (ed.), *Art and Handicraft in the Woman's Building of the World's Columbian Exposition, Chicago* (New York and Paris: Goupil, 1893)

8.12 Mary Cassatt, detail from *Modern Woman*. Photo: from Pauline King, *American Mural Painting* (Boston: Noyes, Platt, 1902)

9 Anonymity, artistic brotherhoods and the art market in the *fin de siècle*

9.1 Maurice Denis, *Regatta at Perros-Guirec*, oil, 41 × 32cm, 1892, Musée Maurice Denis, Paris, © copyright ARS/New York, ADAGP Paris

9.2 Emile Bernard, *Breton Peasants on a Wall*, oil, 81 × 116cm, 1892, Josefowitz Collection

9.3 Paul Gauguin, *Eve*, watercolour and pastel on paper, 34 × 31cm, 1889, Marion Koogler McNay Museum, Saint Antonio, Texas, bequest of Marion Koogler McNay

9.4 Paul Sérusier, *Breton Eve*, oil, 73 × 60cm, *c*. 1889, Musée D'Orsay, Paris

Contributors

AMY BINGAMAN is a PhD candidate in the Department of Art History at the University of Chicago. Her dissertation is entitled 'Furnishing Utopia: William Morris, Hand-production and the Pre-Raphaelite Economy of Desire'. Ms Bingaman currently teaches art and architectural history at the American Academy of Art and Columbia College, Chicago.

MITCHELL B. FRANK completed his PhD at the University of Toronto. His dissertation examined the work and life of Friedrich Overbeck. He worked as a research assistant on the 'Baltic Light' exhibition, which opened at the National Gallery of Canada. He has taught art history at the University of Toronto, the University of Manitoba, and John Abbot College, Montreal. He is currently completing a book-length manuscript on the changing nature of German Romanticism.

SARAH KATE GILLESPIE received her BA from Mount Holyoke College and her MA from The George Washington University. She is currently in the history of art PhD programme at The City University of New York, Graduate School and University Center.

ROSALIND POLLY GRAY is a lecturer in the History and Theory of Art at the University of Kent at Canterbury, UK. Her articles on Russian art and patronage have appeared in various journals, and her book on nineteenth-century Russian painting was published by Oxford University Press in 2000.

LAURA MOROWITZ is Assistant Professor of Art History at Wagner College, N.Y. She is the author of several articles and reviews on nineteenth-century art which appeared in *The Oxford Art Journal*, *The Art Bulletin*, *The Art Journal*, *Art Criticism* and *The Journal of Popular Film and Television*. She is currently co-

authoring a book, with Elizabeth Emery, entitled *Consuming the Past: The Medieval Revival in* Fin de Siècle *France* for Ashgate Publishing.

JANE MAYO ROOS teaches art history at Hunter College and The Graduate Center of the City University of New York and has written widely on nineteenth-century French art. She is the author of *Early Impressionism and the French State, 1866–1874* (Cambridge, 1996), editor of *A Painter's Poet: Stéphane Mallarmé and his Impressionist Circle* and a contributor to *Rodin's Monument to Victor Hugo* (Merrell Holberton, 1998).

JASON ROSENFELD is Visiting Assistant Professor of Art History at Assumption College in Worcester, Massachusetts. He is the author of 'New Languages of Nature in Victorian England: The Pre-Raphaelite Landscape, Natural History and Modern Architecture in the 1850s', his doctoral dissertation. He is currently writing a scholarly monograph on Sir John Everett Millais for Phaidon Press.

WILLIAM VAUGHAN is Professor of the History of Art at Birkbeck College, University of London. He is the author of several books on art of the eighteenth and nineteenth centuries including *Romanticism and Art* (Thames and Hudson 1979/94), *German Romantic Painting* (Yale University Press 1980/ 94), *Art in Bourgeois Society* (Cambridge 1998, co-edited with Andrew Hemingway) and *Jacques-Louis DavidÆ's Marat* (Cambridge University Press 2000, co-edited with Helen Weston). He is currently working on a book for Yale University Press, *Painting in English: the making of the British School*.

SUSAN WALLER is Assistant Professor of Art History at the University of Kentucky, Lexington, Kentucky. She received her PhD from Northwestern University and has taught at Drake University, the University of Southern Maine and Maine College of Art. She edited *Women Artists in the Modern Era: A Documentary History* (1991) and is currently working on a book examining stereotypes of the artist's model in nineteenth-century Paris.

Acknowledgements

My first debt goes to my co-editor, William Vaughan, for enthusiastically sharing this project with me. The majority of the essays were originally presented at our panel, 'Artistic Brotherhoods in the Nineteenth Century' at the 1998 College Art Association in Toronto, Canada. Working with Will was both an inspiration and a great pleasure. I extend my sincerest gratitude to all those who collaborated on this project – Amy Bingaman, Sarah Gillespie, Polly Gray, Mitchell Frank, Jane Mayo Roos, Jason Rosenfeld, and Susan Waller. Their hard work and great insights are responsible for the high quality of this volume. I thank them for their devotion to the project and for putting up with endless nagging e-mails over the course of the last two years.

Special thanks goes to Pamela Edwardes, of Ashgate Publishing, for first suggesting the volume on brotherhoods and for her embrace of the project. Thanks also to Ruth Tierney for her work on the book and to Ellen Keeling for her editorial assistance. Many friends and colleagues also contributed their suggestions and ideas, and discussed aspects of the project from its inception to its conclusion. These include Maura Reilly, Debra Wacks, Ariella Budick, Françoise Lucbert, Lori Weintrob, Lisa Rafanelli, Barbara Larson, Laurie Lico Albanese and Elizabeth Emery. I deeply appreciate the daily support and laughter from my talented and caring friends at Wagner College – Katica Urbanc, Larry Nolan, Lori Weintrob, Steve Snow and many more.

Thanks to Eric, whose love and patience (not to mention his great editorial skills!) are the centre of my life. And finally, thanks to my Isabelle, whose own birth coincided with the birth of this project, and whose existence gives meaning to everything in the world.

Laura Morowitz

My first debt is to my co-editor Laura Morowitz, who has been the prime mover behind the conceptualization and realization of this volume, and a wonderful colleague to work with. Like her, I should like to offer my thanks and gratitude to our co-authors, and to Pamela Edwardes, Ellen Keeling and all others at Ashgate who have worked on this book.

In addition, I should like to thank in particular Helen Weston for her most helpful suggestions for my essay on the *Barbus*, and my son, Sam Peppin Vaughan, for his help in constructing the index.

William Vaughan

Introduction

Laura Morowitz and William Vaughan[1]

In the *Salon of 1846*, Charles Baudelaire bitterly denounced the 'spirit of individualism' that had invaded the domain of art:

… the present state of painting is the result of an anarchic freedom which glorifies the individual, however feeble he may be, to the detriment of communities – that is to say, of schools [which] are nothing else but organisation of inventive force. This glorification of the individual has necessitated the infinite division of the territory of art. The absolute and divergent liberty of each man, the disjunction of human will, have led to this weakness, this doubt, and this poverty of invention. A few sublime and long suffering eccentrics are a poor compensation for the swarming chaos of mediocrity.

Individuality – that little place of one's own – has destroyed collective individuality. It is the painter that has killed the art of painting.[2]

Baudelaire's diagnosis was a response to an emerging market strategy, which rested on the elevation of one artist at the expense of another. On a broader note, his remarks answer to the growing isolation of the artist in the political, economic and social spheres of the nineteenth century. As the artist became ever more isolated, the dream of communal production became ever more seductive. And nowhere was this communal utopia more deeply embodied than in the artistic brotherhood, a solution that promised to banish competition, loneliness and sexual anxiety with one firm pledge of eternal friendship.

The phenomenon of the brotherhood must be seen as both a response to, and a reflection of, the particular economic, social and political crises of the nineteenth century, no more so than in its paradoxical nature. The ideals and realities of the various brotherhoods are marked by a number of shared paradoxes. Concerns both economic and spiritual intertwine in the brotherhood, for its establishment was intended to provide the artist with a secure footing in both these realms. Indeed the brotherhood served multiple aims, offering its members better, more noble lives, while – first

and foremost – promising the opportunity to *live*, that is to survive economically after the withdrawal of previous forms of state and royal patronage. This intertwining of the economic and the spiritual is a familiar condition in avant-garde art of the nineteenth and twentieth century. It can serve to remind us how, in the period following the French Revolution, the formation of brotherhoods was one amongst many strategies adopted by artists to break the control of the existing hierarchies. As every student of nineteenth-century art knows, this was the period in which increasing unease was felt throughout Europe and America by artists at the power and activities of the Academies. These institutions – which had gradually grown in authority since the Renaissance to exercise a critical role in the training and professional accreditation of artists and the exhibition and sale of their works – were seen increasingly as restrictive bodies. They appeared either unwilling or unable to adapt to the new conditions of artistic production as these emerged in post-revolutionary society. The struggle to challenge and eventually replace the Academies was a slow and painful one that extended throughout the century.

It is significant from this point of the view that the first identifiable artistic brotherhood emerged in the studio of the French painter Jacques Louis David. The Barbus – to use one of the many names they were called – can be seen to have been at the beginning of that challenge to authoritarian structures that became the leitmotif of avant-garde art in the nineteenth century. However, it is not enough simply to see the emergence of brotherhoods at this time as a symptom of the general conditions that underpinned the whole development of avant-garde art. For brotherhoods are in fact only partially to be explained in terms of progressive developments. Indeed, it is one of the fascinations of brotherhoods that they seem to be simultaneously radical and reactionary. The utopian ideal of the brotherhood was, by its very nature, marked by contradiction. Aiming for a 'better tomorrow', and promising an enlightened future, the brotherhoods took their vision from an idealized past. While deeply influencing, even foreshadowing, some of the central tenets of the twentieth-century avant-garde, these groups are characterized by a profound nostalgia and were oftentimes reactionary, both in their style and in their social vision.

Paradoxical, too, is the way in which the all-male brotherhoods both maintained and called into question hegemonic codes of masculinity. The source of the brothers' strength was also a site of vulnerability, for 'to be a man's man is separated only by an invisible, carefully blurred, always-already-crossed line from being "interested in men"'.[3] Nowhere is the 'gendering of the art world' more apparent than in the exclusionary structure of the brotherhood. Women's prohibition from this realm of brothers was a priori, even tautological.[4] The absence of women in these groups reflects

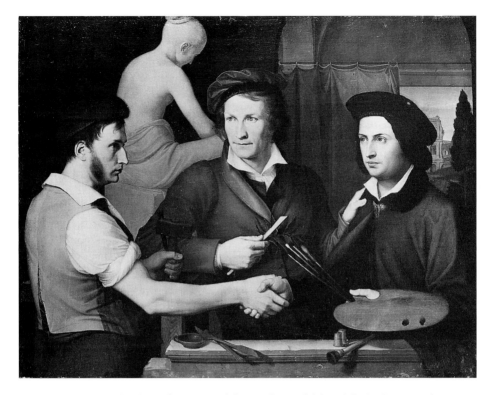

0.1 Wilhelm von Schadow, *The Artist with his Brother Rudolph and the Sculptor Bertel Thorwaldsen*, 1816.

their expulsion from the public stage, while testifying, in fact, to their threat in the artistic sphere, among others.

Historiography

Most brotherhoods are as famous for what has been written about them as for what they produced. Indeed, while major groups such as the Nazarenes (Figure 0.1) and the Pre-Raphaelites, can also claim to have left an indelible pictorial heritage, others (notably the Barbus) are now far better known from the colourful accounts of their activities than from their actual works.

There is a certain irony in the amount of art historical writings devoted to the 'secret' and 'esoteric' brotherhoods of the nineteenth century. We now have available to us letters, journals and other personal papers which reveal a great deal about the aims and visions of the various brotherhoods, writings originally intended only for the eyes of the 'initiated' or 'elite'. Nevertheless,

a great deal of information still remains elusive to us (for example on the members of the Barbus or Primitifs, or on the specific rituals adhered to by the Nabis or Visionists). In the course of writing this book, we encountered dozens of obscure 'brotherhoods' excluded from mainstream or canonical histories of art.[5]

Not surprisingly, while some excellent group studies exist,[6] the vast majority of literature on the members of artistic brotherhoods is in the form of monographs. Even within the group-focused writings (i.e. the exhibition catalogues from the 1984 Pre-Raphaelite exhibit at the Tate Gallery or the 1993 Nabi Retrospective at the Musée d'Orsay)[7] the studies tend to be arranged according to artist, rather than divided by theme. To this day, the communal structure of the brotherhood conflicts with the standard modernist account of a transcendent individual talent.

In part, the failure of the literature to convey the communal structure of the brotherhood is because these groups have tended, in retrospect, to become prey to the conditions of individualism that have underpinned modernist developments. Whatever the ideals of each brotherhood, they have tended to result in the emergence of one or two powerful individuals, who often subsequently pursue separate careers. It is frequently the case that one such prominent (and successful) member of the brotherhood has managed to become, after a long and protracted battle, the owner of its history or story (a point made well by Jason Rosenfeld in his essay on the Pre-Raphaelites). Thus the construction of the brotherhood has often been shaped by this chosen (or self-chosen) leader of the group: Maurice Denis (Nabis); Samuel Palmer (the Ancients), William Holman Hunt (Pre-Raphaelites).[8] Such individuals have not only determined the 'official' make-up of the group,[9] but promoted a highly distorted and 'mythic' history of the brotherhood, whose elements have continually been repeated in the literature, despite their lack of factual accuracy.[10] In other cases, the story has been externally shaped (by critics) around a particular powerful individual in the circle, for example Maurice Quai, leader of the Barbus or Primitifs. For a variety of reasons, the events surrounding the formation and aim of the brotherhood have been exaggerated, omitted and subject to a revisionist history.

Due to their conservative and 'quaint', eclectic styles, many of the brotherhoods fell out of favour with twentieth-century vanguard taste; for instance, since 1963, only one English language study has been devoted to the Nazarenes.[11] With postmodernism, an interest in these historicist and picturesque groups returned.[12] In the past two decades major shows have been mounted on several of the brotherhoods.[13] While studies have been devoted to concrete links between the groups (for example, William Vaughan's *German Romanticism and English Art*[14] and the literature on the Morris/Burne-Jones circle), no attempt has been made to examine the brotherhoods as a

general nineteenth-century phenomenon distinct from other artistic forma-
tions and worthy of close examination.

Defining the brotherhood: a typology

The artistic brotherhood is a distinct phenomenon within a wider spectrum
of protest against the artistic hierarchies emerging from the Revolution. Are
we justified then in seeing the nineteenth-century artistic brotherhood as a
discrete formation? Can we map out a typology that helps to differentiate
these groups from the variety of artistic communities, colonies, schools and
emerging avant-gardes? Below is an attempt to define the brotherhoods
according to a series of shared characteristics and elements.

To begin with, paralleling established practice in the Academies, the
brotherhood must conceive of itself as a separate, elitist group, set apart from
the mass of working artists. In that sense, the brotherhood is not an aggregation
(a group of all available individuals) but a select and *chosen* assembly.[15] One
must be invited and must somehow 'join' the brotherhood. Moreover, the
brotherhood must conceive of itself as such, and usually bears a name reflecting
this idea (the Nabis (prophets), the Pre-Raphaelite Brotherhood, the Visionists,
etc.). The particularity of the members is often signalled by lifestyle – in the
peculiar manner of dress, for example (both the Barbus and the Nazarenes
adopted flowing robes and long hair, while the beards and dress of the Ancients
drew great attention). Charles Nodier, a contemporary of the Primitifs, who
would go on to become an important force in the Romantic movement, summed
it up as such: 'It was a question of nothing less than a reform of society based
on a plan, not precisely similar to that of the Saint-Simonians, but of the same
type, and which had to begin with a change of costume.'[16]

In contrast to the dominant artistic 'schools' of the period, such as the
Barbizon or the Impressionists, brotherhoods are characterized less by style
than by practice.[17] What, after all, is the stylistic link that can be drawn
between a meticulous piece of *plein air* realism by Holman Hunt or Millais,
and the broadly painted, richly archaic idealism of a Rossetti 'stunner'?
Uniformity of manner was, it is true, an ideal sought after by most
brotherhoods and even occasionally achieved in their very early stages. Such
fitted in with their dream of communal practice. But this 'anonymous' style
sought (and on rare occasions achieved) at the early formation of the
brotherhoods, gives way to one of greater individuality as I argue later.[18]
Style becomes an arena in which tension between a communal vision and
individual needs is played out.

So, too, the brotherhood contrasts with the artistic school in its more 'literary'
dimensions. Diaries and private journals by various artistic brothers abound

– testifying to the self-conscious nature of their artistic ventures. Moreover, the unifying production of many of the brotherhoods was often a collaborative journal (such as the Pre-Raphaelite *The Germ* or the Visionists' *The Knight Errant*).[19] Even in those cases where the brotherhoods did not publish their own collective periodical, they often banded around a particular one, which came to be seen as their organ or artistic vehicle (such as the case with the Nabis and *La Revue Blanche*).[20] The importance of journals among artistic brotherhoods underlines their collaborative, communal spirit, and draws attention to spiritual or philosophical links over more formal ones.

Like the artists' colony, there is often a connection between painting and other media – most often the decorative arts – emphasizing the social impetus of the brotherhood (in contrast to the more purely aesthetic one of the school). Both colony and brotherhood share an interest in challenging the existing artistic hierarchy. But they were organized along different lines. The colony was bound together by none of the intense ritualistic practices of the brotherhood. It is symptomatic of this difference that there is a highly important distinction in their choice of physical location. The brotherhoods are typically located in *urban* centres and often at the very heart of the cosmopolitan city (London, Rome, Vienna, Paris, Boston).[21] The geographical setting of the brotherhoods also contributes to the tension and dialogue between the members' ideals and the larger context of the art establishment. While the colony requires removal from the city to a distant rural location, the retreat of the brotherhood is symbolic in nature, a fortress within the modern world. In contrast, the physically inaccessible colony need not be secretive; its very location provides protection against exterior penetration. A further distinction lies in the choice of familial model: the colony more readily evoked the extended family, with females and even children present, in opposition to the strictly fraternal nature of the brotherhood.

Many of the above criteria might legitimately be applied to avant-garde groups, for example Die Brücke in Dresden. But we can point to three distinct characteristics that are invariably present in the brotherhoods: secrecy, interest in medievalism and a spiritual emphasis (this last both complex and crucial, necessitating more prolonged attention later in this Introduction). These elements lead back to earlier social networks, rather than forward to the twentieth century.

As the early twentieth-century sociologist Georg Simmel observed, secrecy is a vital component in maintaining elite (and for him 'aristocratic') social groups.[22] In the case of artistic brotherhoods it is certainly employed to protect their specialness. Much mystery and secrecy surrounded the various brotherhoods – their formation, membership and, most prominently, the 'initiation' and social rituals that drew the brothers together. The secret nature of the brotherhoods made them both special and, to some, dangerous.

When the paintings of Rossetti, Millais and Hunt were exhibited in 1849 at the Free Exhibition and the Royal Academy, the cryptic initials of PRB written on the canvases troubled as much as the 'blasphemous' style in which they rendered their scenes. Reading the letters exchanged between brothers – often sealed with obscure emblems – we often find the use of 'secret' jargon and languages (e.g. the Nabi term *phalanstere*, a coded word for studio). The secret nature of the brotherhoods made them at once more enticing and increased their sense of self-importance and elitism. Yet to be successful, the brotherhood had to take the form of an 'acknowledged secret', one whose existence was known, but one whose details remained largely hidden.

One characteristic that links together the different brotherhoods, while distinguishing them from other groups, is the presence of a profound medievalism. Interest in the medieval world impacts both the formal style and the ideology of these groups to an unprecedented degree.[23] Not only were the Middle Ages erroneously believed to be the starting point of the artistic brotherhoods, but the period was glorified in the nineteenth century for its associations with chastity, piety and community.[24] So many of the brotherhoods explicitly or indirectly attempted to emulate the medieval artist. This emulation is reflected in their names (Nazarenes or Dürerists, Pre-Raphaelites, Primitifs) and in their social visions (Morris, Nazarenes). Their style, too, often rested on a reinterpretation of medieval art through a nineteenth-century lens. In modelling themselves on the medieval creator, the brotherhoods strove for an artistic purity. The quest for purity circles back to the notion of exclusion and enclosure, elements central to the brotherhood. The issue of purity touches on the spiritual element of the brotherhood, a subject to which we turn more attention below.

This striving towards purity also indicates the fact that brotherhoods were habitually established in response to anxiety about a threat. Ostensibly this is the threat that the academic or establishment milieu in which they find themselves has undermined the possibility of achieving the noblest and highest aims of art. But it is equally an anxiety about the preservation of a masculine ideal.

The problem of male anxiety brings us to the final, if most obvious, criteria of the brotherhood: by definition the group is male-oriented and encourages male bonding. In its gender specificity it echoes the male-centred structure of modernism,[25] but does so more insistently and explicitly. We are speaking here of homosocial[26] networks – male to male bonding along a wide spectrum of power and intimacy – an issue that we must more thoroughly engage with later in our discussion of the brotherhood.

Social origins of the brotherhood

What kind of tales did men tell men
she wonder'd by themselves?

Alfred Lord Tennyson, *The Princess: A Medley* (1847)

While the nineteenth century saw the rise of artistic brotherhoods,[27] the all-male social group has a long and complex history in Europe. As Mary Anne Clawson has written 'fraternalism was one of the most widely available and persistently used forms of collective organization in European and American history from the Middle Ages forward'.[28] Confraternities, guilds, *compagnonnages*, *Gesellenverbande* and countless other social organizations are rooted in fraternalism. The structure of the brotherhood was set up both to reinforce patriarchal structures (through the system of masculine privilege) and also to provide a temporary structure, an alternative system of community, outside the biological family. For the most part it served young and unmarried males at the transition point in their lives between leaving their birth family and beginning their own household. This alternative and exclusively male community operated within, and alongside, the larger matrix of heterosexual society.

Clawson sees four traits central to the brotherhood,[29] all of which can be usefully applied to our groups under study. Invariably, the brotherhood is characterized by corporatism, ritual, propriety and masculinity. Such criteria derive from the social function which the brotherhood is intended to serve. However, it should be noted that artistic brotherhoods which sought to adopt such practices did so with varying degrees of literalness and success. A huge gap separates the almost complete enactment of the ideal by the Nazarenes in their early years from the far looser association of the Pre-Raphaelites and the Nabis. This emphasizes the point that all artistic brotherhoods were in a sense also 'artificial' brotherhoods. As will be made clear in the sections below on the economic and political functioning of the artistic brotherhood, they never achieved the level of organization, continuity or independent action of successful professional and religious brotherhoods. There was always a level of play-acting involved. Even the Nazarenes in their early years failed to achieve that full level of self-regulation that characterized the true brotherhood.

The brotherhood promotes the notion of 'corporate identity', or the interdependence of the members. This idea of the 'communal good' stands in stark contrast to the divisive strategies of capitalism. Indeed, within guilds or international 'brotherhoods of workers' this principle realizes itself as the immobilizing strike. When the Symbolist painter Emile Bernard dreamed of a brotherhood of 'Anonymous Ones', the 'corporate' nature of his vision is

revealed: 'Each member contributes his effort to the whole project. Each one could no more be taken away from the group than could a stone from a house, a beam from a wooden framework.'[30] As Mitchell Frank later discusses in his essay on the Nazarenes, the artistic brotherhood has elements of both the *Gesellschaft* (community) and the *Gemeinschaft* (business).

The brotherhoods are marked by rituals which serve the function of binding together the members and generating a series of 'secret' practices. In addition, the ritual marks the passage from the former life to the new allegiance of its members (the seventeenth-century *compagnonnage* (or journeyman) was 'baptized' with a new name upon entry).[31] Literature on the artistic brotherhoods repeatedly includes colourful references to 'sacred' or ritualistic acts performed by the members. Rituals of the Primitifs included 'drinking from the cup of Maurice Quai and smoking his calmet'.[32] The Nazarenes joined together for communal singing and painting on a regular basis.[33] The rituals of the Nabis (which may have included the wearing of strange costumes as indicated by Serusier's *Portrait of Ranson* (1890)[34] took place at the 'Temple', as the home of artist Paul Ranson was designated. In her essay on the Golden Dawn, Sarah Gillespie discusses some of the rituals of 'silence' and 'secrecy' practised by F. Holland Day and his circle.

The last two traits of proprietorship and masculinity are bound together and inseparable from the power structure of patriarchies: ownership implies maleness, and maleness implies ownership. The members of brotherhoods (whether guild or village youth organization) are those who will *eventually* acquire power, not those excluded from it.[35] In the psychoanalytical language of Jacques Lacan, we can describe the brothers as those for whom access to the phallus is delayed (but not denied). Thus while the brotherhoods may seem to challenge the dominant terms of patriarchy, they are in fact a sort of rehearsal for it. It should not surprise us that the first artistic brotherhood to emerge – that of the Primitifs or Barbus – does so in the insistently male climate of the French Revolutionary period.

The artistic brotherhood and the nineteenth century

If fraternalism is a cross-cultural and historically variable structure it is nevertheless true that the artistic brotherhood is a nineteenth-century phenomenon. Why should it appear with such frequency at this time? We might begin by addressing some of the more pressing issues and concerns of the period.

A central issue here is the changed social relations that emerged during the French Revolution. As Alan Barker has observed in his study of fraternity amongst French peasants in the nineteenth century:

The Revolution of 1789 involved, *inter alia*, the construction of a problematic about the relations between the private and the public spheres of life, about the relations between the individual and the State, which structured the ideological context within which organised groups of individuals – fraternal associations – were developed during the succeeding decades and even during the following two centuries.[36]

Artists, like other professional groups, experienced the disorientation caused by this problematic and some turned, as others had, to the security of the brotherhood as a means of securing their position.

One of the main ideological developments that emerged from this problematic was the construction of the nation state as a new and overarching corporate form with which the individual could identify. The history of the brotherhood – like so much else in the nineteenth century – is inevitably tied up with nationalism.[37] The desire on the part of the brothers for return to a pre-industrial, and most often medieval, culture cannot be seen aside from the issue of national identity. The Romantic yearning for the past, the construction of folklore, history and racial myth, and the glorification of 'peasant culture' was largely in alignment with the philosophies and ideals of the brotherhoods. The essays of Frank, Rosenfeld and Gray reveal that even when brotherhoods were initially conceived in opposition to larger societies, their historiographies were often subsequently modelled to accord with nationalist readings. Rather than a direct response to the nationalism of nineteenth-century Russia, for example, the Abramtsevo was a response to the underlying issues contributing to the rise of Slavophilia. This is not to imply that either medievalism or the ideals of the brotherhood can be reduced to questions of nationalism, but rather to point up their common sources.

In subscribing to the myth of a 'unified' nation, the brotherhood could see itself as an agent for combatting two of the most disturbing symptoms of modern, fragmented society. On the one hand it could challenge the class divisions of the capitalist system. On the other it could oppose the mayhem threatened by the modern 'liberated' woman. Thus the brotherhood could 'nullify' or render less urgent two of the most potent threats to nineteenth-century European society. The brotherhood was a social organization that crossed class boundaries (at least in its ideals and theory, if not in reality). The model for the brotherhood was a communal, classless or, more exactly, pre-capitalistic society, most often that of the Middle Ages. Unlike so many other social associations, the brotherhood drew its members from a wide spectrum of wealth, education and social connections (this is the case with the Nabis and Primitifs for example).[38] At a time of growing class conflict (and consciousness) the brotherhood offered a haven where such distinctions were obliterated and divisions replaced by bonds of mutual respect and dependence.

Within the brotherhood 'the problem of women' ceased to exist. By simply excluding females as artistic competitors, the brotherhood avoided the anxiety which their literal presence aroused, both politically and sexually. While eliminating the negative side of female presence, the ideals of beauty, tenderness and eroticism were salvaged by being transferred to the realm of men.[39] Thus Abigail Solomon-Godeau has cogently argued in *Male Trouble*, the figure of the *ephebe* allowed for a recuperation of the female 'inside the masculine'.[40] Instead of compromising, or even acknowledging, the needs of women (to participate in exhibitions for example) the brotherhood ignored them. As the world outside the 'closed circle' grew more threatening, the gates were locked tighter and an all-male 'private' sphere came to parallel the masculine public stage.

The brotherhood functioned as a compensatory realm in the increasingly treacherous terrain of developing capitalism. As Clawson has written:

During the nineteenth century the fraternalism of the workshop was under persistent attack; craft ideals were increasingly less possible to realize within the workplace. The rise of social fraternalism closely parallels this decline of traditional craft relations in the work world. If these ideals could no longer be realized at work, they could instead be transferred to a purely social setting, the fraternal order.[41]

The structure of the brotherhood thus proliferated *outside* the world of work, creating an all-male 'sanctum sanctorium'[42] in the form of lodges, gentlemen's clubs, etc. The artistic brotherhood, however, returned the form of fraternalism back to the field of production. Often the brotherhood – that is the Morris Group or the Abramtsevo – was particularly keen on the resurrection of traditional craft techniques or the artisanal method.

By the nineteenth century, definitions of masculinity were intrinsically bound up with the market-place.[43] Male sexual aggression and 'hunting skills' were seen to be directly transferable from the sexual to the economic realm and back again.[44] If the very notion of masculinity depended upon negotiation of the market-place and the earning of income, the financially strapped artist faced a constant challenge to his manhood. The artistic brotherhood served as an alternative way of acquiring masculinity, one that would prove extremely useful in many ways.

Economic functions of the brotherhood

It has already been seen that the brotherhood was a response to economic as well as social circumstances. But the question remains as to how effective this strategy actually was in a material sense. Did the establishment of an artistic brotherhood actually provide its members with an economic base for their activities, in the way that successful brotherhoods in other crafts and

professions did? The ways in which artistic brotherhoods serve an economic function is problematic. While brotherhoods in other professions tend to have a well organized structure, which includes the charging of fees for membership, this does not seem to be a feature of artistic brotherhoods. They are more fanciful than that and tend to be set up with a more or less anti-commercial interest in mind. Their harking back to the Middle Ages, the 'age of faith' where art was produced for spiritual rather than material purposes, helped to fuel this fantasy.

Yet brotherhoods had to exist in the material world, and so economic considerations could not be avoided. The fact that most artistic brotherhoods (unlike their counterparts in professional and political circles) were short-lived was to a considerable extent a consequence of the fact that they had no real economic viability; that they neither generated income nor proved in the long run to be a commercial asset to their members. Frequently the duration of a brotherhood was commensurate with the duration of the private funds that its members had at their disposal. The British Ancients in the 1820s were operative in the Kent village of Shoreham during the period when one of their leading members, Samuel Palmer, was living off an inheritance from his grandfather. The collapse of the Shoreham community more or less coincides with the moment when Palmer was no longer able to subsist on this inheritance.[45] Lack of funds also seems to have been a significant factor in restricting the ambitions of the Barbus community in Chaillot, thereby hastening its collapse.[46]

On the other hand, the existence of a community usually implied a lifestyle that was cheaper than living separately, and this must have been a stimulus to groups of impecunious young students banding together to establish a communal place to live. The Barbus' retreat to Chaillot was certainly influenced by this. The monastery, after all, was derelict, so there was little rent to pay. Similarly the German and Austrian artists who came to Rome as the Brotherhood of St Luke and stayed to triumph as the Nazarenes found cut-price lodgings in a half-used convent. The decision of the Ancients to move out of London to the village of Shoreham was similarly a move from high to low rent properties.

Apart from economies brought about by sharing, brotherhoods had a place in the new economic market as publicity strategies. Brotherhoods, however much they proclaimed themselves to be turning their backs on the commercialism of the modern world, were still hoping to succeed in that world, and were using their group identity as a means of drawing attention to their position. It is perhaps a particular feature of artistic as opposed to other forms of brotherhoods, that this self-advertisement was a key feature. For artistic brotherhoods sought to succeed through gaining general recognition and thereby selling their works. Paradoxically, their very

opposition to commercialism was their best selling point. It was the means of establishing that their art was motivated by the purest of sentiments and was unsullied by commercial considerations – something that made it much more saleable. Viewed from this light, artistic brotherhoods can be seen as one of the strategies for success in a rapidly changing art world influenced by a growing capitalist economy. They emerged in parallel to a new series of artist's societies – and also to avant-garde groups – which all had the intention of using the combined forces of their members to achieve a publicity not available to the individual. More importantly, all such groups sought their own kind of outlets to address an art-loving (and buying) public. While academy exhibitions were still used, these were supplemented by one-man shows, showing in independent galleries. In the case of design – notably William Morris's group – this could lead to the setting up of a full commercial firm. But by the time this had happened the brotherhood had ceased and Morris was effectively acting as a capitalist entrepreneur pandering, as he sourly observed, 'to the swinish luxury of the rich'.[47]

It would be hard to generalize about the conditions by which a brotherhood achieved fame and thereby economic success. It always involved, however, an acceptance by the forces that dominated the art market. It might be influential patrons, as it was in the case of the Nazarenes, where the Prussian Consul Salomon Bartholdi commissioned a fresco cycle for his reception room.[48] It might be an influential critic, as in the case of John Ruskin's celebrated trumpeting of the Pre-Raphaelite Brotherhood.

But one thing is clear. That is, that ultimate success was as effective in breaking up the brotherhood as was failure. For, as Baudelaire noted in his review of the *Salon of 1846*,[49] the modern commercial market favoured individualism. And while being a 'Nazarene' or a 'Pre-Raphaelite' might help a moderately successful artist to place work, the leaders of such groups soon went on to establish individual careers. This is how they were marketed, as Verkade ruefully remarked.[50] Rossetti and Hunt, for example, were not to be confused with each other when it came to the sale of their works.

Brotherhoods, therefore, play an ambivalent economic role. They establish a space by means of which new initiatives could be built up on relatively advantageous terms. But eventually they had to return to the market-place and succeed or fail according to its pressures. In the later nineteenth century the triumph of the dealer system ensured that brotherhoods performed an increasingly symbolic role, and played into the hands of the very segment of the art market that they wished to denounce. It was the dealer system, too, that prevented, to a large degree, the brotherhood becoming the dominant mode of art organization in the twentieth century.

Political functions of the brotherhood

As this essay so far makes clear, the emergence of artistic (as opposed to professional and political) brotherhoods can be seen as an outcome of the changes in the concept of brotherhood that were foregrounded during the French Revolution. From being a protective professional organization, the brotherhood became 'universal', open to all male (significantly male) members of the community along the lines of the fabled democracy of Athens in classical antiquity. This vision did not lead in a direct manner to the formation of artistic brotherhoods. Indeed, the pressure could be said to have been in the opposite direction. Universal brotherhood implied a communality rather than the excluding practices of a discreet brotherhood. Such openness was exemplified by David in his own studio – in which he attempted to provide a liberal view of training unlike the hierarchical one of the Academy. Significantly it was only after the collapse of the ideal of universal brotherhood during the directoire period that artistic brotherhoods came into being. The Barbus were students in David's studio who mounted a rebellious critique of the master. They formed their brotherhood because they believed the Revolution had been betrayed, that the institutions formed to support it had been undermined. Many of the leaders of the Barbus were from a proletarian background and would have had little chance of receiving the training appropriate for an artistic career prior to the Revolution. This was certainly the case with the Franque twins, sons of a shepherd, who were educated by David free of charge as 'children of the Nation'.[51] The leader of the group, Maurice Quai, was also from a proletarian background (his father was a market gardener). His adulation of the life and culture of Ancient Greece was aimed, in the first instance at least, at keeping in focus an art supposedly based on democratic principles.

Equally important for the setting up of brotherhoods is the notion that artistic movements should emulate or relate to political ones. This is a development that does not simply affect the formation of brotherhoods alone. It is rather the context within which these emerged. After the period of the French Revolution it became widely assumed that art would address its public in a more politically engaged manner – hence the development in the Restoration period of the term 'avant-garde' to describe the cutting edge of innovation.[52] This is partly a reflection of the fact that the age of 'universal brotherhood' – however briefly it lasted – did bring in a new public to the arena of political debate and decision-making. The bourgeoisie were empowered by the Revolution and this same bourgeoisie became the principal audience for art. Artists themselves were, of course, part of this new bourgeoisie and the adaptation by some of them of the brotherhood structure – previously reserved for professional and religious organizations – was part

of their empowerment as well as a means by which to get their message through to their new public.

The relation between brotherhoods and revolutionary politics can certainly be found elsewhere. Holman Hunt, in his autobiography and history of the PRB, famously remarked that the group was moved by the 'revolutionary fervour' of the time (1848) when setting up the brotherhood.[53] Certainly Rossetti saw it more as a *cosa nostra* than a gentleman's club. Yet, as has been observed earlier, artistic brotherhoods are ambivalent – even promiscuous – in their political affinities. It would be wrong to see the brotherhood concept as being one that was specially – or even predominantly – bound up with radical politics. It is true that there is a history of radical brotherhoods leading back to the Middle Ages. But there is also a history of conservative, right-wing, ones. In general, it would probably be true to say that more brotherhoods can be associated with right-wing revivalism than with left-wing progressive radicalism. The Barbus oscillated between the two polarities, shifting from democratic radicalism in David's studio to romantic medievalism in the monastery of Chaillot. The Ancients and the Nazarenes were emphatically right wing. The Pre-Raphaelites shared the ambivalence of the Barbus and the Nabis. While William Morris developed his socialist dream of community, his close friend and associate Edward Burne-Jones moved increasingly to the right. Yet they remained, in their own eyes at least, devotees of the Pre-Raphaelite Brotherhood and saw their last great communal venture, the Kelmscott *Chaucer*, as the ultimate Pre-Raphaelite venture. What unites these tendencies towards opposing political poles is the sense of marginalization and the need to campaign and advertise to try and regain the central ground of politics. Thus the Barbus could be seen simultaneously as an attempt to continue the revolution undermined by the directoire and a nostalgic return to the craft and guild structures actually suppressed during the Revolutionary period as a sign of the new, broader, universal brotherhood.

Artistic brotherhoods, then, share common ground as outsider groups, on the margins of art politics and usually (though not always) having sympathies with extreme political groups of either the right or the left – or both. Perhaps it is for this reason that they seem to emerge most in periods of intense political upheaval, such as the Revolutionary and Napoleonic periods (the Barbus, the Brothers, the Brotherhood of St Luke (Nazarenes), the Ancients), 1848 (Pre-Raphaelites) and the 1890s (Nabis, Visionists, Brotherhood of the Linked Ring).

It is also striking that the artistic brotherhood is a phenomenon less frequently associated with revolutionary moments in the twentieth century. Perhaps the lesser significance of the brotherhood in this era is because, from a political point of view, socialist movements (and Communism in particular)

provided a different organizational model, replacing the brotherhood ideal of the French Revolution with one of class solidarity. On the other hand, the decline of the brotherhood may well be a sign that the contemporary artist no longer possesses that possibility of self-organization and self-determination that seemed to be offered in the period of the Age of Revolutions.

Spiritual aims of the brotherhood

This generation is rising and is demanding Cloisters.

Charles Nodier (1803)[54]

As we briefly touched on above, spiritual aims are one of the defining characteristics of artistic brotherhoods. They are very much the product of that new view of the aesthetic as a form of spiritual exercise. Undoubtedly the emergence of brotherhoods as an artistic formation in the period of revolution was partly caused by the attractive history of brotherhoods as religious organizations. It can be no accident that this occurs in a period when there has been a wholesale revival of interest in the Freemason, that form of brotherhood that emphasized more than any other the mystical and secret side of their being.[55] If nineteenth-century artistic brotherhoods modelled themselves on the arch-brotherhood of the Freemasons, they ignored neither their social vision nor their spiritual impetus. Behind these fraternal societies looms the shadow of the cloister – a protected, idealized world of piety and community. Within the brotherhood, art would be restored to its noble purpose of serving God and heightening men's spiritual awareness. Whether Catholic or mystical and occult, the religious rituals of the brotherhood bound its members into a higher, transcendent circle.

For so many artists, the idea of the brotherhood was inseparable from the pure and romanticized vision of the Middle Ages. Indeed, the majority of artistic brotherhoods fall into the larger history of nineteenth-century medievalism. Wilhelm Wackenroder's 'art-loving monk'[56] became the model in many ways for the pious and self-sacrificing artistic brother.

The Catholic monastery forms the literal backdrop for the brotherhood. It was surely in part to signal themselves as 'heirs' of religious fraternities that the Barbus or Primitifs set up their practice in the deserted Convent of the Visitation of Saint Marie. In Rome, the Nazarenes lived and worked at the abandoned cloister of San Isidoro, even referring to themselves as monks on occasion.[57] One of the less known Nabis – the Dutch born Jan Verkade – converted to Catholicism in 1892 and spent the remainder of his career as a brother in the monastery of Beuron, Germany. For all these examples, there were many more artistic confraternities envisioned – such as the one that the

writer J. K. Huysmans hoped to organize in the 1890s – which never came to pass.[58] In such literal emulations of religious confraternities, the artists blurred the line between the spiritual and the artistic. The actual religious practice and devotion of the members (which varied considerably) was less important than imbibing the general atmosphere of purity and piety.

The creation of the brotherhood often went hand in hand with the commitment to a renewed Christian art. Indeed, a large number of the brotherhoods were devoted to reviving – or more accurately reformulating – Christian art. We must acknowledge the large amount of religious subjects (albeit in decidedly non-traditional form) produced by the Ancients, the Nazarenes, the Nabis and the Visionists. The first important group project of the Russian Abramtsevo group was the building of a church, Spas Nerukotvornyi, in 1882. For the Nazarenes and the Pre-Raphaelites, the very act of visually referencing a purer, more religious era would sanctify their own works (see Figures 2.3, 3.2 and 4.1). In the case of Samuel Palmer (leader of the Ancients) and F. Holland Day, their heartfelt devotion resulted in works where their own identity and visage merged with that of Christ.[59]

Even when the brotherhoods were not so literally identified with religious sites or works their image was deeply coloured by an exemplary or mythic notion of the religious fraternity. Denis' dream of 'an artistic brotherhood', which he described in his journal at the age of 15 (and which he attempted to bring to pass with the Nabis) clearly echoes descriptions of confraternity celebrations of patron feast days, which culminated in the celebration of mass following a winding procession:

And then – oh it would be beautiful! – I should erect in the middle of profane Paris a sumptuous chapel, where my brothers and I would dedicate ourselves to adorning paintings, frescos, panels, predellas, lunettes … And each year our artistic-religious society would come hear mass with their canvases held in their arms … the exhibition ends with a second mass in our church![60]

Historically, the brotherhood was often bound up with occult practices and religions. From the Freemasons, to the Rosicrucians, to the Theosophists, the notion of a select brotherhood of initiated played a central role in doctrine and practices. Books such as Burcham Harding's *Brotherhood: Nature's Law* (1897) preached the notion that 'Brotherhood is both a law and a fact of nature, taught by every object, and cannot be ignored without dire consequences. All lives belong to one great brotherhood, as sparks of the one life or as drops of the mighty ocean.'[61]

In the *fin de siècle*, when interest in esoteric subjects reached a new height – witness the creation of the Salons de la Rose+Croix from 1892–7[62] – the emerging brotherhoods were often powerfully drawn to occult themes. The very term Nabi (prophet) was taken from a popular 'best-seller' of esoterica – Edouard Schuré's *Les Grands Initiées*.[63] Nabi artists such as Paul Ranson

and George Lacombe were schooled in such mystical texts. In her essay on the F. Holland Day group, Sarah Gillespie shows how these artists modelled themselves on the British occult group of the Golden Dawn.

Less significant than the particular belief system to which they were drawn, is the fact that brotherhoods recognized the spiritual component of art. From the ranks of the brotherhoods come many of the artistic zealots – such as Samuel Palmer, William Holman Hunt, Maurice Denis, even Vincent Van Gogh (who dreamed of a brotherhood of artists living communally at the Yellow House in Arles). Even the truly unorthodox – like Maurice Quai, whose beliefs included vegetarianism – were often compared to religious leaders such as Moses, Mohammed and Christ.[64]

Artistic fraternalism provided a very important spiritual function in the 'materialist' nineteenth century. For those of traditional religious bent, its structure recalled the most sacred of groups and institutions – Christ and his apostles, the Holy Orders, the monastery. The artistic brotherhood recreated the conditions and the mindset of these sanctified groups. Alternatively, for those who did not subscribe to organized religion, the artistic brotherhood replaced or substituted more traditional practices. The members had a structured, lofty purpose to which they could dedicate their art and from which they could draw spiritual sustenance in an increasingly competitive and aggressive age.

Sexuality

There is something artful, spiritual, in man's love for another.

Charles Kingsley (1843)[65]

One of the most important aspects of the artistic brotherhood – its promotion of exclusive and intimate male relationships – has often been downplayed in the literature, if not entirely ignored.[66] To understand these groups – artistically, politically, socially – requires nuanced discussion of male bonding and the changing definitions of masculinity issuing from the Revolutionary period through the nineteenth century. Beginning in the 1980s, many authors have contributed useful studies on the constructions of masculinity during this time.[67] The artistic brotherhoods of the nineteenth century both conform to and contest dominant masculine ideals of the period. Just as it provided a compensatory realm in the economic sphere, and often substituted for religion, the artistic fraternity offered an *alternative* means for reinforcing the rules of masculinity at a time of strictly regulated gender divisions.

We must see the male-to-male bonds of these groups within a far more fluid and larger context of homosociality, within which the marked eroticism

of their relations occupies only one point on a much wider spectrum. As both Solomon-Godeau and Patricia Berman[68] have noted, psychobiography or discussion of individual sexual preference is far less important than the culture, the economy of desire, within which these images circulated. Moreover, whether the members engaged in physical intimacy is not only of little relevance, but largely unknowable. The literature on the brotherhoods is rife with comment's like Thomas Crow's that French artist Jacques Louis David was 'carried away by the affection he had for Drouais',[69] as well as the numerous declarations of attachment expressed by one 'brother' to another. What we can be certain of here is a culture in which men far more openly communicated passion, warmth and emotional attachment to each other. As Eve Kosofsky Sedgwick warns, however, the precise slippage between the homosocial and the homosexual differed and must be nuanced in each individual case.

Moreover, as Sedgwick noted, the homosocial continuum of each society is solidly linked to issues of class and gender. By offering a common ground of generic 'maleness', the fraternity papered over and obscured vast differences.[70] In the case of the late eighteenth and nineteenth century, the promotion of homosocial ideals relates directly to the banishment of women from the public realm. Moreover, same sex bonding was both expected and encouraged in such highly sex-segregated cultures. Male adoration and attachment was as much an expression of fear and loathing for women, as it was an illustration of love for one's fellow man. The absence of women in these groups reflects their explusion from the public stage, while testifying to the threat of their growing presence, in the artistic sphere among others. The very banishment of women's contributions was a response to the potential power promised to them by the growing feminist movements of the nineteenth century.[71]

Male bonding and rivalry

I swear that I shall know neither father nor mother, nor brother, nor sister, nor wife nor child, but the brotherhood along where the brotherhood leads or pursues, there shall I follow or pursue; its foe shall be my foe.

> Pledge of candidate to Great Hung League, Han Dynasty (AD 185)

The particular social standing of the artistic brothers – for the most part young bachelors – both permitted and required intensified relations and bonds between the members. The brotherhood took its shape from the dominant culture, and from the artistic institutions of the period, which were insistently and exclusively male (a phenomenon that continued well

into the twentieth century as Carol Duncan and the Guerrilla Girls, among others, have continually observed).[72] In England, for example, the Royal Academy not only denied entry to female artists, but forbad the wives of members to attend the banquet held in their husbands' honour at the Annual Exhibit.[73]

The world of nineteenth-century studios, art schools and institutions was a rugged, hierarchical and often cruel one. In Susan Waller's revealing essay, we come to see the Ecole des Beaux-Arts and the Parisian *ateliers* as crucibles for the formation of artistic men, complete with the confusing and humiliating rituals so common to fraternities and male societies, where one's chips are earned in humbling struggle. Her illuminating study allows us to see the brotherhood as a softer 'mirror' of such official institutions, one which reinforces the larger patriarchal systems. The brotherhood was an attempt to create an alternative structure of masculinity, one which drew on and shared patriarchal and hegemonic criteria, while differing in key aspects; it allowed for a kinder, gentler masculinity. If the brotherhood was also a boys' club, it consisted of decidedly 'nicer' boys, whose masculinity was not measured in physical aggression or sadistic pranks.

While the artistic brotherhood provided a means to acquire masculinity in a more egalitarian, and less antagonistic setting, it nevertheless also bound its members into intense intragroup rivalry. While competing with each other artistically, these rivalries could also take the form of an 'exchange of women'.[74] The Pre-Raphaelites provide a classic example; Jane Morris, Effie Ruskin and Georgiana Burne-Jones were all used as pawns in a game of competition (a subject discussed in the essay of Amy Bingaman). Thus, as in the case of courtly love, even the relationship between members of the opposite sex serves to delineate status between men.[75]

On an ideal level at least, the brotherhood replaced the classical Oedipal struggle with the father with that of sibling rivalry. Part of what distinguished the fraternity was the far less formal structure of hierarchy, as well as the shared leadership. Julie Codell notes that William Holman Hunt's 'struggle with painting was bound up with his struggle with his father', leading him to have 'resisted the parental model of earlier histories, preferring a more democratic ideal of brotherly equality'.[76] If Hunt rebelled against his father, however, he also identified with him.

In a similar vein, Joan Landes, among others, has pointed out that for all its rhetoric of *fraternité*, Revolutionary society itself was deeply paternalistic.[77] Jacques Louis David, who lost his father at an early age, attempted to recreate a family dynamic (with himself as the father) within his studio.[78] The brotherhood once again may be understood as a rehearsal, or reiteration, of the dominant patriarchal structures, rather than their refusal.

Homoeroticism

If the relations between brothers often mimicked that of parent/child, it also echoed that of lovers. To a far greater extent than in the twentieth century, homoeroticism was incorporated into the wider bond of male attachment, and at times was seen to strengthen rather than diminish one's masculinity.

For eighteenth- and nineteenth-century educated persons, the notion of 'Greek love' remained a vital part of the classical world. Crow asserts that David and his circle were well aware of these ideas, evidenced by works such as *The Death of Socrates* (1787).[79] For Solomon-Godeau, such concepts contributed to the production of the 'ephebic male' in so many neoclassical works, like that of the *Death of Hyacinth* (1801) by the Primitif Jean Broc. The existence of male homosocial affection allowed for desire, without the taint of materiality and carnality posed by the female body. Such 'chaste' desire was also validated by the world of letters in the nineteenth century, as well as that of the monastery.[80]

These ideas saw a resurgence in the *fin de siècle*. Despite the ambiguity of F. Holland Day's sexuality (and the confirmed homosexuality of Herbert Copeland),[81] the homoerotic photographs he created (most especially those of young boys on Five Islands, Maine) must still be seen within this larger cultural context.[82] Books such as Edward Carpenter's *The Intermediate Sex* (1908)[83] and John Addington Symond's *A Problem in Modern Ethics* (1896)[84] testify to the interest in these issues among Day and his circle.

It is against such a background that we must interpret the insinuations and declarations of physical intimacy within the artistic brotherhoods. Surely there was an erotic charge to such rituals as the Primitifs bathing nude '*à la antique*' in the Seine[85] or their giving 'in the morning and in the evening the brotherly kiss'.[86] The band of Bouzingos, led by the painter-poet Petrus Borel, were evicted from his home for sitting nude in his garden.[87] Within cultures predating the scientific categorizing of sex, the spiritual, sensual and sexual were often allowed to blend in more permissible fashion, and were sanctioned by traditions both classical and Christian. Peter Cornelius described the Nazarenes as a 'brotherhood to promote art, and in an exemplary way, to love one another'.[88]

This, too, helps to situate the frequent tendency within the artistic brotherhood to cast each other within androgynous[89] or evenly distinctly feminine guise. Not only did this allow for the recuperation of the complete range of feminine and masculine traits (in a world where women had been banished), but it also gave expression to their desire for intimacy. Denis was described by his fellow Nabi Jan Verkade as one who 'resembled a young girl who had never left her mother's side'.[90] Indeed, there is no

shortage of 'androgynous' male nudes among the works of the Primitifs or, for example, the circle surrounding Rossetti.[91] Perhaps the most compelling case of this female allegorization are the several portraits created by the Nazarenes Phillip Overbeck and Franz Pforr. Pforr's *Allegory of Friendship* (1808) and Overbeck's *Shulamite and Maria* (1811) as well as the more famous *Italy and Germania* (1811–28) all allude to the friendship between the artists in the form of coupled females. The figure of Italy, for example, is largely taken to 'represent' Overbeck (smitten with the art of the *quattrocento*), while that of Germania references Pforr, with his love for the art of the North. As Overbeck stated,

What I really meant to portray, to put it in a more general way, is the yearning which the north always has for the south, for its art, its nature, its poetry, and I wanted to portray this in the form of a bride adorned for her wedding, which would represent both her own yearning and the object of her love.[92]

With such an image, Overbeck gave abstract form to his desire, confusing the bonds between friendship, love and sexual yearning. In this way the brotherhood provided for all the needs of its members, without compromising their purity or endangering their heterosexual masculinity.

By the middle of the century, however, things had begun to change. All male groups became somewhat distrustful for they 'violated the script for achieving bourgeois manhood'.[93] Masculinity came to be defined in opposition to sexual deviancy, marking an age of gender anxiety. To be *too* exclusionary was dangerous; the refusal to participate in compulsory heterosexuality could undermine one's masculinity, leaving one vulnerable to suspicion. As McLaren has written, 'Although in nineteenth-century culture bachelorhood was praised and the loss of freedom attendant upon marriage ritually lamented, the man who remained celibate could be regarded by his peers as not having attained full adult status.'[94]

Thus the brotherhoods might be suspect on many counts: for their exclusivity, their bachelorhood, their tendency to effeminize certain members. The source of the brothers' strength was also a site of vulnerability, for 'to be a man's man is separated only by an invisible, carefully blurred, always-already-crossed line from being "interested in men"'.[95] As modernist doctrine came to rely more and more upon the notion of a sexually predatory, virile, macho artist,[96] one's artistic identity as a gentle 'brother' came to be untenable. Artistic success virtually required aggressive contact with females (most often those of the lower class), a position at odds with the spiritually oriented, often 'chaste' image of the isolated male brotherhood.

The artistic sisterhood?

Thus the answer must be this, Why is not masonry open
to the female sex? Because females are not *men*.

Robert Morris, *Light and Shadows of Freemasonry* (1852)[97]

Women were excluded from brotherhoods on the basis of their sex. The
flourishing of artistic brotherhoods cannot be seen apart from the misogyny
and attempt to subjugate women that characterizes the nineteenth century
as a whole. Yet, despite all efforts to squelch them, women continued to defy
the odds and to produce art throughout the nineteenth century.[98] Was there
such a thing then as the artistic 'sisterhood'? With very rare exception, the
artistic sisterhood remained a dream, one that could hardly be envisioned,
let alone realized.

Ironically, however, the period saw a great increase in the number of working
female artists, with special institutions created to serve them. These include
the Society of Women Artists (1862) – known from 1872 as the Society of
Lady Artists – in England and the Union des Femmes Peintres et Sculpteurs
in France.[99] These societies were established in direct response to women's
strict prohibition from the important institutions like the Royal Academy
and Ecole des Beaux-Arts. Even when they managed to physically infiltrate
such male bastions, their presence was often erased or symbolically negated
(i.e. they were left out of group portraits).[100] Despite recent titles that might
imply otherwise (Tamar Garb's *Sisters of the Brush* or Jan Marsh's *Pre-Raphaelite
Sisterhood*),[101] these groups do not form the female equivalent of the
brotherhoods. In some cases, like that of Marsh's *Pre-Raphaelite Sisterhood*,
the term is really a misnomer. The women in the Pre-Raphaelite circle were
polite friends at best, and some either did not know each other at all (i.e.
Annie Miller and Jane Morris) or were openly hostile to one another. For
example, it is doubtful that any of Rossetti's paramours would have welcomed
the company of Fanny Cornforth, a prostitute whose very friendship would
have compromised their reputations.

Most female artistic unions took the form of official or regulated societies,
drastically different in aim and character from the male brotherhoods. The
Union des Femmes Peintres et Sculpteurs had the primary goal of bringing
the work of female artists to the public. Its very purpose, therefore, went
against the notion of secrecy so crucial to the ideal of the brotherhood.
Rather than obscure ritual, these 'sororities' were characterized by official,
recognized activities (such as the publication of organs like the *Journal des
femmes artistes*[102]). The term 'society' is telling: these were democratic
structures, neither aggregations nor elitist groupings. Membership was not
had on the basis of quality, and certainly not on spiritual allegiance, but in

some cases on the mere willingness to pay membership fees. Nor was the union composed of female youth: as the painter Mme Aron-Caen stated, the union existed both for the 'advancement of the older members and the flowering of the younger ones'.[103] Such groups were hardly 'counterculture' or Bohemian, but worked within the system, even as they tried to reform it.

These differences are not the result of women artists' lesser needs or aims, but of their more limited situation. The illicit congregation of females was far more threatening. Women did not have the opportunity to join clandestine societies, which already had a strong tradition among working and middle-class men. As feminist scholarship has shown,[104] Bohemia was not a space hospitable to bourgeois women. Outlandish clothing, esoteric rites, secret jargon were not only far more closely regulated among females (any divergence of conformity could serve to taint a woman's moral reputation) but likely severely punished (by labelling with terms like 'hysteria' or even incarceration in mental hospitals).[105] While the male artist could be eccentric, the female artist was insane.

This is not to imply a lack of female bonding, only that it could not be given the same form (as Jane Mayo Roos explores in her essay). With so few women having earning power, the notion of communal living arrangements becomes even less tenable. Such arrangements were possible only among the independently wealthy, that is, members of the White Marmorean Flock or the circle around Anna Mary Howitt. That being said, however, the relationships between women remained far more fluid, and in many ways less threatening, perhaps because their economic status (if not their socialization) forbad them, with some rare exceptions, to forgo marriage.

Sisters in art

In aim and living arrangements, two groups – the so-called White Marmorean Flock and the circle around Howitt and Barbara Bodichon in Munich – might legitimately be called sisterhoods. In the 1850s and 1860s, a group of unmarried American women sculptors, which included Harriet Hosmer, Louisa Lander, Emma Stebbins, Margaret Foley, Florence Freeman, Anne Whitney, Edmonia Lewis and Vinnie Ream Hoxie, lived and worked very closely together in Rome.[106] Henry James referred to them as 'a strange sisterhood of American lady sculptors, who at one time settled upon the seven hills in a White Marmorean Flock'.[107] Despite the acceptance of intimate female friendship within their culture, their bachelorette status was obviously regarded as a threat: comments on Hosmer's 'tomboy' qualities and the censor they received for exhibiting casts of female nudes clues us in to the 'gender trouble' such groups must have raised.[108]

In 1850, Anna Mary Howitt, Barbara Bodichon and Jane Benham, three independently wealthy British artists, associated with the growing suffragette movement,[109] pledged to found 'a beautiful sisterhood in Art, of which we have all dreamed long, and by which association we might be enabled to do noble things'.[110] The group engaged in shared study and communal living, inspiring other women artists such as Bessie Rayner Parkes and Eliza Fox (whose classes later became a centre for agitation against exclusion from the Royal Academy). In her memoirs, Anna Mary Howitt described the passion and joy of painting in Munich beside her fellow sister-artists Benham and Bodichon:

The clock ticked as loudly as usual: there stood the two sister easels, and sister paintings – blouse hung on each; the casts; the books, the green jug with flowers, all looked so familiar, that to set to work at once and to fancy that I had only dreamed of Justina [pseudonym of Bodichon], seemed the most natural thing. But there she really stood in the body.[111]

Bodichon conveyed her dream of an 'inner and outer Sisterhood': living together in an Associated Home, the inner sisterhood of artists would be cared for by the outer circle of women workers. This failed to come to pass, however, with Bodichon's marriage in 1857, and that of Howitt in 1859. Two years earlier, in response to a scathing critique by Ruskin, Howitt withdrew completely from painting into spiritualism.[112]

If their 'beautiful sisterhood' could not be fully realized in actuality, it was in fiction. In 1852, Anna Mary Howitt published a novella, *The Sisters in Art*, in the *Illustrated Exhibitor and Magazine of Art*. The fictional story traces the life of an orphan, Alice Law, sent to live with her uncle, a curiosity dealer named Mr Silver. Lodging with him allows Alice to continue her drawing lessons. In the course of the story, Alice meets up with two other art students, Lizzie and Esther Beaumont. With unexpected money left to her, Alice vows to form, along with her friends, 'a noble school, A Women's College of Art, worthy of the time and its needs'.[113] As if in acknowledgement of such a fragile dream, the last paragraph of the story reasserts the girls' compliance in the system of traditional heterosexuality:

It is rumored, and I believe truly, that Alice is engaged to Dr. Beaumont, Esther to the English sculptor ... and Lizzy to the eldest son of an imminent English potter. But for the present they remain together teaching and working – sisters in love and unity – as sisters in Art.[114]

The characters remain suspended in that moment before their submission to the dictates of bourgeois society, much as did the male artist in the nineteenth-century artistic fraternity.

Conclusions

The essays in this volume further the main threads and issues outlined in our introduction. The importance of the rising art market to the ideology of the brotherhood is the focus of Laura Morowitz's essay, as well as that of Mitchell Frank. Sarah Gillespie traces the spiritual doctrines of the F. Holland Day Group, while Jason Rosenfeld examines the historiography and changing identity of the Pre-Raphaelite circle. The question of utopian brotherhoods is the subject of the studies by Will Vaughan, Amy Bingaman and Polly Gray. The exclusion of women from our subject of study is redressed by both Amy Bingaman and Jane Mayo Roos.

We might note that all the groups in our study are directly linked, forming a kind of 'brotherhood of brotherhoods'. The Nazarenes have a direct impact on British artists like William Dyce, who would transmit their knowledge to the Pre-Raphaelites. Links between the Pre-Raphaelites and the later Morris Circle are well established. Elizabeth Siddall, an intimate of the Pre-Raphaelites, knew and was supported by Barbara Bodichon and members of her circle, even if she did not share their independent wealth and the sense of self-worth that would have led her in turn to join such a group. Bodichon and Howitt were among the very rare women who submitted work to the Pre-Raphaelite Folio Club, and the latter was included in an issue of *The Germ*. In the 1890s, Day was greatly interested in the work of Morris and made his acquaintance in the summer of 1893; the first intended publication of Copeland & Day was Rossetti's *House of Life.* So, too, the Abramtsevo group drew directly on the example of Morris. The links having been established, however, we hope to have shown, aside from any direct associations, that the phenomenon of the artistic brotherhood emerges out of the cultural, artistic and social milieu of the nineteenth century. In this sense, and perhaps to the chagrin of the artists themselves, these fraternities form a point of connection, rather than one of withdrawal, with the larger society that existed outside their tightly guarded walls.

Notes

1. Apart from those on the political and economic functions of the brotherhood (which were written by William Vaughan), all sections of this essay are substantially the work of Laura Morowitz. Both authors have profited greatly from their discussions about each other's sections, and the views expressed here are shared by both of them.

2. Charles Baudelaire, *Salon of 1846*. Translated and quoted in Geraldine Pelles, *Art, Artists and Society: Origins of A Modern Dilemma, Painting in England and France 1750–1850* (Englewood Cliffs, NJ: Prentice-Hall, 1963), p. 96. One cannot but note the irony here, since Baudelaire is far more commonly associated with the 'culte de moi' than with the backlash against individualism.

3. Eve Kosofsky Sedgwick, *Between Men: English Literature and Male Homosocial Desire* (Columbia University Press, 1985), p. 89.

4. There are occasional instances of a woman becoming a member of a brotherhood, for example Lucille Messageot in the case of the Barbus. However these rare exceptions do not undermine the general rule.

5. The Russian Abramstova is one such group, illuminated in the essay by Polly Gray.

6. Examples include *The Pre-Raphaelites* (Tate Gallery, 1984); Marcia Pointon (ed.), *Pre-Raphaelites Reviewed* (Manchester: Manchester University Press, 1989); Ellen Harding (ed.), *Reframing the Pre-Raphaelites: Historical and Theoretical Essays* (Aldershot: Ashgate, 1996); Claire Frèches-Thory and Antoine Terrasse, *The Nabis: Bonnard, Vuillard and their Circle* (New York: Abrams, 1991); George Levitine, *The Barbus Rebellion and Primitivism in Neoclassical France* (University Park: Penn State University Press, 1978); Klaus Gallwitz (ed.), *Die Nazarener in Rom*, exh. cat., Galleria Nazionale d'Arte Moderna, Roma (Munich: Prestal, 1981).

7. See *The Pre-Raphaelites*, 1984; Claire Frèches-Thory and Ursula Petrucchi-Petri, *Nabis: 1888–1900* (Paris: Musée d'Orsay/Zürich Kunsthaus, 1993).

8. On Hunt's construction of the brotherhood see Julie F. Codell, 'The Artist Colonized: Holman Hunt's "Biohistory", Masculinity, Nationalism and the English School', in Harding 1996, pp. 211–29; Laura Marcus, 'Brothers in the Anecdotage: Holman Hunt's Pre-Raphaelitism and the Pre-Raphaelite Brotherhood', in Pointon 1989, pp. 11–21.

9. Jason Rosenfeld discusses the way in which Hunt selected a 'core' group of Pre-Raphaelites from the 'minor' or 'lesser' members. In his later writings, Maurice Denis often 'added' members to the roster of the Nabis, such as Aristide Maillol.

10. In their essay 'Woman as Sign in Pre-Raphaelite Literature: A Study of the Representation of Elizabeth Siddall', *Art History*, 7 (June 1984): 206–27, Griselda Pollock and Deborah Cherry deconstruct the mythic history of Elizabeth Siddall's 'discovery in a hat shop'.

11. Keith Andrews, *The Nazarenes* (Oxford: Oxford University Press, 1964).

12. Certainly their artistic 'redemption' was at least in part also market driven, as the appearance of their works in upscale galleries and auction houses during this period would attest.

13. Literature and exhibition on the Pre-Raphaelites has been especially fruitful. See for example Staley and Harding, *The Pre-Raphaelite Landscape* (Oxford: Clarendon Press, 1973). Writings on Morris and his circle have become a virtual cottage industry (see the comprehensive bibliography by Fiona MacCarthy, *William Morris* (London: Faber, 1994). In 1993, the Musée d'Orsay and Kunsthaus, Zürich held the first large-scale Nabi retrospective. See Frèches-Thory and Perruchi-Petri, 1993. In the German speaking world, catalogues on the Nazarenes have appeared: Klaus Gallwitz (ed.), *Die Nazarener* (Frankfurt: Städelisches Kunstinstitut, 1977) and the catalogue from the Galleria Nazionale d'Arte Moderna, Roma, Gallwitz 1981.

14. William Vaughan, *German Romanticism and English Art* (New Haven: Yale University Press, 1979).

15. For distinctions between aggregations and male groups, see the writings of the anthropologist Lionel Tiger, *Men in Groups* (NY/London: Marion Boyars, 1969/84).

16. Charles Nodier, quoted and translated in Levitine, 1978, p. 63. Originally quoted in Etienne-Jean Délécluze, *Louis David, son école et son temps, souvenirs* (Paris: Didier, 1855).

17. For this important characteristic of the artistic school I am indebted to Renato Poggioli, *Theory of the Avant-Garde* (Cambridge, Mass.: Harvard University Press, 1968).

18. Such is the case, for example, with the Pre-Raphaelites, and the Nabis. See also Chapter 9.

19. I am grateful to Jason Rosenfeld for pointing out this important point.

20. On this subject see Grace Seiberling and Brett Waller, *Artists of the Revue Blanche*, Rochester: University of Rochester Art Gallery, 1984.

21. The Ancients' Shoreham may serve as an exception, although it is geographically very close to London, and remained focused on the London art world.

22. Georg Simmel, *The Writings of Georg Simmel*, trans. Kurt Wolff (Glencoe: Free Press, 1950).

23. The Barbus stand as somewhat of an exception, with their stronger interest in a 'primitive' classicism. This can be explained in part by the early date of the group, which precedes the Romantic obsession with the Middle Ages. It should be noted, however, that the term 'Primitif' conflated several archaic or 'primitive' styles, including both the medieval and the classical.

24. The literature on nineteenth-century medievalism is enormous and ever growing. For a general introduction see Paul Frankl, *The Gothic: Literary Sources and Interpretations through Eight Centuries* (Princeton University Press, 1960). On France see Paul Michael Driskell, *Representing Belief: Politics, Religion and Society in Nineteenth Century France* (Philadelphia: University of Pennsylvania Press, 1992) and Laura Morowitz, 'Consuming the Past: The Nabis and French Medieval Art', Ph.D. diss., New York University, 1996; On England see Edward Kaufman and Sharon Irish, *Medievalism: An Annotated Bibliography of Recent Research in the Art and Architecture of Britain and North America* (New York: Garland Publishing, 1988). On historiography and criticism see R. Howard Bloch and Stephan G. Nichols (eds), *Medievalism and the Modernist Temper* (Baltimore: John Hopkins University Press, 1995).

25. On this issue see Griselda Pollock, 'Feminity and the Spaces of Modernity' in Norma Broude and Mary Garrard (eds), *The Expanding Discourse: Feminism and Art History* (London: Harper Collins, 1992). See also the writings of Carol Duncan, *The Aesthetics of Power: Essays in Critical Art History* (Cambridge University Press, 1993).

26. The term here is Sedgwick's.

27. As George Levitine (1978, p. 76) observes 'It is hardly necessary to note that the old dream of utopia, continually recurring throughout the eighteenth century, was very much alive at the turn of 1800 – yet, amid the vast expanse of utopian systems which could have been known to the *Barbus*, a utopian group of artists and poets represented a most unusual variant on the theme.'

28. Mary Anne Clawson, *Constructing Brotherhood: Class, Gender and Fraternalism* (Princeton University Press, 1989), p. 13.

29. Ibid., p. 4.

30. For the entire quote and commentary on it, see Chapter 9.

31. Clawson 1989, p. 2.

32. Levitine 1978, p. 80.

33. Ulriche Finke, *German Painting from Romanticism to Expressionism* (London: Thames & Hudson, 1975), p. 49.

34. The granddaughter of Ranson, Madame Brigitte Ranson-Bitker indicated in personal conversation with me in 1994 that she thought the costume was merely a pictorial device and was never actually worn.

35. Clawson 1989, p. 47.

36. Alan R. H. Baker, *Fraternity among the French Peasantry* (Cambridge University Press, 1999), p. 31.

37. I am grateful to Jason Rosenfeld for his insights on this issue.

38. The Nabi members ranged from solidly middle class (Edouard Vuillard was the son of a widow who ran a corset shop) to affluent (the Nabi sculptor Georges Lacombe was independently wealthy and never sold his works for profit). Levitine claimed that the social standing of the Primitifs 'varied from poverty to wealth' (Levitine 1978, p. 55).

39. In the case of the Pre-Raphaelites, this process of transference does not apply in the sense that they constructed a powerful image of the feminine ideal. However, it should be noted that the Pre-Raphaelite Brotherhood was in many ways not typical of the more extreme forms of brotherhoods such as the Nazarenes and the Nabis. It should be remembered too that this constructed ideal is still a male-dominated one.

40. Abigail Solomon-Godeau, 'Ephebic Masculinity: The Difference Within', in *Male Trouble: A Crisis in Representation* (London: Thames and Hudson, 1997).

41. Clawson 1989, p. 146.

42. The term is used by Tamar Garb, *Sisters of the Brush: Women's Artistic Culture in Late Nineteenth-Century Paris* (New Haven and London: Yale University Press, 1994).

43. McLaren 1997; Sussman 1995.

44. To some extent, this idea is still promoted by Tiger 1969/84.

45. G. Grigsam, *Samuel Palmer: The Visionary Years* (London: Kegan Paul 1947), pp. 49, 111–12.

46. Levitine 1978, p. 77.

47. MacCarthy 1995, p. 4–12.

48. Andrews 1964, p. 34.

49. See note 1.

50. See Chapter 9, p. 189.

51. See Chapter 1, p. 34.

52. Whilst it has endlessly been debated whether a true artistic avant-garde existed before the twentieth century, there is no doubt that the term began to be used to describe progressive art and artists in France around 1830. See Linda Nochlin, 'The Invention of the Avant-Garde: France 1830–1880', in *The Politics of Vision* (Boulder, Colo.: Westview Press, 1989), pp. 1–18.

53. Holman Hunt, *Pre-Raphaelitism and the Pre-Raphaelite Brotherhood* (London: Macmillan, 1905), vol. 1, p. 114.

54. Quoted in Levitine 1978, p. 73, from Délécluze, 1855.

55. For a discussion of Freemasonry in the period, see Margaret C. Jacob, *Living the Enlightenment. Freemasonry and Politics in Eighteenth-century France* (Oxford: Oxford University Press, 1991) – see especially chapter 9, pp. 203–14.

56. Wilhelm Wackenroder, *Outpourings of An Art Loving Monk* (1797), in *Confessions and Fantasies*, trans. Mary Hurst Schubert (University Park: Penn State University Press, 1971).

57. Cornelius defined the Nazarenes as a 'brotherhood of monks' in a letter written to Carl Mossler on 10 July 1809. Quoted in Finke 1975, p. 49.

58. See Morowitz, 'Artistic Brotherhoods', below, p. 189.

59. See Samuel Palmer's *Self Portrait as Christ c*. 1833, collection of D. C. Preston and Day's *Seven Last Words* series (1898), discussed by Gillespie, Chapter 6 this volume.

60. 'Et alors – oh ce que serait beau – Je lui élèverais en plein Paris profane une somptueuse chapelle que mes confrères et moi s'ingénieraient à orner de tableaux, de fresques, de tavoles, de prédelles, de lunettes … Oh! Que ce serait beau. Et chacque année, notre société artistico-religieuse y viendrait entendre la messe avec sa toile sur les bras … L'exposition se terminerait par une seconde messe dans notre église!', Denis, *Journal*, 1 (12 August 1885) (Paris: Editions du Vieux Colombier, 1957).

61. Burcham Harding, *Brotherhood: Nature's Law* (New York: Theosophical Publishing Company, 1897), 93.

62. For a recent publication on this group see Jean da Silva, *La Salon de la Rose+Croix (1892–7)* (Paris: Syros Alternatives, 1991).

63. Edouard Schuré, *The Great Initiates: Sketch of the Secret History of Religions*, trans. Fred Rothwell, 2 vols (London: William Rider and Sons, 1913).

64. Levitine 1978, p. 46.

65. Quoted in Sussman 1995, p. 55.

66. See for example Thomas Crow, *Emulation: Making Artists for Revolutionary France* (New Haven and London: Yale University Press, 1997), which fails to problematize some of the more thorny issues surrounding David and his circle.

67. These include Sedgwick 1985, Solomon-Godeau 1997, Sussman 1995. See also Angus McLaren, *The Trials of Masculinity* (University of Chicago Press, 1997).

68. Solomon-Godeau, 1997. See Patricia Berman's excellent discussion of Frederick Holland Day and his homoerotic photographs, 'F. Holland Day and his "Classical" Models: Summer Camp', *History of Photography*, Special issue dedicated to F. Holland Day, ed. Verna Posever Curtis (Winter 1994).

69. Crow 1997, p. 20.

70. Solomon-Godeau 1997, p. 212, writes 'as a man, one was nevertheless allied in fraternity with one's bourgeois brethren in the Convention'.

71. For an excellent introduction to these issues see Jennifer Waelti-Walters and Stephen C. Hause (eds), *Feminisms of the Belle Epoque: A Historical and Literary Anthology* (Lincoln: University of Nebraska Press, 1994).

72. See Carol Duncan, 'Virility and Domination in Twentieth Century Avant-Garde Painting', in *The Expanding Discourse: Feminism and Art History* (London: Harper and Row, Icon Editions,

1992), pp. 293–314. The Guerrilla Girls are a group of anonymous women who draw attention to the sexism in the New York art world via public posters and gestures.

73. Sussman, 1995, p. 114. For a full discussion of these issues see Deborah Cherry, *Painting Women: Victorian Women Artists* (New York/London: Routledge, 1993). After the admission of Mary Moser and Angelica Kauffmann in 1769, women were barred from becoming members until 1922.

74. See Luce Irigiray's classic study, 'Women on the Market', in *The Sex Which is Not One*, trans. Katherine Porter (Ithaca: Cornell University Press, 1984).

75. This point is made by both Sedgwick 1985 and Tiger 1969/84.

76. Codell 1996, pp. 217, 221.

77. Joan B. Landes, *Women and the Public Sphere in the Age of Revolution* (Ithaca: Cornell University Press, 1988).

78. This is certainly one of Crow's major theses. Crow 1997.

79. Ibid., p. 99.

80. Sussman 1995.

81. Day's biographer, Estelle Jussim, *Slave to Beauty: The Eccentric Life and Controversial Career of F. Holland Day: Photographer, Publisher, Aesthete* (Boston: David Godine, 1981) was particularly cagey on the issue of his sexuality. While acknowledging his 'crush' on his youthful friend Jack, and his 'increasing fascination with homosexuality' (p. 99) she also insisted on insinuating a relationship between him and Louis Guirney, insisting that 'what his sex life was, nobody could tell.'

82. See Berman 1994. Also see James Crimp, 'F. Holland Day: Sacred Subjects and "Greek Love"', *History of Photography*, Special issue on F. Holland Day, ed. Verna Posever Curtis (Winter 1994).

83. Edward Carpenter, *The Intermediate Sex: A Study of Some Transitional Types of Men and Women* (London: 1908).

84. John Addington Symonds, *A Problem in Modern Ethics, being an inquiry into the phenomenon of sexual inversion ...* (London: 1896).

85. Pelles 1963, p. 85.

86. Levitine 1978, p. 80, cites this as one of their rituals.

87. Pelles 1963, p. 87.

88. Cornelius' letter to Carl Mossler (10 July 1809) quoted in Finke 1975, p. 49.

89. In a paper delivered at the panel, 'Historizing the Nation: The Nationalist Imaginary,' at the International Medievalism Conference in Kalamazoo, Michigan (6 May 1999) Cordula Grewe discussed the androgynous images of the Nazarenes in relation to nationalist ideals of the body.

90. Dom Willibrod (Jan) Verkade, *Yesterdays of An Artist Monk*, trans. John L. Stoddard (New York: P. J. Kennedy and Sons, 1930), p. 70.

91. On the Primitifs see Solomon-Godeau 1997. On Simeon Solomon see 'Simeon Solomon and Pre-Raphaelite Masculinity', in Harding 1996, pp. 195–209. On androgyny in the *fin de siècle* see Shearer West, *Fin-de-Siècle* (Woodstock, NY: Overlook Press, 1998).

92. Overbeck letter quoted in Finke 1975, p. 51. See also the images of male nudes posed in the monastery.

93. Sussman 1995, p. 143.

94. McLaren 1997, p. 55.

95. Sedgewick 1985, p. 89.

96. Duncan 1992; Pollock 1992.

97. Robert Morris, *Light and Shadows of Freemasonry* (Louisville: J. F. Brennan, 1852), p. 122.

98. For a general overview of women's art production in modern Europe see Whitney Chadwick, *Women, Art and Society* (London: Thames and Hudson, 1994); Wendy Slatkin, *Women Artists in History: From Antiquity to the Present* (Englewood Cliffs, NJ: Prentice-Hall, 1985).

99. On these institutions see Cherry, 1993; Garb, 1994.

100. This point is made by Chadwick in relation to the Royal Academy, and Solomon-Godeau in relation to David's studio.

101. Garb 1994; Jan Marsh, *The Pre-Raphaelite Sisterhood* (New York: St. Martin's Press, 1985).

102. The journal is discussed by Garb 1994, p. 6.

103. Garb 1994, p. 9.

104. Pollock 1992; Janet Wolff, 'The Invisible *Flaneuse*: Women and the Literature of Modernity', *Theory, Culture, Society*, **2** (3) (1985): 37–45.

105. See the literature on women and mental illness in the nineteenth century, for example Elaine Showalter, *The Female Malady: Women, Madness and English Culture* (New York: Pantheon Books, 1986).

106. See William Gerdts, *The White Marmorean Flock: Nineteenth Century American Women Neoclassical Sculptors*, exh. cat. Vassar College Art Gallery (Poughkeepsie, New York, 1972); Jane Mayo Roos, 'Another Look at Henry James and the "White Marmorean Flock"', *Woman's Art Journal*, **4** (Spring/Summer 1983).

107. James quoted in Chadwick 1994, p. 198.

108. On this see Mayo 1983.

109. Barbara Leigh Smith Bodichon formed the Langham Place Group and was the founder of the feminist *Englishwoman's Journal*.

110. Quoted in Cherry 1993, p. 48. For information on these women see Jan Marsh and Pamela Gerrish Nunn, *Pre-Raphaelite Women Artists* (Manchester City Art Galleries, 1997); Pamela Gerrish Nunn (ed.), *Canvassing: Recollections of Six Victorian Women Artists* (London: Camden Press, 1986); Jan Marsh and Pamela Gerrish Nunn, *Women Artists and the Pre-Raphaelite Movement* (London: Virago, 1989).

111. Howitt, *An Art Student in Munich* quoted in Nunn 1986, p. 31.

112. Nunn 1986.

113. Howitt in Nunn 1986, p. 336.

114. Ibid., p. 364.

The first artistic brotherhood: *fraternité* in the Age of Revolution

William Vaughan

The French Revolution led to a reshaping of the concept of *fraternité*, as it did to those of *liberté* and *egalité*.[1] With the rebellion against the father figure of the monarch and the hierarchical structures that supported him, a new pressure was put on 'lateral' forms of social and political organization. As Thomas Crow has expressed it recently 'a king who embodied all patriarchal authority was put to death and a republic of equal male brotherhood proclaimed'.[2] This was a principal part of the ideology of the most powerful revolutionary sect, the Jacobins, who in their many festivals emphasized a sense of sharing and community – at least as far as males were concerned.[3] Such practices brought a new sense of universality to the concept of brotherhood. Traditionally fraternities had existed as protective organizations, usually related to a religious or professional practice, functioning to promote the interests of a particular group. In Revolutionary France fraternal organizations were presented not as exclusive but as normative forms. Under the Jacobins they became the model for a system of government, the means by which power was acquired and dispensed. However, with the coming of the 'Reign of Terror' and the subsequent collapse of Jacobin power, such a universalist view of brotherhoods receded. During the Directorate more hierarchical political structures returned – a process that continued during Napoleon's regime. Yet while the universalist view of the brotherhood disappeared from government, it was not forgotten. It remained a revolutionary ideal, re-invoked in moments of political crisis as these have recurred over the centuries. It also persisted as a dream in the illusory world of art.

It is perhaps not surprising to find that the first recorded attempt to establish an artistic brotherhood in practice should have arisen in the studio of Jacques Louis David. This was the sect that called themselves the 'Meditateurs' (short for 'Meditators of the Antique'), but which has

subsequently become best known by one of its nicknames – 'Barbus' – a reference to their habit – then extremely unusual – of growing beards.

As is well known, David had a close involvement in revolutionary politics in the early years of the French Revolution, and played a leading role in the art organization of the period.[4] David seized on the Revolution as an opportunity to campaign against the hierarchical and repressive Academy of Fine Arts – a campaign that led to the institution's replacement. At the same time David responded to the concept of *fraternité* by introducing a greater degree of shared activity with his students in his own studio practice. While he remained *primus inter pares*, David encouraged the view that he and his students were engaged on a common project. This fraternalizing was an extension of the intense personal relationships he had previously established with his students. This can be seen in particular in his involvement with the brilliant young history painter Jean-Germain Drouais, who died in 1788. David both supported Drouais and used his work as a challenge and stimulus for his own productions. When Drouais died David lamented 'I have lost my emulation'.[5]

This fraternal spirit was at its height in David's studio during the Revolutionary period, when the artist was a leading member of the Jacobins. It did not, however, survive beyond their fall from power. David was imprisoned at that time and narrowly escaped execution. When he re-emerged in 1795 he was a reformed and contrite character. He was also re-instated by the new regime as a leading figure in art politics. He was made a member of the new Institut de France which was introduced to emulate some of the activities of the old Academies of the Ancien Régime. Although David himself insisted that the artist contingent in this new organization was of quite a different kind to the old Academy of Fine Arts, putting artists on a par with writers and intellectuals and equal members of the *Classe des beaux-arts et littérature* in the Institut, it nevertheless represented a re-introduction of exclusivity and hierarchical order.

This re-engagement with hierarchy can also be seen in the way that David reorganized his studio. In place of the fraternal spirit that had predominated, he now imposed a tight control on production. This was particularly noticeable in the procedure he adopted for the painting of *The Rape of the Sabines*. He had conceived the subject while still a prisoner. The huge work formed his major artistic activity between 1795 and 1799. Its subject was deliberately aimed to promote the spirit of appeasement. It showed the Sabine women who had been abducted by the Romans now intervening to prevent bloodshed between their former and current menfolk (Figure 1.1). Yet the picture which depicted a battle being halted was apparently the cause of a battle being started in the artist's own studio. According to the accounts of contemporaries, it was the problems that surrounded the style of the painting of the Sabines that goaded

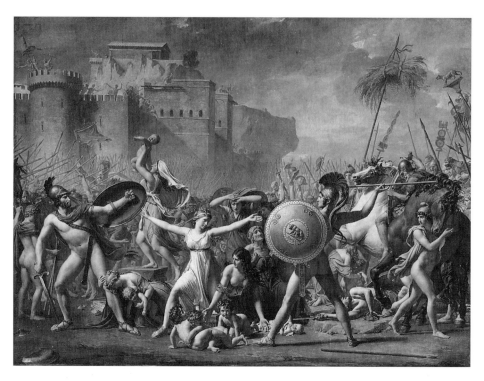

1.1 Jacques Louis David, *The Rape of the Sabines*, 1795–9

the nascent Barbus group into open opposition.[6] Recently Crow has suggested that this rebellion was the outcome as much of David's re-establishment of hierarchy in his studio practice as of disgust at the appearance of the painting itself.[7] For while a number of students were brought in to assist the master they were never allowed to manifest their individual presence in the finished work. As one observer commented 'They would do the preparing and the master would do the finishing.'[8] This might not have mattered had the students not previously experienced an earlier and more liberal regime. One of David's principal assistants on *The Sabines*, Jean-Pierre Franque, had entered the studio in 1792. The son of a shepherd, he had been recommended to David with his twin brother Joseph. David had accepted them in a letter full of revolutionary fervour in which he described his new charges as 'children of the nation'. Franque was himself staunchly radical at this time, and clearly regretted the change of regime. He became one of the members of the breakaway sect and was so vociferous in his criticisms of the master that he was eventually dismissed.

The brotherhood that formed during the painting of *The Sabines* sought in effect to challenge the master whom they felt had betrayed them. David

himself no longer espoused the fraternal principles that had guided him during the years of Jacobin ascendancy. What was worse, while he returned to the corrupt old ways, he still claimed to be a reformer, in aesthetic matters at least. For while he may have abandoned his political egalitarianism, become a bastion of the new Institute and was setting about relaunching his career with a picture on the theme of compromise, he was claiming to continue his pursuit of radicalism in purely pictorial terms. *The Sabines* was a 'radical chic' picture, adopting the popular taste for the Grecian primitive, as exemplified by the vogue for Grecian urns and the outline designs à la grecque of the British sculptor John Flaxman. The Barbus sought to call David's bluff, in parodic manner, by taking his claims to their logical conclusion. He said he was Greek. They said he was not Greek enough, that *The Sabines* was in fact no more austere or primitive than the corrupt art of the Ancien Régime. They mocked it, using epithets such as 'pompadour' and 'rococo'. They also implied censure of David's growing distancing of artistic style from personal political conviction by claiming that Grecian purity was only attainable by those who lived, as well as painted, according to the principles of the art. This was the message of the leader of the Barbus, Maurice Quai.

Maurice Quai appears by all accounts to have been a charismatic figure both in appearance and talent. Sadly neither the portrait of him that survives – one attributed to Riesener (Figure 1.2) – nor the few studies by him give any sense of this charisma. He came from a modest background – his father was a market gardener – and appears to have received a limited education. He entered David's studio in 1796, possibly like the Franque brothers being brought there because of his proletarian background, yet another son of 'the People' to receive the education of the master. It was he who began matching his critique of the softness of David's new Grecian manner with a new lifestyle. He grew his beard, adopted Grecian costume and eventually withdrew altogether from the studio. When Jean-Pierre Franque was dismissed by David this precipitated a general exodus. The group removed themselves to settle in the disused and dilapidated monastery of Chaillot on the outskirts of Paris.

When the group withdrew to the monastery to set up a communal existence they were joined by another striking figure. This was the young painter Lucile Messageot. By all accounts Messageot was a person of considerable talent and great personal allure. Contemporaries talking of her were drawn to analogies with the figures on Grecian vases and Raphael's *St. Cecilia*, as well as being put in mind of Ossian's Malvina and other literary creations.[9] Her connection with the Barbus was initially romantic. While studying painting in Paris (with an unknown master) she began an affair with Jean-Pierre Franque. They had a child in 1799, and eventually married in 1802. By

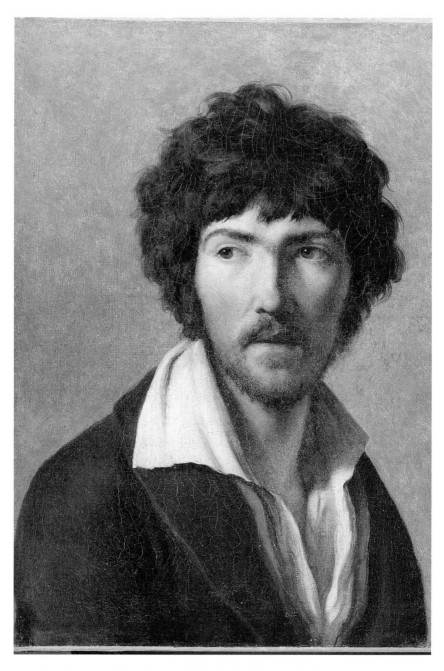

1.2 Henri-François Riesener (attrib.), *Portrait of Maurice Quai, c.* 1800

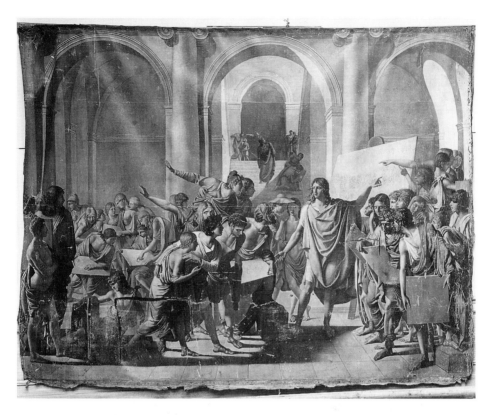

1.3 Jean Broc, *The School of Apelles*, 1800

this time she was already afflicted with consumption, the disease she died of on 23 May 1803.

For a short while after their withdrawal to Chaillot the Barbus achieved a degree of success. Some of their works, such as Jean Broc's *The School of Apelles* (1800) (Figure 1.3), caused a stir when shown at the Salon. They also began to attract followers – literary figures as well as artists. Principal amongst these was the dissident novellist Charles Nodier. It was through Nodier's accounts that we have some image of their reputation at that time. In 1880 he wrote excitedly to his friend Charles Weiss:

Have you heard anything about this society of painters and poets to whom common people referred as the *Illuminati of the Arts*, who were more generally called the *Observers of Man* and who had unassumingly named themselves *Meditators of the Antique*? You must have often heard of these young men who took pride in having resurrected among themselves the beautiful forms, the beautiful customs, and the beautiful clothes of the first centuries; of these artists who wore the Phrygian costume, who ate nothing but vegetables, who lived in common, and whose pure and hospitable life was a living picture of the golden age? Well, I have found them.[10]

Yet Nodier found them only just in time. Soon Quai and Messageot were to die and the group were dispersed. Most of the members sank into oblivion, or pursued careers as minor historical painters and portraitists, as was the case with the Franque brothers and Jean Broc.

While the revolt of the Barbus was over by 1803, they did continue to have some impact in the artistic world. David remained badly rattled by the notion that he was no longer at the forefront of aesthetic radicalism and struggled to retain his credibility as a painter of Grecian severity – a struggle that led to some of his more intractable later works, such as the gloomy *Leonidas* of 1814.[11] Similarly it can and has been argued that the revolt of the Barbus encouraged a number of other students of David to develop a new form of pictorial primitivism – notably the maverick mingling of gothic and Greek by Ingres.[12]

Yet the principal legacy of the Barbus was not to be felt for a generation, when their memory was resurrected to provide a genealogy for deviancy of the young *romantiques* of the Restoration era.

The immediate source of the revolt of the Barbus may have been their dissatisfaction with the changes in David's studio. But it was also part of a broader disillusionment with the collapse of the revolutionary ideal. In the realm of art, this signified for those with a radical view of the Grecian achievement the collapse of the possibility of the revival of excellence to match that of the antique. David was far from being the only person to look to a new dawn for art in the revolutionary fervour of the early 1790s. The critic and antiquarian Quatremère de Quincy, for example, argued that the new equality of opportunity offered by the Revolution could lead to an age of excellence that approached that of Ancient Greece. Like David, Quatremère believed that the corrupt and protectionist practices of the Academy during the Ancien Régime had been a hindrance to the achievement of true excellence. His ideas were expressed in his treatise criticizing the Academy and pressing the need for a new form of public promotion and patronage of art, his *Considérations sur les arts du dessin, suivi d'un plan d'Académie, ou d'école publique et d'un système d'encouragements* of 1791.[13] As a historian de Quincy did, it is true, also express the pessimistic view that modern art could never fully rival that of the ancient world since modern social conditions were not of the perfect kind enjoyed in Ancient Greece. In this he was following the line so forcefully argued by the German historian of Grecian art, Johannes Winckelmann.[14] On the other hand, he did feel the situation could be dramatically improved if hierarchy was replaced by open competition and judicious state support. De Quincy was indeed more extreme in the level of openness for the arts that he proposed and which he tried to implement through a series of public competitions, notably for radical revolutionary art for the Pantheon. For a time at least it seemed that the 1793 Constitution had

convinced him that if artistic reform could keep pace with the radical transformation that society was undergoing as a whole then art could once again achieve the perfection that had been present in Ancient Greece. De Quincy's radicalism was too much even for David and there was a strong suspicion at the time that when De Quincy was imprisoned during the latter days of Jacobin power David might have had a hand in it. After 1795, as the radical reforms abated in both society and in the art world, De Quincy returned to a more thorough pessimism about the necessary decline of modern art. It was such a view, too, that encouraged the Barbus to feel that they could only achieve Grecian perfection by returning themselves as artists to the state of primitive splendour of Ancient Greece. Their brotherhood would emulate the democratic form of Grecian society that had been so central to this achievement. However, now that society at large had turned away from such a project, they would have to perform it on their own.

The choice of the Sabines for David's picture was troubling not only because of the theme of reconciliation that it espoused, but also because of the dominant role that it gave women. Here again it would seem that the Barbus – who at that time were an all-male community – felt a particular threat.

The early revolutionary period had been one of insistent maleness. The rebellious brotherhoods were challenging paternalistic authority. But they were not intending to share the power that they gained with their sisters. All the imagery of the period insists on the male nature of the rebelling group. This can be seen, for example, in the popularity of oath taking, in which 'brothers' (either literal brothers or equal companions) swear to join together to defend the interests of country or class. This is the mood celebrated by David in his *Oath of the Tennis Court* (unfinished, 1791, Musée National du Château, Versailles), in which a fraternal oath is shown in the form of three representatives of the three estates joining hands to swear fraternal rebellion against the king. Visually David was drawing here on a tradition of male-dominated 'oath' pictures which included his own *Oath of the Horatii* (1784, Musée du Louvre, Paris), and Henry Fuseli's *Oath of the Rutlii* (1780, Kunsthaus, Zurich). The latter, indeed, is directly quoted in the three figures in the front of the tennis court.[15]

It should be remembered that this ideal of male fraternity was seen not as an innovation, but as the restoration of an ancient ideal condition. The democratic model provided by Periclean Athens was particularly important; but there was a more general assumption that a fraternal form of organization was a feature of the earliest civilized societies.[16]

It is striking that this spirit of sharing was not extended by the Revolutionaries to women. Indeed, moves were taken early on to maintain the family role of women and prevent them using the new found liberties of

the Revolution to start their own democratic organizations. The Jacobins, while initially supporting or at least tolerating female clubs, soon began to repress them.[17]

As well as signalling the end of revolutionary radicalism, *The Sabines* seems also to signal the end of this period of aggressive containment of female Revolutionary fervour. In his *Horatii* and *Brutus* (1789, Musée du Louvre, Paris) David had shown men of stern resolve making dangerous and unpleasant political decisions, setting country before family, privileging the male rather than the female position. *The Sabines* reverses all of this. It is not about action being taken, but about action being halted. The women throw themselves between the warring males. Instead of choosing the usual scene for artists from the story of the Sabines, in which the abduction is taking place, David shows the end of the story, when the Sabine women who have been abducted prevent their menfolk from reclaiming them.[18] There is no doubt at all that this is a deliberate scene of reconciliation, to heal the wounds in France after the Revolution. This in itself could be seen as a betrayal of the Revolution – as it most certainly was by those left-wing members of David's studio (and members of the Barbus), the Franque brothers and Broc. But worse than this was the betrayal of the male community. For it is women, not men, who are taking the action. *The Sabines* represents a community of women taking political action; something that must have resonated all the more poignantly since the Jacobins had gone to such lengths to deny women a place in public life, suppressing the female Jacobin clubs. It seems perhaps most of all that the Barbus objected to the feminity of the theme, and the suggestion implicit within it that women had a public role in politics. This is perhaps what is behind the cries of 'rococo' and 'pompadour' that Maurice Quai uttered in its presence – cries that could not really be understood within a purely stylistic context. Their own Grecian dream is severe and masculine – doubtless the beards helped to underline this.

The Barbus wished to carry on the revolution that they felt David had abandoned. They seem to have seen this failure in terms of a personal defect, a lack of male resolve. Délécluze, David's biographer who had had a first-hand experience of the Barbus in the artist's studio, recounts them as having said that

David had started the great work of artistic reform, but that the incertitude of his character and the lack of scope of his ideas had been the cause of his political downfall and did not give him the energy necessary to complete the revolution which had to be achieved in art.[19]

But there was more than aesthetics at stake here. For following the elevated view of art that David had subscribed to in the early years of the Revolution, they saw the matter as being moral and political, as well as aesthetic. Nodier

– who was allowed into the inner sanctum of the group (the studio of Franque in the Louvre) – recorded how 'It was a question of nothing less than of a reform of society based on a plan, not precisely similar to that of the Saint-Simonians, but of the same type, and which had to begin with a change of costume'.[20]

Nodier's reference to the importance of costume may have been ironic. However, the principle of 'cognitive dressing'– as it is called by sociologists – was an important one in the 1790s for signalling political affiliations. Much attention was paid to dress amongst the Revolutionaries and David himself had designed a costume for the officials of the new republic which drew upon classical antiquity to produce a decidedly 'sans culotte' look.[21] Certainly the trouserless Grecian costume adopted by the Barbus was associated by right-wing commentators with Revolutionary fervour. As the Duchess d'Abrantès recalled in her Mémoires in 1831: 'Young men were roaming in the streets, like true sans-culottes, with a little tunic, a cloak, or rather an ample toga; for, once borrowed from all types of republics, that is in order to do evil.'[22]

However this costume adaptation was taking place after the revolutionary fervour had subsided and when there had been a return to more regular modes. In the case of the Barbus this cognitive dressing – while recalling the revolutionary period – was also signalling difference. As Clawson has observed, it is a common feature of cognitive dressing in Brotherhoods that it signals group identity, simultaneously separating the group off from others and advertising this fact.[23] As with political and religious brotherhoods they used ritual and dress cognitively, to express difference and draw attention to themselves (when, according to Nodier, Napoleon asked their leader Maurice Quai (when interviewing him as a prospective drawing master for his nieces) why he adopted a type of dress 'which separates you from the world' he replied 'In order to separate myself from the world'. According to Nodier, this was a sentiment that the first consul (soon to be Emperor) recognized and approved.[24]

It should further be observed that this costume – in particular the growing of beards which gained the group their most enduring nickname – emphasized maleness and signalled a firm rejection of the 'effeminate' nature of modern male dress.

Yet there is a particular problem in the maleness constructed by the Barbus, especially in its later phases. This is caused by the presence of the female painter Lucile Messageot in their midst. Messageot's connection with the group was through romance – her alliance with Jean-Pierre Franque. But it is clear that she was a dominating presence. She did not perform the passive role of object of adoration that is seen typically in other artistic brotherhoods. She was no Jane Morris, a woman of lowly birth and poor education being

refashioned to fit the fantasies of an educated gentleman. Messageot was very much a woman of the 1790s – the kind that had developed a radical sense of independence despite the best efforts of Jacobins and reactionaries alike to keep them in their place. She is more comparable from this point of view to such leading figures as Olympe de Gouges and Mary Wollstonecraft. She came from an educated bourgeois background, lived openly with a lover, and appears to have defied social convention with aplomb.

It is hard to determine altogether what her role in the group was – although much has been achieved by Levitine in reconstructing her activities.[25] It is clear from the accounts of Charles Nodier that she was the second most important figure in the group while they were at Chaillot.[26] Her death from consumption seems to have occurred at around the time when the group definitively split up after which Franque – now a widower with a small child – began to move increasingly towards building up a conventional career.

While Messageot's role cannot be fully determined, it is striking that her presence occurred during the time when the brotherhood had definitively made a withdrawal from the public arena. This is, so to speak, the beginning of their 'private' existence, when they had abandoned David's studio to live a life of separateness. Messageot herself had not been a pupil of David's, so this move would have made it possible in any case for her to assume a more central role in the group. It did, in a sense, become her 'salon', thereby moving the group away from the male image of brotherhood to that other more common form of cultural domination organized around a female presence. It is striking that it was during the Chaillot period that the group included writers as well as artists in their midst.

Perhaps in the end it was this feminization of the group that hastened its downfall, the collapse of its cohesive power. But there were certainly other forces at work both within and without the group. On the larger scale, it might seem that the coming to power of Napoleon had its impact. Following the 'feminized' period of the Directorate there was now an emphatic return to male authority – and to an authority that the group could invest admiration in. Despite the somewhat curious encounter between Napoleon and Quai concerning the latter's dress, it seems they had many cultural tastes in common – most importantly the taste for the primitive, a passion that spread to Ossian as well as the Greeks. A strong part of Napoleon's charisma came from his successful tapping of a different kind of primitive to that of the fraternal brotherhood – that of the heroic leader. It was something that he eventually underpinned by having himself proclaimed Emperor. Before Napoleon's advent, it might have seemed there was a need for a protest group to emphasize an exclusive primitivism. Napoleon brought that back into the public arena. Furthermore, he was not one to brook opposition in

1.4 Jean-Pierre Franque, *Allegory on France Before the Return from Egypt*, 1810

cultural any more than in political matters, as was made clear by his censoring of Chateaubriand and of Mme de Stael. Amongst the Barbus, Charles Nodier, who rashly published a critique of Napoleon, came under censure.

From this point of view it is surely significant that Jean-Pierre Franque should subsequently produce a picture showing France imploring Napoleon to return from Egypt to save her. This *Allegory on France Before the Return from Egypt* was shown at the Salon of 1810 (Figure 1.4), from which it was acquired by the state. The picture is cast in a Ossianic mode and refers to the period in which the Barbus were staging their revolt in David's studio. Franque seems here to be recalling that period and seeing the solution in the new hero figure of Napoleon coming to redeem him and the others from the doldrums. Stylistically the picture has lost all trace of Grecian severity. It is evocative and fantastic, somewhat in the manner of Girodet but straying even further from that in its rejection of hard-edge forms.[27]

The Barbus have long held honoured places in the history of the avant-garde. Their ill-fated fraternal protest has been seen as one of the early signs of that development of alternative artistic practices that was eventually to generate a fully fledged avant-garde in France in mid-century. For the most part the accounts of the brotherhood, even by those who were members of the group like Nodier or had first-hand experience of the group like Délécluze, were not written until the 1820s and 1830s, by which time the romantiques and the vogue for the *vie bohème* were dominating the artistic world. Indeed, it was the experience of this new form of oppositional art and artistic life that caused the reminiscences to be written down, and it is hard to avoid the conclusion that the prescient nature of the group was exaggerated in part to provide more recent developments with a genealogy. Such accounts almost certainly exaggerated the idealism of the group, the tragic pathos of Quai, since such matters helped to reinforce the elevated view of art and the dedicated nature of the work produced. Above all it seemed to secure the concept of art from contamination with practical and commercial considerations.

Yet in the end, can one be so certain that this really was what was going on? For the establishment of an alternative group identity – underpinned by cognitive dressing – was also an attention-seeking device, and one that was practised by other groups with success. While turning their backs on society in one sense, the Barbus still made their presence felt and, most important of all, sought a public arena for their art through the Salon. The use of the Salon to launch novelties was a strategy already successfully practised by their master, David. As Thomas Puttfarken has shown, David's striking deviancies in historical picture making – deviancies that brought him constant criticism from the Academy and from academic critics – were aimed at the new growing art public of the later eighteenth century. This public was broad – broader than in other countries at the time – and was already beginning to be a powerful market force in its own right, acting increasingly independently of the tenets of the Academy. David's impatience with the Academy was essentially fuelled by this tension. By contrast, he saw exhibition as the means by which originality could address the public at large and win approval.[28] With *The Sabines* he took the further step of exhibiting outside the Salon, mounting his own exhibition and charging entry for it. In a leaflet accompanying this exhibition David justified this practice, drawing attention amongst other things to the way in which it was already common in Britain. On one level it gave the artist a new form of independence. On another it was a thoroughly commercial speculation – one that in this case led to David amassing a substantial profit.[29] David was certainly bringing art more firmly into the market-place by this strategy. He even increased the sensationalism of the whole event by a particularly skilled piece of *coup de théâtre*. This was

the inclusion of a large mirror in the room in which *The Sabines* was displayed. This allowed people to look in the mirror and see themselves actually standing before the picture. There are accounts of how sometimes the women – in their classical dresses – almost became confused with the painted Sabines themselves.[30] There could have been no more dramatic way of emphasizing that the act of reconciliation being carried out in the picture was a direct association with the events taking place in the lives of the spectators in Paris at that time. This dramatic bringing together of art and life could not be imitated as such by the Barbus. But they were addressing an audience already accustomed to confusing shifts between the real and the imaginary. Were these intense young men togged up in Greek gear in their midst genuine or part of some elaborate show? Like most of the artistic brotherhoods that followed them, this group of 'separated' individuals were using their separateness as a marketing ploy, as a means of drawing attention to themselves, or stressing originality and sincerity.

There is one way in which they did perhaps differ from brotherhoods later in the nineteenth century. They still lived at a time when professional independence for the fine artist seemed to be an attainable goal. David's assumption of the role of the impresario for his own show was an example of this, and it is significant that he drew attention to British precedents for such action. For it was both through the organization of special shows and the management of the production and sale of engravings that many British artists, from Hogarth onwards, had become commercially self-sufficient. At the same time as the Barbus were advertising their separateness, other groups were forming to establish independent identities with a view to enhanced commercial success. The London group of water-colourists who styled themselves 'The Brothers' were seeking to establish a new identity for water-colourists at a time when such work was felt to be prejudiced against it in the Academy.[31] Led by the innovative water-colourist Thomas Girtin, they used fraternal group identity to set up a new practice – one that eventually encouraged the founding of a separate water-colour society. It has been argued, too, that the Norwich society of artists was based on a similar situation. Even more successfully, a few years later, the Lukasbund was established in Vienna by a group of disaffected Academy students. In their later guise as the Nazarenes, this group became internationally famous, the first artistic brotherhood to achieve such a feat. In all these cases artists themselves assumed the leading role in the management of the group's affairs. This was different from most organizations, where dealers, patrons and connoisseurs tended to have the upper hand.

Looking back at the Barbus, it would seem that this was the context in which they, too, hoped to succeed. Instead they encountered failure. But for a later generation that very failure became the symbol of their authenticity.

However, by that time the market for contemporary art was firmly in the hands of the dealers. The days of the entrepreneurial artist were over – at least in the sphere of fine art – as were those of the Revolutionary fraternity.

Notes

1. M. David, *Fraternité et Révolution* (Paris, Aubier, 1987), pp. 10–11.

2. T. Crow, *Emulation: Making Artists in Revolutionary France* (New Haven and London: Yale University Press, 1995), p. 1. The key text for pioneering the understanding of the use of imagery of the period to articulate revolts against the father figure is Carol Duncan 'Fallen Fathers: images of Authority in Pre-Revolutionary France', *Art History*, **IV** (June 1981): 186–202. See especially p. 199.

3. For an account of the Jacobin Clubs and their organizational structure see Michael L. Kennedy, *The Jacobin Clubs in the French* Revolution (Princeton University Press, 1982). For a discussion of these in the context of fraternity see especially pp. 4–10 and p. 303. See further A. R. H. Baker, *Fraternity among the French Peasantry: Sociability and Voluntary Associations in the Loire Valley, 1815–1914* (Cambridge University Press, 1999) pp. 46ff.

4. Crow, 1995, p. 31.

5. Ibid., p. 1.

6. P. Coupin, *Essai sur J.-L. David* (Paris, 1927), p. 63.

7. Crow, 1995, pp. 185–6.

8. 'Ils préparaient et le maître terminait', Coupin, 1927, p. 63.

9. G. Levitine, *The Dawn of Bohemianism: The 'Barbu' Rebellion and Primitivism in Neoclassical France* (University Park: Penn State University Press, 1978), p. 47.

10. Jean Larat, *Le tradition de l'exotisme dans Charles Nodier* (Paris, Edouard Champion, 1923), p. 23. Translation from Levitine, 1978, p. 75.

11. *Léonidas aux Thermopyles*, 1814, 395 × 531 cm, Musée du Louvre, Paris.

12. Robert Rosenblum, *Ingres* (New York: Abrams, 1967), p. 10.

13. Yvonne Luke 'The Politics of Participation: Quatremère de Quincy and the Theory and Practice of "Concours publiques" in Revolutionary France 1791–1795', *Oxford Art Journal*, vol. 10, 1987.

14. A. Potts, *Flesh and the Ideal: Winckelmann and the Origins of Art History* (New Haven: Yale University Press, 1994), p. 14.

15. A. Schnapper, *David* (1980), p. 106.

16. M. A. Clawson, *Constructing Brotherhood: Class, Gender, and Fraternalism* (Princeton University Press, 1989), p. 4.

17. Helen Weston, 'The Corday-Marat Affair: No Place for a Woman', *Jacques-Louis David's Marat*, ed. W. Vaughan and H. Weston (Cambridge: Cambridge University Press), p. 144.

18. Crow, *Emulation*, p. 185. For a discussion of the positive stance of women, see Louise Juliet-Govier, '"Invisibles et presentes par-tout": re-viewing women from the ancient past in late Eighteenth-Century French Art', Ph.D., U.C.L., Univ. of London, 1999, pp. 145ff.

19. *From Delacroix to David*, p. 90.

20. Ibid., p. 71. Levitine, 1978, p. 63.

21. Records of these are preserved in drawings in the Musée Carnavalet. See Schnapper, 1980, pp. 146–8.

22. *Mémoirs* (1831), vol. 1, p. 140; Levitine, 1978, pp. 66–7.

23. Clawson, 1989, p. 36.

24. Charles Nodier, 'Les Barbus', *Le Temps*, 5 October 1832. Quoted in Levitine, 1978, p. 2.

25. Levitine, 1978, pp. 47–8, 109–10, 118–20.

26. Ibid., p. 109.

27. *De David à Delacroix; Le peinture française de 1774 à 1830* (Paris: Grand Palais, 1974), no. 61, pp. 418–19.

28. Thomas Puttfarken, 'David's *Brutus* and theories of pictorial unity in France', *Art History*, **4**(3) (September 1981): 291–304.

29. M. E. J. Delécluze, *Louis David. San école et son temps*, Paris, Didier, 1855, p. 243.

30. Ewa Lajer-Burchart, 'David's *Sabine Women*: Body, Gender and Republican culture under the Directory', *Art History, XIV* (Sept. 1991) pp. 406–7.

31. Jean Hamilton, *The Sketching Society, 1799–1851* (London: Victoria and Albert Museum, 1971), pp. 1–13.

The Nazarene *Gemeinschaft*: Overbeck and Cornelius

Mitchell B. Frank

In 1812 Franz Pforr died and Peter Cornelius took his place as co-leader, with Friedrich Overbeck, of the Lukasbund or the Brotherhood of St Luke, now frequently referred to as the Nazarenes. A line is frequently drawn between an early phase of the Brotherhood (1808–12), when the artists formed a closed and 'insular student group', and a mature phase (1812–19), when the Brotherhood was a more outward-looking and socially active 'association of like-minded artists'.[1] This division is due to a perceived incompatibility between the inner focus of the first phase, which is usually seen as static and confining, and the outer focus of the mature phase, seen as dynamic and liberating. A critical point of no return has been created, beyond it the Brotherhood either comes to an end or loses its focus, splintering into two factions, a religious one led by Overbeck and a classical/nationalist one led by Cornelius.[2] In this essay I propose to examine the evolution of the Nazarene brotherhood through a discussion of historical and historiographical issues that have been used to characterize the division between early and mature phases. In particular, I will turn to the notion of *Gemeinschaft* (community), which Ferdinand Tönnies brought into sociological use in his 1887 book *Gemeinschaft und Gesellschaft*, and which has often been employed to describe the *Lukasbund*.[3] If Tönnies' notion of community is understood not as being incompatible with its polar opposite, society at large (*Gesellschaft*), but rather as always co-extensive with it, then the Brotherhood's evolution can be seen as a continuum. I will show how the *Lukasbund*, throughout its existence, always defined itself through an interplay of two concepts, that of an enclosed community and that of a larger arena beyond.

A *Gemeinschaft* is a community in which its members live together in harmony, each working for the betterment of the group. Communal life, according to Tönnies, is 'real and organic' as compared to the artificial and mechanical structure of society at large.[4] In the community, one derives

one's identity from the group and acts altruistically. In society each individual is isolated and self-interest determines action. The *Gemeinschaft/Gesellschaft* opposition stems from a distinction between inner life and outer world: the internally focused life is led in accordance with one's true natural self as compared with a life focused on the outer world, characterized by artificiality and custom. As Tönnies puts it: 'All intimate, private, and exclusive living together … is understood as life in Gemeinschaft. Gesellschaft is public life – it is the world itself.'[5]

Tönnies' work includes a series of oppositions which relate to his two main categories:

Gemeinschaft (community) vs. *Gesellschaft* (society)
female vs. male
artistic people vs. sophisticated people
youth vs. old age
common people vs. educated classes
morality vs. shame
belief vs. disbelief

Gesellschaft, Tönnies believed, was the dominant social structure of the nineteenth century, and so, like many sociologists of his time, he saw his era as having distinctive and novel characteristics. One can think of other similar oppositional theories: Weber's traditionalism vs. rationalization or Simmel's non-monetized vs. monetized economies, for example.[6] For Tönnies there is a sense of the inevitability of modernization, for he believed that 'a period of Gesellschaft follows a period of Gemeinschaft'.[7]

To describe the *Lukasbund* as a *Gemeinschaft* is not necessarily anachronistic: Tönnies' categories, to a great degree, had already been formulated by members of the Romantic circle in Berlin and Jena in the late 1790s and were part of the mindset of the painters that formed the Nazarene brotherhood in 1808. For Friedrich von Hardenberg (Novalis), Friedrich Schlegel, Ernst Daniel Schleiermacher and their set, the result of enlightenment principles, especially as embodied in Revolutionary France, was civil society (*bürgerliche Gesellschaft*), in which self-interest and rationalism were the motivating forces and material needs the primary focus. Friedrich Schlegel believed that 'the bourgeois man is first and foremost fashioned and turned into a machine' and that life was being approached as 'a common trade'.[8] The only way to remedy the modern condition, in which man 'had lost his sense of community, his feeling of belonging to a group', was through *Gemeinschaft*, communal life.[9] As Novalis put it in one of his aphorisms, 'flight from communal spirit [*Gemeingeist*] is death'. And Friedrich Schlegel called for a republic, where there would be a 'true community of morals [*Gemeinschaft der Sitten*]'.[10]

These concerns were shared by the members of the *Lukasbund*. When it was formed in 1808, Europe was then under the control of Napoleon's empire, the effects of which the artists felt not in an abstract but in a very tangible way. They were in Vienna when Napoleonic troops entered in 1809, and when the group arrived in Rome in 1810 the city was under French control. Moreover, established social structures were under attack: 'The French overthrew the existing secular and ecclesiastical princes, abolished the tithe, ended seigneurialism, eliminated guilds, overturned monopolies, nullified privileges, emancipated the Jews, introduced religious toleration, and secularized church lands.'[11] For the Nazarenes and other Germans, these changes were very much felt as an effect of the French Revolution. The formation of the Brotherhood of St Luke can thus be considered an enactment, perhaps reactionary in nature, of Romantic political principles. As I will argue in this essay, the Brotherhood, as a *Gemeinschaft*, both removed itself from and at the same time was constituted within the social, that is public, realm.

In 1808 a group of disgruntled students at the Viennese Academy began meeting three times every fortnight in order to show each other their work 'communally [*gemeinschaftlich*]' and have it 'critiqued honestly'.[12] In 1809 the Brotherhood was formally established: 'we joined hands and an association [*Bund*] was founded, which will, we hope, remain solid'.[13] The Brotherhood originally had six members: Friedrich Overbeck, Franz Pforr, Joseph Sutter, Konrad Hottinger, Ludwig Vogel and Joseph Wintergerst. Overbeck and Pforr were considered the group's leaders, as Sutter stated in a letter to Overbeck of 1810: 'You are our priest and Pforr is our master. Religion and wisdom guide us through you, dearest ones, accompanied with the blessing of heaven.'.[14] The religious nature of the group was clear from the start: their chosen name referred to the patron saint of painting, St Luke, who was depicted in the group's device designed by Overbeck. This device was to appear on the back of every painting finished by a member and approved by the group. It also appeared on the diploma (Figure 2.1) received by each brother. These diplomas gave the group's statement of purpose:

In lasting memory of the guiding principle of our order, truth, and of the promise to remain true to this principle all our lives, to work towards it with all our strength, and to work enthusiastically against every academic manner.[15]

As this statement suggests, the painters were dissatisfied with their training at the Viennese Academy, which was then under the directorship of Heinrich von Füger, a pupil of Anton Raphael Mengs. The mode of instruction at the Academy was based upon an eclectic and transformative version of imitation recommended by Mengs: the skilful painter, like a bee, 'gathers from all the creations the best and most beautiful parts'.[16] Mengs advised that students

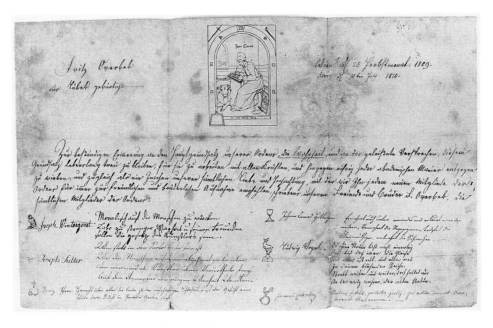

2.1 Friedrich Overbeck's *Lukasbund Diploma*, 1809

study aspects of the great masters and combine them in order to surpass their models.

With specific artistic goals in mind, the Brothers of St Luke rejected this training on the grounds of inconsistency. Writing to his father, Overbeck cites the academic precept whereby the novice must learn to compose like Raphael, to paint like Titian, to shade like Correggio, and to combine all these estimable qualities with the powerful personal style of Michelangelo. Yet such a painter, Overbeck declares, 'has not considered that these different merits are so opposed to one another as to be impossible to bring together'.[17] In place of the academic model of technical proficiency, the Brothers strove for artistic sincerity or authenticity. They thus looked to pre-Renaissance masters, painters from the past who practised what they considered to be a plain or natural style. For Overbeck, the works of the early Raphael, Giotto and Masaccio show an execution which 'flowed entirely out of feeling and not from acquired skill'.[18] Pforr, with Winckelmanian flair, praised the 'noble simplicity' of the Old German painters: 'Here was no bravura of the brush, no bold method of treatment, everything there was simple, as if it had not been painted but had grown.'[19] Pforr distinguishes here between the academic style, considered to be ornamental and artificial, and a simpler style, defined as organic and natural. For the Nazarenes natural, to invoke the terms of classical rhetoric, does not relate so much to the imitation of *natura naturata*

as it does to the creative aspect of *natura naturans*. An organic, natural or pure style has to do with the painter's self, a self that has not been corrupted, as, for example, by the mannered and decadent Academy with its penchant for eclecticism. In the view of Frank Büttner, the Nazarenes reinterpreted imitation (*Nachahmung*) as following (*Nachfolge*), a notion with distinct spiritual overtones.[20] The Nazarenes followed artists they deemed sincere and considered themselves equally sincere in their own practice. Their anti-academic declaration is thus a criticism of the academic painter's inauthenticity, in that his work does not make reference to or reflect his inner self. The 'guiding principle' of the Brotherhood, as stated on their diplomas, was 'truth', which meant in part creating works that were true to and expressive of one's personal nature. In this vein, Overbeck hopes: 'If only one day I could become an Overbeck.'[21]

In May 1809, the Viennese Academy was closed due to the Napoleonic invasion of Vienna, and when it was reopened later that year, Overbeck, Pforr and Vogel were not readmitted. These three along with Hottinger decided to travel to Rome, which they all longed to see. On 15 May 1810 they left Vienna and, after visiting Venice, Urbino and other places of interest, they arrived in Rome on 20 June 1810. The four lived in the Villa Malta for a few months before moving into the monastery of St Isidoro for a two-year stay. This Irish Franciscan monastery, although secularized due to Napoleonic decree, was not completely abandoned; some of the Franciscan monks, including the prior, still lived there. This did not stop the Brothers of St Luke, the *Klosterbrüder* as they came to be called, from enacting their ideal of a communal life that fused art and religion. They spent time alone in their cells; in the evenings they met in the refectory to draw together after models and to discuss their work. Overbeck, at this time, wrote to his father: 'Now we thus become monks!'[22]

In pursuing their ideal life of monastic solitude, the Brothers were consciously attempting to revive quattrocento art and life. Concerning one of his role models, Fra Angelico, Overbeck wrote in his diary: 'How pure the soul of the pious Fiesole [Fra Angelico] must have been, how so entirely without longing, entirely devoted to the heavenly, that is Christian love! how strict and regulated his monastic way of life!'[23] It was Goethe who pointed out Wackenroder's faulty syllogistic reasoning, which the Brothers of St Luke seem to have adopted as well: it does not follow that because some monks were painters, all painters ought to be monks.[24] But in living like monks, the artists were replacing the model of the academic painter with the role of the monk-artist. They were trying to authenticate their work through their lifestyle. As Pforr, in agreement with Overbeck, states: 'a painter, in order to be great, must be not only an artist, but also a human being.'[25] This notion of authenticity is a common theme in Romantic writing. Friedrich

Schlegel, for example, puts it this way: 'He who does not have and does not know the inward life, cannot reveal it magnificently also as artist.'[26]

In St Isidoro Overbeck and his Brothers believed that they had created a pure world separate from quotidian life, an artistic realm in which spirituality had pride of place. Pforr clearly states this belief in a letter to Johann David Passavant, in which he cites the Franciscan virtues: 'I would like to ask the man, who wants to consecrate himself to art, what we ask the man who wants to become a monk: can you take and observe the vows of poverty, chastity, and obedience? If so, enter.'[27] Pforr's remark preserves the distinction between the Nazarenes and actual monks, while erasing the distinction at the same time. This moulding of art and religion is also evident in the oddly traditional type of imitation they practised in the social sphere. In playing the role of the monk-artist, the Brothers were following a pattern that had already been outlined in Vasari's 'Life of Fra Angelico' and was reiterated by Wackenroder in his *Confessions from the Heart of an Art-Loving Friar*.[28] The various qualities attributed to Fra Angelico can be found in Overbeck's device for the Brotherhood of St Luke portraying their patron saint (see Figure 2.1): seclusion, austerity, devotion to God and to an art inspired by God. In his diary, Overbeck expressed the tenets of this creed as follows: 'only an orderly, pure, and innocent way of life provides the tranquillity of spirit and mind which is absolutely necessary in order to bring forth truly pure works'.[29]

Overbeck, more than any other, professed a desire for purity. Already in Vienna, he asserts that the young painter 'above all guards his feelings, he never allows so much as an impure word to pass through his lips, so much as an impure thought to enter into his soul'. He must aspire to the blessed state of Raphael, who 'felt himself to be pure, and his heart … full of divine feelings'. In order to protect himself, to guard his spiritual centre, Overbeck decides not to study anatomy from cadavers or from female models: 'I prefer to draw less correctly,' he announces, 'than certainly damage my feelings, which are the artist's greatest treasure.'[30] The state of purity that Overbeck sought was free not only of the systematization of the academy but also of the world of matter, corrupting and corruptible. His decision not to work after cadavers and naked women, much like his resolve to enter into a cloister-like seclusion with his fellow Brothers in St Isidoro, was an attempt to keep himself whole, impermeable to the world of death and sex.

This notion of protection is also an ingredient of the friendship that unites the members of the Brotherhood. Unlike other friendship groups, which helped launch their members into public life, the Brotherhood of St Luke provided shelter against the temptations of the world.[31] The Brotherhood exemplifies what George Mosse attributes to the rise of respectability in the nineteenth century: 'The sentimentality of eighteenth-century friendship was

going out of fashion as friendship became an act of almost religious chastity and dedication.'[32] Overbeck shows such dedication in a letter, in which he describes his friendship with Pforr:

> We were separated from everyone and lived only for ourselves and for art; we were shut away from all others, only we both were one. We always began our pictures together and tried to finish them at the same time. Pforr loved the Middle Ages and painted stories from them; I preferred the bible and chose my subjects from it.[33]

Overbeck here characterizes his relationship with Pforr in terms of both a sense of unity and an individual integrity. Friendship is viewed as a complementarity whereby two individuals complete one another to form a greater whole. In such male friendships, as Mosse explains, eroticism 'was difficult to banish', but more often than not 'it was combined with a quest for sexual purity'.[34] Such an understanding of friendship accords well with the Nazarenes' chaste ideal.

The Nazarenes' insistence on individuality, their decision to form a community of artists with like beliefs, and the community's medieval model should all be understood, as I argued above, in relation to principles laid down by the Romantic circle in Berlin and Jena in the late 1790s. The artists' construction of a *Gemeinschaft*, of a world within a world, a pure realm where friendship had pride of place, countered the *Gesellschaft*, with which they were dissatisfied because they felt it to be materialistic and corrupted. To yearn for purity is to yearn for an original or natural condition or a return to this state, if additions or mixtures have occurred.[35] Mary Douglas argues that purity should be seen in the context of a society's beliefs regarding pollution: for there to be a concept of purity, there must also be the concept of dirt or 'matter out of place'.[36] Purification rituals are procedures that re-establish order; they are a reaction to a situation that is deemed ambiguous or anomalous or to a world that is felt to be in crisis. This is exactly the situation felt by the Nazarenes in Napoleonic Europe with all its changes and upheavals: through the creation of an enclosed community, the artists were striving 'to keep the body (social and physical) intact'.[37] The artists believed that by keeping themselves pure they could change the world outside the Brotherhood for the better.

The Nazarenes' social agenda has been described as a criticism of the notion of autonomous art developed in the German tradition from Kant to Schiller. 'Only by giving up its autonomy,' Frank Büttner asserts, 'could art [according to the Nazarenes] resume its true place in the life of the people.'[38] In rejecting this enlightenment notion, Manfred Jauslin argues, the Nazarenes attempt to re-unite art and life through the revival of a historical model (the Middle Ages) in which art and life had been as one.[39] But it should be pointed out that while the Nazarenes' intention may have been to challenge

the enlightenment notion of art as an end in itself, they nevertheless adopted a strategy that contains elements of the notion they were trying to defeat. In making claims to purity, the Nazarenes removed themselves from the quotidian world. And such a removal perpetuates the bourgeois conception of the artist as marginal to society and as needing this marginality in order to create works that can move the viewer into a realm beyond the everyday. To understand the utility of this material/spiritual distinction one must go back to the emergence of the bourgeoisie, when it was important to be able to claim that status should not depend upon inherited rank but rather on personal worth. The spiritual and/or the artistic realm erased all privilege and provided a new starting point for measuring merit. It is just such a levelled hierarchy that Overbeck describes in a letter to his father in which he makes a case for the superiority of Catholicism to Protestantism. He argues that within the Catholic church, there are no class distinctions.

And in the [Catholic] churches, is not it wonderful how all differences of class are removed before God? There the beggar kneels next to the counts and princes, the woman next to the man, the child next to the old man, and everyone beats his breast humbly and thinks: God have mercy on me, the poor sinner … Oh why is this equality of classes before God removed with us? Why do we go into the church, as we go to the theatre, not to pray but rather to listen to preaching? Why is it that we do not kneel anymore?[40]

What we have here, to use Peter Paret's phrase, is an 'embourgeoisement of the Middle Ages', a sentimental conception of an older, humbler faith characterized by equality and universality.[41] The same kind of equality in worship applies to the enlightenment notion of autonomous art: those who create works of art and those who contemplate and are improved by these works must be equally reverential. Art appreciation, in fact, is often described in religious terms. Francesco Francia, in Wackenroder's *Confessions*, even becomes canonized as a martyr 'of art enthusiasm'.[42] Art returns one to wholeness by moving one into a religious realm or an aesthetic one (or by collapsing one into the other). Art protests against the evils of this world by projecting an image of a better world. But this movement, as Peter Bürger has written of autonomous art, is one into 'semblance' only, with the result that the social status quo is relieved 'of the pressure of those forces that make for change. They are consigned to confinement in an ideal sphere.'[43]

If the first phase of the Nazarene brotherhood should be seen in terms of an interaction between *Gemeinschaft* and *Gesellschaft*, then so too should the second. In 1812, Franz Pforr dies and the painters leave the monastery of St Isidoro. These events mark the end of the first phase. In the second phase, 1812–19, the Brotherhood is led by Overbeck and Peter Cornelius, who arrived in Rome in 1811 and joined the Brotherhood in 1812. By early 1813, the make-up of the group had changed substantially: Overbeck was the only

original member remaining in Rome and the ranks had been filled by Cornelius, Wilhelm Schadow and by 1815 Philipp Veit and others. This second phase is defined frequently more by the artists' endeavours than by their social interaction. It is the period when the artists exhibit patriotic pride, gain contracts for work and have exhibitions and parties for prospective patrons.

From the outset, Cornelius's convictions were more nationalist. After being in Italy for just a few months, he writes to his friend Karl Mosler (March 1812): 'I tell you, Mosler, and believe it strongly: a German painter should not leave his fatherland!'[44] Cornelius's nationalism was of course connected to the political situation: the German nations were at that time at the mercy of Napoleonic France. Fichte had earlier claimed in his *Addresses to the German Nation* of 1808 that the true German has not strayed from his original habitat.[45] Cornelius puts forward nationalist concerns again in an often quoted letter of 1814 to the Catholic journalist Josef Görres. This letter was written after Napoleon's first defeat when there was more optimism for the German cause. Cornelius states his belief that 'the [German] nation is free, free by its own strength and virtue and through God, who has conferred this freedom upon it; it knows this strength and longs for its primary source in everything positive.'[46] Cornelius again seems to be putting forth Fichtean principles: freedom is the original and essential nature of the German people. For Fichte and Cornelius, freedom includes not only political freedom from external rule, but also, in the Kantian tradition, freedom of action in accordance with moral law. And this type of freedom can only come about through education (*Bildung*): for Fichte, philosophy is at its core; for Cornelius, in the tradition of Friedrich Schlegel, Novalis and other Romantics, art is the essential endeavour. Cornelius makes just this point when he states, in the same letter to Görres, that fresco painting is 'the infallible means to give German art the appropriate direction for the foundation of a new great age and spirit of the nation'.[47]

Because of his ardent beliefs and powerful rhetoric, Cornelius has been regarded as Overbeck's opposite in terms of character and strengths. This has been an important reason for the division between an early Nazarene phase and a mature one. Art historian and Cornelius biographer Ernst Förster, for example, writes that 'Cornelius was born a Catholic with the soul of a reformer, while Overbeck was born a Protestant with the soul of a Catholic.' Furthermore, fate assigned them complementary spheres of activity: Cornelius, the stronger one, was called back to the fatherland to engage with the present, while Overbeck, 'the quieter, more withdrawn one, stayed behind in Rome to live an almost monastic existence'.[48] Johann Sepp, in a commemorative speech given in Munich on the occasion of Overbeck's death in 1869, reiterates the frequent comparison of Overbeck and Cornelius with their Renaissance predecessors:

Raphael's meeting with Michelangelo could not be more logical than Cornelius's meeting with Overbeck ... Next to the powerful masculine nature of Cornelius one discovers Overbeck, certainly more feminine; he represents conciliatory feeling next to critical understanding, holy poetry next to philosophy, belief next to science.[49]

In the literature, Cornelius is often praised at Overbeck's expense. Förster wants to make it clear that Cornelius, due to 'his healthy, entirely German' nature was 'a dam against the hyperromantic flow' started by Overbeck.[50] Alfred Kuhn, in his 1921 Cornelius monograph, distances Cornelius from Overbeck with the suggestion that Overbeck and the original members of the Brotherhood were 'non-German, Jewish' in nature, as compared to the heroic, robust and very German Cornelius.[51] Kuhn furthermore insinuates that the friendship bond between the first members of the Brotherhood was homosexual in nature (a *Männerbunderotik*), while Cornelius 'possessed a robust Rhineland sexuality'.[52]

In the comparison of Overbeck and Cornelius, there is a similar array of oppositions to the ones that define, as discussed above, *Gemeinschaft* and *Gesellschaft*. It should come as no surprise that Overbeck is regarded as embodying the enclosed and communal Nazarene movement, as compared to Cornelius the great and patriotic public painter. Overbeck is considered the artist who best personifies Nazarene values and who never relinquishes them: 'Overbeck is the only one who took up this direction with conviction, developed it fully with artistic ingenuity, and preserved it with faithful love.'[53] His decision to stay in Rome, rather than return to Germany, is taken as evidence for this view. On the other hand, it is often mentioned that Cornelius did not stay in St Isidoro, the monastery, and that he was continuously working on his very German Faust and Nibelungenlied drawings while in Italy.[54] Cornelius returns to Germany and becomes the great painter of the fatherland. So Tönnies' formulation of societal development parallels the characterization of the Nazarene brotherhood: just as a period of *Gemeinschaft* gives way to a period of *Gesellschaft*, so the first phase of the Nazarenes, dominated by Overbeck, gives way to the second, dominated by Cornelius.

I do not want to suggest that Overbeck's and Cornelius's reception later in the century is independent of the actions and works of the painters themselves. Actually, Overbeck and Cornelius construct selves and play roles which bear out their subsequent reception. Overbeck chooses not to work after cadavers and the female nude to protect his purity, and he converts to Catholicism. In short, one can say that he, more than any other Nazarene, successfully played the role of the monk-artist. Cornelius, on the other hand, portrayed himself much more as the proficient painter pursuing the cause of German nationalism. While Overbeck's monk-artist persona immediately suggests a separation from the world at large in its asceticism and purity,

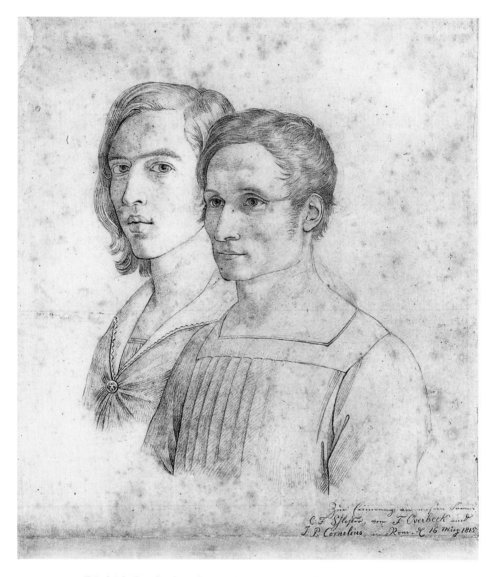

2.2 Friedrich Overbeck and Peter Cornelius, *Double Friendship Portrait*, 1815

Cornelius's suggests an engagement with the world, an attempt to conquer the public sphere.

The *Gemeinschaft/Gesellschaft* opposition may help us see the differences between these two leaders of the Brotherhood of St Luke and the two phases of the Brotherhood, but the case should not be stated too strongly. Just as there can be no *Gemeinschaft* without *Gesellschaft*, so Overbeck's self-

representation as the monk-artist is constituted in the social, that is public realm. And Cornelius's notion of the ideal German nation is an extension of the communal, or what he called 'republican', nature of the Brotherhood to the world beyond.[55] Furthermore, this sense of community and friendship still existed among the members of the Brotherhood in the second phase. In their double friendship portrait of 1812 (Figure 2.2), Overbeck and Cornelius depict each other one behind the other, suggesting a unity of purpose that is apparent in other such group friendship portraits.[56] Their mutual admiration is evident in this image as it is in their letters. Cornelius writes in 1812 that the 'gentleness of soul and the power of [Overbeck's] noble spirit, has gathered all the others around him ... [H]e is true humility and modesty personified.'[57] In August of that same year, Overbeck writes to his parents after the death of his closest friend Franz Pforr that 'my friend Cornelius is before all others, he who replaces [Pforr] for me, the same striving also binds me with him in a spiritual friendship'.[58]

Overbeck and Cornelius, as their double portrait suggests, saw themselves as fighting the same cause.[59] This unified front is apparent in many activities that the artists took part in. For example, they were among a group of artists (some within the Brotherhood, others without) who held parties, nationalist in character, to celebrate the first defeat of France in 1814 and Dürer's birthday in 1815. In 1818, they held a party for Ludwig I, then Crown Prince of Bavaria, on the occasion of his departure from Rome. The event was to honour the prince as patron of the arts, a theme evident in the painted decorations for the party, which showed the great patrons of the arts (including Lorenzo de Medici and popes Leo X and Julius II) and the great artists (including Giotto, Dürer and Raphael).[60] However the Nazarenes' most important artistic endeavour while in Rome, and the one for which they gained the most fame in Germany, was the Bartholdy frescos.

The fresco cycle from the life of Joseph was commissioned by Jakob Salomon Bartholdy, the Prussian Consul General in Rome. He wanted Prussian artists to decorate a sitting room in his residence, the Palazzo Zuccari. Three of the four painters originally chosen were from the Brotherhood (Cornelius, Veit and Schadow). Overbeck, the only non-Prussian, was asked to join the ranks a bit later when Franz Catel decided to participate only in a limited fashion. (He painted two small landscapes.) Interpretations of these frescos have connected the paintings with their sources (such as Raphael and Pinturicchio), with German Nationalism (they are said to herald the rebirth of German painting), with the Brotherhood's Christian beliefs (Joseph is seen as a forerunner of Christ), and with the artistic principles of the Brotherhood (truth and authenticity).[61] What has hardly been discussed is the story itself, with its theme of brotherhood versus the larger world, and its importance to the artists themselves. In the first scene, painted by Overbeck,

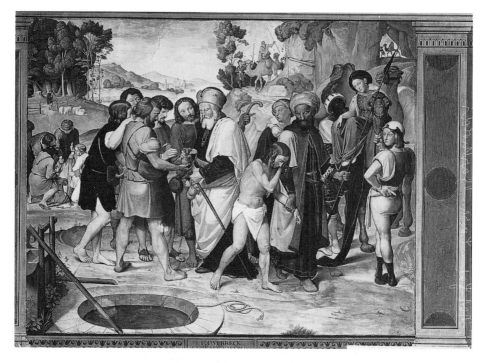

2.3 Friedrich Overbeck, *Joseph Sold by his Brothers*, 1816

Joseph is sold by his brothers (Figure 2.3). The old Ishmaelite (with white beard, red dress and white cloak) in the centre of the composition is the dividing line between the world within and without the Brotherhood. With the exchange of Joseph for money, he is expelled from his blood brotherhood and becomes a commodity in a foreign world. In this world, Joseph is valued only in terms of the self-interest of others.[62] When Potiphar's wife covets Joseph, as depicted in Veit's fresco, he is esteemed for his beauty. In the scene in jail, as painted by Schadow, the winemaker and baker value Joseph for his ability to interpret dreams. Cornelius depicts Joseph before the pharaoh and his courtiers, who appreciate Joseph again for his ability to read dreams and his ability to manage the resources of the nation. In the final scene (Figure 2.4), also by Cornelius, Joseph is reconciled with his brothers, but only after he tests them to make certain that they will not treat Benjamin, the youngest brother, as a commodity. When they pass the test, Joseph knows that they have changed in that they now understand the true meaning of brotherhood. In Cornelius's fresco, the bodily gestures and facial expressions of the brothers show their fear, surprise, shame and repentance. Joseph's embrace with Benjamin is the climax of the story in that it provides narrative

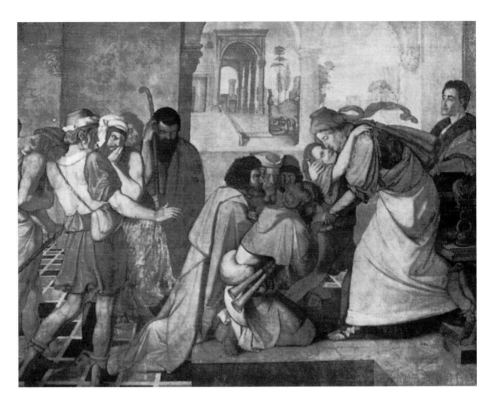

2.4 Peter Cornelius, *The Recognition of Joseph by his Brothers*, 1816

closure: Joseph, who was led away from his brothers in the first scene, is reunited with them through a gesture that shows brotherly love and friendship. This embrace illustrates what Joseph, in Thomas Mann's *Joseph and his Brothers*, says at this point of the story: 'the great thing of all is that we are twelve once more'.[63]

In the Bartholdy frescos, the artists of the *Lukasbund* continue to espouse the idea of an enclosed community or *Gemeinschaft* in contrast to the *Gesellschaft* or the world at large. A very different idea of the group is suggested in Carl Philipp Fohr's drawings of the Café Greco, a popular meeting place for German artists in Rome (Figure 2.5). Fohr, although not an official member of the Brotherhood, was very much involved in Nazarene activities in Rome before his early death in 1818. In this and other drawings of the café, Fohr depicts Overbeck, Cornelius and Veit around a table (on the right side) in a coffee house, as part of a larger contingent of German artists in Rome.

Cafés, like salons and reading societies, were part of the bourgeois public sphere, so well described by Jürgen Habermas: an inclusive arena in which

2.5 Carl Philipp Fohr, *The Café Greco in Rome*, 1818

status is disregarded, where discussions are of issues of 'common concern', and where everyone is welcome to participate.[64] In the Café Greco, as Fohr's drawings show, the Nazarenes did not isolate themselves; they did not think of themselves as separate from society at large. Rather they were active participants in public life. That the Nazarene brotherhood displays different aspects, some more insular, others more open, suggests that Tönnies' *Gemeinschaft*/*Gesellschaft* categories are helpful, not as exclusive opposites, but rather as concepts that are mutually dependent upon one another. As such these categories assist us in understanding the Nazarene brotherhood and other communities like it.

Notes

1. Robert McVaugh, 'The Casa Bartholdy Frescoes and Nazarene Theory in Rome, 1816–1817', Ph.D. diss., Princeton University, 1981, p. 32. A similar break is also suggested in Keith Andrews, *The Nazarenes* (Oxford: Clarendon Press, 1964), p. 33.

2. For the view that the Brotherhood comes to an end with Pforr's death, see Richard Benz and

Arthur Schneider, *Die Kunst der deutschen Romantik* (Munich: Piper, 1939), p. 98. For the view that the group loses its unity after Cornelius's arrival in Rome, dividing between religious and secular pursuits, see Athanasius Graf Raczynski, *Geschichte der neueren deutschen Kunst*, trans. Friedrich Heinrich von der Hagen, 3 vols (Berlin, published by the author, 1836–41), vol. I, pp. 49–52; William Vaughan, *German Romantic Painting* (New Haven: Yale University Press, 1980), p. 177.

3. Kurt Lankheit and Nikolaus Pevsner make reference to the sociological theory of *Gemeinschaft* in their discussion of the Nazarenes. See Lankheit, *Das Freundschaftsbild der Romantik* (Heidelberg: Carl Winter, 1952), p. 97; Pevsner, 'Gemeinschaftsideale unter den bildenden Künstlern des 19. Jahrhunderts', *Deutsche Vierteljahrsschrift für Literaturwissenschaft und Geistesgeschichte*, **9** (1931): 126. For a more recent discussion of the communal ideal, see Ursula Peters, 'Das Ideal der Gemeinschaft', *Künstlerleben in Rom: Berthel Thorvaldsen (1770–1844)*, ed. Gerhard Bott and Heinz Spielmann (Nürnberg: Germanisches Nationalmuseum, 1991), pp. 157–87.

4. Ferdinand Tönnies, *Community and Association*, trans. Charles P. Loomis (London: Routledge and Kegan Paul, 1974), p. 37.

5. Ibid.

6. Derek Sayer, *Capitalism and Modernity: An Excursis on Marx and Weber* (London: Routledge, 1991), pp. 11–12.

7. Tönnies 1974, p. 270.

8. Friedrich Schlegel, 'Über die Philosophie', *Kritische Friedrich-Schlegel-Ausgabe* (Munich: Verlag Ferdinand Schöningh, 1963), vol. VIII, pp. 49–50. As quoted in Frederick C. Beiser, *Enlightenment, Revolution, and Romanticism: The Genesis of Modern German Political Thought, 1790–1800* (Cambridge: Harvard University Press, 1992), p. 234.

9. Beiser 1992, p. 231.

10. Novalis, 'Blütenstaub', *Novalis*, ed. Walther Rehm (Frankfurt: Fischer, 1956), p. 82; Schlegel, 'Versuch über den Begriff Republikanismus', *Kritische Friedrich-Schlegel-Ausgabe* (Munich: Verlag Ferdinand Schöningh, 1963), vol. VIII, p. 18. Both quoted in Beiser 1992, p. 235.

11. David Blackbourn, *Fontana History of Germany, 1780–1918: The Long Nineteenth Century* (London: Fontana Press, 1997), p. 71.

12. Franz Pforr, letter to Johann David Passavant (9 August 1808), as quoted in Jens Christian Jensen, 'Über die Gründung des Lukasbundes', *Der Wagen. Ein Lübeckisches Jahrbuch* (1958), p. 116: 'Wir haben jetzt hier eine kleine Gesellschaft von angehenden Künstlern errichtet, wobei wir uns unsere Arbeiten gemeinschaftlich vorlegen, und über die dann brav rezensiert wird. Wir kommen alle 14 Tage dreimal zusammen.'

13. Franz Pforr, 'Geschichte des Studiums in Wien', in Margaret Howitt, *Friedrich Overbeck: Sein Leben und sein Schaffen*, 2 vols (Freiburg: Herder'sche Verlagsbuchhandlung, 1886; reprint Bern: Herbert Lang, 1971), vol. I, p. 86: 'Wir gaben uns die Hände, und ein Bund war geschlossen, der hoffentlich fest bestehen soll.'

14. Sutter, letter to Overbeck (4 December 1810), Howitt 1886, I, p. 159, n. 1: 'Du bist unser Priester und Pforr ist unser Meister. Religion und Weisheit leiten uns durch Euch, Geliebteste, mit dem Segen des Himmels begleitet.'

15. Howitt 1886 I, p. 102: 'Zur beständigen Erinnerung an den Hauptgrundsatz unseres Ordens, die Wahrheit, und an das geleistete Versprechen, diesem Grundsatz lebenslang treu zu bleiben, für sie zu arbeiten mit allen Kräften, und hingegen eifrig jeder akademischen Manier entgegen zu wirken.'

16. Anton Raphael Mengs, 'Reflections upon Beauty and Taste in Painting', *The Works of Anthony Raphael Mengs, First painter to the Catholic Majesty Charles III*, tr. from the Italian (London, 1796), vol. I, p. 19.

17. Overbeck, letter to his father (Vienna, 5 February 1808), Howitt, 1886, I, pp. 68–9: 'Wer nun gar verlangt von einem jungen Künstler, er müsse sich bestreben, weil Rafael der größte in der Composition war, so componiren zu lernen wie Rafael, weil Tizian der größte Maler war, so malen zu lernen wie Tizian, weil Correggio am größten im Helldunkel war, so beleuchten zu lernen wie dieser, oder wohl weil Michel-Angelo den mächtigsten größessten Stil besessen hat, sich diesen Stil zu eigen zu machen, und alle diese Vorzüge vereinigen: der zeigt, daß er wenig von der Sache verstehe; daß er nicht bedacht habe, daß diese verschiedenen Vorzüge einander so widersprechend sind, daß es sich gar nicht zusammen denken läßt.'

18. Overbeck's diary (15 September 1811), Howitt, 1886, I, p. 176: 'Giotto, Masaccio u. – weil bei ihnen die Ausführung ganz aus der Empfindung herfloß und nicht aus erworbener Fertigkeit.'

19. Pforr, 'Geschichte des Studiums in Wien', Howitt 1886, I, p. 83: 'Die edle Einfalt sprach mit der bestimmten Characteristik laut an unser Herz, hier war keine Bravur des Pinsels, keine Kühne Behandlungsart, einfach stand alles da, als wäre es nicht gemalt sondern so gewachsen.'

20. Büttner, 'Der Streit um die "Neudeutsche religios-patriotische Kunst"', Aurora, 43 (1983): 66.

21. Overbeck, letter to his father (Vienna, 5 February 1808), Howitt 1886, I, p. 68: 'wenn ich denn nur einmal ein Overbeck werde'.

22. Overbeck, letter to his father (Rome, 29 September 1810), in P. Hasse, 'Aus dem Leben Friedrich Overbecks: Briefe an Eltern und Geschwister', Allgemeine konservative Monatsschrift für das christliche Deutschland, 45 (1888): 39: 'Nun werden wir also Klosterbrüder!'

23. Overbeck's diary (9 October 1811), Howitt 1886, I, p. 182: 'Wie rein mag die Seele des frommen Fiesole gewesen sein, wie so ganz leidenschaftlos, ganz der himmlischen d. i. der christlichen Liebe hingegeben! wie streng und pünktlich sein klösterlicher Lebenswandel!'

24. Goethes Werke, ed. Sophie von Sachsen (Weimar: Hermann Böhlau, 1892), XXXV, p. 141: 'Einige Mönche waren Künstler, deßhalb sollen alle Künstler Mönche sein.' This quotation is often cited in the literature on the Nazarenes. See, for example, Rudolf Bachleitner, Die Nazarener (Munich: Wilhelm Heyne, 1976), pp. 17–18. For a discussion of Goethe's reaction to Wackenroder's Herzensergiessungen (in which this passage from Goethe is also cited), see Schubert's introduction to her translation of Wackenroder's Confessions and Fantasies (University Park: Pennslvania State University Press, 1971), pp. 12–15.

25. Pforr, 'Geschichte des Studiums in Wien', Howitt 1886, I, p. 81: 'daß ein Maler, um groß zu sein, nicht allein Künstler sondern auch Mensch sein muß'.

26. Friedrich Schlegel, 'Gemäldebeschreibungen aus Paris und den Niederlanden', Kritische Friedrich-Schlegel-Ausgabe (Munich: Verlag Ferdinand Schöningh, 1963), vol. IV, pp. 149–50: 'Wer das innre Leben nicht hat und nicht kennt, der kann es auch als Künstler nicht in großer Offenbarung herrlich entfalten.'

27. Pforr, letter to Passavant (Rome, 15 December 1810), Fritz Herbert Lehr, Die Blütezeit romantischer Bildkunst. Franz Pforr der Meister des Lukasbundes (Marburg: Verlag des Kunstgeschichtlichen Seminars der Universität Marburg, 1924), p. 275: 'Ich möchte den, der sich der Kunst weihen will, fragen, wie man einen, der Mönch werden will, fragt: kannst Du das Gelübde der Armut, der Keuschheit und des Gehorsams ablegen und halten, so tritt ein.'

28. Vasari, Lives of the Artists, trans. George Bull (London: Penguin, 1965), vol. I, pp. 204–6; Wackenroder 1971, p. 145.

29. Overbeck's diary (9 October 1811), Howitt 1886, I, p. 182: '[N]ur ein ordentlicher reiner und unsträflicher Lebenswandel giebt ihm diejenige Ruhe des Geistes und Gemüthes, die unumgänglich nothwendig ist um wahrhaft reine Werke hervorzubringen.'

30. Overbeck, letter to his father (Vienna, 27 April 1808), Howitt 1886, I, pp. 171–2: 'Der junge Maler also wache vor allen Dingen über seine Empfindungen, er lasse nie so wenig ein unreines Wort über seine Lippen, wie einen unreinen Gedanken in seine Seele kommen. ... Und fühlt [Raphael] sich rein, und hat er sein Herz gefüllt mit heiligen Gefühlen. ... Aus der Ursache bin ich auch jetzt entschlossen, die Anatomie nicht nach Cadavern zu studieren, weil man doch dadurch gewisse seine Empfindungen abstumpft ... [und] nie nach dem weiblichen Modell zu studieren aus eben der Ursache. Lieber will ich weniger richtig zeichnen, als gewisse Empfindungen einbüßen, die des Künstlers größter Schatz sind.'

31. Manfred Jauslin, Die gescheiterte Kulturrevolution (Munich: Scaneg, 1989), p. 52.

32. George Mosse, Nationalism and Sexuality (New York: Howard Fertig, 1985), p. 76.

33. Overbeck, letter to August Kestner (Vienna, 24 March 1810), in August and Charlotte Kestner, Briefwechsel zwischen August Kestner und seiner Schwester Charlotte, ed. Hermann Kestner-Köchlin (Straßburg: Karl Trübner, 1904), p. 359: 'Wir sonderten uns von allen anderen ab und lebten nur uns und der Kunst; gegen alle andern waren wir verschlossen, nur wir beyde waren Eins. – Unsre Bilder fingen wir immer zusammen an, und suchten sie zu gleicher Zeit zu vollenden. Pforr liebte das Mittelalter und malte Geschichten daraus, mich zog die Bibel besonders an, und ich wählte daraus meine Gegenstände.'

34. Mosse 1985, p. 67.

35. In the Grimm dictionary 'pure' (rein), in the material sense, is defined as 'free from foreign mixing, free from any additions'. See Jacob and Wilhelm Grimm, Deutsches Wörterbuch (Leipzig: S. Hirzel, 1893), p. 681: 'frei von fremdartiger beimischung [sic], von geringerem zusatze [sic]'.

36. Mary Douglas, Purity and Danger (London: Ark Paperbacks, 1966), p. 35.

37. Ibid., p. 140.

38. Büttner, 'The "Official" Art of Romanticism as a Synthesis of the Arts', *The Romantic Spirit in German Art 1790–1990*, ed. Keith Hartley *et al.*, exh. cat. Royal Academy of Art, Edinburgh (Stuttgart: Oktagon, 1994), p. 307. For the heteronomous view of Overbeck's art, see Berthold Hinz, 'Der Triumph der Religion in den Künsten: Overbecks "Werk und Wort" im Widerspruch seiner Zeit', *Städel-Jahrbuch*, **7** (1979): 149–70.

39. Jauslin 1989, p. 196.

40. Overbeck, letter to his father (Rome, 29 April 1811), Hasse 1888, p. 44: 'Und in den Kirchen, wie herrlich ist es nicht, daß aller Standesunterschied vor Gott aufgehoben wird? Da kniet der Bettler neben dem Grafen und Fürsten, das Weib neben dem Manne, das Kind neben dem Greise und Alles schlägt demüthig an seine Brust und denkt: Gott sey mir armem Sünder gnädig! ... O warum ist diese Gleichheit der Stände vor Gott wohl bei uns aufgehoben? warum geht man wohl in die Kirche wie ins Theater, nicht um zu beten, sondern peroriren zu hören? warum kniet man wohl nicht mehr bei uns?'

41. Peter Paret, *Art as History* (Princeton: Princeton University Press, 1988), p. 131.

42. Wackenroder 1971, p. 90.

43. Peter Bürger, *Theory of the Avant-Garde*, trans. Michael Shaw (Minneapolis: University of Minnesota Press, 1984), p. 50.

44. Cornelius to Karl Mosler (Rome, March 1812), Ernst Förster, *Peter von Cornelius*, 2 vols (Berlin: Georg Reimer, 1874), vol. I, p. 117: 'Ich sage Dir, Mosler, und glaube es fest: ein deutscher Maler sollte nicht aus seinem Vaterland gehen!'

45. Fichte, *Addresses to the Geman Nation*, trans. George Armstrong Kelly (New York: Harper and Row, 1968), p. 47.

46. Cornelius to Joseph Görres (Rome, 3 November 1814), Förster 1874, I, p. 153: 'daß die Nation frei ist, frei durch ihre eigne Kraft und Tugend, und durch den Gott, der sie verliehen; sie kennt diese Kraft und sehnt sich nach der Urquelle in allem Positiven'.

47. Cornelius, letter to Joseph Görres (Rome, 3 November 1814), Förster 1874, I, p. 155: 'Jetzt aber komme ich endlich auf das, was ich, meiner innersten Ueberzeugung gemäß, für das kräftigste und ich möchte sagen unfehlbare Mittel halte, der deutschen Kunst ein Fundament zu einer neuen, dem großen Zeitalter und dem Geist der Nation angemessenen Richtung zu geben: ... die Wiedereinführung der Fresco-Malerei.'

48. Förster, 'Die deutsche Kunst in Rom', in *Athanasius Graf Raczynski, Geschichte der neueren deutschen Kunst*, trans. Friedrich Heinrich von der Hagen (Berlin, 1836–41), vol. III, p. 325: 'Cornelius ist mit der Seele eines Reformators als Katholik, Overbeck mit der eines Katholiken als Protestant geboren. Das Schicksal hat beiden einen geschiedenen Wirkungskreis angewiesen: den kräftigeren freieren zu thätigen, umfassenden Eingreifen in die Gegenwart ins Vaterland gerufen; den stilleren, sich beschränkenden in die Eingezogenheit eines fast klösterlichen Lebens in Rom gelassen.'

49. Johann Nepomuk Sepp, 'Friedrich Overbeck. Gedächtnißrede in der Künstlerversammlung zu München', *Allgemeine Zeitung*, **359–60** (1869): 6: 'Raffaels Zusammentreffen mit Michel Angelo konnte nicht folgewichtiger sein als Cornelius' Begegnung mit Overbeck. ... Neben der männlichen Kraftnatur des Cornelius empfindet Overbeck allerdings mehr weiblich; er repräsentirt das allversöhnende Gemüth neben dem kritischen Verstand, die heilige Poesie neben der Philosophie, den Glauben neben der Wissenschaft.' For the comparison of Overbeck and Cornelius to Raphael and Michelangelo, see also A. Hagen, *Die deutsche Kunst in unserem Jahrhundert* (Berlin: Heinrich Schindler, 1857), vol. I, p. 182; Franz Binder, 'Zur Erinnerung an Friedrich Overbeck', *Historischpolitische Blätter für das katholische Deutschland*, **65** (1870): 573; J. Beavington Atkinson, *Overbeck* (London: Sampson Low, Marston, Searle, and Rivington, 1882), p. 20.

50. Förster, 1874, I, p. 126: 'Bald aber hatte [Cornelius] sich selbst wieder gefunden und wurde mit seinem weit überwiegenden Talent, mit seiner freien, allem Großen und Hohen in Kunst und Leben zugewandten Bildung, seiner gesunden, grunddeutschen, wahrhaftigen Natur ein Damm gegen die hyperromantische Flut.'

51. Alfred Kuhn, *Peter Cornelius und die geistigen Strömungen seiner Zeit* (Berlin: Dietrich Reimer, 1921), p. 89: 'Sagt man also, wie es geschehen ist, der Nazarenismus sei undeutsch, jüdisch, so ist dies so wahr und so falsch, als solche Formulierungen zu sein pflegen.'

52. Ibid., pp. 107–8.

53. Franz Kugler, 'Fragmentarisches über die Berliner Kunstausstellung vom J. 1836', *Museum*, **39** (1836), reprinted in *Kleine Schriften über neuere Kunst*, vol. 3 of *Kleine Schriften und Studien zur Kunstgeschichte* (Stuttgart: Ebner & Seubert, 1854), p. 177: 'Overbeck ist der Einzige, welcher diese Richtung mit Ueberzeugung in sich aufgenommen, mit künstlerischer Genialität durchgebildet und mit treuer Liebe bei ihr ausgeharret hat.'

54. Alfred Freiherr von Wolzogen, *Peter von Cornelius* (Berlin: Carl Duncker, 1867), p. 20; David Koch, *Peter Cornelius. Ein deutscher Maler* (Stuttgart: J. F. Steinkopf, 1905), p. 49; Christian Eckert, *Peter Cornelius* (Bielefeld and Leipzig: Velhagen & Klasing, 1906), p. 35.

55. Cornelius, letter to Karl Mosler (Rome, March 1812), Förster 1874, I, p. 120: 'Da aber unser Verein republikanisch ist, so muß und soll ein Jeder das Herz eines Jeden gewinnen, weil die Liebe ist das Band.' ('Since our association is republican, each one must and should win the heart of the other, because love is the bond.') Cornelius is here using 'republican' in the romantic sense of the term. As Frederick Beiser argues, the Romantics 'believed that the true community will come into existence only through the liberty, equality, and fraternity of a republic' (Beiser 1992, p. 223).

56. Lankheit 1952, p. 126. For a more recent discussion of this work, see Hinrich Sieveking, *Fuseli to Menzel: Drawings and Watercolors in the Age of Goethe from a German Private Collection* (Munich: Prestel, 1998), p. 94 (cat. 29).

57. Cornelius, letter to Karl Mosler (Rome, March 1812), Förster 1874, I, p. 118: 'Overbeck aus Lübeck ist derjenige von ihnen, der durch die Milde seiner Seele und die Kraft seines edlen Geistes die Andern alle um sich versammelt … Dabei ist er die wahre Demuth und Bescheidenheit selbst.'

58. Overbeck, letter to his father (Ariccia, 20 August 1812), Hasse 1888, p. 49: 'Mein Freund Cornelius ist es vor allem jetzt, der mir ihn (Pforr) ersetzt, gleiches Streben verbindet mich auch mit ihm zu inniger Freundschaft.'

59. For the compatibility of Cornelius's early view of art with that of the Nazarenes, see Frank Büttner, *Peter Cornelius. I: Fresken und Fresken Projekte* (Wiesbaden: Franz Steiner, 1980), pp. 56–8.

60. For a discussion of this party and the decorations, see Frank Büttner, 'Die Kunst, die Künstler und die Mäzene. Die Dekorationen zum römischen Künstlerfest von 1818', *Romantik und Gegenwart: Festschrift für Jens Christian Jensen zum 60. Geburtstag*, ed. Ulrich Bischoff (Cologne: Dumont, 1988), pp. 19–32.

61. For a thorough treatment of the history, original placement and various interpretations of these frescos, see Robert McVaugh's dissertation, 'The Casa Bartholdy Frescoes and Nazarene Theory in Rome', and his article 'A Revised Reconstruction of the Casa Bartholdy Fresco Cycle' *Art Bulletin*, **66** (1984): 442–52. McVaugh himself persuasively argues that the frescoes illustrate the Nazarene ideal of truth and authenticity.

62. W. Lee Humphreys, *Joseph and his Family* (Columbia: University of South Carolina Press, 1988), p. 87.

63. Thomas Mann, *Joseph and his Brothers*, trans. H. T. Lowe-Porter (Harmondsworth: Penguin, 1978), p. 1115.

64. Jürgen Habermas, *The Structural Transformation of the Public Sphere*, trans. Thomas Burger (Cambridge, Mass.: MIT, 1989), pp. 36–7.

The Pre-Raphaelite 'otherhood' and group identity in Victorian Britain

Jason Rosenfeld

When the *Illustrated London News* of 4 May 1850 revealed the meaning of the mysterious initials 'PRB' that had appeared inscribed on three paintings exhibited in 1849, the floodgates opened for a torrent of writings on the Pre-Raphaelite Brotherhood and its formation, predecessors, aims, accomplishments, inter-member relationships and legacy.[1] Such writings defined the PRB as a movement, and combined to form its history or, at least, a certain history. I want to take issue with some of the assumptions and constructions that run through written texts pertaining to the group and its art. That often-overlooked appendage 'Brotherhood' forms an essential image of the artists' and writers' communality, their masculinity, their secretiveness and their union. But what was the significance of the term 'brotherhood' for these seven young men in 1848 and then, a few years later, when the group became 'subject to the usual laws of modernist fission'?[2] While connecting the Pre-Raphaelites with modernist artists and writers presents a somewhat unsteady project in pictorial terms, in their activities and the ways in which they were received such artist groups from the nineteenth century did set precedents for later modernist identifications in the twentieth century. With this notion of a brotherhood linked to past artisanal traditions and a pseudo-nostalgia for medieval communal practices, the Pre-Raphaelites sought to romanticize the cooperative modern experience, but pressures of a commercial and public nature ultimately destabilized their project and led to the group's splintering.

In this essay I will discuss precursors for such a group formation and I will analyse the extent of the Pre-Raphaelites' success and failure in forming a brotherhood, how they worked divisively against one another, and how this is construed in later descriptions of the movement. I will also look at the disunity revealed in their self-imaging, with emphasis on the use of each other in early subject paintings and portraits, and on the differences from the

traditional and subsequent forms of self-imaging in the historical avant-garde.

Artistic groups in the nineteenth century

In mid-nineteenth-century Britain, groups of artists formed in wilful opposition to a larger more powerful authority were not welcomed by a staid artistic culture heavily dominated by the Royal Academy. Innovation in art was not a problem point; after all, inventive individual artists had frequently found their works accepted by official exhibitions, and they form the backbone of nationalist constructions of British art history. But the clamour that ensued in 1850 from the revelation of the meaning of the initials PRB exposed a deep distrust in artistic and critical establishments of even the most mildly oppositional groups. It reflected a general fear of insurrection in the nation as Britain sought isolation, politically and socially, from events occurring on the continent.

Subsequently, historians have tended to make rather large claims for the Brotherhood, linking them to medieval guilds or crusaders banded together in a spirit of chivalry and loyalty for a common cause. Frequent comparisons with King Arthur's Knights of the Round Table, while appealing in terms of pure romance and symbolic nationalism, bear little relation to the facts of the group's orientation or approach. Such simplistic analogies only serve to fictionalize and historicize the PRB.[3] For Dante Gabriel Rossetti to write, in 1853, of John Everett Millais's election to the Royal Academy as an associate, 'so now the whole Round table is dissolved', was simply the poet being poetic. Despite their interest in Malory, Arthurian knights were not the precedents the PRB were looking for in their union. In this sense, Allen Staley's description of the artists as giving themselves 'a corporate unity' is more effective and appropriate and will inform much of my discussion.[4]

More relevant are parallels with the French Primitifs and the German St Luke Brotherhood or Nazarenes.[5] The Primitifs were satirically referred to as the Barbus, the bearded-ones, and their fame and name were more a result of their bohemian physical appearance than their scant artistic productions since, despite the sparkling pedigree of having come out of David's studio, they were seemingly the least industrious of his many students. Their 'sect' encompassed a few core figures, but was marked by an indeterminacy of membership; it did not operate in a formal fashion (see Chapter 1). For a time, the group resided in the ramshackle ruin of the Convent of the Visitation de Sainte Marie in Chaillot.[6] This utopian enclave's 'atmosphere of cloistered meditation' replicated a communal form of primitivism apart from what was viewed as the dominant rationalism of the day, and resulted in more of

a lifestyle choice than an artistic retreat. The Primitifs promulgated a spiritual existence based on shared experiences, literature and contemplation, but in a pursuit of a primitivism aimed more at a social change and evincing a cultural phenomenon than an aesthetic current.

The Primitifs' relative obscurity and small number of works could not be further from the artistic productivity and religious ideals of the St Luke Brotherhood (SLB), whom the PRB more closely resembles (see Chapter 2). The German artists had articles of incorporation, a code of ethics and an emblem intended for the backs of paintings.[7] In 1810 the SLB lived in a Rome monastery as the *Fratelli di San Isidoro*, working in solitude during the day and gathering at night for meals, readings, sketching and companionship. Their practice of wearing flowing robes and letting their hair and beards grow to great lengths 'alla nazarena', earned them the depreciatory name Nazarenes. The group did not hold formal meetings, and they decided on new members not through voting but rather by general agreement, unlike the PRB who never expanded.[8]

If the SLB was a Pre-Raphaelite Brotherhood predecessor it was more as a like-minded artistic and stylistic inspiration than as a concise formative blueprint. The PRB had personal contact with a number of artists who had worked under Nazarene painters, such as Ford Madox Brown and William Dyce (1806–64), but, significantly, they later denied any German influence in order to make their own movement seem more original.[9] William Holman Hunt and John Ruskin (1819–1900) firmly rejected Nazarene ideas on revivalism and naturalism,[10] despite the apparent German influence on the PRB's early sketches and finished drawings, the British group's most stylistically unified works. Even so, the specific connections between the Nazarenes and the Pre-Raphaelites are somewhat forced; after all, the German movement was 40 years old at the time of the PRB's inception. By that time the multivalent term Nazarene referred to a wide range of Christian revivalist art on the continent.

Aspects of these two continental movements were unappealing to at least one member of the PRB. In his article of 1850, 'The Purpose and Tendency of Early Italian Art', in the Pre-Raphaelite circle's publication *The Germ*, Frederic George Stephens wrote that 'The modern artist does not retire to monasteries, or practice discipline; but he may show his participation in the same high feeling by a firm attachment to truth in every point of representation, which is the most just method.'[11] Stephens supported the importance of following an artistic programme over communal discipline, and saw that for the modern artist in the mid-nineteenth century the cloistered life was untenable, if only on a basic level because it was not economically feasible. In this sense, Pre-Raphaelite 'corporate unity' seems apt, as commercial concerns formed a great part of the early experience of the Pre-Raphaelites. The lifestyle of the

Primitifs or the sequestered SLB was not an option for the PRB, members of a rigid class structure who saw social aims as dependent upon economic success. However, it should be noted that the group did consider getting lodgings together to form a PRB commune in the spirit of Chaillot or San Isidoro on at least two occasions, but in the face of heavy expenses this was never conclusively realized.[12] Such a plan, as was typical of the Brotherhood, seemed more practical than spiritual, and was not carried out for those very same reasons of practicality and economics.

For the young men who formed the Pre-Raphaelite Brotherhood in John Everett Millais's family home late in 1848 there were a number of British precedents for artistic societies, the most familiar being The Clique.[13] Formed in 1837, the year of Victoria's ascent to the throne, and disbanded four years later, The Clique comprised a number of the Royal Academy School's students including William Powell Frith (1819–1909), Henry Nelson O'Neil (1817–80), Augustus Leopold Egg (1816–63), Richard Dadd (1819–87) and John Phillip (1817–67), and was subsequently expanded to include Edward Matthew Ward (1816–79), Alfred Elmore (1815–81) and others.[14] More unified by being at a similar state of schooling than through a resolutely rebellious agenda, all these artists with the exception of Dadd became full or associate Royal Academicians. They were well known to the Pre-Raphaelites in the early 1850s: some as enemies, like Frith and O'Neil, others like Egg, Phillip and Ward as friends, colleagues and even patrons. If The Clique, with their weekly sketching and socializing meetings, seemed to fulfil only the most tenuous conception of a group formation, this was also borne out in the members' lack of group initiative. They did not exhibit outside of traditional venues, their aim being less to subvert than to enter the Royal Academy.[15] There are no group portraits of these artists. They did not write a manifesto of their aims, use special markings on their works, or publish a journal. Additionally, The Clique did not encounter much critical resistance. Artists and public did not perceive them as a threat to the established artistic order. It is evident that the aims of the earlier generation were exclusively social and commercial, not rebellious as those professed by the later Pre-Raphaelites, and their alliance was more informal.

The Clique emulated the example of casual clubs such as the Sketching Society and the Painters' Etching Society over more separatist groups like Samuel Palmer's Shoreham circle, 'The Ancients' (1824–30). Such casual groups fostered communality over consistent aims or agendas.[16] Subsequent attempts at forming groups in Victorian Britain included the ultimately aborted scheme by the architect George Edmund Street (1824–81) to form a 'society or college' in 1848 wherein 'students should not only be instructed in religious art by competent masters', who were themselves to be members of the college, 'but should also be under certain religious ordinances and live

a life in strict accord with the lofty character of their work'.[17] In a period of great religious revivalism in art and life, such schemes were probably common, especially those along the lines of guilds or schools in medievalizing modes. Street's aim 'to promote a new manner of national design' was broadly similar to early Pre-Raphaelite desires although its implied monasticism was not.

Some immediate precursors involving future PRBs included a designing club at the British Museum that Hunt was involved in around 1845,[18] and a failed literary society in 1848. Secretiveness and exclusivity were early considerations in such projected enterprises. Yet the less clandestine sketching group called the Cyclographic Society was the closest precursor to the Pre-Raphaelite Brotherhood. Established in early 1848 by all of the eventual Pre-Raphaelites except for William Michael Rossetti,[19] it was a kind of casual out-of-the-Academy study group with artists circulating their current works in monthly portfolios for peer criticism. There were meetings, but Hunt for one apparently never attended them. However, he was at Millais' house when they opened a portfolio with a drawing by Dante Gabriel Rossetti, bringing Rossetti to their attention for the first time.[20] Despite the seemingly informal nature of the enterprise, the artists had a surprisingly serious approach to the project and to each other's work, proving the club to be a place of artistic improvement as well as honing of criticism skills. There were some 15 members in the coterie which did not have a very long life, ending in September 1848.[21]

Later manifestations of group alignments involving PRBs include the Medieval Society, which was formed in 1857 to promote study and preservation, and the Hogarth Club initiated the following year.[22] The Hogarth Club was more of a straightforward corporate enterprise than the Pre-Raphaelite Brotherhood had been. Conceived as a social and exhibiting venue, the Club ran from 1858 to 1861 and was a serious attempt to provide an institutional opposition to the Royal Academy and to promote realism, although it did not acquire the ideals or secretiveness of a brotherhood. Its ranks eventually included all of the PRB except for Millais who declined membership.[23] Despite a rocky commencement of the project, including inter-member arguments and differences of opinion on elections and exhibition submissions, the Club became a formidable venue. The display of 1860 included Rossetti's *Bocca Baciata* of 1859 (Museum of Fine Arts, Boston), a remarkable oil of a close-up view of a female head. Critical reaction to this image stoked Hunt's ire, as evidenced in a letter to a patron wherein he castigated critics for thinking this work 'the triumph of *our school*', and Rossetti 'for gross sensuality of a revolting kind peculiar to foreign prints that would scarcely pass our English Custom house from France even after the establishment of Free Trade', and for pursuing 'the mere gratification of

the eye'.[24] Thus by 1860 a certain conception of Pre-Raphaelitism had been firmly established in the public's mind, and it had been linked irrevocably to this incipient aestheticism visible at the Hogarth Club, an ironic result considering the Club's stated focus on narrative painting.[25] Hunt was beginning to object to contemporary definitions of Pre-Raphaelitism and its association with Rossetti, whose work he found drained of subject and narrative and thus of moral resonance.[26] And while opposition to the RA was certainly the aim of some Hogarth members, it was not the central purpose for all, many of whom, including Rossetti, simply wanted more exposure and increased commercial possibilities.

The construction of the Pre-Raphaelites and their style

While the formation of artistic groups was not uncommon in the Victorian era, the particularities of the PRB in England in 1848, are crucial. The appendage 'Brotherhood' is a qualifier that has a long history, emerging from traditions of medieval religious organizations and subsequent transformations in commercial cooperatives. Moreover, the gendered specificity of such a denomination and the exclusion of women remained fundamental to the Pre-Raphaelite project. Lest we consider the PRB to be a model of unified endeavour, as would be assumed in a traditional brotherhood, the truth is that ever since the emergence of biographical writings about the artists in the 1880s (around the time of Rossetti's death) the group's inherent disorder, its 'otherhood', has been most lauded as the essential means of the artists' individual successes. The most important generative forces in the movement were at that point narrowed down to distinctions among the works of Rossetti, Hunt and Millais.[27] In the late nineteenth century, the concept of Pre-Raphaelitism came to signify more fully than the monolithic Pre-Raphaelite Brotherhood itself, a case made plain in the ordination of the title of Hunt's memoirs, *Pre-Raphaelitism and the Pre-Raphaelite Brotherhood*, published in 1905. This is divergent from the recent broadly unified conception of the group in popular culture and the exhibition world.[28]

The PRB is an insistently patriarchal construction. Despite the important work of a number of female artists and writers within their circle, including Christina Rossetti (1830–94) and Elizabeth Siddall (1829–62), the seven-member group itself was exclusively male. Of course, this is unsurprising in a cultural milieu where genders existed in separate spheres and women played little if any role in public life. Even in his memoirs Hunt all but denied not only the role of women in the nineteenth-century art world but, uncommonly for the period, also the actions and even names of women in his own life, including his wives. As Julie Codell has recently argued, Hunt

saw history in terms of nationalist masculine endeavour not personal history, and the Pre-Raphaelite Brotherhood fits squarely into such a schematic of homosocial alignment for progressive, anti-institutional action.[29] And as Eve Kosofsky Sedgwick has shown, such homosocial alignments are wedded to class interests in their particular eras. The young Pre-Raphaelites, all from the broad middle classes, all wanting to escape professional non-artistic pursuits, banded together for mutual sustenance and advancement in art and in society. The choice of a secret society was apt in this case, and conforms to the theories laid out by Georg Simmel and others. This option in urban cultures is indicative of a reaction against the growing impersonality of city life and a struggle against some centrally organized power, in this case the Royal Academy.[30] The Pre-Raphaelite Brotherhood was formed in what sociologists characterize as a 'charismatic' group, lacking a systemized allocation of rank and gravitating towards a free-flowing camaraderie.[31] A sense of *ésprit* permeated their early endeavours. Lionel Tiger, following along Simmel's lines, wrote of seeing secret societies as 'in close relation to political opposition or subversion', particularly charismatic societies that show an impetus towards change in the dominance hierarchy. The PRB worked initially within the world of artistic politics to overcome and overrun its older operations while creating a new nationalist aesthetic. However, claims for larger aims are not out of the question; witness the artists' interests in Chartism, their activities in the homosocial Working Men's College, their imperialistic attitudes. In many ways, the early stage of the PRB can be seen in relation to the rise of workers' brotherhoods, artisan cooperatives, and labour organizations in Europe in the nineteenth century[32] – groups like the semi-clandestine Brotherhoods of Companonnage, who garnered much publicity in the revolutions of 1848.[33] As anticipated, the secretiveness of the PRB did indeed 'excite the hostility of established authority',[34] creating a bias that Hunt perceived for the next 30 years or so, even if the Royal Academy did welcome Millais into their ranks as soon as he became eligible in 1853.

Thus the concept of a brotherhood is revealing. Unlike secret brotherhoods along the lines of the Masons, who had a long tradition in England, or the Rosicrucians, who were similarly a part of contemporary culture and literature, the Pre-Raphaelites engaged in no rituals, wore no special identifying symbols or clothing, swore no oaths.[35] They never wrote out a manifesto or charter, and had only one official position, that of secretary which was filled by the artistically non-productive William Michael Rossetti who kept a fairly free-flowing journal of their activities. Their lack of cohesion is no more evident than in their biographical and artistic output.

William Holman Hunt's *Pre-Raphaelitism and the Pre-Raphaelite Brotherhood* of 1905 is the most accessed text on the movement, and his vast two-volume

history has been dissected and laid bare by a number of contemporary art historians. Yet Hunt's construction of the PRB reigned nearly unchallenged for over half a century, despite protestations by Stephens and William Michael Rossetti. These three initial historians of the PRB agreed about the particulars of the group, especially their monthly meetings at their peak point of activity, and about membership, the rejection of Charles Allston Collins and Walter Deverell and the resulting protestations of certain individual Brothers.

Rossetti attributed the idea of the Brotherhood to his brother, and Hunt maintained that while this was so the name 'Pre-Raphaelite' was his decision, over suggestions of 'Early Christian'. Hunt's memoirs portray him as the paterfamilias of the group, instrumental in conceiving their ideas, bringing Millais into his line of thinking and working with him to bring Dante Gabriel Rossetti into the fold. Hunt saw Woolner as a viable talent, but he made it clear that Collinson, William Michael Rossetti and Stephens were just there to fill their numbers. While Millais and Hunt were fairly successful in this period, Dante Gabriel Rossetti faltered badly after only two exhibitions, and Woolner and Collinson never truly got their careers underway. Woolner did not even exhibit in public during the first round of PRB activity between 1848 and 1852, when he was more concerned with sketches and portrait medallions.

Stephens described Woolner as occupying 'an eminent position' in the group, and cited his contributions to *The Germ* as essential to that project.[36] However, Stephens and William Rossetti considered *The Germ* to have been more important to and representative of the movement than did Hunt who was biased towards fine art.

It is through the group's early paintings and drawings that we can trace both the PRB's linkage and subsequent disunion. With the exception of a spare drawing published in Hunt's memoirs, purportedly Arthur Hughes' copy of an original sketch by Hunt, there are no formal group images of the artists. This drawing does not, of course, include Hunt and is a rather banal view of a bourgeois fireside scene (Figure 3.1). The lack of group portraits is surprising considering the tradition of such images in British art, such as those of Joshua Reynolds and James Barry, and the sheer amount of mutual portraiture that went on within the group.[37] PRB mutual portraiture culminated in six individual portrait drawings sent to Thomas Woolner in Australia in 1853. However, these remain one step removed from the conclusive act of identity melding in *Freundschaftsbild* or friendship portraits so common in continental art circles, in which the artists drew one another, often on the same page (see Figure 2.2).[38] Thus in the absence of a manifesto or statement of purpose, the Pre-Raphaelite Brotherhood also refrained from commemorating their communal likeness, precisely the kind of activity that would serve to cement artistic ties and allegiances in subsequent periods.

spite of our friendly probation of the unproved candidates, whether Gabriel did not unduly overlook the argument against their success in the evidence that their indifference to art so far did not show the want of natural instinct for it ; his unfaltering certainty in their future shamed our scepticism. No one, however, could be more sudden or wholesale in correction of a too favourable estimate of his impulsively recommended protégés, whether they were those we had adopted, or outsiders over whom

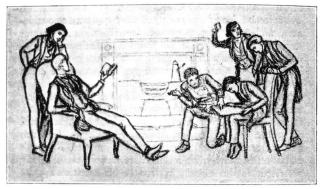

THE PRE-RAPHAELITE MEETING, 1848, BY ARTHUR HUGHES, FROM SKETCH BY W. H. H.

he at times went into paroxysms of wild laudation, until the disillusion came. In fact, he was then as extreme in his condemnation as he had been in his too extravagant praise.

In my own studio soon after the initiation of the Brotherhood, when I was talking with Rossetti about our ideal intention, I noticed that he still retained the habit he had contracted with Ford Madox Brown of speaking of the new principles of art as " Early Christian." I objected to the term as attached to a school as far from vitality as was modern classicalism, and I insisted upon the designation " Pre-Raphaelite " as more radically exact,

3.1 Arthur Hughes after William Holman Hunt, *The Pre-Raphaelite Meeting*, 1848

Even such a loose confraternity like the Impressionists and avant-garde artists and writers in Paris commemorated their frequent gatherings through group portraits. Consequently, Henri Fantin-Latour's *Homage to Delacroix* of 1864 and *A Studio in the Batignolles Quarter* of 1870 (both Musée d'Orsay, Paris) are two works that have come to reflect the conception of the Impressionists as a group with a composite identity, even if the artists and writers depicted did not always exhibit or work together, and often did not see eye to eye. Courbet had made similar group images for his realist circle

earlier in the century, and this type of visual commemoration of groups or like-minded individuals has since become standard in the twentieth century. Individualism, 'otherhood', appears on one level to be part of the Pre-Raphaelite visual record as well as the written one.

None the less, this was not initially so. It is intriguing to note how many of Hunt's important early Pre-Raphaelite pictures are narratives concerning inter-male fidelity in times of need. In his first Pre-Raphaelite picture, *Rienzi Vowing to Obtain Justice for the Death of his Young Brother, Slain in a Skirmish between the Colonna and Orsini Factions* (1848–9, private collection), Hunt depicted Bulwer Lytton's protagonist swearing an oath against the ruling authority over the still body of a familial brother. The image is a picture of unity, of solemn bonds and of steadiness in the face of great trial and adversity; perhaps Hunt was romanticizing his own perceived position at the time, bracing for the anticipated coming fight against presiding factions which would seek to repel the PRB.[39] Hunt's next major work, *A Converted British Family Sheltering a Christian Missionary from the Persecution of the Druids* of 1849–50 (Ashmolean Museum, Oxford), similarly shows brotherly distress, in this case fraternal religious proselytizers persecuted and pursued by pagans, the artist in his choice of subject unwittingly presaging the virulent critical reaction towards the PRB in the year of this work's exhibition. The following year's submission, the Shakespearean *Valentine Rescuing Sylvia from Proteus* (Figure 3.2, Birmingham Museums and Art Gallery), concentrates on the theme of reconciliation between best friends, the two male protagonists on the right. Sylvia has already been rescued. The focus here is on Valentine forgiving the supplicant Proteus. It is little wonder that so many critics got the title wrong.[40] The expression in the picture seems to dilute the plight of the woman in favour of the two men sundered by tragedy but instantly working to heal their rent bonds. Hunt worked on this picture in Kent and he brought Dante Gabriel Rossetti with him to paint in the out-of-doors in a final attempt to bring the reluctant oil painter to a Pre-Raphaelite style.[41] While not wanting to reduce the meaning of this work to mere autobiography, it may be argued that following Rossetti's betrayal of the secret meaning of the group's initials earlier in the year, Hunt may have modified this subject as a kind of rapprochement.[42] In terms of what we know of the fate of the movement in the succeeding years, it is fitting that after stalking around the woods for a while and repeatedly quitting painting early in the day to write poetry, Rossetti returned to London with an aborted canvas.[43] Unlike Proteus before Valentine, Rossetti was not about to bow to the restrictions and reproaches of Hunt. In Hunt's subsequent work, psychological themes of male unity disappear, replaced by allegorical and symbolic images of love and lust and morality, landscapes and, most important, religious scenes. In the wake of the early dissolution of the Brotherhood, grand narratives gave

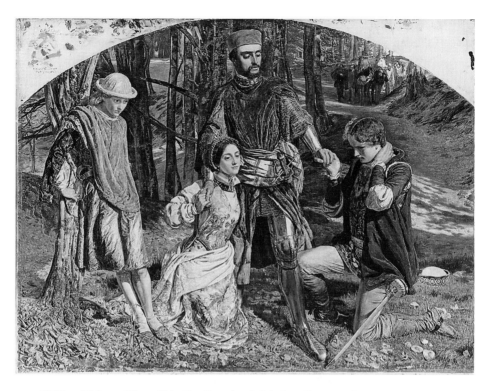

3.2 William Holman Hunt, *Valentine Rescuing Sylvia from Proteus*, 1850–1

way to less-fervent Victorian dramas, tales less overt in their meanings, less complicated in their compositions, and more esoteric and subtle in their convoluted references. There is a similar change in Millais's art in the same period. It is indicative of the gradual evolution of the PRB from a secret society to a more mainstream artistic group, from presumed corporate unity to more individualistic pursuits resulting in accessible works in a more marketable style.

Also typical of Pre-Raphaelitism was the use of friends and family in figure paintings. Hunt never appears in his companion's works, in perhaps a mark of inter-brotherhood rivalry because he claimed to be far too busy working to be able to sit. Additionally, it must be said, Hunt lacked the distinctively attractive features of his fellows. Millais was a common model in early PRB works, and was often described as angelic, in a mark of racial difference, as we might say 'like a choirboy' in modern parlance to describe a youthful Northern European face. Dante Gabriel Rossetti was of Italian heritage. As a result, his features were often used in the role of an outsider, a distinction Rossetti cultivated in his long hairstyle and later with a goatee.

Similarly, Hunt tried to portray Rossetti as an outsider in his memoirs to distance him further from the PRB effort. Rossetti filled ethnic and often somewhat negative roles in his companions' paintings, although not in his own. He is a memorably deep-eyed drinker in Millais's *Isabella* (1848–9, Walker Art Gallery, Liverpool), a suspicious jester in Brown's *King Lear* (1848–9, Tate Gallery, London), the clown Feste in Deverell's *Twelfth Night* (1849–50, Forbes Magazine Collection) and the Italian Rienzi in Hunt's eponymous painting of 1849. Stephens made up for his lack of painting acuity and productivity with starring roles as a malevolent brother in *Isabella*, the hero in the same artist's *Ferdinand Lured by Ariel* (1849–50, Makins Collection) and Christ in Brown's *Jesus Washing Peter's Feet* (1851–6, Tate Gallery, London). William Michael Rossetti, also presumed to be less active artistically than the others, had time to figure as a cheap model in a number of important pictures although not as an outsider; he did not seem to cultivate his heritage as his brother did. These insertions, so often the subject of tedious biographical investigations of these artists' pictures when specific female models are involved, were common in Victorian and continental painting.[44] And while the subtly transformed faces of the Pre-Raphaelites and their associates often inhabit the same canvas, such group portraits lie firmly in the realm of role playing, the artists inscribing each other's features on the face of a character in a painted religious, historical or literary drama. However, without more documentary group images of the PRB, these disparate fictions and the individual portraits that predominated serve to cast doubt on the cohesiveness of their endeavour and the concreteness of their 'Brotherhood'.

Nineteenth-century groups and the twentieth-century avant-garde

In the twentieth century artistic groups dropped the suffix brotherhood, were rarely referred to as such, and usually were not given the option of naming themselves regardless. Writers and critics typically gave them pejorative monikers: Fauves, Cubists, Ash Can School artists, Abstract Expressionists (labelled 'The Irascibles' in a *Life* magazine photo of 1951, a name which happily did not stick). Or if self-named, artists chose high-minded identifiers, usually liberated from specific artistic references: Vorticists, Futurists, Die Brücke, Der Blaue Reiter, Situationists. In this nomenclatural sense, avant-garde groups in the twentieth century are derived from earlier precedents. After all, Barbus, Nazarenes, and Pre-Raphaelites are all names that began as defamation, just like the initial connotations of Impressionists in 1874, and with the exception of the PRB, their names were not reflective of their art.

Consciously or not, the Pre-Raphaelites acted out the now-established role of avant-garde artists, working briefly in purported union and then as individuals to carve out a new style in the quondam solid rock of British art. The perpetuation of their disunion in their later anecdotage, while on one level a kind of petty bickering amongst sadly splintered old friends, also reflects the critical importance of just who was writing their history and the larger history of nineteenth-century British art. The sheer scope and pomposity of works such as Hunt's two-volume summation is enough to justify attention. But the inherent biases of his constructed story are worthy of continued scrutiny. And concentration on the few years of group Pre-Raphaelite activity, as distinct from later medievalism, Aestheticism, or Academicism is not at all limiting. Rather it is only by divining the specific nature of such artistic yet ostensibly social, commercial and rhetorical groups that we can better understand the mechanisms of cooperative behaviour in Britain in the period. Rooted in larger societal traditions of homosociality, inspired by the youthful ardour of its members, conveniently disparaged by the apparent world at large and then subject to natural splintering, Pre-Raphaelitism presages tropes that became familiar in histories of modernism. No naïve fraternal alignment, the PRB was representatively symptomatic of its period, originally conceived in a spirit of endeavour, set back by a lingeringly conservative art market and critical establishment, and forced into disunion in order for the members to survive economically. They eventually and cannily worked within the changing and modernizing commercial world to further their aims and, in their later constructions of their experiences, made much of their separateness over their union, a mark of alienation familiar in twentieth-century art history.

Notes

Thanks to Karen Gottlieb, Tim Barringer, Aruna D'Souza, Tom McDonough and the editors of this volume for their help with this essay.

1. The seven Pre-Raphaelites were James Collinson (1825–81), William Holman Hunt (1827–1910), John Everett Millais (1829–96), Dante Gabriel Rossetti (1828–82), William Michael Rossetti (1829–1919), Frederic George Stephens (1828–1907) and Thomas Woolner (1826–92).

2. Simon Schama, 'Tunnel Vision,' *New Yorker* (10 November 1997): 100.

3. Compare Timothy Hilton's description of the group as a *cosa nostra*, conspiratorial young artists strong-arming older Academicians in *The Pre-Raphaelites* (London: Thames & Hudson, 1970), p. 32.

4. Allen Staley, *The Pre-Raphaelite Landscape* (Oxford: Clarendon Press, 1973), p. 1. It is clear that Staley was not using the term in its capitalist economic sense as I do in this essay.

5. See Chapters 1 and 2 in this volume.

6. George Levitine, *The Dawn of Bohemianism: The 'Barbu' Rebellion and Primitivism in Neoclassical France* (University Park: Penn State University Press, 1978), p. 75.

7. Such a tangible symbol of unified intent and production is similar to the use of 'PRB' on Pre-

Raphaelite works in 1849. This practice was halted once the meaning became public. The initials exist on only three paintings and some drawings and letters.

8. James Collinson's PRB spot remained vacant after his resignation in 1850.

9. See Kenneth Bendiner, *The Art of Ford Madox Brown* (University Park: Penn State University Press, 1998), pp. 15–19 and 169, n. 35. These contacts also included William Cave Thomas (1820–1906) and Anna Mary Howitt (1824–84).

10. Ruskin, *Works*, Cook, E. T. and A. D. O. Wedderburns, eds, 39 vols, 1903–1912, vol. XXXI, p.23.

11. John Seward [Frederic George Stephens], 'The Purpose and Tendency of Early Italian Art,' *Germ*, **2** (February 1850): 59.

12. William E. Fredeman, *The P.R.B. Journal* (Oxford: Clarendon Press, 1975), pp. 22–3, 84 and 208.

13. Paul Barlow, '"The Backside of Nature", The Clique, Hogarthianism, and the Problem of Style in Victorian Painting', diss., University of Sussex, 1989, and Hilarie Faberman, 'Augustus Leopold Egg, R.A. 1816–1863', diss., Yale University, 1983, pp. 36–40.

14. William Bell Scott (1811–90), later a member of the PRB circle, had also accepted an invitation to one of their meetings.

15. The group did at one time consider forming an exhibition space for the use of students. See Barlow, 1989, p. 54 and William Holman Hunt, 'Notes of the Life of Augustus L. Egg', *The Reader*, **1**(16) (May 1863): 486.

16. Jean Hamilton *The Sketching Society 1799–1851* (London: Victoria & Albert Museum, 1971).

17. Arthur Edmund Street, *Memoir of George Edmund Street, R.A., 1824–1881* (London: John Murray, 1888), p. 56.

18. William Holman Hunt, *Pre-Raphaelitism and the Pre-Raphaelite Brotherhood* (London: Macmillan and Co., 1905), vol. I, p. 43.

19. Fredeman, 1975, pp. 108 and 188; William Michael Rossetti, *Dante Gabriel Rossetti, His Family Letters with a Memoir* (London, 1895), vol. I, p. 121.

20. Hunt, 1905, I: 102–3.

21. The Cyclographic members who most grated on the ones with clearly superior talent were then probably left out of the PRB. Oswald Doughty and John Robert Wahl (eds), *Letters of Dante Gabriel Rossetti* (Oxford, 1965), vol. I, p. 42, and W. M. Rossetti, 1895, p. 122. See also Fredeman, 1975, pp. 108–12.

22. Deborah Cherry, 'The Hogarth Club: 1858–1861', *Burlington*, **122** (April 1980): 243, n. 68. The Medieval Society members included Hunt, Brown, Morris, Ruskin and the Rossettis.

23. Millais anticipated the dilemma that later faced Frederic Leighton, who joined by the end of 1858. Leighton withdrew, according to Hunt, because he thought that the Club set itself against the Academy (Hunt, 1905, II, p. 146, see also Cherry, 1980, p. 242). The Hogarth Club is an early example of artists coming together in professional groups to exhibit and promote their works. In the 1870s, with ventures such as the Grosvenor Gallery, this became a more common practice.

24. Hunt to Thomas Combe, 12 February 1860, Bodleian Library, Oxford, MS Eng. Lett. c. 296, fol. 71. Quoted in Cherry, 1980, p. 241.

25. There is evidence that reviewers thought of the club as an exclusively Pre-Raphaelite venture. *Art Journal*, (December 1858): 374; (May 1860): 159.

26. This was continued in a series of articles Hunt wrote stressing his role in the formation of the PRB style, 'The Pre-Raphaelite Brotherhood: A Fight for Art', *The Contemporary Review*, **49** (April 1886): 471–83; (May 1886): 737–50; (June 1886): 820–33, and in works like Hunt's *Il Dolce Far Niente* (Forbes Magazine Collection) begun in 1860 as a possible reaction to Rossetti's work.

27. Deborah Cherry and Griselda Pollock, 'Patriarchal Power and the Pre-Raphaelites', *Art History* (December 1984): 480–95.

28. This was continually established in comprehensive exhibitions such as 'The Pre-Raphaelites' (Tate Gallery, London, 1984), 'Pre-Raphaelite Patrons' (Laing Art Gallery, Newcastle, 1990) and 'Visions of Love and Life: Pre-Raphaelite Art from the Birmingham Collection, England' (Birmingham and various American locations, 1995–6).

29. Julie F. Codell, 'The Artist Colonized: Holman Hunt's "Bio-history", Masculinity, Nationalism and the English School', in Ellen Harding (ed.), *Reframing the Pre-Raphaelites: Historical and Theoretical Essays* (Aldershot: Scolar Press, 1996), pp. 211–29.

30. Lionel Tiger, *Men in Groups*, 2nd edn (New York: Marion Boyars, 1984), pp. 127–36.

31. Ibid., p. 133.

32. Camille Pissarro, in writing the charter for the Société anonyme coopérative d'artistes-peintres, sculpteurs, etc., later known as the Impressionists, in 1873, based it on that of a bakers' union in Pontoise. *The New Painting: Impressionism 1874–1886* (Oxford: Phaidon, 1986), pp. 104–5.

33. Cynthia Maria Truant, *The Rites of Labor: Brotherhoods of Companonnage in Old and New Regime France* (Ithaca: Cornell University Press, 1994). The Companonnage typically organized to enter in labour conflict with master artisans, just as the PRB organized to work against the RA. See Truant, p. 13 and Chapter 1 in this volume.

34. Tiger, 1984, p. 136.

35. The PRB is treated as an avant-garde pseudo-monkish brotherhood by Herbert Sussman in *Victorian Masculinities: Manhood and Masculine Poetics in Early Victorian Literature and Art* (Cambridge: Cambridge University Press, 1995), and the argument for the group as nonconformists is expanded suggestively by J. B. Bullen in *The Pre-Raphaelite Body: Fear and Desire in Painting, Poetry, and Criticism* (Oxford: Oxford University Press, 1998).

36. Frederic George Stephens, 'Thomas Woolner, R.A.', *Art Journal*, **56** (March 1894): 82–3.

37. For example, Reynolds's Society of the Dilettanti images (1777–9) and Barry's Society of Arts Murals (1774–84).

38. As in Cornelius and Overbeck's *Double Portrait* of 1815 (private collection). *The Romantic Spirit in German Art 1790–1900*, exh. cat. (Edinburgh, 1994), p. 471. See Richard Ormond, 'Portraits to Australia: A Group of Pre-Raphaelite Drawings', *Apollo*, **85** (January 1967): 25–7.

39. Likewise, in *Isabella* Millais created a kind of manifesto for Pre-Raphaelitism, declaring 'his allegiance to brothers of a more wholesome character than those of Isabella' by signing 'PRB' on it twice. Tim Barringer, *The Pre-Raphaelites: Reading the Image* (London: Weidenfeld and Nicolson, 1998), p. 12.

40. The *Athenaeum* called it *Valentine receiving Sylvia from Proteus*, making the heroine the product of a masculine transaction (1851, p. 609), and *The Times* titled it *Valentine receiving Proteus*, missing the triangulated relationship completely (7 May 1851).

41. Hunt, 1905, I, p. 237.

42. Martin Meisel, *Realizations: Narrative, Pictorial, and Theatrical Arts in Nineteenth-Century England* (Princeton: Princeton University Press, 1983), pp. 360–3.

43. Later transformed into *The Bower Meadow*, 1871–2 (City of Manchester Art Galleries).

44. See Overbeck's *The Entry into Jerusalem* (1809–24, destroyed 1842), and Schnorr's *Marriage at Cana* (1819, Hamburg Kunsthalle). Dadd frequently portrayed his fellow artists in solo character portraits, but these were jocular exercises, not weighty in their associations. See Patricia Allderidge, *The Late Richard Dadd 1817–1886* (London: Tate Gallery, 1974), p. 56, and Stephanie Grilli, 'Pre-Raphaelite Portraiture 1848–1854', diss., Yale University, 1980, pp. 106, n. 38, 40, 41.

The business of brotherhood: Morris, Marshall, Faulkner & Company and the Pre-Raphaelite culture of youth

Amy Bingaman

In June 1860, William and Jane Morris moved into their newly built home in Kent; it was there that Morris discovered his vocation as a decorator. With his strict oversight, this house – which came to be known as Red House – was designed by Philip Webb, the young architect Morris had met during his apprenticeship to G. E. Street in Oxford. With the help of his friends, Morris intended to transform the house into a 'small Palace of Art'. The furniture, like the house itself, was to be solid and durable with many medieval overtones. The decoration was meant to be poetic: murals and embroideries with chivalric imagery in the main rooms, stained glass in some of the smaller windows, painted tiles for the fireplace, and simple medieval patterns stenciled and painted free-hand on the ceilings. Much of this was undertaken, but the decorative scheme was never completed. However, the work to design, decorate and furnish this house determined Morris's career.

In 1861, calling themselves Morris, Marshall, Faulkner & Company (the Firm, for short), Morris and his friends set themselves up in business as 'Fine Art Workmen in Painting, Carving, Furniture and the Metals'. The Firm grew rapidly, setting up shop in London's Red Lion Square, where it obtained abundant commissions. Largely because the business was doing so well and demanding more of his time in the city, William Morris gave up the very home that had inspired his career. In 1865 he reluctantly sold Red House and moved his family back to London where the Firm continued to flourish.

The decorative arts have long been considered the 'ugly stepsisters' of painting, sculpture and architecture. Likewise Victorian arts, in general – be they decorative or fine – are frequently relegated to footnotes in histories of European art in the nineteenth century. William Morris's Pre-Raphaelite

brothers were practitioners of the decorative arts, as well as the most active painters in England between the founding of their fraternity in 1848 and the death of Queen Victoria in 1901. As such, they have, in the twentieth century, gained a reputation of being sentimentalizing and technically deficient; critics consider them as falling short of the only slightly more estimable tradition of English portraiture and not even appearing within the scope of the much worthier tradition of French history painting.

In contrast to the present discipline of material cultural history which tends to examine decorative objects as representative of the cultures from which they come,[1] my approach is to interrogate specific objects from the Morris circle – a house, a jewellery box, a wardrobe, an illuminated manuscript and some highly decorative paintings – as moments in the historical narrative of that culture.[2] By examining several Pre-Raphaelite artistic and social practices, this essay shall demonstrate that interpreting the gendered production *contexts* of particular Victorian decorative arts may enhance a late twentieth-century vision of the operations of material culture in what I shall call the Pre-Raphaelite economy of desire.

'Brotherhood', was not a unique phenomenon for these young artists; it was, rather, part of a much larger set of cultural circumstances. The nineteenth century saw a great upsurge in young men's associations, such as debating clubs, literary societies and other social groups. These brotherhoods mimicked boys' clubs in their dual emphasis on nurture and competition, while performing particular tasks for the socialization of their members. Between the end of boyhood (marked by leaving home and either entering university or taking a first job) and the beginning of manhood (marked by the establishment of a career and marriage) was a long, transitory phase. During this time in a young middle-class man's life, the people closest to him – in the office, in the university – were likely to be his own age and sex. In the absence of women and older men, these men trained one another to tame the passions of childhood and learn the habits of power and self-discipline needed for the active life of the market-place. There was, however, 'a quality of play in these relationships, something both passionate and whimsical, which set them apart from manhood with its serious, determined tone'.[3] These relationships – which were sometimes romantic – functioned as an essential part of the youth's transition from boyhood to manhood – they trained him for both his career and his marriage, at which time they ceased to exist.[4]

I wish to consider William Morris's medievalizing relationship to Red House and its contents as akin to that between a child and his toys. I further wish to assert that it was during these years and only the eight or nine years immediately following the Red House residence that Morris conceived of

himself as a member of a brotherhood of artists – unlike his later self-definition as independent businessman and designer. Not only did the years Morris spent at Red House mark the beginning of his story as a designer, businessman and traditional Victorian family man, but they also saw the commencement of his lifelong examination of the relation between materiality and meaning. The lessons Morris gleaned from the earnest play and experimentation during his early career, coupled with an intensification of already unconventional gender dynamics – particularly those involving his own wife, Jane – precipitated the major shift in his ideology from a radical dependence upon fraternity to a more conventionally modern (but still idealized) reliance upon patriarchal economy.

Speaking of Red House in her 1995 Morris biography, Fiona MacCarthy states that it was a playful 'amalgam of surprises, gables, arches, and little casements of a size to shoot an arrow through'. It was a 'touching design, childlike, a house in the Dutch toy-town Morris played with as a boy'.[5] Designed, decorated and inhabited by William Morris and his circle of friends between the years 1859 and 1865, Red House was where Morris matured from youth into adulthood. It was where he moved with his new wife Jane, where both of their daughters were born and where the Morris, Marshall, Faulkner & Company design firm was founded. Red House was, however, every bit a toy – even a doll's house – in as much as Morris controlled every detail and invited only his best friends to come in.

Other participants in the Red House social corps and (inevitably) in the Firm included Ford Madox Brown, also an already well-known Pre-Raphaelite painter; Edward Burne-Jones and Philip Webb, both at the beginning of their careers in painting and architecture, respectively; Charles Faulkner, an Oxford mathematics don; and Peter Paul Marshall, an amateur painter. They set before themselves the task of revolutionizing the British public's estimation of the decorative arts. The work for Red House began to call into question any distinction between the fine and the decorative arts. It did so in part by involving a group of professional artists in a project that was about designing the space of its own domestic and leisure community as much as it was about breaking new ground in the public art world.

Rossetti commented later in his life that Morris, Marshall, Faulkner & Company had been a 'mere plaything at business'. Charles Harvey and Jon Press argue that this might well have reflected Rossetti's feelings about the Firm's purpose, but that it said very little about the feelings of the other members.[6] Morris possessed a hearty appetite for work as well as the knowledge that he could not rely forever on the trust his father had left him. Burne-Jones, Harvey and Press remind us, was anxious about money his whole life, and was perhaps more eager than anyone to make the Firm financially successful. He, like Webb and Faulkner, needed work, not

membership in a time-consuming, unprofitable club. Furthermore, they note, it is unlikely that the already established Madox Brown would have given much time to the sort of casual business concern described so offhandedly by Rossetti. The Firm's operations and finances were planned and worked out in strict detail from the very beginning. Morris, Marshall, Faulkner & Company was no mere frivolity as Rossetti's tone suggests. However, a very meaningful element of play did implicate itself in the Firm's establishment and early activity.

Located in the countryside, the professional and personal enterprise at Red House sought both to invent and to perform a kind of domesticity that contrasted with urban life in London. Red House made the household, not the street, the site of combined social and business interaction and thereby directly confronted the contemporary doctrine of the separation of spheres.[7] By taking business back to the home, where it had been in centuries past, Morris and his friends re-enacted the lives of those whom they believed had once worked in a healthier, more spiritually resolute atmosphere. This belief that the towns and villages of the Middle Ages had been populated by happy, hard-working and playful yet spiritually solid individuals was based in a dominant Victorian fiction idealizing medieval domesticity and labour largely because its sources were the romances of such medieval authors as Chaucer, Malory and Froissart.

The medieval overtones of Red House's architecture included such things as a turret on the roof and a large mead hall-like, barn-sized drawing room. The structure itself emulated those of ancient monastic communities, with their workshops and houses arranged around central courtyards. As such, Red House symbolized Morris's act of separation, retreat and defiance of modern worldliness. However, in that this courtyard also imparted many Arthurian innuendoes, it was also a symbol of Morris's departure point for his crusade against the age.[8] Nevertheless, the practical dimensions of details, such as the drawing room which expressed Morris's belief that life would be lived in one huge and lovely room when the simplicity of a utopian world was achieved, are diminished to mere decoration when one considers their size. The mead hall, is, in reality, no larger than living rooms in most modest, middle-class modern homes, and distinctly smaller than the drawing rooms of country homes such as Wightwick and Standen – homes whose owners commissioned Morris's company for their interior decoration. Morris's utopian world was a miniature one.

The house's furnishings were primarily handcrafted for and given to the Morrises by their friends, via an internal exchange system based on gift-giving and the trading of services. These rituals bound the objects to their producers, and the producers to the objects' recipients. The building came to be the destination of the gifts various friends made for the Morrises upon

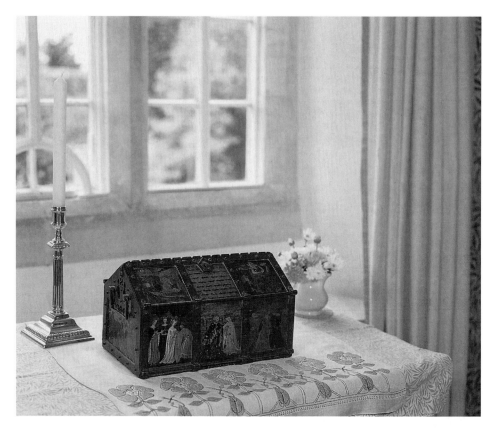

4.1 Dante Gabriel Rossetti and Elizabeth Siddall, Jane Morris's Jewel Casket, c. 1860

their marriage and where each donor could enjoy or use the very gifts he or she made. It was also the site where the earliest examples of the types of objects made by the Firm were actually produced and displayed.[9]

Two such objects are the jewel casket (Figure 4.1), now at Kelmscott Manor, made by Dante Gabriel Rossetti and Elizabeth Siddall and given to Jane as a wedding present, and the so-called Prioress's Tale Wardrobe (Figure 4.2), now in the Ashmolean Museum, made by Burne-Jones and given to Morris. Once painted all around with scenes of courtly love, the jewel casket has decorations that have been nearly completely destroyed by unsuccessful restoration attempts. Only the front and side panels have paintings that are now legible. Not all the sources of the paintings are identifiable, but the centre panel on the front of the box is certainly derived from one of the miniatures in a manuscript volume of the poems of the medieval French poetess Christine de Pisan[10] – a manuscript in the Harleian collection and the British Library.[11] This painting shows a young couple conversing in a typically

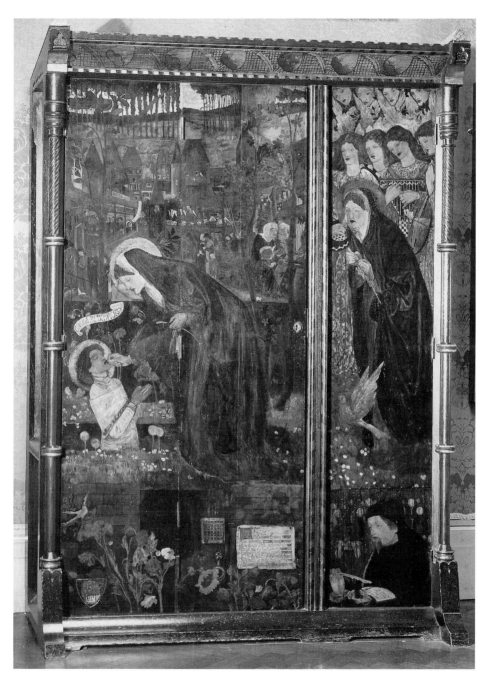

4.2 Edward Burne-Jones, The Prioress's Tale Wardrobe, *c.* 1860

medieval walled-garden setting. Though the sources of the other extant panels are not so definitive, the subject matter is similar: chivalric, courtly exchanges between young men and women.

The form of the casket also has its precedents. Constructed with a steeply gabled roof, it simulates the reliquaries of the Romanesque and early Gothic periods and is therefore characteristic of heavily constructed post-Pugin Gothic revival furnishings. As a vessel for the storage of Jane's precious belongings and given by two members of this self-consciously anachronistic community to another, the box sanctifies Jane's fundamentally Pre-Raphaelite aesthetic – a look formulated by the Brotherhood and cultivated in the predominantly working-class women whom they drew into their company.

A similarly representative piece of furniture, given as a wedding present from Burne-Jones and placed in Jane's bedroom at Red House, is the Prioress's Tale Wardrobe, so-called for its paintings on the exterior which depict episodes from Chaucer's 'Prioress's Tale'. With a member of the circle now posing as one of the central figures, this object depicts a scene from a literary source contemporary to that of the jewel casket. Jane Morris poses for the Virgin Mary on the outside of this large and heavily decorated cabinet.

With its expanding need for exhibition examples, the brotherly business used the wardrobe to satisfy two needs. Documentation suggests that this piece was initially a collaborative project between Morris and Burne-Jones, begun in the very early years of their acquaintance when they kept rooms together in Red Lion Square in London. Marked, however, with the inscription 'EBJ to WM' in a heraldic-style shield in the lower left corner of the left-most door, the wardrobe bears the trace of having been finished by Burne-Jones and given to Morris as a gift on the occasion of the latter's marriage. Furthermore, correspondence between Burne-Jones and his friend Cormell Price indicates that it was hurriedly finished for an exhibition at the Hogarth Club in 1858.[12]

The evidence implies that the furniture of Red House, which was designed almost entirely by members of the nascent Firm, both illustrated and enacted the multifarious and contradictory economies that produced these personae and implicated each in the production of the others. The chivalric, saintly and consumer-driven narratives painted on the furniture, and created by it, suggest internal economies which met several of the circle's necessities. They enact neo-medieval/utopian ideals (such as egalitarianism, artistic communi-tarianism and maintenance of community by gift-exchange); and they sanctify female beauty and the role of women in embodying Pre-Raphaelitism's very essence and simultaneously desecrate the women themselves by devaluing their labour. Each piece was part of an intricate tapestry that wove together testimony, on the one hand, of the love and friendship among the women and men who lived in and visited Red House and, on the other, the desire to

use such intimately and painstakingly crafted goods for purposes of propagating both business and public artistic reputation. The complications of Morris's proto-socialist labour theory began to appear here: for him – if not always for the other members of the group – play and work were one. He enjoyed his vocation to such a degree and believed so heartily that the world would be beautiful if everyone experienced such joy in labour, that Red House came to represent his desire to stitch together not only the separate fabrics of art and domesticity, but also those of social exchange and production. And yet, the seams were necessarily visible.

These early years were a time of negotiating both personal relationships and artistic careers for the Pre-Raphaelite brothers. Only three years prior to the settlement of Red House – while painting frescoes in the new Oxford Union Debating Hall in 1856 – they had met Jane Burden, a working-class girl. Jane married Morris, and modelled for Rossetti's countless paintings that today are considered so quintessentially Pre-Raphaelite. According to popular lore, the attraction between Rossetti and Jane was initially very strong, but already engaged to marry Elizabeth 'Lizzie' Siddall, Rossetti stifled (but notably never completely suffocated) his affections and encouraged Morris to pursue Jane's attention. Rossetti, however, continued to paint her, and to love her, until his death in 1882.[13]

Morris painted Jane as well. Among his early work, her face and figure appear on two full-scale panel paintings, several pieces of medievalized furniture and in the cartoons for the never-completed Red House murals. As one of the earliest examples of Morris's handiwork, *La Belle Iseult* (Figure 4.3) – a medievalized portrait of Jane painted in 1858, the year of their engagement – is significant for both its biographical narrative and its mythic subject matter.

Under heavy romantic and artistic encouragement from Rossetti, and after the decoratively – though not structurally – successful collaborative Oxford Union project,[14] Morris found new confidence in both fields. He commemorated this self-possession by painting Jane's portrait in the guise of the heroine, la Belle Iseult. His medieval vision is depicted both in the style and in the courtly theme of the never-quite-attainable beautiful maiden. Now in the Tate Gallery, this painting echoes fourteenth- and fifteenth-century Northern European stylistic conventions apparent in Jan van Eyck's *Arnolfini Wedding Portrait*, a painting well-known to Morris in the National Gallery. Jane's body is painted with a subtly swaying line: tiny head on a long, slender neck, upper body tilted back, hips and belly thrust slightly forward. The room in which she dresses herself is appropriately textile-strewn; the furniture dark and heavy. On the dressing table cum pray-dieu rests an illuminated prayer book.

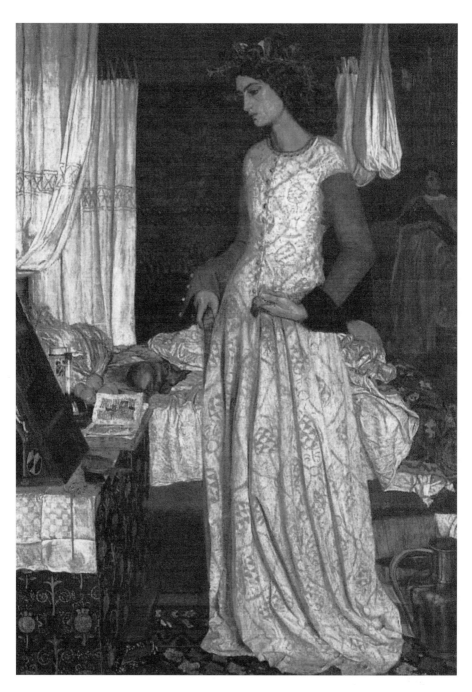

4.3 William Morris, *La Belle Iseult*, 1858

The theme of courtly love persists. Two men are in love with one woman; one of the men travels great distances to secure the object of his affection, only to be checked by his societal superior. The story is a familiar one and comes to rest here in two significant details: the narrative of Tristam and Iseult is retold in Arthurian lore as that of Lancelot and Guenevere, *Guenevere* being the alternative title for this painting over which scholars continue to squabble; further, either rendering of the story lends a peculiarly premonitory aura to this painting, for within a decade of its completion, Morris had lost the affection of his beloved to the stronger erotic will of Rossetti.

Scrawled on the back of this roughly wrought work, in Morris's hand is the phrase, 'I cannot paint you, but I love you'. As if to admit his defeat in fine art, but assert the strength of his devotion, Morris gives his betrothed a gift of prophetic portent.

Portraiture styled as Arthurian adventure illustration endured through the Red House years. The programme planned for the house's wall murals and cupboard doors is redolent with these themes. One cupboard, designed by Webb for the hall, models five members of the household in full Arthurian regalia. Faulkner, Edward Burne-Jones and his wife Georgiana, Elizabeth Siddall and Jane pose for the ten figures that illustrate the story of Sir Tristam and La Belle Iseult in the garden of the Castle of the Joyous Gard. It is a *plein-air* scene, with fruit trees and daisies, 'a Pre-Raphaelite version of *Déjeuner sur l'herbe*'.[15] In theme and execution, this was intended to be a playful group project: young men and women frolicking together in common pursuits of love and beauty.

This collaborative attempt to associate the Red House community with a heroic period in Britain's past illuminates interpretation of the St George's Cabinet, made by Philip Webb and painted by Morris between 1861 and 1862 (Figure 4.4). While this piece was never intended to be a part of the decoration of the house, it is particularly illustrative of the participants' multiple roles as actors in a self-consciously staged play for their own pleasure and as designers for a market of middle-class art consumers.

The narrative depicted on the cabinet's panels is that of St George and Princess Sabra. The princess, modelled on Jane, is cast out into the wilderness where she is threatened by a dragon. St George, the patron saint of England, modelled on the figure of Morris himself, slays the dragon and – in typical heroic fashion – rescues the helpless princess and wins her love. The theme – once again, a chivalric one – holds many similarities to biographical details in the lives of its models and makers: the hero (middle-class Morris) rescues the beautiful and helpless young girl (working-class Jane) from the great threat of alienation and annihilation by a society unaware of the possibilities for her to be made noble.

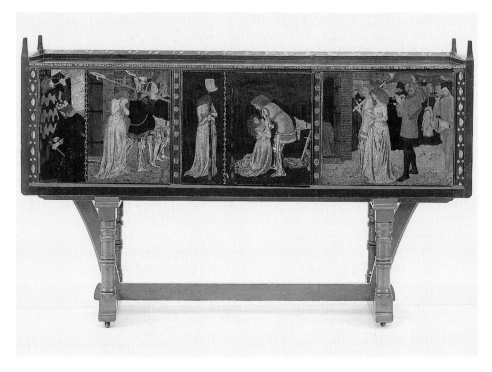

4.4 Philip Webb and William Morris, St George's Cabinet, 1861

Displayed in the Firm's booth at the International Exhibition of 1862, the St George's Cabinet stood as an example of the best the designers had to offer. With its architectonic structure, based on dark and heavy Gothic furniture designs, and its richly decorated panels illustrating England's valiant history, it catered to an emerging taste among the burgeoning English consumer culture. Privately and publicly, therefore, the St George's Cabinet symbolized collaboration in the production both of a beautiful, well-made object intended for commodification and of a social group identity which was, in large part, opposed to the ramifications of that very commodification. Both corporate and corporeal identification were at stake.

When viewed in the pictorial and narrative contexts of *La Belle Iseult*, the Prioress's Tale Wardrobe, and Jane's jewel casket, the St George's Cabinet becomes part of the complex web of human interactions and definitions of Pre-Raphaelite femininity that resulted from the circulation of Jane's image. The circulation of hers was not dissimilar to that of other Pre-Raphaelite stunners and can therefore stand as an illustrative example. In the Pre-Raphaelite fictions, she was variously a saint (even the Virgin Mary), a queen, a princess and eventually several mythological personages; in life she

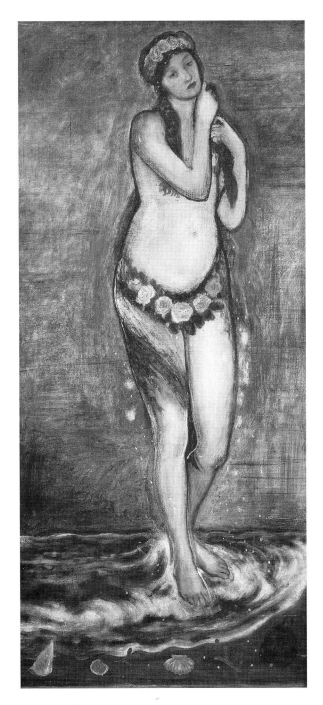

4.5 William Morris, *Aphrodite, c.* 1870

was a model (posing for the fictions), a worker (executing those fictions with needle and thread), a wife, mother and lover (given and taken, producing and reproducing the fictions in endless literal and metaphorical repetitions). She was an essential variable in the shifting economies of the Pre-Raphaelite community.

Now at Kelmscott Manor, *Aphrodite* (Figure 4.5) is Morris's only other extant full-scale oil painting. Dating from the very late 1860s or perhaps 1870, it foreshadows the style of Morris's later textiles and illuminated manuscripts and typifies the Renaissance classicism manifest in the subject matter of the later paintings by his friends and colleagues Rossetti and Burne-Jones. The colours and tones Morris uses in *Aphrodite* are muted in comparison with his previous work and his use of line is much freer. The model for this work is unclear; however it is certainly not Jane. Furthermore, the theme is no longer that of courtly love. Morris has departed from his images of chivalry, religiosity and sacred love and begun to explore the formal and thematic possibilities of classicism, untempered eroticism and profane love. And yet, *Aphrodite* is apparently the last painting on furniture, canvas or panel that he did.

Painting for Morris seems to have been a medium especially tied to community and consequently to youth. It was only in these early years of intense involvement with his Pre-Raphaelite brothers that he painted at all. Stylistically, thematically and socially, this painting marks Morris's transition from youth to manhood, from playful experimenter to head of household and market-savvy businessman. From this point, Morris focused his energy in his furniture and book design and pattern-making.

Characterized by a fundamental integration of work, labour and business on the one hand, with love, friendship and brotherhood on the other, Morris's early utopian vision differed very little from the ideals of most young middle-class men in the nineteenth century – except in that it was much more radical and made earnest attempts to put those ideals into practice on a scale that might extend beyond its immediate community. But fundamentally and on the most personal level, Morris wanted to discover a means to stability and commitment in work and love. However, when the two arenas mixed too thoroughly – or in ways he could not anticipate – he became unsettled and sought ways to pry them apart again. In 1870, the year of Rossetti's open avowal of love for Jane, Morris's professional and private lives completed their first major transformation. He perhaps realized that he was not comfortable with his own radical ideals of communalism and the thorough integration of love, brotherhood and work. When he came to comprehend that he could not control the channels into which he had hoped would flow the tributaries of work and love, he altered his utopian vision and therefore his professional and personal practices.

In 1864, when Burne-Jones refused to move his family permanently from London to Red House, Morris sold the home and moved Jane and his two daughters back to the city, where he established his business and residence in Queen's Square and where the Firm's trade expanded rapidly.[16] Burne-Jones, whose infant son had recently died and whose elder son was recovering from scarlet fever, argued that the dampness of the Kent countryside would have been detrimental to the fragile health of his family. However, one may speculate that with each member of the Firm by this time establishing a career that was independent from the common pursuits, there may have been some internal strife which historians have yet to uncover. In the early days of the circle, enthusiastic affection among new friends had been balanced and mutual, but the young men, who had once turned to one another for support in the passage from boyhood to manhood, were now passing through their turbulent phases and beginning to find their respective niches in work and love. Unfortunately for Morris, in the wake of Elizabeth Siddall's death from a laudanum overdose in 1862, both Rossetti and Morris increasingly shared the same love niche.[17]

In May 1871, Morris and Rossetti took Kelmscott Manor on the remote Oxfordshire edge of Gloucestershire on a joint tenancy in what may seem an eccentric move for two men engaged in such a struggle. The manor, in form and function, typified Morris's shift to Renaissance ideals from Gothic ones. The oldest part of the house dates from 1570, additions from 1670. Although, as Morris himself said, 'in that out of the way corner people built Gothic till the beginning or middle of the last century',[18] the seventeenth-century elements such as classical pediments over the windows and richly panelled walls strongly suggest the influence of Elizabethan design.[19] From the date of his acquisition of Kelmscott Manor, William Morris became professionalized as a true 'Renaissance man'. While his firm was flourishing in its new location at Merton Abbey, he founded the Society for the Protection of Ancient Buildings (also known as the Anti-Scrape Society), became a vocal socialist and composed several long prose romances and a great deal of poetry.

This mutually owned bucolic harbour of refuge from hectic commercial London existence quickly became a haven for the love between Jane and Rossetti.[20] Three weeks after the signing of the lease, Morris took Jane there and left for his first trip to Iceland, fleeing his own retreat and leaving his wife to enjoy the house and its surrounding countryside with Rossetti. One likely explanation for the impetus behind these decisions that seem so contrary to reason may be that Morris neither wanted nor would have easily acquired a divorce from Jane; in the interest of maintaining family respectability, he escorted Jane to Rossetti and arranged for their privacy.

By 1872, Rossetti was permanently installed at Kelmscott Manor following a nervous breakdown. Finally in 1874, Morris grew tired of his own

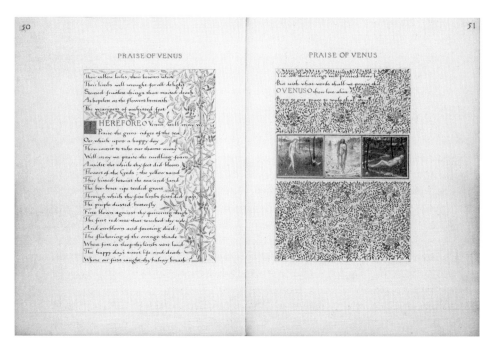

4.6 William Morris, *A Book of Verse*, 1870

unhappiness with the situation and asked Rossetti to sign over his portion of the lease and move out. From this point on, Rossetti's relationship with Jane was meant to be limited to an erotically neutral one between an artist and his model.[21]

A peculiar counterpoint to the events of these years is Morris's giving of *A Book of Verse* (Figure 4.6) to Georgiana Burne-Jones in 1870. This beautifully scripted volume of love poems written by Morris himself seemingly indicates an erotic exchange between its maker and its recipient. The book, however, as the final colophon reveals, was the collaborative project of several men. One of these men was the recipient's own husband, who painted a gouache of two separated lovers on the first page.

By the final pages of the volume, Morris had completely taken over the poetry, painting and decoration; stylistically, as well as thematically, the project evinces his dabbling in Renaissance classicism. A flattened italic script and lacy, lush, fertile pages decorate 'Praise of Venus', the book's final poem. Where Morris's gothicism always possessed an element of the sacred – such as that conjured by the Prioress's Tale Wardrobe, here he moves unabashedly into the profane:

Therefore O Venus well may we
Praise the green ridges of the sea
O'er which upon a happy day
Thou cams't to take our shame away.
Well may we praise the curdling foam
Amidst the which thy feet did bloom
Flowers of the Gods …
The bee-beset ripe seeded grass
Through which thy fine limbs first did pass;
The purple-dusted butterfly
First blown against thy quivering thigh;
The first red rose that touched thy side
And overblown and fainting died …
But with what words shall we praise thee
O Venus O thou love alive
Born to give peace to souls that strive.

The poetic images are of emotion's extreme physicality. The vivid proclamation of glorious sensuality in this poem promises release of all previous pain and tension and ends finally in the peaceful repose of fully requited love.

The miniatures on this page, centred amidst a thick design of red roses in full bloom, depict the nude figure of Venus first walking through a sunny, thick green field of similar roses with two white birds in the foreground, then in a Botticelli-like pose at the water's edge with the bright sun on the horizon, and finally posed drowsily as a prone *Venus Pudica* in a darker and thicker field of red flowers and greenery. Like the painting *Aphrodite*, on which these miniatures were based, these pages visually move Morris closer to a neo-Renaissance aesthetic. 'Praise of Venus' stands out as the most fully synthesized verse – text and image entirely complementing one another – and shines brightly as the zenith of the book. This final page stands in starkest contrast to the disintegration of the first page for which Burne-Jones designed the miniature and George Wardle did the ornaments. As a gift to Georgiana, the ritual of this book's production is undeniably complicated.

As the Firm gained momentum, to keep up with demand as well as to provide a sustainable income for his family, Morris became increasingly reliant upon more modern methods of mass production. This may have generated a desire to counterbalance the generic anonymity of the Firm's work by producing a piece that was once again unique and recognizably hand-produced. Furthermore, Morris wished to respond to what he perceived as the general aesthetic failure of Victorian printed books – a wish that ultimately resulted in the founding of the Kelmscott Press.

Wrought in painstaking detail, *A Book of Verse* bespeaks a desire to reciprocate the preciousness of Georgiana to Morris, but also, as a forerunner of the Kelmscott Press books, it signals a longing to introduce a literature that was beautiful – both poetically and materially – to the book-buying

community. Morris's casting of Georgiana in one of the poems as the Muse of the North – warm and attractive, but finally elusive – may further speak to this parallel between human desire and the modern material world: in true courtly tradition, what he wants he cannot have, but he will put forth every effort, within the bounds of decorum, to let his desire be known.

Concurrent with these events, Morris became increasingly concerned about insuring his income and keeping the Firm on a course that offered the prospect of sustained growth. Since the other partners were engaged nearly full-time with their own respective projects, Morris was no longer prepared to split the profits with those who did little or no work. In August 1874 (just a few months after Rossetti's effectual eviction from Kelmscott Manor), Morris announced his desire to close the business of Morris, Marshall, Faulkner & Company and reconstitute the Firm under his sole ownership. Following a prolonged debate about how to divide up the assets, the partnership was dissolved and re-established as Morris & Company.

After this there were no more communal living ventures. Morris was no longer an impetuous activist striving to get his friends to unite with him in the hopes that their utopia might serve as an example to the world. His activist gestures gradually became more public and more practical. In 1881 he converted to socialism, began his public speaking career and opened the Merton Abbey textile factory. His political speeches – combined with a mechanically-oriented production process which looked after its workers in the best possible Marxist fashion and yielded beautiful objects – were the new strategies in his pursuit of social change.

Knowing all this, is it possible to understand what precipitated the great shift from the Red House social experiment to this highly modern work ethic? As socialist as Morris claimed to be, by the 1880s, his business practice was, after all, with its mechanization and predominantly middle-class clientele, nothing short of a capitalist venture. The need to support his family or simply the desire to make more money are reasonable, but perhaps rather naïve explanations. Another more probable account for these apparently paradoxical transformations in Morris's political and business practices lies in a closer examination of the social mechanisms of gender and the politics of labour that defined everyday life at Red House. One answer to why the utopia could not succeed in practice is that there were too many bodies – too many types of bodies – with their own needs and their own desires. The collaborate, corporate production of *A Book of Verse* thematizes this failure of the utopia of incorporation.

The community seems to have supported an unusual alliance between the sexes. At Red House, men and women occupied themselves with often

similar tasks in identical spaces. Women were very involved in the processes of decorating Red House and executing work in the Firm. William and Jane Morris worked together on the painting of the ceiling in the drawing-room and on the textiles. At the house as well as later in the Firm, Georgie Burne-Jones and Lucy and Kate Faulkner painted fireplace tiles. Jane and her sister, Bessie Burden, worked in the Firm supervising a group of women embroidering designs on silk and cloth. However, this egalitarian ideal was soon found to be unsustainable because it depended too much upon the female members to bear the weight of its excess.

Women often complained of the inability to keep up; they could neither learn new techniques quickly enough nor execute the designs with swiftness sufficient to meet the increasing commercial demands of the Firm. The reasons they were unable to pursue their artistic talents to the same degree as the men were sometimes usual, sometimes extraordinary. Jane, for example, gave birth to both of the Morrises' daughters during the first two Red House years. While women participated greatly in decorating Red House, they usually only helped to execute the men's designs. When they did design their own projects, the craft was usually the historically feminine one of embroidery.[22] Furthermore, in addition to being wives, mothers and workers, Jane, Lizzie, Georgiana and Emma Madox Brown were also models for many of the Pre-Raphaelite brothers' paintings. The women were, in fact, the only ones performing labour for which they were neither commissioned, nor necessarily joyous. They became dolls in the elaborate play at Red House – props asked to play a part without reaping any remuneration or self-satisfaction. Objects, rather than subjects of their own lives, these women were extracted from both the neo-medieval and the proto-socialist economic models.

Morris had wished to install a pre-state economic community at Red House, one in which the family was not-yet-nuclear – an extended clan. However, this 'non-traditional family' was structured not on an elders–children model nor even on a model of a commune of couples, but rather on a very strict notion of fraternity. It was a community of men bound by friendships and common pursuits, not unlike the other young men's organizations that commenced during this period. The exchange required for the maintenance of this organization was both that of goods and services, as previously discussed, and also that of women themselves. The female members of the community were frequently excluded from the agency of giving and receiving. They were themselves also given and received – in marriage, in childbirth, in art. The time, talent *and bodies* of women became the ultimate media of exchange within the brotherhood.[23] In such an order where all the modalities of productive work were recognized, valued and rewarded by the 'brotherhood', women became exchangeable objects for the primary purpose of cementing

relationships between men. Within the Red House interior, women were dressed up, propped up and posed in an ongoing attempt to create another world, one that was characterized by excruciating attention to ornament and detail. In the end, the women themselves were abstracted, becoming symbols as well as reproducers of the Pre-Raphaelite culture.

The toy, Susan Stewart remarks, is a point of beginning for narrative: 'To toy with something is to try it out within sets of contexts, none of which is determinative.' The beginning of narrative time here, she says, is not an extension of everyday time, but rather the beginning of an entirely new temporal world: 'The real world is miniaturized in such a way as to test the relation between materiality and meaning'.[24]

Perceiving Gothic art's greatness to be the social repercussions of its commonality of living, leisure and labour and its freedom from what he later called 'useless toil', Morris attempted to combat the alienation of modernity by engendering pre-modern conditions at Red House by miniaturizing the social worlds of love, labour, and art so that he might understand the mutuality of meaning and materiality. His utopian notion focused on exploratory projects rather than particular institutions, and he hoped that one day it would be possible to carry these projects out into the larger world.

The intricately and perhaps even over-decorated Red House may well have been William Morris's masterpiece, inasmuch as it demonstrated its designer's expertise and prolific ability. But even more, by its execution, it established Morris – a self-styled neo-medieval guildsman – as a young man who had graduated from apprenticeship to master of his craft. The nostalgia he had been performing at Red House had been, after all, both for the state of humanity at a particular time in its history, as well as for childhood. By reviving the activities of the child and his idealized guildsman – by playing with toys and making serious play out of work – he restored the body to the mind, craft to art, the story to the object. But this utopian model was contingent upon the bodies, crafts and stories of women to bear the burdens of its internal contradictions.

Once he had been abandoned by many of his closest supporters who were increasingly pursuing their own vocations – artistic and otherwise – he still aimed to educate desire by disrupting the taken-for-granted alienation of present-tense labour and life. With respect for history as well as for modernity, he continued to strive toward embodying medievalism's communal essence, and returning the stories of objects to their makers. He never stopped testing that mutuality. But, between 1865 and 1870, he came to realize that rigid communitarianism was not an ideal that he could realistically broaden and carry into the future.

As Morris grew older, he seems to have formed compartments in his mind. The first half of his career had been characterized by a wish to integrate love, friendship, labour and business; the second half by a division between his idealism, socialism and medievalism on one side and his commitments to business and family on the other. Evidence suggests that his desire to paint had indeed been connected to his feelings about community, love and friendship. Painting had been a means to intimacy. The end of this artistic practice around 1870 marked the beginning not only of a biographical and economic shift, but also of a re-evaluation of his relation to materiality and representation.

Active though they may have been, the stunners – Jane, Lizzie and the others – were treated as mere dolls in the miniaturized world at Red House. It was only when either their bodies or their images were removed from circulation by one means or another that the utopia could operate free from contradiction. Morris could stop painting Jane – extract her from the circulation of his objects – in order to detach his professional and personal worlds. He could also continue to permit Rossetti to paint Jane, but evict him from Kelmscott Manor, in a vain hope to put an end to the erotic element of Jane and Rossetti's professional relationship. Any of the Red House women could, at any time, be alienated from the subjectivity of their labour for the artistic component of the corps were they to have children or merely become overwhelmed by the social obligations that wives of such men necessarily experienced. Lizzie Siddall, whose very identity was utterly a construct of Pre-Raphaelite male fantasy, could take an overdose of laudanum, removing herself from circulation altogether. Several economies were, therefore, at work in Morris's incessant tinkering. The economies of material and erotic desire, of scale, and of modes and means of representation, production and reproduction were all implicated in his attempts to find the perfect measure of each as he sought an ideal societal structure that could alone be defined by love, beauty and art.

Youth – a time for experimentation and the taming of desires – was for Morris a period of toying with various structures of desire. The Middle Ages, historically understood as the 'childhood of Man', seemed the perfect archetype for both its visual styles and its familial and economic milieu. However, as he realized the ways in which that model did not work, he increasingly moved toward a Renaissance framework, reflected in the patterns and subject matter of his later designs, as well as in his business practices and personal life.

William Morris had tried to re-ritualize art and maintain its integrity by turning artistic production into a communal enterprise. In doing so, however, he found that he was unable to maintain his neo-medieval utopia in the public and private spheres at once. He ran up against several obstacles:

women were simultaneously objects and subjects in the circle and, despite its function as a social circle – a community bound by art-as-gift – the design firm actually did produce commodities and members depended upon the advertisement and selling of the goods for their livelihood. The fraternal element of the Firm served its purpose: the young men mutually nurtured one another while each grew acquainted with the ways of work and love. The brotherhood was simultaneously competitive enough for each to gain a strong sense of individuality. And yet, it was that very individuality – that movement away from the spirit of communalism and corporate identity that the Victorians believed had been so integral to Gothic culture and toward the independence and entrepreneurialism more characteristic of the seeds of capitalism planted during the Renaissance – that made the fraternity not only unnecessary, but also burdensome. The degree to which the commodification of the Pre-Raphaelite female aesthetic became inextricable from this process can still be witnessed today in the countless prints of Lizzie Siddall as the Lady of Shalott and Ophelia or Jane Morris as la Belle Iseult, Proserpine or Astarte Syriaca circulated by large museums like the Tate Gallery. In short, interpreting the role *brotherhood* played in William Morris's decorative art production bears witness to the operations and implications of and contradictions in the Pre-Raphaelite economy of desire.

Notes

1. A Louis XV chair, for instance, with its plump, undulating form and polychromy, comes to stand for the all the extravagance and gross excess of the French monarchy. Examples of such decorative arts scholarship are Geoffrey Beard's *The National Trust Book of English Furniture: The Proceedings of the 1975 Winterthur Conference*; Ian M. G. Quimby, ed., *Material Culture and the Study of American Life*, proceedings of the 21st Winter Conference (1975), (New York: Norton, 1978); and Ray Watkinson's *William Morris as Designer* (London: Trefoil, 1990).

2. Authors who have dealt forcefully with what decoration *means,* and who have therefore been influential in the formulation of my own theories include Ernst Gombrich, Jules Lubbock and Leora Auslander. Gombrich, in *The Sense of Order: A Study in the Psychology of the Decorative Arts* (London: Phaidon, 1975), illustrates how decorative craftsmanship from a variety of cultures can be seen as a manifestation of tendencies also observed in human play, poetry, dance and architecture. Lubbock, in *The Tyranny of Taste: The Politics of Architecture and Design in Britain 1550–1960* (New Haven: Yale University Press, 1995), and Auslander, in *Taste and Power: Furnishing Modern France* (Berkeley: University of California Press, 1996), seek to paint detailed pictures of the manifestations of desire for capital and goods and the social repercussions of those manifestations during particular historical moments.

3. E. Anthony Rotundo, *American Manhood: Transformations in Masculinity from the Revolution to the Modern Era* (New York: Harper Collins, 1993), p. 87.

4. Other social histories of gender and sexuality of particular relevance to this discussion are those derived from Carroll Smith-Rosenberg's essay 'The Female World of Love and Ritual in Nineteenth Century America' *Signs: Journal of Women in Culture and Society*, 1(1) (1975) and Gayle Rubin's 'The Traffic in Women: Notes on the "Political Economy" of Sex', in Rayna Rapp Reiter (ed.), *Toward an Anthology of Women* (New York: Monthly Review Press, 1976). Scholarship related to the former include Rotundo's work and Eve Kosofsky Sedgwick's *Between Men: English Literature and Male Homosocial Desire* (New York: Columbia University Press, 1985); together, these provide useful models for me insofar as each views homosocial communities and

romantic same-sex friendships in nineteenth-century middle-class society from cultural and social perspectives, rather than psychosexual ones. See also Luce Irigaray's *This Sex Which is Not One* (Ithaca: Cornell University Press, 1985) which further examines the concept of women as objects of exchange that help bind relationships between men. Picking up, in some ways, where the seminal ethnographic texts of Lévi-Strauss and Mauss left off, each scholar probes issues of kinship and exchange, asking questions such as: Why can't men be objects of exchange? Why are women subordinate in this particular way?

I am aware of many of the problems with these dated feminist tracts; however, as outlined above, the scholarship provides very useful models for my exploration of the ways many types of objects circulated in the Pre-Raphaelite Brotherhood. For instance, taking part of my method from Irigaray, I pull material objects from their traditional symbolic contexts and re-assign them roles based on new knowledge of their potential functions.

5. Fiona MacCarthy, *William Morris: A Life for our Time* (New York: Knopf, 1995).

6. Charles Harvey and Jon Press, *William Morris: Design and Enterprise in Victorian Britain* (Manchester: Manchester University Press, 1996).

7. Used by nineteenth-century middle-class men and women to give order to an increasingly confusing social world, the doctrine of the separation of spheres was an elaborate system of signs and symbols which divided the domain of the social into two realms defined roughly as the home and the world. Home, the 'naturally' pure and pious women's province, provided an atmosphere of virtue in which to raise children. Men were supposedly strengthened and renewed here after each daily moral weakening out in the morally corrupt world of business and public life. The presumed power, greed, selfishness and aggression of men made them particularly suited to the world, but this necessary sullying needed continuous cleansing in the home.

8. MacCarthy 1995, p. 156.

9. The goods and services that were exchanged in the common interest of decorating Red House were not vital ones. Aside from the fact that most of the work actually took place in the home, qualitatively it differed very little from that which may have taken place in a traditional cabinet maker's workshop where different craftsmen may have offered their varying expertise. Furthermore, this was by no means a self-sufficient utopia subsisting in pastoral paradise; it was merely decoratively self-sufficient. For everything else – food, clothing, coal, and even the consumption of its own products to provide capital for survival – it depended on the outside world. Red House was a limited utopia.

10. Jennifer Harris, 'Jane Morris's Jewel Casket', *The Antique Collector*, **12** (1984): 68–71.

11. Harleian MS. 4431.

12. Frances Collard, 'Furniture', in Linda Parry (ed.), *William Morris* (London: Philip Wilson Publishers in association with the Victoria and Albert Museum, 1996), p. 156.

13. While it goes against the grain of my feminism to identify the men by their last names and the women only by their first, it seems necessary here both for ease of recognition and for brevity.

14. At this time, the young artists knew little about the technique of painting frescos that would endure through the ages; the murals began to disintegrate almost as soon as they were finished.

15. MacCarthy 1995, p. 159.

16. Morris even went so far as to have Webb draw up architectural plans for the Red House addition that would complete the quadrangle, housing Burne-Jones and his family and providing workshop space for all.

17. Ford Madox Brown remarked that after Morris's move in 1865, Rossetti's obsessive drawing and painting of Jane and the evident love between painter and sitter seemed to threaten all their relationships and imperil the Firm.

18. William Morris, quoted in A. R. Dufty, 'William Morris and the Kelmscott Estate', in Linda Parry (ed.) *William Morris: Art and Kelmscott* (London: The Society of Antiquaries of London, 1996), p. 82.

19. Donald W. Insall, 'Kelmscott Manor and its Repair', in Parry 1996, p. 106.

20. Jan Marsh, 'Kelmscott Manor as an Object of Desire', in Parry 1996, p. 71.

21. I do hope that readers will take this 'erotic neutrality' with all the irony that is intended. At the William Morris Centenary Conference at Exeter College, Oxford, in 1996, Jan Marsh maintained that it was unlikely that Jane's relationship with Rossetti was ever actually consummated due to the omnipresence of both children and servants at Kelmscott Manor during Morris's absence. I

shall allow my readers to make up their own minds, bearing this in mind: not only is there a great deal of uninhabited countryside in the environs of Kelmscott Manor, but also there were countless occasions on which the 'stunner' modelled for the artist – probably in completely unattended, unchaperoned privacy.

22. See Rozika Parker's *The Subversive Stitch* (London: Women's Press, 1984) for an account of how women have used this stereotypically feminine occupation to corrupt the patriarchal symbolic order.

23. See Sedgwick's *Between Men* for a discussion of how women's bodies are exchanged between men as a means of binding the men's relationships.

24. Susan Stewart, *On Longing: Narratives of the Miniature, the Gigantic, the Souvenir, the Collection* (Durham, NC: Duke University Press, 1993).

Questions of identity at Abramtsevo

Rosalind Polly Gray

In 1870, the Russian tycoon Savva Mamontov (1841–1918) bought the country estate of Abramtsevo, a property about 70 km north-east of Moscow. Mamontov was a keen patron of the arts and, having amassed a fortune in Russia's burgeoning railway industry, he decided to use his money to support an artists' colony on his estate. From the mid-1870s onwards, Mamontov invited some of the most notable artists of the day to live and work there at his expense, including Ilya Repin (1844–1930), Valentin Serov (1865–1911) and Mikhail Vrubel (1856–1910). He instigated a series of amateur theatrical productions, in which family, friends and resident artists were all encouraged to participate, and he supported the establishment of applied art workshops on the estate, which revived and popularized traditional Russian crafts. In contrast to the Eurocentric approach which had been introduced to Russia by Peter the Great, the Abramtsevo workshops took their inspiration from vernacular styles, identifiably Russian motifs and the medieval art and architecture of the pre-Petrine era.[1] The Abramtsevo circle also aimed to remove the distinction between the fine and the decorative arts, promoting the latter as both accessible to the people and of practical use to society.

Much of the ideology of the Abramtsevo artists echoes that of William Morris and his colleagues, which later underpinned the major discourses of the Arts and Crafts movement. However, the Abramtsevo artists shared neither the anti-industrial impetus of the British Arts and Crafts Movement, nor Marx's notion of the alienated worker which flavoured the rhetoric of William Morris.[2] Rather, they were brought together by a man who had made his money in industry, and they realized from the start that the survival of the *kustar*, or peasant craft, industry depended on adapting it to suit the demands of a modern, urban consumer.[3] How then did the Abramtsevo artists define themselves? This essay will examine the way in which their sense of 'brotherhood' was constructed, for despite the fact

that Abramtsevo products display a variety of styles and media, ranging from Serov's *plein-air* Impressionism to Vrubel's Symbolist ceramics, there was a distinct Abramtsevo identity.

The obvious starting point for a discussion of the Abramtsevo identity is the figure of Mamontov himself. Only 29 when he bought Abramtsevo, Mamontov had been investing in the railway and mining industries since 1866, and on the death of his father Ivan in 1869 he became the major shareholder in the Moscow–Tuoitze railway, which Ivan had built at the beginning of the decade.[4] By the time that Mamontov moved to Abramtsevo, he knew that his heart lay in theatre and the arts: he took singing lessons in Milan in the early 1860s and at about the same time began to invite artists to his house in Moscow. Earlier, his father had entertained artists in the family home, including the marine painter Ivan Aivazovsky (1817–1900) and the engraver Fedor Iordan (1800–83).[5] Mamontov had therefore grown up in an environment which welcomed artists, he had artistic aspirations of his own and, by 1870, he was in a financial position to indulge these interests. Art was to become the ruling passion of his life. At the civic wake held in Mamontov's honour in the Moscow Arts Theatre, the theatre director Stanislavsky claimed that 'art secretly directed everything that Savva Ivanovich did. … He became a lion when he had to defend art from the coarse violence of ignorance.'[6] In 1883 Mamontov had himself written that he was completely preoccupied with 'the rehearsals of The Crimson Rose, the staging and all sorts of domestic troubles (not to mention the railways, which one really shouldn't ignore)'.[7] This comment shows the order of Mamontov's priorities, with business interests taking a back seat to his artistic and theatrical activities.

Mamontov's compelling enthusiasm for the arts contributed enormously to the development of an Abramtsevo identity. He would coerce and cajole artists into considering areas of artistic enterprise previously foreign to them with tactics that verged on bullying. Victor Vasnetsov (1848–1926) spoke of Mamontov's 'inspirational despotism',[8] while to Alexandre Benois (1870–1960) 'the despotic Mamontov, so enamoured of show and glory, was, along with Diaghilev, a crucial figure to whom young Russian art primarily owed its prosperity'.[9] Mamontov tempered his despotic streak with an inimitable sense of humour and panache. When, for example, the actor playing Zeus in an Abramtsevo theatre production caught his costume on a table being used as Mount Olympus and found himself naked, 'sitting on his throne in Adam's costume, as if he were on one of the shelves in a banya', Mamontov simply laughed and refused to hand back the errant robe.[10] Mamontov's spirit remained unbroken even when, in September 1899, he went bankrupt and faced charges of the mismanagement of his railway and factory investments. Waiting for the court case under house arrest, Mamontov calmly sculpted

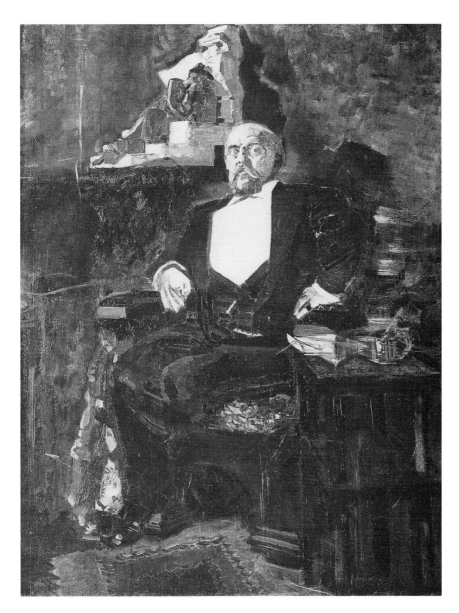

5.1 Mikhail Vrubel, *Portrait of Savva Mamontov*, 1897

his guards.[11] His charisma and energy played a fundamental role in forging a community spirit at Abramtsevo.[12]

The question arises as to how such a forceful and domineering personality did not alienate the delicate sensibilities of his talented circle. In the first

place, Mamontov presented no professional threat, as he himself remained a dilettante in the arts, occasionally to the frustration of contemporaries who believed him capable of more.[13] Second, he recognized and embraced his role as nurturer and financial backer, taking it upon himself to provide artists with conditions conducive to developing their talent and individuality to the full.[14] Finally, for all his exuberant and coercive approach, Mamontov possessed a significant measure of tact: he was, for example, the only major patron of Vrubel's who never fell out with his volatile protégé.

Mamontov encountered the first of the artists who would become part of his circle in 1872, when he took his young family to Rome. There he met the sculptor Mark Antokolsky (1843–1902), the painter and graphic artist Vasily Polenov (1844–1927) and the art historian Adrian Prakhov (1846–1916). He began to take sculpture lessons with Antokolsky, who was soon captivated by his new friend. 'He is simple, kind, he loves music and he himself is not bad as a poet. When he arrived in Rome he suddenly began to sculpt, and soon showed extraordinary progress!'[15] The following year Mamontov met Repin and the young Serov in Paris. The fact that Mamontov and these artists met and first bonded abroad is a significant factor in the later strength of the Abramtsevo circle.

Isolated from their homeland, artists studying abroad had long formed close bonds with their compatriots. In Rome, they inevitably gravitated towards those who had also been drawn to the city's incomparable treasures, and the affection held between artists travelling to or resident in Rome is apparent in numerous instances: the friendship and loyalty of the Nazarenes is legendary; and Jacques Louis David (1748–1825), who enjoyed a close relationship with his pupil Jean-Germain Drouais (1764–88), wrote 'this reciprocal affection, which extended to a virtual idolatry on his part, determined my decision to make a second journey to Italy'.[16] As had been the case with these German and French artists, a sense of community between Mamontov and the future Abramtsevo artists was accelerated and intensified by the communal sense of 'otherness' which arose while they were abroad.

In Paris a distinct Russian artistic community was already in existence, revolving around the landscape painter Aleksei Bogolyubov (1824–96), who in 1872 was asked to act as a mentor to the Academy pensioners studying in France.[17] Bogolyubov took this supervisory role seriously, helping amongst others Antokolsky, Repin, Polenov, Konstantin Savitsky (1844–1905) and Vasily Vereshchagin (1842–1904).[18] The students would work in Bogolyubov's studio, stay in his flat when he was away,[19] and participate in his Tuesday evening salons. Bogolyubov also organized painting trips to the seaside resort of Veules, and helped the young artists financially.[20] Mamontov would have encountered Bogolyubov's circle, which was in full swing by the time he went to Paris in 1873, and Bogolyubov first visited Abramtsevo later that

year.[21] Mamontov had therefore been exposed to the bonds and loyalty of Bogolyubov's group, and many of the artists who later worked at Abramtsevo, including Antokolsky, Repin and Polenov, already had experience of working in a close-knit, location-specific community.

By 1874, many of the artists whom Mamontov had met in Rome or Paris were yearning for their home country. Repin wrote to Vladimir Stasov (1824–1906) 'I won't stay here much longer. I feel as if I'm in exile',[22] and Polenov voiced similar sentiments in letters to his family.[23] The artists longed for Moscow in particular: in Repin's opinion, 'it is now becoming clearer and clearer that Moscow will again unite Russia. The city is making a huge impression in all the most important manifestations of Russian life.'[24] Their gravitation towards Moscow reflected the general shift in cultural dynamics from St Petersburg to Moscow, which had been assuming an increasing importance since the 1860s.[25] The city had become the proud venue for two new public galleries in 1862, with the opening of the Kokorev Gallery[26] and the Rumyantsev Museum,[27] and the increasingly influential Moscow School of Painting and Sculpture[28] attracted artists dissatisfied with the Academy's hegemony in St Petersburg. Moscow therefore offered a point of reference in the formation of the Abramtsevo group.

Mamontov encouraged the relocation to Moscow, writing to Polenov, 'you would not be wrong to move as an entire group to Moscow to work for a while. Unlike any other artistic centre, Moscow can still provide the artist with a lot of idiosyncratic, fresh, unpolluted material.'[29] Once there, Repin agreed, claiming that '[Moscow] is so artistic and beautiful that I am now prepared to travel to the other end of the earth to see a comparable town. [The city] is unique! ... I am almost beside myself with happiness at living in Moscow!'[30] Vasnetsov echoed his enthusiasm: 'when I arrived in Moscow I felt that I had come home, that there was nowhere else I wanted to go. The Kremlin and St Basil's almost made me cry, so very national and unforgettable did it all strike my soul.'[31] Vasnetsov reveals a growing interest in national, medieval prototypes, which will be examined later in this account as a key factor in defining the Abramtsevo group. What concerns us here is the artists' convergence in Moscow, and its proximity to Abramtsevo.

Mamontov had been inviting artists and cultural historians to Abramtsevo since 1873. There was nothing particularly novel in the idea of artistic interchange on a country estate, as artists, and writers in particular, had long enjoyed the hospitality of country landowners. Priscilla Roosevelt even defines one of the three models of Russian estate life as a pastoral Arcadia of poets and artists.[32] There was a precedent at Abramtsevo, when the writer and theatre critic Sergei Aksakov (1791–1859), the estate's previous owner-occupier,[33] had welcomed a host of literary and theatrical figures including Gogol,[34] Turgenev, Herzen, Belinsky, the serf-actor Mikhail Shchepkin (1788–

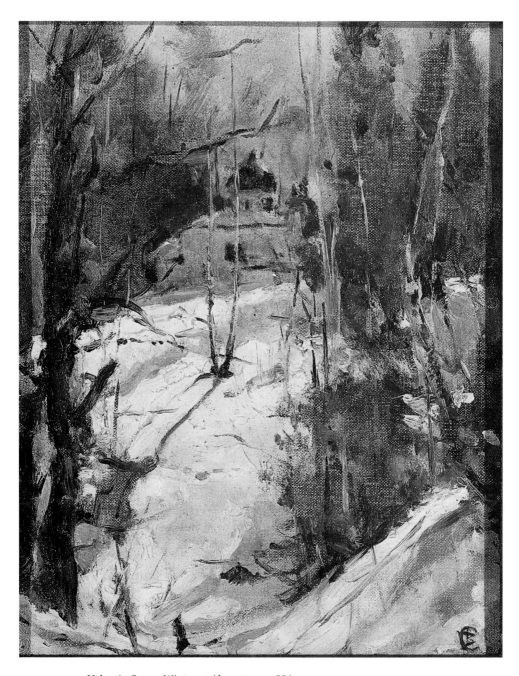

5.2 Valentin Serov, *Winter at Abramtsevo*, 1886

1863) and the artist Konstantin Trutovsky (1826–93).[35] Literati such as these usually relished their time on the estates. As the law professor Boris Chicherin wrote: 'Whereas in the capital one felt that heavy despotism stifling every living thought … in the provinces the endless distances weakened the operation of the system … Even in the darkest days … everyone coming to the country felt he breathed more freely, could think and say what he wished.'[36]

The practice of cultural exchange in the relaxed setting of a country estate provided a matrix for the Abramtsevo group, and initially their artistic enterprise followed the traditional model of writers and poets converging in a rural setting for a period of creative exchange. Adrian Prakhov's brother Mstislav (1840–79), a historian, linguist, poet and translator, began to organize literary evenings and play readings from his first visit in 1873. These developed into staged performances, reviving the musical evenings and amateur dramatics of both Aksakov's Abramtsevo and Mamontov's childhood home of Kireevo.[37] Mamontov, however, brought his characteristic ebullience to the endeavour, and soon eclipsed any previous attempts at private theatre. His productions demonstrated an unprecedented interpenetration of art forms and an intensity of collaboration which was to characterize the Abramtsevo group.

Mamontov's first theatrical production was held at his Moscow residence on Sadovo-Spasskaya in 1878, marking what the Abramtsevo circle saw as its foundation. In 1879, *Two Worlds* by Apollon Maikov was staged at Abramtsevo, followed by plays by Zhukovsky, Ostrovsky, Gogol and nine by Mamontov himself, all of which were performed between 1881 and 1890. Mamontov encouraged his guests to involve themselves in every aspect of the productions, a fact later wryly noted by Vasnetsov when he referred to Serov as 'a ballerina and a decorator'.[38] Each artist was stretched to the limits of his creative and performing abilities. Polenov, for example, not only played the main role in *Two Worlds*, but also repainted the backdrop the night before the performance because he was not happy with the one produced by a professional designer. This versatility led to a new definition of the Abramtsevo artist who no longer specialized, but instead embraced any form of artistic activity, ranging from painting and sculpture to theatre, costume design and, in the 1880s and 1890s, architecture, woodcarving and ceramics. The deconstruction of traditional artistic hierarchies, and the experimentation by Academy-trained easel painters in new media for a new form of artistic consumption – in this case the theatre – parallels the ideology of Morris, Marshall, Faulkner & Co., which saw a painter such as Ford Madox Brown designing basic, functional furniture. The organic synthesis of various art forms also underpinned Mamontov's later Russian Private Opera (1885–91 and 1896–1900),[39] and had a defining impact on the modern art movement in Russia as a whole.

The second major role of theatre in the formation of an Abramtsevo identity was the opportunity it provided to explore the group's defining interest in nationalistic and medieval sources and motifs. Localism again plays a part, for in Aksakov's time Abramtsevo had been a focus for nationalist Slavophile ideology. Aksakov and his sons were firm Slavophiles – as well as debating the theoretical framework of the movement, Ivan collected Russian folklore, while Konstantin wore local peasant costume, to the amusement of polite society, and eschewed the French 'papasha' in favour of the Russian derivative 'otosen'ka' as a term of endearment for his father.[40] On a more serious note, their Slavophile polemics were shaped by discussions with Westerners as commanding as Belinsky, Turgenev and Timofei Granovsky (1813–55), and Slavophiles as fervent as Aleksei Khomyakov (1804–60), Yuri Samarin (1819–76) and the Kireevsky brothers Ivan (1806–56) and Petr (1808–56), all of whom visited Abramtsevo. Publications connected with Abramtsevo, including Aksakov's celebration of Russian country life, *Notes on Angling* (1847), which was written on the estate, and Petr Kireevsky's collection of Russian folk songs, which inspired Ivan Aksakov's research into Russian folklore, reflected that key issue of the Westerner-Slavophile movement – the quest for national identity.

The later Abramtsevo group maintained active links with Aksakov's circle: Repin was commissioned by Pavel Tretyakov to paint Ivan Aksakov's portrait, and Vasnetsov portrayed Konstantin Aksakov and Khomyakov; Mamontov's wife Elizaveta (1847–1908) corresponded with members of the Aksakov family, and religiously preserved artefacts at Abramtsevo which dated from Aksakov's day; and Turgenev, who had visited Aksakov at Abramtsevo twice and conceived *A Nest of Gentry* on the estate, met Mamontov in 1873 and returned to Abramtsevo under its new ownership in 1878. Mamontov and his circle were therefore familiar with the Westerner-Slavophile debates which had underscored the early history of the estate. This familiarity gave their interests in nationalistic subjects a theoretical base.

At the same time, Mamontov had connections with central figures in the medieval revivalist movement.[41] The Slavophile historian Fedor Chizhov (1811–77), who wrote on Russian icons and pre-Renaissance painting in Italy, had been the partner of Mamontov's father Ivan in the railway business, and was a notable influence on his son. Ivan Mamontov had also known the historian and journalist Mikhail Pogodin (1800–75), a specialist in ancient Russian history who advocated a national style in Russian art, and the entrepreneur-collector Vasily Kokorev (1819–89), owner of Moscow's first public gallery and an expert on Russian *kustar* art.[42] In 1856 Kokorev had given Pogodin an extraordinary building called the 'Pogodin Hut', which was one of the first serious attempts to define a national style in architecture. The professional and social triangle of Ivan Mamontov, Pogodin and Kokorev

had been one of the more colourful aspects of Moscow life in the late 1850s,[43] and their interest in local and medieval art forms inevitably had an impact on Mamontov junior. Savva Mamontov, who himself wrote that 'art in its every manifestation must be national above all,'[44] was also close to Mstislav Prakhov, an expert on folk art and mythology, and his brother Adrian, who maintained that art must contribute to the development of national identity. The notion of art feeding into a country's process of self-differentiation by foregrounding identifiably nationalistic forms and motifs had been a pan-European concern for the previous 50 years, and had been championed in Russia by Vladimir Stasov. The Prakhov brothers continued to advocate a national artistic canon, in their case one often predicated on medieval art forms, which would both consolidate and mediate Russia's self-image. Their frequent presence as welcome guests at Abramtsevo stimulated lively discussions on the nature and role of a nationalistic and/or medieval idiom in the arts.

Mamontov and his circle initially explored the application of these nationalistic and medieval revivalist concerns to the performing arts. The plays which they chose or, in Mamontov's case, wrote, often involved Russian history, myth or fairy-tale, such as the famous *Snow-Maiden* by Ostrovsky. This recourse to indigenous legend again finds parallels with the work of Morris, Burne-Jones and their circle in Britain, who frequently derived their inspiration from texts such as Sir Thomas Malory's *Le Morte d'Arthur*. Vasnetsov was entrusted with the stage designs for *Snow-Maiden*, and produced a remarkable visualization of the popular fairy-tale in a setting which borrowed heavily from the decorative art and architecture of ancient Rus.[45] This and other theatrical productions proved crucial to the cohesion of the group for two reasons. First, theatre enabled the circle to reconstruct nationalistic subject matter by acting out and illustrating myths, fairy-tales and legends: these nationalistic concerns which surfaced in the forum of theatre design were to become a unifying trait linking other areas of artistic endeavour. Second, theatrical art and performance necessitated communal activity, enabling the Abramtsevo artists to develop their nationalistic interests by working as a group which was reliant on each and every member of the team. In forming a bridge between written text and visual performance, the plays were a key transitional moment in the group's development from a traditional literary circle to the first, estate-based, cultural community in Russia that focused on the plastic arts, rather than on literature.

A seminal figure in this transition was Victor Vasnetsov, who first went to Abramtsevo in 1878 and soon became pivotal in promoting a nationalistic cultural perspective: as Elena Polenova (1850–98) wrote to Stasov in 1894, 'I didn't study with Vasnetsov in the direct sense of the word – that is, I didn't take lessons with him, but somehow I acquired around him an understanding

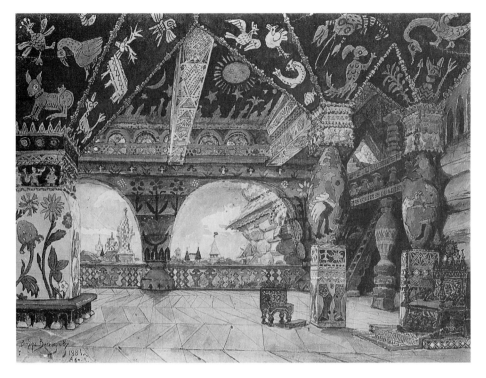

5.3 Viktor Vasnetov, *The Chambers of Tsar Berendey*, a sketch for the stage design of Act II of the opera *The Snow-Maiden*, 1885

of the Russian national spirit'.[46] Vasnetsov himself once claimed, 'I have only ever lived for Rus'.[47] Both he and his brother Apollinary (1856–1933) were particularly inspired by the ancient capital of Moscow which, with its distinctly Slavic, pre-Petrine architecture, was felt to embody the essence of traditional Russian culture. While Apollinary focused on cityscapes of sixteenth- and seventeenth-century Moscow, making the old capital the defining leitmotif of his work,[48] Victor's response was a more subtle form of retrospectivism, assimilating a range of ideas from folklore, ethnographic material, ancient crafts and architecture and icon painting. He was to play a critical role in the formation of the Abramtsevo identity, as it was largely thanks to Vasnetsov's advocacy of Russian sources and motifs that the circle adopted a retrospective, medievalist style in its second major group project – the building of the Church of the Icon of the Saviour (1881–2).

The idea of building a church at Abramtsevo was first mooted in the spring of 1880 when the river Vorya burst its banks, blocking the route to the nearest church.[49] Mamontov had already carried out construction work on the estate, including a hospital in 1873, following the 1871 cholera epidemic,

and a school in 1874. He had also commissioned a studio from Viktor Gartman in 1873, and a 'bathhouse', which was used as a guest house and known as the teremok, from Ivan Ropet in 1878. Both of these buildings attempted a national revivalist style by appropriating early architectural motifs from local sources, but the result in each case was an unsuccessful pastiche of disparate and poorly assimilated elements.[50] Vasnetsov and his colleagues adopted a more scholarly approach to the question of national revivalism in architecture, aiming to extrapolate ancient architectural features from a variety of medieval Russian prototypes, which would then be fully integrated into the final design. Their projection of a national style filtered by medieval practice reflected the way in which culture was being invested with nationalistic meanings in numerous other European countries.

The Abramtsevo artists consulted notable scholars, such as Ivan Zabelin (1820–1909), a curator at the History Museum in Moscow and leading authority on the culture of pre-Petrine Rus,[51] and trawled a range of ancient Russian architecture for inspiration. Polenov, the son of a respected archaeo-logist who served as secretary of the Imperial Archaeological Society, also taught archaeology at Moscow University and studied vernacular church design in Novgorod and Pskov, and Vasnetsov acquired a knowledge of traditional architectural forms by painting the murals of the Cathedral of St Vladimir in Kiev from 1878 onwards.[52] The foundations of the Abramtsevo collection of traditional Russian folk art were also laid in this period, with Repin and Polenov bringing the first exhibit – a carved board from the façade of a hut in the village of Repikhovo – in 1881, and Polenov returning from the Saratov province with several wooden spindles the same year. This range of indigenous sources informed both Polenov's first church design and Vasnetsov's final version of a simple cuboid body, single dome and belfry. Polenov, Vasnetsov, Repin and Nikolai Nevrev (1830–1904) worked on the iconostasis, with later contributions from Polenova and Vrubel, and the church was finally consecrated in 1888. It was immediately recognized as a key monument in the development of Romantic Nationalism in Russia.[53]

In the construction and decoration of the Abramtsevo church, we again see the organicism of Arts and Crafts ideology, with Academy-trained painters 'turning their hand to the applied arts and architecture in a first, unified effort to create a total work of art where painting, sculpture, carving etc. were intimately co-ordinated.'[54] Infectious enthusiasm characterized the entire project. In Vasnetsov's words,

we outlined the façades and ornaments, drew up plans and painted images, while our ladies embroidered gonfalons [a sort of ensign or standard] and shrouds and even climbed the scaffolding surrounding the church to carve ornaments in the stone like real stonemasons. The surge of energy and artistic creativity was

extraordinary: everybody worked tirelessly, competing with one another, but in a selfless manner. It seemed that the artistic impulse which lay behind the creativity of the Middle Ages and the Renaissance was again hammering in the key.[55]

Building the church obviously served a social purpose, as it catered for the local community, and some of the Abramtsevo artists were motivated by the belief that their art should be of use to society. Antokolsky had written to Mamontov from Rome, 'soon we will all see each other at your Abramtsevo … I sense that my dreams will soon come true, and we will all happily work together in the field of art, for the good of the people.'[56] However, the Arts and Crafts notion of the social function of art was only really put into practice at Abramtsevo by Elizaveta Mamontova and Elena Polenova, whose work in reviving the *kustar* art industry by establishing applied art workshops on the estate was underpinned by philanthropic and educational aspirations. Here we see an example of traditional gender divides, with the women of the community undertaking a form of artistic enterprise in keeping with a caring, nurturing role. Charitable work and the decorative arts were both acceptable occupations for women, and the revival of the *kustar* industry offered a forum in which they could make an active social and artistic contribution.[57] As was the case with the Arts and Crafts Movement in Britain, Ireland and America in particular, women played key roles in decorative arts associations in Russia towards the end of the century: the *kustar* workshops which they ran included the Solomenko embroidery workshop, which was established during the famine of 1891, and the famous artistic community founded by Princess Maria Tenisheva (1867–1928) at her estate of Talashkino, near Smolensk, in 1893. Tenisheva, herself a practising artist, based Talashkino on the Abramtsevo model, inviting professional artists, including Vrubel, Aleksandr Golovin (1863–1930) and Sergei Malyutin (1859–1937), to live on the estate, and encouraging them to revive the cottage art industries.[58] Salmond makes the interesting point that the centrality of women in these *kustar* endeavours, whose products helped to mould the primitivist articulation of the Russian avant-garde, offers one explanation as to why women figure so prominently in the development of Russian modernism.[59]

As far as Abramtsevo was concerned, Polenova initially conformed to gender stereotypes by using her artistic talent for philanthropic purposes, in her case by attempting to tackle the degradation of rural traditions and recover skills which had been lost in the Industrial Age in order to provide means of employment for an otherwise disenfranchised rural craft community. However, Polenova's desire for creative self-expression grew, apparently with the full support of the male-dominated community, causing her to abandon the cultivation of traditional folk material in favour of new motifs of her own invention. As Salmond has noted, this move away from the collective, social goals of the 1860s towards a more introspective concern

with her own, individual craft was symptomatic of the progression of nineteenth-century Russian art as a whole.[60] Polenova's personal development now revolved around new priorities based on fulfilment in an artistic, rather than in an altruistic, capacity, and she retired from the workshops, which she had directed since 1885, in 1893. Elizaveta Mamontova, whose gender conditioning enforced a charitable urge to put her own skills at the service of the local community, continued to run the workshops after Polenova's departure, but Mamontova's original, philanthropic orientation was now undermined by the workshops' commercial success.[61] Moreover, without Polenova's supervision, the mass production of her designs led to a decline in quality, and the workshops became a commercial, rather than a socially enhancing, exercise. The other, male artists at Abramtsevo, although showing a healthy and supportive interest in Polenova's craft workshops, did not put her social concerns into practice in their own work: the church, for example, was a play-thing of the artists themselves, rather than providing employment for the skilled local community. With the exception of the female-instigated activities in the workshops, an emphasis on social involvement as a factor in the formation of the Abramtsevo identity would therefore be misplaced.

Nevertheless, by the 1880s, a sense of 'brotherhood' at Abramtsevo had been well established, primarily by the communal work on both the theatre productions and the church. The estate was acknowledged to be an inspirational place for an artist to work, with Antokolsky declaring that 'I have certain subjects which I could only tackle in Abramtsevo'.[62] At the same time, the community had established themselves as a centre of the Russian Romanticist movement, exploring diverse interpretations of 'Russianness' and national identity. Vrubel, who first came to the estate in 1890, wrote shortly after completing a stove for the church in 1892, 'I am in Abramtsevo again, and again I have felt, no not felt, but heard that intimate national note which I so want to catch on canvas and in ornament'.[63] Nationalistic concerns provide a common thread to paintings as diverse as Vasnetsov's *Battle of the Scythians and the Slavs* (1881, State Russian Museum, St Petersburg) and *Alyonushka* (1881, State Tretyakov Gallery, Moscow), Mikhail Nesterov's *Vision of the Boy Bartholomew* (1889, State Tretyakov Gallery, Moscow) and Repin's *Zaporozhe Cossacks Writing a Letter to the Turkish Sultan* (1878–91, State Russian Museum, St Petersburg), all of which were painted or conceived on the estate. Mamontov's daughter posed for *Alyonushka*, and both the pond in that painting and the setting for Nesterov's *Vision of the Boy Bartholomew* were based on the Abramtsevo landscape.

Apart from this common recourse to Russian history, myth, fairy-tale and folklore, the paintings and drawings produced at Abramtsevo share few defining features, which could be seen to explode any notion of group identity. Serov's impressionist *Girl With Peaches* (1887, State Tretyakov Gallery, Moscow)

and Vasnetsov's monumental *Bogatyrs* (1898, State Tretyakov Gallery, Moscow), for example, have little in common on either a stylistic or an iconographic level. However, one final, unifying characteristic of the Abramtsevo circle surfaces in its two-dimensional art – namely, the practice of *plein-air* landscape. *Plein-air* work had flourished in areas of Europe throughout the nineteenth century as part of the 'back to nature' movement which followed rapid urban and industrial expansion. As far as Russia was concerned, it had featured in the painting and teaching methodology of the peasant artist Aleksei Venetsianov (1780–1847), it played an important role in the career of Aleksandr Ivanov (1806–58) in Rome in the 1840s and 1850s, and it resurfaced in the activities of Bogolyubov and his Paris-based community in the 1870s. However, at Abramtsevo the experimentation with direct visual experience in an outdoor setting was taken further than ever before in the history of Russian art. A host of sketches and drawings demonstrate a Ruskinian return to direct observation from nature, while other key canvases painted at Abramtsevo, including Serov's *Girl in Sunlight: Portrait of Maria Simonovich* (1888, State Tretyakov Gallery, Moscow), reveal an Impressionistic delight in capturing the play of light on outdoor forms. As had been the case with the Barbizon community in the 1840s, a *plein-air* cult inspired by total immersion in a rural setting and by direct contact with peasant culture provided a rallying point in the artists' otherwise disparate lines of artistic enquiry.

To conclude, the Abramtsevo group was never a formal organization, such as the Artel set up in St Petersburg by Kramskoi and his colleagues after the 'Revolt of the Fourteen' in 1863, or the Society of Travelling Art Exhibitions of 1870. It followed no set aesthetic, and distributed no ideological programmes or manifestos. An artist simply had to be invited or taken to the estate in order to participate. However, once there, the newcomer discovered that his fellow artists at Abramtsevo had created a forceful group image which stemmed from a complex web of interconnecting stimuli. These included shared foreign experiences, common interests in nationalistic and medieval imagery, a concern for the survival of peasant craft culture, and a strong affinity with the Russian countryside, all of which gelled under the benevolent gaze of the irrepressible Mamontov. The circle was not bound by stylistic homogeneity, but by shared interests and ideals, and by a mutual affection which radiates out of the artists' portraits of one another. As they themselves wrote in 1924,

we came here completely different people ... but, inspired by one and the same – truth and honesty in art – we became at Abramtsevo one tight-knit family which, however divided by distances which roads barely cover and times which are hard, still joins those of us who remain with the unbreakable bonds of great and genuine human friendship.[64]

Notes

1. The Russian use of the word 'medieval' ('srednevekovyi') is problematic, as Russian periodization is different from that of the West: Russia did not have a 'Middle Ages' comparable to that in Europe, coming between a classical and a Renaissance past, and the use of the word 'medieval' to imply something in the middle is therefore misleading. Correctly speaking, the term refers only to Western Europe, while the word 'drevnerusskii' ('Old Russian') denotes pre-Petrine Russia. However, to avoid such an unfamiliar word, and in line with much contemporary use in Russia, this account will understand the word 'medieval' in a Russian context to refer to the period extending from Kievan times to the seventeenth century. I am grateful to Professor Lindsey Hughes of the School of Slavonic and East European Studies in London for help in clarifying this terminology.

2. Morris read Karl Marx's *Das Kapital* in French in 1882.

3. This point has been conclusively demonstrated in W. Salmond, *Arts and Crafts in Late Imperial Russia: Reviving the Kustar Art Industries, 1870–1917* (Cambridge: Cambridge University Press, 1996).

4. Mamontov was to become a key figure in the Russian railway expansion, funding, amongst other enterprises, the railway from Moscow to the Arctic coast at Arkhangelsk.

5. E. R. Arenzon, 'Mamontovy v Abramtseve: istoki i stimuly khudozhestvennoi aktivnosti' in G. Yu. Sternin (ed.), *Abramtsevo: khudozhestvennyi kruzhok, zhivopis', grafika, skul'ptura, teatr, masterskie* (Leningrad: Khudozhnik RSFSR, 1988), p. 35.

6. K. S. Stanislavsky, 'Vospominaniya o S. I. Mamontove, prochitannye na grazhdanskikh pominkakh v Moskovskom khudozhestvennom teatre' in Sternin 1988, p. 264. Stanislavsky, who was the cousin of Mamontov's wife Elizaveta, was probably alluding to the famous incident in 1896, when two huge canvases by Vrubel, *Princess Reverie* and *Mikula Selyaninovich*, were commissioned for but then rejected by the All-Russian Art and Industry Exhibition in Nizhny-Novgorod. Mamontov responded by building a special pavilion for Vrubel's work, gaining the artist what Jeremy Howard has termed 'Courbet-like recognition' (J. Howard, *Art Nouveau: International and National Styles in Europe* (Manchester: Manchester University Press, 1996), p. 141). The incident confirms that Mamontov was more than willing to challenge authority for the sake of art.

7. Letter from S. I. Mamontov to V. D. Polenov, 31 December 1883: quoted in Sternin 1988, p. 80.

8. Quoted in V. S. Mamontov, *Vospominaniya o russkikh khudozhnikakh* (Moscow: Izdatel'stvo Academii khudozhestv SSSR, 1950), p. 64.

9. Quoted in O. I. Arzumanova, A. G. Kuznetsova, T. N. Makarova and V. A. Nevskii, *Muzei-zapovednik 'Abramtsevo'* 2nd edn (Izobrazitel'noe iskusstvo, Moscow, 1988), p. 97.

10. Stanislavsky 1988, p. 263.

11. Ibid., p. 266. The charges were dropped in July 1900, but Mamontov's business and artistic enterprises never recovered. See M. Jacobs, *The Good and Simple Life: Artist Colonies in Europe and America* (Oxford: Phaidon Press, 1985), p. 118.

12. Vasnetsov later declared that '[Mamontov's] most characteristic trait as a man was the ability to inspire and establish around himself a creative enthusiasm.' V. M. Vasnetsov, 'Rech' na sobranii Abramtsevskogo kruzhka, yanvar' 1893' in Sternin 1988, p. 258.

13. See the letter of F. Chizhov to V. D. Polenov, 5 March 1875: E. V. Sakharova (ed.), *V. D. Polenov: pis'ma, dnevniki, vospominaniya* (Moscow/Leningrad: Iskusstvo, 1948), p. 83.

14. Mamontov also financed the Society of Travelling Art Exhibitions and the World of Art group.

15. Quoted in Arzumanova *et al.* 1988, p. 98.

16. T. Crow, *Emulation: Making Artists in Revolutionary France* (New Haven/London: Yale University Press, 1995), p. 18.

17. Grand Duke Vladimir Aleksandrovich (1847–1909), Vice-President and later President of the Academy, asked Bogolyubov to 'become acquainted with the activity of the Academy pensioners working abroad, and send me detailed information on the following: what works each of the aforesaid artists are carrying out, exactly what benefit the foreign trip is bringing them, and any other comments you consider relevant to bring to my attention.' Letter from Grand Duke Vladimir Aleksandrovich to A. P. Bogolyubov, 21 April 1872, TsGALI, f. 705, ed. khr. 84: quoted in M. L. Andronikova, *Bogolyubov* (Moscow: Iskusstvo, 1962), p. 30.

18. For the engraver Vasily Mate's (1856–1917) appreciative account of the haven which Bogolyubov offered to the newcomers, see V. V. Mate, 'Stat'ya Mate, Vasiliya Vasilievicha o A. P. Bogolyubove', Gosudarstvennyi Russkii muzei, otdel rukopisei, f. 14, ed. khr. 78, p. 1.

19. Ivan Kramskoi (1837–87) stayed in Bogolyubov's flat in 1876. See letters from I. N. Kramskoi to P. M. Tretyakov, 6 and 13/25 June 1876: I. N. Kramskoi, Pis'ma v dvukh tomakh (Leningrad: Izogiz, 1937), vol. 2, pp. 24 and 26.

20. Bogolyubov offered financial support in two ways: he himself purchased paintings from the pensioners, and he urged others to buy their work. Grand Duke Vladimir Aleksandrovich, for example, was persuaded to buy Repin's unfinished Sadko (1876, State Russian Museum, St Petersburg) so that the artist could afford the costumes and models which he needed to complete the work (report from A. P. Bogolyubov to the Academy of Arts, 28 March 1874, TsGIA, f. 789, op. 9, ed. khr. 257, p. 2: quoted in E. K. Valkenier, Ilya Repin and the World of Russian Art (New York: Columbia University Press, 1990), p. 57. Bogolyubov also persuaded the Tsarevich to buy Savitsky's Travellers in Auvergne (State Russian Museum, St. Petersburg) for 2000 roubles, causing Savitsky to write that Bogolyubov 'is simply tearing himself apart in order to make the best possible arrangements for me.' Letter from K. A. Savitsky to I. N. Kramskoi, Paris, 20 November 1874: Perepiska I. N. Kramskogo v dvukh tomakh, vol. 2, Perepiska s khudozhnikami (Moscow: Iskusstvo, 1954), p. 460.

21. See letter from I. E. Repin to V. V. Stasov, 7 August 1873: I. E. Repin i V. V. Stasov: perepiska v 3-kh tomakh (Moscow: Iskusstvo, 1949), vol. 2, p. 35.

22. Letter of 8 January 1874: quoted in Arzumanova et al. 1988, p. 103.

23. See, for example, letter from V. D. Polenov to M. A. Polenova, 5/17 January 1874: Sakharova 1948, p. 40.

24. Arzumanova et al. 1988, p. 104.

25. See S. Monas, 'St Petersburg and Moscow as Cultural Symbols' in T. G. Stavrou (ed.), Art and Culture in Nineteenth Century Russia (Bloomington: Indiana University Press, 1983), pp. 26–39.

26. For the development of the Kokorev Gallery, see R. P. Gray, 'Muscovite Patrons of European Painting: the Collections of Vasily Kokorev, Dmitry Botkin and Sergei Tretyakov', Journal of the History of Collections, 10 (2) (1998): 189–98; A. Andreev, 'Kokorevskaya kartinnaya galereya', Severnaya Pchela, 24 (1862): 96; and A. N. Andreev, Ukazatel' kartin i khudozhestvennykh proizvedenii gallerei V. A. Kokoreva (Moscow: La zarevskii institut vostochnykh yazykov, 1863).

27. For the history and holdings of the Rumyantsev Museum, see N. M. Lisovsky, 'Opisanie Rumyantsevskogo muzeya', Rossiiskaya bibliografiya, 86 (1881); Katalog kartin' Moskovskago Publichnago Muzeuma (Moscow, 1862); Katalog kartin' Moskovskago Publichnago Muzeuma (Moscow, 1865); and Illyustrirovannyi katalog kartinnoi gallerei Moskovskogo publichnogo i Rumyantsevskogo muzeev, 3 vols (Moscow, 1901).

28. For the history and politics of the Moscow School of Painting and Sculpture, see N. Dmitrieva, Moskovskoe uchilishche zhivopisi, vayaniya i zodchestva (Moscow: Iskusstvo, 1951).

29. Quoted in Arzumanova et al. 1988, p. 103.

30. Ibid., p. 105.

31. Ibid., p. 104.

32. P. Roosevelt, Life on the Russian Country Estate: A Social and Cultural History (New Haven/London: Yale University Press, 1995), p. xii.

33. Aksakov bought the estate in 1843 and lived there regularly until his death in 1859. Mamontov acquired it from his heirs.

34. Gogol stayed at the estate for long periods after his return from Western Europe in 1848, and one of the rooms of the main house, the 'Gogolevskaya', is named after him.

35. For an account of Abramtsevo in Aksakov's day, see S. Mamontov, 'Abramtsevo S. T. Aksakova', Pamyatniki otechestva, 31 (1994): 108–12.

36. B. N. Chicherin, 'Iz moikh vospominanii', Russkii arkhiv, 4 (1890): 501–25: quoted in Roosevelt 1995, pp. 514–15.

37. See Arenzon 1988, p. 33.

38. Vasnetsov 1988, p. 258.

39. Mamontov's company was the first response to the lifting of the state monopoly on theatre production in 1882.

40. See Arzumanova *et al.* 1988, p. 26.

41. The term 'medieval revivalist' is of Western, rather than Russian origin. It denotes a practice which began in the nineteenth century whereby inspiration was derived from the architecture and icon tradition of ancient Rus.

42. Kokorev housed his collection of *kustar* art in a specially designated building on his Moscow property.

43. See Arenzon 1988, pp. 26–30.

44. E. V. Paston, 'Formirovanie khudozhestvennogo kruzhka' in Sternin 1988, p. 57.

45. See E. V. Paston, '"Snegurockha" Vasnetsova v kontekste esteticheskoi napravlennosti Abramtsevskogo khudozhestvennogo kruzhka', in L. I. Iovleva and E. V. Paston (eds), *Viktor Mikhailovich Vasnetsov, 1848–1926: Sbornik materialov* (Moscow: Gosudarstvennaya Tret'yakovskaya galereya, 1994), pp. 85–99.

46. Quoted in Sternin 1988, p. 94.

47. Quoted in Arzumanova *et al.* 1988, p. 177.

48. Apollinary, a member and one-time president of the Society of Friends of Old Moscow, once wrote 'I was struck by the view of Moscow, and of course most of all by the Kremlin ... my favourite walks after work were around the Kremlin, whose towers, walls and cathedrals I so admired.' Quoted in Arzumanova *et al.* 1988, p. 215.

49. Although the project of building a church together would suggest a religious commonality, I have not found any evidence of a strong religious connection among the members of Abramtsevo.

50. For the history of the studio and the bathhouse, see Arzumanova *et al.* 1988, pp. 81–7.

51. See Salmond 1996, p. 34.

52. See I. V. Plotnikova, 'O religioznoi zhivopisi Vasnetsova vo Vladimirskom sobore v Kieve' in Iovleva and Paston 1994, pp. 47–62.

53. For the particular contribution of Vasnetsov to the rise of Romantic Nationalism in Russian architecture, see E. I. Kirichenko, 'Vasnetsov i neorusskii stil' (Arkhitekturnye raboty khudozhnika i russkoe iskusstvo kontsa XIX – nachala XX veka)', in Iovleva and Paston 1994, pp. 5–24.

54. Howard 1996, p. 137.

55. Quoted in Arzumanova *et al.* 1988, p. 89. Elizaveta Mamontova also commented on the chaotic productivity which surrounded the design stage of the church. See Arzumanova *et al.* 1988, p. 137.

56. Ibid., p. 154.

57. See Salmond 1996, p. 9.

58. For further information on both Tenisheva and her artistic community, which survived until 1914, see J. Bowlt, 'Two Russian Maecenases. Savva Mamontov and Princess Tenisheva', *Apollo*, **XCVIII** (142) (Dec. 1973): 444–53; L. Zhuravleva, *Knyaginya Mariya Tenisheva* (Smolensk: Poligramma, 1994); and L. S. Zhuravleva, *Talashkino: ocherk-putevoditel'* (Moscow: Izobrazitel'noe iskusstvo, 1989).

59. Salmond 1996, p. 10.

60. Ibid., p. 8.

61. The workshops' products won medals at, amongst others, the All-Russian Art and Industry Exhibition in Nizhny Novgorod in 1896, the Paris Exposition Universelle in 1900, and the First All-Russian *Kustar* Exhibition in 1902. See Salmond, 1996, p. 42.

62. Quoted in Arzumanova *et al.* 1988, p. 152.

63. Letter to A. A. Vrubel, summer 1891: E. P. Gomberg-Verzhbinskaya and Yu. N. Podkopaeva (eds), *Vrubel: perepiska, vospominaniya o khudozhnike* 2nd edn (Leningrad: Gomberg-Verzhbinskaya, 1976), p. 57.

64. Letter from the members of the Mamontov circle to V. D. Polenov, 2 June 1924: quoted in Sternin 1988, p. 95.

Envisioning the Golden Dawn: the Visionists as an artistic brotherhood

Sarah Kate Gillespie

The Visionists were a group of artists, poets and writers who formed a secret society in late nineteenth-century Boston. Though the group did not specifically form as an artistic brotherhood, they can be read as such by the unity of themes and ideals that are present in the works they produced. They saw themselves as an association, united for a common purpose. They worshipped aestheticism, spiritualism, medievalism and the supernatural. The idea of the Visionists as an artistic brotherhood can be furthered by their interest in the occult and in spiritual matters. Specifically, there appears to be a connection between the Visionists and England's Hermetic Order of the Golden Dawn, a secret society devoted to theosophy and Rosicrucianism that was also active in the late nineteenth century.[1] Imagery which appears to be based on Golden Dawn rituals appears in many Visionist works.

The Visionists formed from the 'madder and more fantastic members'[2] of the Pewter Mugs, a drinking and literary society to which most of Boston's bohemian crowd belonged.[3] Most of the members resided on or near Pickney Street, which became something of a nexus for the Visionists.[4] A members' list for the group appears as early as 1891.[5] This members' list details some of the more well-known members of the group, such as photographer and publisher F. Holland Day, writer Alice Brown and poet Philip Savage. Other Visionists included architect Ralph Adams Cram, publisher Herbert Copeland, designer Bertram Grosvenor Goodhue, poet Louise Imogen Guiney, designer and painter Thomas Meteyard, and poets Richard Hovey and the Canadian Bliss Carman. Many of the Visionists' relationships were originally forged in the esoteric environment of Harvard in the 1880s: Carman, Copeland, Meteyard and Savage were all classmates.[6] The group included men and women, and the members' list mentioned above illustrates this by pairing columns of men's and women's names of equal length. The idea of this group as a brotherhood is strengthened by the interpersonal relationships

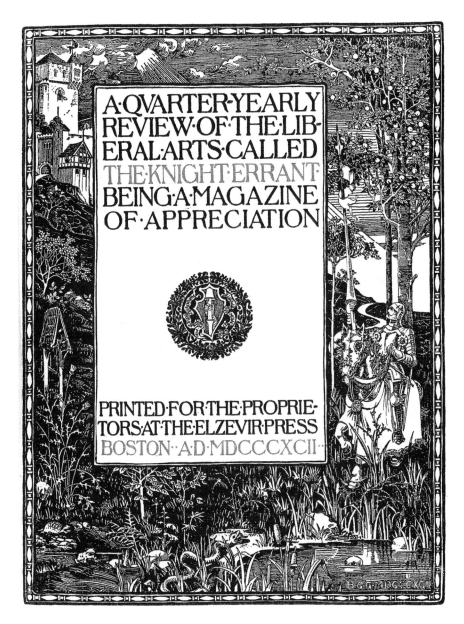

6.1 Bertram Grosvenor Goodhue, *The Knight Errant*, 1892

that existed among the members. Douglass Shand-Tucci has explored the idea of the Visionists as being a vital part of Boston's then emerging gay subculture. Many Visionist works are joint ones, often appearing to be

collaborations between partners. If Shand-Tucci is to be believed, most of the Visionists were homosexual, men and women both.[7]

The most straightforward Visionist venture was one in which the whole group was active: the journal *The Knight Errant, a Quarter-Yearly Review of the Liberal Arts, Being a Magazine of Appreciation* (Figure 6.1). The sole production of the quarterly consisted of four issues published between 1892 and 1893. The designs for the journal were produced by Bertram Goodhue, the editor for the work was Ralph Adams Cram and it was staffed by both Fred Day and Herbert Copeland. The articles range from reviews of recent books, to essays on Correggio, to a justification for the contemporary craze for Asian art.[8] It is this short passage published in the first volume, however, that succinctly summarizes the Visionists' anthem, and that is the closest approximation to a manifesto they left behind:

Men against an epoch; is it not that after all? One by one in this last night, the beautiful things have disappeared, until at last, in a world grown old and ugly, men, forced to find some excuse for the peculiarity of their environment, have discredited even beauty itself, finding it childish, unworthy, and – unscientific: not only beauty in Art, but beauty in life and death, until the word had become but a memory and a reproach. This is the condition that demands the new chivalry.[9]

The Visionists were interested in no less than salvaging what they saw as the decay of their era through beauty (the journal did prove to be influential – it is remembered as 'the beginning of a new period of bookmaking in America'[10]). The group's new chivalry is embodied in the image of the knight on the frontispiece; he is in full armour, ready to battle modernity. Their chivalry, of course, took the form of further artistic works.

One of the most influential members of the Visionists was F. Holland Day. He was an avowed bibliophile who also worshipped the supernatural, often engaging in seances and consulting with Boston's leading medium, Mrs Piper.[11] In 1893 he and fellow Visionist Herbert Copeland opened the publishing firm Copeland & Day, which is regarded still as one of the most exquisite of Arts and Crafts publishers. The firm's seal was the lily, and its motto was 'Sicut lilium inter spinas', or, 'Like a lily among thorns'.

Through Copeland & Day many Visionist ventures were to take shape, many modelled after the books produced by Pre-Raphaelite William Morris's Kelmscott Press. The similarities between Morris's *Chaucer*, published in 1896 and designed in collaboration with Pre-Raphaelite Edward Burne-Jones, and Louise Guiney's *Nine Sonnets Written at Oxford*, published by Copeland & Day in 1895, are fairly evident. Bertram Goodhue's elaborate designs for *Nine Sonnets* show the same intricate foliate motifs that characterize Morris's work. Goodhue does include medieval architectural elements that are missing from the Kelmscott *Chaucer*, however, and it is most likely that Guiney herself is depicted in the gothic arch on the right side of the first page.

Goodhue has continued the theme of chivalry begun in *The Knight Errant* by also depicting knights tangled in the foliage that runs the length of the right side of the title page.

Another Visionist venture was *Songs from Vagabondia*, a book of poems published by Copeland & Day in 1894. It was written by Bliss Carman and Richard Hovey, and designed by Thomas Meteyard. The cover design depicts Carman, Hovey and Meteyard in a sphere, described by a contemporary reviewer as 'three men in a decadent moon'.[12] The decision to depict all three of these men, not just the authors but the designer as well, emphasizes the importance of this work as a collaboration.[13] Similarly, Goodhue's deliberate depiction of Guiney in her niche in the design for *Nine Sonnets* emphasizes his realization of her importance in that work. In all three of these works, *The Knight Errant*, *Nine Sonnets* and *Songs from Vagabondia*, there is evidence of solidarity of thought and action.

It is worth mentioning that this solidarity of thought and action is primarily driven by the men in the group. Despite their being named in the members' list and the occasional appearance of their works, the women remain a largely inactive portion of the brotherhood. This is evident not only through their lack of visibility in the mentioned publications, but also in the language that is employed in these publications. *Songs from Vagabondia* is a prime example of this exclusion; it is fiercely collegiate, an anthem to male camaraderie, including verses such as the famous 'Midnights of revel/and noondays of song!/Is it so wrong?/Go to the devil!'[14] There is little place for Louise Guiney, who supported herself as postmistress of a small town in Massachusetts, in such a verse. While Copeland and Day published many of their female friends, including Guiney and Alice Brown, the group as a whole did not appear to include the female members in the late night spiritualist activities discussed below. As we shall see, these activities are the qualifying force in distinguishing the Visionists as an artistic brotherhood, as opposed to a social club that happened to produce art.

The resurrection of beauty through artistic book production, medievalism and camaraderie as the Visionist ideal is furthered by the group's interest in spiritual matters. Spirituality and the artistic brotherhood often go hand in hand, as the idea of the artistic brotherhood is most easily traceable in Western history to the artistic guilds and monastic organizations of medieval times. After the dissolution of artistic guilds in the fifteenth and sixteenth centuries (concurrent with the emergence of the Renaissance ideal of the individual artist as genius), collaborative artistic output, especially in the context of a brotherhood, was almost solely the domain of religious organizations. While the idea of the artistic brotherhood was revived in the nineteenth century in a variety of forms, in Boston it seems to have remained primarily connected with spirituality. This is largely due to Boston's

involvement in the Arts and Crafts movement, in which the Visionists were a pivotal force. This movement began in England in the 1860s as a response to the dehumanization of the Industrial Revolution. It called for a reinstallation of handcraftsmanship and aestheticism in everyday household objects, such as furniture, as well as in architecture and the visual arts. The movement spread from England to America in the 1870s via Charles Eliot Norton, the renowned Harvard scholar who was close friends with John Ruskin, on whose writings the movement was based.[15] It is primarily through the Arts and Crafts movement that one finds other artistic brotherhoods or sisterhoods in Boston at this time, and most were specifically religious orders. The Sisters of the Society of St Margaret are a prime example of this. The Society of St Margaret was (and still is) an Anglican order based in Sussex and established in Boston in 1873.[16] The sisters were renowned for their ecclesiastical textiles and embroidery; Visionists Cram and Goodhue both contributed designs for their work.[17] The sisters exhibited in the 1897 Society of the Arts and Crafts exhibition, the first of its kind to be held in America. The various members of the Visionists were instrumental in founding and promoting the society: Cram and Goodhue were both charter members.[18] Indeed, Bertram Goodhue designed the catalogue for the 1897 exhibition.

While the individual members of the Visionists were interested in a wide range of spiritual and religious organizations,[19] the Visionists as a group tended to concentrate on theosophy and the occult. Their meeting place at 3 Province Court in Boston was called the 'Hall of Isis', Isis being the Egyptian goddess who, in *fin de siècle* America, was enjoying a surge of popularity. This was largely due to the publication in 1877 of a book by Madame Helena Blavatsky called *Isis Unveiled*, which inspired many societies fixated on ancient Egyptian gods and goddesses.[20] In his autobiography, Cram comments on the Visionist's fascination with Isis through a description of their meeting place:

On the walls, the painter-members had wrought strange and wonderful things: the Lady Isis in her Egyptian glory, symbolic devices of various sorts, mostly Oriental and esoteric ... Herbert Copeland officiated as Exarch and High Priest of Isis, clothed garishly in some plunder from Jack Abbott's trunks of theatrical costumes.[21]

Cram's memoirs suggest that the Visionists were not always very serious, as does the announcement written by a Visionist proclaiming, 'In as much as Pasht our cherished and most admirable cat hath presented to us two most seemly kittens, it seemeth good that we should consult among ourselves concerning the names to bestow upon them.'[22]

Analysis of the imagery produced by the Visionists, however, reveals a more serious interest in the occult. The connection between the Visionists and England's Hermetic Order of the Golden Dawn seems to have stemmed

from F. Holland Day's possible involvement with that group. It is possible that the Visionists thought of themselves as a smaller, less serious branch of the Golden Dawn.[23] Such a connection can be drawn from a comparison of the respective and joint artistic efforts by members of the Visionists with the writings and imagery featured in Golden Dawn texts.

The Hermetic Order of the Golden Dawn was a group that believed in and practised magic as the key to wisdom of all ages and religions. They had strict orders to adhere to vows of secrecy. All members had secret names, as did the Visionists. Day was certainly alerted to, if not a full member of, the Golden Dawn after a trip to England with Louise Guiney in 1890. Guiney introduced Day to the Rhymers' Club, where he met the Irish poet William Butler Yeats. Yeats was highly interested in Rosicrucianism and was a fully initiated member of the Golden Dawn.[24] At the Rhymers' Club, Day would have also met the British author Oscar Wilde whose wife was a fully initiated member. Day and Yeats, however, had discussed the occult in some fashion and continued to do so in their ensuing correspondence of 1891 and 1892, arguing over black magic. In April 1891, Day wrote to Yeats, 'a line from you now and again would be appreciated in spite of the black magic'.[25] The subject was broached again in February 1892, also from Day to Yeats, 'Your poor Mme. Blavatsky has gone to the eternal shades! Are you now reinstated in your old theosophical (philosophical) position from which the heresy of black magic drove you?'[26] The Visionists were aware of the difference between black magic and white, or good magic and bad, as evidenced by Cram's book of ghost stories which discusses black magic, called *Black Spirits and White*, which he was either writing or preparing for publication in 1894–5.[27] The written and visual links between the Golden Dawn and the Visionists, however, are too strong to believe that Yeats fully attended to his vows of secrecy regarding the group. Despite the apparent differences of opinion Day and Yeats had regarding black magic, these links are evidence that they discussed white magic, which was the Golden Dawn's magic,[28] as well.

Day's possible involvement with the Golden Dawn is evidenced by the photography he was producing at this time. Two works in particular have subject matter which links them to rituals associated with the occult in general and the Golden Dawn in particular. *The Lacquer Box* (in the Metropolitan Museum of Art, New York), of around 1899, can be seen to represent a practice that was popular in the 1890s: it was believed that the rubbing of a Japanese lacquered box would emit voices of spirits and create connections with the dead.[29] A lacquered box also is evident in Golden Dawn rituals, however, as the line drawing by Mrs Mathers (who was the wife of the High Priest of the Golden Dawn) from the title page of the Golden Dawn text *The Sacred Magic of Abra-Melin the Mage* reveals. The figure in Day's photograph is not rubbing the box, rather he is revealing or

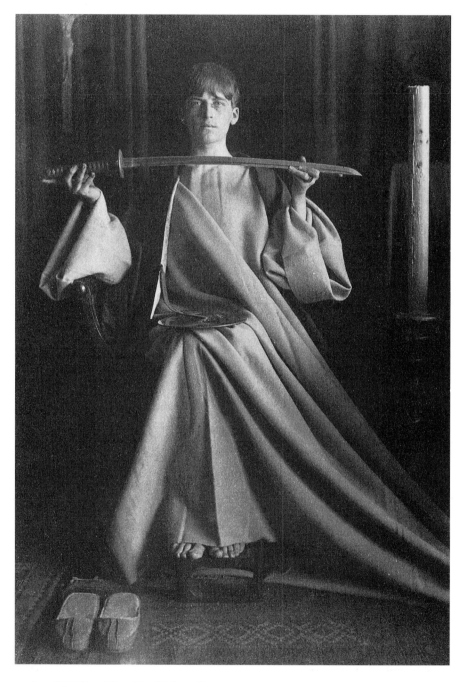

6.2 F. Holland Day, *The Vigil*, c. 1899

displaying it to the viewer, looking intently at us. These factors, combined with the figure's elaborate robes, types of which are also seen in Mrs Mather's drawing, indicate that Day's photograph is more a representation of Golden Dawn ritual than one of a spiritual parlour game.

The Vigil, also of around 1899, again appears to represent or recreate a Golden Dawn rite (Figure 6.2). Here the elaborate robes from *The Lacquer Box* are even more apparent and carefully arranged. Robes have special significance in Golden Dawn rituals; they represent the silence and secrecy under which the group was to work.[30] The diagonal drape Day creates becomes a focal point of the work, drawing our eye upward, into the work, to rest on the lit face of the figure and the sword he holds. The sword also has special significance to the Golden Dawn. It represents reason, analysis and is to be used against the demons of doubt.[31] In a more practical sense, it was to be used physically to defend against or to banish evil forces.[32] There is an elaborate ritual to consecrate the sword, as it is one of the Golden Dawn's primary tools.

Day's interest in the Golden Dawn culminates in his series of sacred photographs produced throughout 1898 and 1899. Suffering as a spiritual outlet was an idea popular in the late nineteenth century. The Golden Dawn espoused such ideals: 'This essential state of enlightenment … glorified through trial and perfected by suffering … an act of sincerest aspiration of self-sacrifice alone makes possible the descent of the Light within our hearts and minds.'[33] Day combines suffering and the spiritual in a very real way in *Seven Last Words* of 1898. The seven photographs were placed in an architectural frame for exhibitions (the frame was designed by Day), and they depict a series of close-ups of Day posing as Christ undergoing the agony of dying. Day attached a mirror to the camera so he could see himself at the time of exposure.[34] Day also created a series of crucifixion scenes in which he takes suffering as a spiritual outlet further: in these photographs Day again plays the Christ figure, tying himself to a cross made of wood imported directly from Syria (Figure 6.3).[35] As evidenced in *Crucifixion in Profile, left*, Day underwent literal suffering to produce these pictures, as he starved himself for weeks prior to the shooting to appear a properly emaciated Christ (he also grew his hair and beard for the role).[36] A Golden Dawn ceremony required the candidate to undergo a symbolic crucifixion upon a 'cross of suffering'.[37] Though Day was interested in establishing the right of the photographer to treat sacred scenes, as he argues in his essay of 1899 entitled 'Sacred Art and the Camera',[38] the timely connections between Day's interest in Rosicrucianism and these photographs leaves little doubt as to his knowledge of the rites of the Golden Dawn.

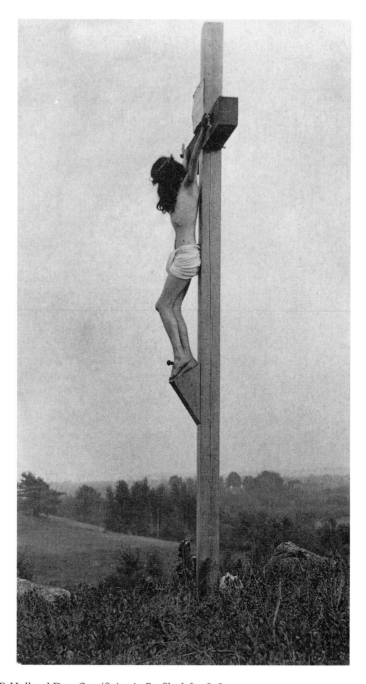

6.3 F. Holland Day, *Crucifixion in Profile, left*, 1898

Day's interest in and possible direct involvement with the Golden Dawn seems to have had a trickle-down effect on the Visionists. The Visionists' interest in Isis, which was discussed earlier, becomes significant in that the Golden Dawn had a special interest in Isis. The Golden Dawn's founder, William Wynn Westcott, had a letter from Madame Blavatsky herself granting him the right to charter the founding temple.[39] The letter is now known to be a forgery, but the London temple was called the Isis-Urania Temple, and the group invoked Isis in many rituals.[40] The Visionists' meeting place was, as mentioned, the Hall of Isis, and there is also Cram's mention of Herbert Copeland officiating as the High Priest and Exarch of Isis.

Another connection is from Cram's 1894 novella *The Decadent, Being a Gospel of Inaction*, published by Copeland & Day. As the novella was printed privately for the author only 110 copies were published, and it is easy to imagine that the book was written and published largely for the Visionists. The protagonist preaches against modernity in the form of factories and cities. Expressing an Arts and Crafts preference for the handmade, he urges his reluctant friend to join his sanctuary, stating, 'Action has striven and failed, and wreck and ruin are ending thereof; but across the desert of failure and despair bursts *the flame of the Dawn*; the far-forgotten spirit of the world rises towards dominion again.'[41] (italics mine). There are several layers of meaning in this passage that have relevance to the Visionists: first, there is the tone of disgust and despair with modern life, which was also evident in the passage from *The Knight Errant*. The chivalry of the knight, however, who was battling for beauty, here takes the form of the flame of the Dawn (which, importantly, is deliberately capitalized in the text), whose far-forgotten spirit of the world is rising toward dominion. The far-forgotten spirit of the world can easily be read as the amalgam of religious creeds and ancient magic symbols used by the Golden Dawn.

This analysis of *The Decadent* is furthered by Shand-Tucci's translation of Cram's dedication to Bertram Grosvenor Goodhue, who was mentioned as the designer for many Visionist publications:

To you, my dear B.G.G., due to whose efforts and a reward which was not his alone was being paid to that man who, thanks to your help, is the Exarch and to the brothers of that group which defines its own dreams and finally to all the select members over the entire world I dedicate this book with thanks.[42]

Cram's references to 'select members' and 'brothers' of a group that is global, especially in conjunction with his reference to the Exarch, suggest that the Visionists did see themselves as a part of a larger organization.[43]

A final verbal connection between the Visionists and the Golden Dawn may be found among Day's papers. The Order's most basic creed is, 'Long hast thou dwelt in darkness. Quit the night and seek the day.'[44] Upon

admission to the group, the candidate is brought 'from the darkness into the order of the Golden Dawn as well as to the light'.[45] Upon being invited to join the Visionists in 1892, publisher Francis Watts Lee wrote to photographer F. Holland Day: 'They say I am a visionary in some ways, but I do not know that I am therefore a Visionist. May I seek light from Dies?'[46] The distinct wording of this letter, as well as the deliberate use of Day's nickname, makes it clear that Day's friends were strongly influenced by the rhetoric and themes of the Golden Dawn.

The Golden Dawn's origins are in freemasonry. Specifically, it was formed in 1887 by a Freemason, the aforementioned Westcott, who wanted a group that included men and women, and that was more devoted to the type of theosophy that Mme Blavatsky preached.[47] Westcott joined forces with S. L. MacGregor Mathers, who created the Golden Dawn's construction of relationships and philosophies utilizing the cabalistic tree of life, alchemy, astrology, tarot trumps and so on.[48] Alchemical symbolism is inherent in Rosicrucianism and freemasonry, and the Golden Dawn retained many of the traditions and ideals espoused by their parental organization. Specifically, they view their initiation process as an alchemical transition, in which the raw matter of the initiate is transformed into the one who can receive the Light.[49] As a result, alchemical imagery appears in many Visionist works. An example of this is the moon which features prominently on the cover of *Songs from Vagabondia*. The moon is an emblem of borrowed light and represents the passive, though necessary, side of alchemical transformation.[50] It frequently appears, though usually with the sun, in alchemical texts.

The lily used by Copeland & Day for their seal can also be read as having alchemical symbolism. The lily, a five-leafed flower, is often used to symbolize the holy number five in Rosicrucian imagery. Five is holy as it represents the pentagram. The flower and the pentagram both symbolize the House of Eternity or the City of God, in short, heaven.[51] The ritual of the pentagram is the first and most basic form of magic one learns as a Golden Dawn initiate, the ritual one begins with before moving onto more complicated matters.[52] Day's photograph *The Lacquer Box* features a peacock feather in the background; this is also an emblem of the alchemical process, as it symbolizes the many different colours the philosopher's stone turns.[53]

One of the authors of *Songs from Vagabondia*, the poet Bliss Carmen, published a small booklet entitled, *Saint Kavin: A Ballad* (Figure 6.4). This work was published by Copeland & Day in 1894, 'made and printed in fifty copies for the Visionists and the Guests of their house at No. iii in Province Court, Boston'.[54] The tone of the work is jovial, naming each of the Visionists in turn, calling them all, 'Visionists without a view, dreams their fad, and drool their forte'.[55] Bertram Goodhue's design for the frontispiece of this booklet demands attention. The design features Saint Kavin, a fictional

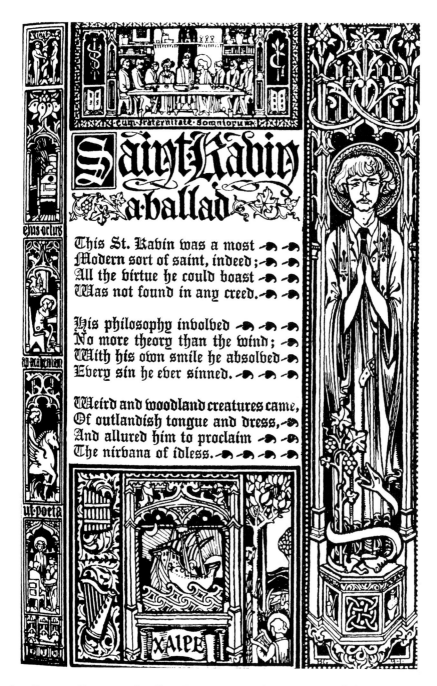

6.4 Bertram Grosvenor Goodhue, Frontispiece to *Saint Kavin, a Ballad*, by Bliss Carmen, 1894

character who is probably Carmen's Visionist alter ego,[56] in a medieval niche on the right side of the page. The position of this figure is strikingly similar to the description of the ceremony for Admission of the Candidate into the Golden Dawn, in which the candidate stands between two pillars, in a position of balanced power. It is significant to recall that Goodhue also places Louise Guiney and another figure in similar niches on his design for Guiney's *Nine Sonnets Written at Oxford*. In the St Kavin image, however, not only is the figure standing straight and tall between two pillars, but there is a snake wrapped around his legs three times. In the Admission ceremony, a triple cord is wrapped around the body of the neophyte, symbolizing binding and restriction of the lower nature.[57] The snake also has alchemical symbolism in that it represents the 'guardian of the threshold'. It is the dragon which guards the treasure of higher knowledge and it must be overcome.[58] There is also a snake in the foreground of Goodhue's design for *The Knight Errant*. Reading these images in such a context suggests that the Visionists were utilizing the symbol of the snake to represent what their chivalry was to overcome; it was both the decay of modernity, to be salvaged by beauty, and it was also the obstacle to further knowledge of mystical matters. Once the candidate to the Golden Dawn has passed the Admissions ritual, of course, the triple cord, shown in *Saint Kavin* as a serpent, is removed and that knowledge can be accessed.

The Visionists are pictured in the frieze at the top of *Saint Kavin* seated around a table as if attending the Last Supper. The brotherhood seems to have been aware of the Golden Dawn's rituals, and Fred Day is the member most likely to be sharing the Order's secrets. If the Visionists were also aware, as they most likely were, of the ritual crucifixions candidates were required to undergo, then it follows that Day is most likely pictured as the Christ figure.

The Visionists united to quit modernity as they knew it, and to salvage beauty through art and create a new modernity that glorified in hand-craftsmanship. They can be read as a brotherhood by analysing their collective artistic output, which is tied together through the members' shared ideals and goals of anti-modernity. These ideals, ultimately displayed in their artistic production, are filtered through a common interest in spiritualism. To the Visionists, the occult was the ultimate in anti-modernism, and its symbolism pervades the many works they left behind.

Notes

1. Briefly defined, Rosicrucianism is the application of mystic religious doctrine to modern life through one's association with a brotherhood devoted to that purpose.

2. Ralph Adams Cram, *My Life in Architecture* (Little, Brown: Boston, 1936), p. 91.

3. For a complete discussion of Boston's literary and artistic scene, see Douglass Shand-Tucci, *Boston Bohemia 1881–1900, Ralph Adams Cram: Life and Architecture* (Amherst: University of Massachusetts Press, 1995).

4. Shand-Tucci fully explores Pickney Street as the bohemian centre of Boston, ibid., pp. 5–56.

5. See *F. Holland Day Papers, 1858–1977*, Archives of American Art, Smithsonian Institution, Washington, DC, microfilm reel 4954.

6. There is an interesting parallel here between the Pre-Raphaelites' formative ties at Oxford University and the Visionists' similar formative ties at Harvard University. The idea of nineteenth-century artistic brotherhoods having a basis in academic, homosocial environments is worth further exploration. Harvard in the 1880s had a reputation for being of the 'Oscar Wilde School' of studied nonchalance and languidity. See Charles Flandrau, *Harvard Episodes* (Boston: Copeland & Day, 1897). Harvard can also be read as having a tradition of secret societies interested in mysticism and its visual applications, for example see David Bjelajac, *Washington Allston, Secret Societies, and the Alchemy of Anglo-American Art* (Cambridge: Cambridge University Press, 1997), pp. 10–20.

7. Day's sexuality is rarely disputed by scholars, and Shand-Tucci makes a convincing case for his partnership with Herbert Copeland. Shand-Tucci also pairs Cram and Goodhue, as well as Carman and Hovey. More convincing is the relationship of Alice Brown and Louise Guiney, who probably had a 'Boston marriage'. See Shand-Tucci 1995, pp. 20, 36–56, 140–7.

8. *The Knight Errant*, **1**(3), 1893.

9. *The Knight Errant*, **1**(1), p. 2.

10. Nancy Finlay, *Artists of the Book in Boston* (Cambridge, Mass.: Houghton Library, Harvard University, 1985), pp. x, 12.

11. Estelle Jussim, *Slave to Beauty, the Eccentric Life and Controversial Career of F. Holland Day* (Boston, Mass.: D.R. Godine, 1981), p. 45.

12. Finlay 1985, p. 11.

13. Joe Kraus, *Messrs. Copeland and Day, 69 Cornhill, Boston, 1893–1899* (Philadelphia: Macmanus, 1979), p. 23.

14. Bliss Carman and Richard Hovey, 'Vagabondia', *Songs from Vagabondia* (Boston: Copeland & Day, 1894), p. 4.

15. See Marilee Boyd Meyer (ed.), *Inspiring Reform, Boston's Arts and Crafts Movement* (New York: Harry Abrams Inc., 1997), p. 15.

16. Nicola J. Shillman, 'Boston and the Society of Arts and Crafts: Textiles', *Inspiring Reform*, 103.

17. Ibid. While it is not the purpose of this essay to examine artistic sisterhoods in late nineteenth-century New England, it should be noted that several did exist. The Society of St Margaret is one; another is the Society of Blue and White Needlework, Deerfield, Mass., which was founded in 1896. None of the women involved in the Visionists appear to have been involved with any of these groups, possibly due to their sexuality (see note 7). The female members' absence from the primary focus of this essay, that of the Visionists' involvement with the occult, has been discussed.

18. Shand-Tucci 1995, p. 300.

19. Most notably Cram and Day, who were both founders of the Order of the White Rose, a Jacobite order which celebrated the cult of King Charles the Martyr and had strong Anglican ties. See Shand-Tucci 1995, pp. 316–18.

20. Ibid., p. 381.

21. Cram 1936, pp. 92–3.

22. *F. Holland Day Papers, 1858–1977*, Archives of American Art, notice signed by 'John, K.O.V.', and addressed 'To the order of the Visionists'. The group did keep a cat called the Lady Pasht, and as all the Visionists had secret names, it is hard to decipher who John might be. There is a 'Southern John' referred to in *Saint Kavin: A Ballad* written by Bliss Carman for the Visionists and published by Copeland & Day, Boston, 1894; this is probably the same individual.

23. Shand-Tucci 1995, p. 383.

24. Yeats had joined the Golden Dawn in 1890. Much is written on the subject of Yeats and spiritualism. See George Mills Harper (ed.), *Yeats and the Occult* (Toronto: Macmillan, 1975).

25. F. H. Day to William Butler Yeats, 2 April 1891, *F. Holland Day Papers, 1858–1977*, Archives of American Art.

26. F. H. Day to William Butler Yeats, *F. Holland Day letters, 1858–1977*, Archives of American Art. I have seen the letter transcribed from Day's difficult handwriting as both 'theosophical' and 'philosophical'. Given the nature of Day's correspondence with Yeats concerning Mme Blavatsky, though, 'theosophical' seems more likely.

27. Shand-Tucci 1995, p. 385.

28. Ellic Howe, *Magicians of the Golden Dawn, a Documentary History of a Magical Order, 1887–1923*, (Wellingborough: Aquarian, 1985), p. xxiii.

29. Jussim 1981, p. 385, and James Crump, *Suffering the Ideal* (Santa Fe, New Mex.: Twin Palms Publishers, 1996), p. 25.

30. Howe 1978, p. xv.

31. Ibid., p. xiv.

32. Isreal Regardie, *The Golden Dawn: a Complete Course in Practical Magic: the Original Account of the Teachings, Rites and Ceremonies of the Golden Dawn* (St. Paul, Minn., 1989), p. 317.

33. Ibid., p. 27.

34. Jussim 1981, p. 127.

35. Ibid., pp. 121–3.

36. Jussim, pp. 121–35.

37. Howe 1978, p. x, describing the 'third vital ritual'.

38. F. H. Day, 'Sacred Art and the Camera', *The Photogram*, **6**(62) (Feb. 1899): 37–8.

39. Howe 1978, p. xvii.

40. Regardie 1989, p. 239.

41. Ralph Adams Cram, *The Decadent, Being a Gospel of Inaction* (Boston, Mass., 1894), p. 39.

42. Shand-Tucci's translation from the Latin, 1995, p. 383.

43. Ibid.

44. Regardie 1989, p. xvii.

45. Ibid., p. 7.

46. Francis Watts Lee to F. Holland Day, letter of 7 November 1892. In the end, Lee was thought to lack the necessary vision, see Herbert Small to F. H. Day, letter of 1892, both *F. Holland Day Papers, 1858–1977*, Archives of American Art.

47. Howe 1978, p. xvii, and Regardie 1989, p. 17.

48. Howe 1978, p. xxii.

49. Regardie 1989, pp. 25–6.

50. Herbert Silberer, *Hidden Symbolism of Alchemy and the Occult Arts* (New York: Dover, 1971), p. 188. See also Gareth Roberts, *The Mirror of Alchemy: Alchemical Ideas and Images in Manuscripts and Books from Antiquity to the 17th Century* (Toronto, 1994), p. 82, and Bjelajac 1997, p. 55.

51. Silberer 1971, pp. 187–8.

52. Regardie 1989, p. 3.

53. Roberts 1994, p. 56.

54. Bliss Carman, *Saint Kavin: A Ballad* (Boston: Copeland & Day, 1894), p. 9.

55. Ibid., p. 6.

56. Shand-Tucci 1995, pp. 386–90.

57. Regardie 1989, pp. 28, 363.

58. Silberer 1971, p. 276.

Académie and *fraternité*: constructing masculinities in the education of French artists

Susan Waller

Art historians have approached artistic education in nineteenth-century France through pedagogical theories and practices, which is how Jean-Henri Cless represents it in a drawing from 1804 of Jacques Louis David's *atelier* (Figure 7.1).[1] Students crowd the studio, working from the nude figure on the model stand. At the right, younger students sit on straight-backed chairs drawing from the model, while behind them, dominating the left foreground, are older students wielding palettes and maulsticks and working at easels. The students are differentiated by their skills, according to the progression from drawing to painting dictated by academic instruction.

The pedagogical task of the *atelier-Ecole* system was to train students to produce paintings and sculpture according to academic precepts – to acquire specific representational skills – but its social function was to prepare them for a professional role. Sociologist Pierre Bourdieu has characterized the system as one whose particular logic produced a particular type of artist. He suggests that *atelier* training, with its course of strictly defined stages and hierarchies of seniority and competence, and Ecole des Beaux-Arts competitions, which engendered high expectations and higher anxieties, produced a student who was docile and conformist.[2] In Bourdieu's view the *atelier-Ecole* system, in effect, shaped students prepared for careers of official commissions and academic positions by producing artists with temperaments suited only to the conventionalities of an academic style. It was this style, with its emphasis on technical virtuosity and the display of historical erudition, that 'modern' artists – Manet being the exemplary figure – reacted against. While Bourdieu's account, pitting academic against avant-garde, makes no allowances for the distinctions between official, academic and *juste milieu* or modernist and avant-garde that art historians have developed, it opens the way for considering academic education as a process of social as well as skill formation.[3]

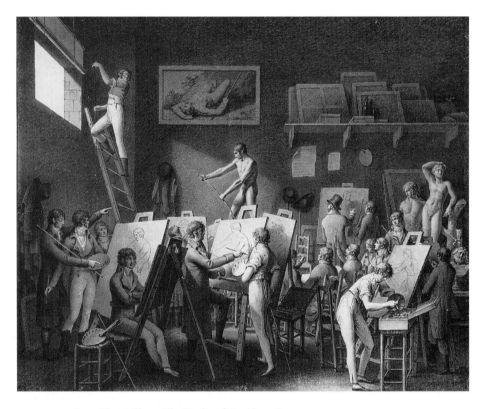

7.1 Jean-Henri Cless, *The Studio of David*, c. 1804

In this essay I want to take up an aspect of the *atelier-Ecole* system ignored by Bourdieu – its homosocial logic – and to examine the system's role in gendering the professional identity of the nineteenth-century artist.[4] While feminist art historians have examined the masculinity of the artist from the perspective of women's exclusion from artistic education, the logic of the pedagogical system itself in perpetuating the gendered identity of the artist has not been examined.[5] This essay focuses on two practices of the system – the *charges* or hazing of the *atelier* and the *concours* or competition structure of the Ecole. I will argue that these served to socialize the student into the homosocial professional group and into the award system that both defined the French artistic arena and comprised a state mechanism for establishing a gender order.

The *charges*, which served as a student's introduction to the profession, were a ritual that took on a new intensity in the years of the July Monarchy. *Charges d'Atelier*, a lithograph by Hippolyte Bellangé published in *l'Artiste* in 1832 represents the entrance of a new student or *nouveau* into the *atelier*

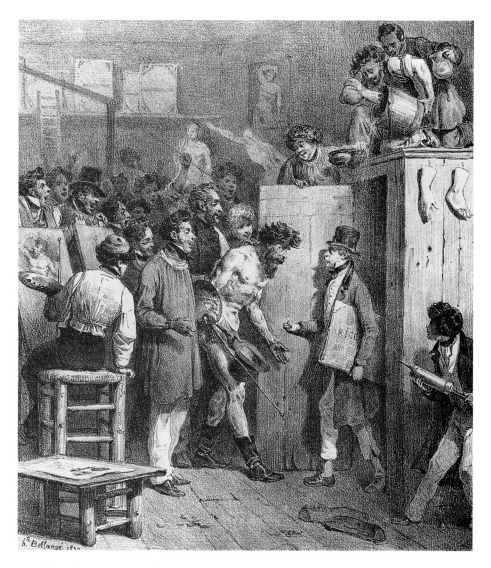

7.2 Hippolyte Bellangé, *Charges d'Atelier,* 1832

(Figure 7.2). He is an awkward figure: if his portfolio and dignified top hat signal his professional aspirations, his skinny ankles protruding from below his pant legs hint that the new role is not yet a good fit. He is met by a cluster of three figures – the *massier*, the master, and the model – and greeted by the laughter of the *anciens* or older students and their mocking remarks about his appearance. Crouching behind the *nouveau* – unseen by him but in view

of all the others in the studio and beholders of the print – students prepare an attack with water and paint. Bellangé's *nouveau* is the unsuspecting victim of an incipient humiliation.

Before 1863, the *charges* were performed in many private *ateliers*, though they varied in intensity. Ingres's *atelier*, for instance, was known to be well disciplined, while Delaroche's was particularly ruthless.[6] After the 1863 reorganization of the Ecole des Beaux-Arts, when the school incorporated *ateliers* for the teaching of painting and sculpture, the *charges* were integrated into the school. There the harsh treatment of new students became a matter of concern to the Director, who warned the Minister of the Interior 'The newcomers pay their footing not only in money, but in teasing, aggravation, harassing, and even, it must be said, rough handling and assaults.'[7]

Students rarely dwelt on the *charges* in the letters they sent home, unless they could boast that they had avoided them, but late in the century some foreign students included accounts of the ritual in their memoirs of the colourful Parisian *vie de bohème*. From these fragmentary descriptions, the outlines of the practice can be pieced together. Alfred de Curzon's memory of his entry into Drölling's studio in 1839 was of shock: 'The coarseness and vulgarity of the students was something that, naturally enough, I had no idea of until then; I received my share of jeers and snubs.'[8] The English artist Val Prinsep assured readers of the *Magazine of Art* that his muscular build had prevented his being 'molested' when he entered Gleyre's studio in the 1850s, but he noted that Thackeray had called French students of the previous generation 'wild and brutal' and their behaviour 'un[re]producible'.[9]

Singing and paying for a round of refreshments are the requirements *nouveaux* mentioned most frequently in letters and memoirs. Bazille, who began studying with Gleyre in 1862, wrote to his parents: 'My entry into the studio was carried out without too many hitches. I was forced to sing, to stand on one leg, etc., etc., it was annoying, but I will be left alone now.'[10] Bazille didn't mention what he sang or how his performance was received, but in some studios explicitly sexual vulgarity was expected. A caricature from 1843 shows a crowd of *anciens* establishing the rules for the reception of the *nouveau*; the caption reads: 'Reception: The Rules ... Article 5. The *nouveau* will give an account of his life and the circumstances which made him choose a career in the fine arts, then in a less elevated style he will tell the story of his first love affairs!'[11]

These forced performances, however, were just the beginning. Often the *nouveau*, by threat or trickery, was compelled to strip. Nudity itself was of course in no way startling in *ateliers* devoted to drawing the model. Even the nudity of students had a precedent: Etienne Delécluze recalled that in David's *atelier* students were encouraged to pose for each other because David considered the rhetorical posturing of professional models unnatural.[12] This

practice was not usual, however; by the 1830s, the *nouveau*'s nudity was a humiliation. In the 1880s Alexis Lemaistre recalled that the *nouveau*'s removal of his clothes was met by a 'une grêle de quolibets'.[13] Decades earlier Henry Monnier recollected the students' response when asked by the *massier* what to do with a *nouveau*: 'First art student: Let's see him. Second: Undress him. Third: Send him back to his family. Why? Nothing in his physique suggests a man called for noble destiny.'[14] As a student in Delaroche's *atelier*, Cham impersonated the master and ordered the *nouveau* to strip. Warning the newcomer, 'I don't want deformed students because deformed students make deformed paintings.'[15] In Gérôme's *atelier* it became customary to compel naked students to fight a duel with loaded paint brushes, as shown in an illustration to the memoirs of John Shirley Fox (Figure 7.3). Shirley Fox, who entered the studio at the same time as two older students, watched them fight such a duel and then was ordered to climb on the model stand and pose nude with the female model.[16] Resistance was no defence and seemed in fact to incite harsher treatment: W. C. Morrow remembered watching a *nouveau* who objected to the proposed programme being forcibly stripped by the other students and painted 'with designs and pictures not suitable for general inspection'.[17]

Although Bazille assured his parents that he would be left alone after the initial hazing, in many *ateliers* the *charges* were the prelude to a period of menial *atelier* labour which entailed cleaning the *anciens'* brushes or running errands – a custom recalling medieval and Renaissance apprenticeship systems.[18] John Shirley Fox remembered that his respect for the *anciens* was such that he welcomed these tasks, but students who resisted could anticipate more harassment.[19]

In time the *nouveau* worked his way up from this lowly position. The most important step was the arrival of another new student, when the *nouveau* would join the *anciens* in tormenting the newcomer, coercing him to perform nude for their amusement. The *nouveau*'s anxiety upon his introduction to the *atelier*, compounded by the *charges* and reinforced by the menial tasks to which he was subjected, was finally resolved in the opportunity to join with the *anciens* in harassing the new *nouveau*. The end of his prolonged ostracism, the opportunity to join the fraternity of the *atelier*, must have been welcomed with relief.

Albert Boime has characterized the *charges* as an open expression of hostilities engendered by the frustrations of competition within the Ecole, where all the students competed for – but few could hope to win – the highest honour, the Prix de Rome. He also observed that such baiting 'seems to be characteristic of all closed fraternal societies'.[20] While hazing and initiation rites are widespread, they vary in their particulars between and within cultures. Anthropological and sociological studies suggest that

7.3 John Cameron, 'They set about each other ... ', 1909

attending to the character of specific initiation practices can elucidate the construction of masculinities within specific cultures or, in this case, professions.[21]

In nineteenth-century France hazing or *bizutage* was routine in such elite schools as the Ecole Polytechnique as well as the Ecole des Beaux-Arts.[22] At the Ecole Polytechnique, which deliberately adopted a military culture when it was founded in 1794, each *nouveau* was assigned to a second year student, who harassed the younger student, calling attention to and suppressing all particularities in the *nouveau*'s speech, walk, dress or even thought. Students who complained of the practice to school authorities later found their careers blocked by alumni. After three months the senior students officially welcomed the chastened and disciplined *nouveaux* into the brotherhood of *polytechniciens* in a secret ceremony. Here, then, hazing served to eliminate deviancy, to establish a standard of correct corporate behaviour.[23]

The *charges* in the *ateliers,* on the other hand, were addressed primarily to collective viewing of the body, and for that reason I would suggest that they were tied explicitly to the visual economy in which students would function as professional artists. Cameron's illustration of the *charges* in Gérôme's *atelier* poses the figures in a manner that respects the conventions of decorum that called for a fig leaf or scabbard to hide the genitals in representations of the male nude. As Abigail Solomon-Godeau has noted, the fig leaf and its variations simultaneously displace and call the viewer's attention to the biological site of masculine identity.[24] The use of the convention in Cameron's illustration suggests that in practice the forced exposure of the *nouveau*'s genitals was the critically transgressive aspect of the *charges*. The *charges* were, in effect, an occasion for obligatory exhibitionism and voyeurism.

Freud's account of scopophilia or voyeurism and exhibitionism provides a framework for analysing this practice. In his view, the initial object of scopophilia is auto-erotic, which in voyeurism is exchanged for an analogous part of someone else's body or in exhibitionism for the display of one's own body to another person.[25] Both serve in a man simultaneously to allay castration anxieties and provide erotic pleasure. Thus, Cham/Delaroche's declaration that he did not want students *mal faits* and Monnier's recollection of his fellow student's judgment of the *nouveau*'s appearance are very suggestive: the *anciens*' view of the *nouveau*'s body served to confirm his genital integrity, reassuring them that he did not embody the threat of castration, in other words, that he was not a woman.

The homoerotic implication of the *charges* is not uncommon in initiations into masculine groups, whether the fraternities of American colleges or the secret societies of 'traditional' cultures.[26] Whatever their purposes, when occurring within a firmly heterosexual culture, such as nineteenth-century

France, such homoerotic rituals bear out what Eve Kosofsky Sedgwick argues is a continuum between homosocial and homosexual association.[27] In such a culture, the homoeroticism of the *charges* would have demanded careful negotiation. A fuller picture of the *charges*, which provided a context for the display, could illuminate *atelier* attitudes. How were the *nouveaux'* accounts of their early love affairs staged? What songs did the *nouveaux* sing and what was the *anciens'* response? How were the *nouveaux'* bodies decorated and which parts of the body did Cham single out for 'correction'? We can't know the answers to these questions, which would surely reveal much about attitudes towards the literal embodiment of masculinity and behaviours considered masculine.

The significance of specific practices is not stable within *ateliers*, however. Duelling, to take a single behaviour which figured both in the *charges* and in *atelier* jokes, has been characterized by Robert Nye as an aristocratic custom of the *Ancien Régime* which was embraced by the post-revolutionary bourgeoisie as a code of alternative law linking justice to manliness and personal courage, both qualities associated with masculine honour.[28] A duel was the honourable Frenchman's response to breaches in the codes of *politesse* that governed social relations between men. Mock duels were frequent in *ateliers*: Horace Vernet's 1821 painting of his studio and Henry Valentin's 1849 wood engraving of Carpeaux's and Roqueplan's studio, for instance, both include a pair of fencing figures.[29] The naked duels imposed on *nouveaux* in Gérôme's *atelier*, however, parodied bourgeois honour codes: not only were the new students humiliated, but the honourable response to a humiliation was undermined. In some *atelier* contexts the duel's social function could reassert itself: Delaroche's *atelier* was closed after a duel provoked by a studio *blague* led to the death of a student.[30] If the significance of duels in the *atelier* was subject to slippage, their frequency suggests that codes of masculinity were a constant preoccupation among students.

While some of the ephemeral and shifting details of the *charges* must remain obscure, one significance of the central practice – the stripping of the *nouveau* – is clear: the transition from *nouveau* to *ancien* – from being the object of the collective voyeuristic gaze of the *atelier* to participating in the collective voyeuristic inspection of another *nouveau*'s body – initiated the student into a visual economy in which the subject of the gaze held the power and the object of the gaze was powerless.[31] Viewing the *nouveau* contributed to the authority of the *ancien*, for each *ancien* knew the students who came after him in a way that they would never know him. This power dynamic distinguishes nineteenth-century *charges* from the practices in David's *atelier*, where students were encouraged to pose for each other. The shift from mutual to coercive exposure in *atelier* routines parallels what Solomon-Godeau has argued is a historical transition in the visual economy

of nineteenth-century culture away from the pre- and post-revolutionary moment when specularity, exhibition and display were identified with masculinity to the period when they were gendered feminine.[32]

The *charges* constructed a hierarchy among the students, by separating *nouveau* from *ancien*, but how was this relationship situated within the larger *atelier* hierarchy, which extended to master and model? Was the significance of the *charges* confined to the *atelier*? Since the practice continued with the tacit approval of *atelier* masters and despite the misgivings of the Ecole's Director, it effectively had a 'semi-official' status. In Delaroche's *atelier*, the *anciens'* authority was linked to that of the master when Cham tricked the *nouveau* by impersonating him.

Bellangé's lithograph is perhaps the most telling depiction of the full *atelier* hierarchy (see Figure 7.2). As they greet the *nouveau*, the smiling profiles of the *massier*, master and model create a unified presence. The model bows in deferential welcome before the new student. (Note that although his genitals can be seen by the occupants of the *atelier*, they are hidden from the magazine's readers by his hat and replaced by the *massier's* maulstick; thus the conventions of decorum are preserved in the public realm of the journal.) The model's nudity here marks the bottom of the *atelier* hierarchy. The master, the top of the studio hierarchy, embodies social power. Standing beside one another, model and master – masculine nudity and social authority – are visually linked, but mutually exclusive. The hierarchy of *nouveau* and *ancien* constructed through the *charges*, repeating the hierarchy of model and master, was thus integral to the larger social hierarchy of the *atelier*: the *nouveau's* initiation into the fraternity of students served as an initiation into the larger professional hierarchy.

Thomas Crow, analysing the complex emotional and professional bonds between David and his students, likens David's pre-revolutionary studio to a family.[33] Comparing the students to fatherless sons, whose participation in the *atelier* drew them into issues of filiation, he notes that the absence of women distinguished the life of the studio from that of most families. Considering the function of the *charges*, I would propose that the *atelier* of the July Monarchy and after became a space *between* the family and the Ecole, *between* the privacy of the home, with its feminine presence, and the masculinized public arena. David Gilmore, in a cross-cultural synthesis of studies of the formation of masculinity, argues that rites of entry – among which we can class the *charges* – serve as a defence against pre-Oedipal identification with the mother and ensure masculine identification with adult males and masculine roles.[34] By this logic, the *nouveau's* initiation into the *atelier* served to establish homosocial bonds within the *atelier* fraternity, sever his relation with the home, and establish him within the masculine context in which he would construct a professional identity.

It was in the Ecole des Beaux-Arts proper, rather than the *atelier,* that the student would begin to lay claim to a public, professional identity, but it was as a member of an *atelier* that he entered the Ecole. Within the pedagogical structure of the Ecole, a student's progress was measured by his rank in the annual series of competitions, for which he became eligible once he had placed in the *concours des places.* Competitions, which early academic theorists considered useful in stimulating students' capacity for *emulation,* had long been a part of the French Academy.[35] By the first half of the nineteenth century the number of competitions increased, becoming in effect the primary focus of the Ecole.[36] Each year the distribution of awards was celebrated in a ceremony staged in the Hémicycle, decorated with Paul Delaroche's mural of the great artists of the past and the allegorical figure of Fame, kneeling at the centre to toss laurel wreaths to the winners.

The master and the *atelier* were the student's link to the Ecole and its competitions. In fact, competitive trials began as soon as a student entered a private *atelier* to prepare for the *concours des places*: in many *ateliers* competitions imitating those of the Ecole were organized by the master or students themselves.[37] After they entered the Ecole, students continued to identify and be identified with their *atelier.* This was reinforced by Ecole regulations: sponsorship by a recognized master was required of students and each drawing placed in Ecole competitions was labelled with the name of the student's master as well as its maker.[38] *Ateliers,* too, looked on members who competed in the Ecole as representatives of the group. When Auguste Ottin, discouraged by the rigours of life in the *loges,* was ready to abandon the Prix de Rome competition, he was recommitted to the effort by the reminder that other *atelier* members were counting on him.[39]

The Ecole *concours,* in turn, socialized students into the defining professional practices of French art: since 1793 the arena of artistic production had been structured by the system of awards distributed to French artists.[40] As Pierre Bourdieu summarizes the system, the nineteenth-century artist had 'a career, a well-defined succession of honours, from the Ecole des Beaux-Arts to the Institute, by way of the hierarchy of awards given at Salon exhibitions'.[41] Although the numbers and types of medals awarded and the make-up of the jury that selected winners differed with each government, the award ceremony at the close of the Salon was a state occasion and the practice of conferring honours continued into the Third Republic and even after management of the Salon was turned over to the Société des Artistes Français. In addition artists were honoured by medals at the international expositions and membership in the Légion d'Honneur. By the Second Empire, the grades of medals and honours an artist had won were noted in the *livret.* Such accolades provided a means of ranking artists, and despite the developing role of dealers and private exhibitions at the close of the century, the award

system retained its importance, for collectors reviewed an artist's awards when planning purchases.[42]

The award system was not of course unique to the arts. From the annual awards given to schoolboys to the grades of the Légion d'Honneur that Napoleon established in 1802, medals and prizes created a symbolic field in which accomplishment was acknowledged and measured and honour and prestige were granted. In the hierarchies of absolutist pre-revolutionary France, categories of blood and birth determined a Frenchman's social distinction. Post-revolutionary France was to be a meritocracy, in which state-sponsored honours established a new hierarchy among citizens according to criteria based not on their birth or inheritance, but on their accomplishments and their contributions to the state.

A man's awards, his rank in the Légion d'Honneur, became a part of his public identity, to be included in listings like those of the Parisian commercial guide, Didot-Bottin, established in 1838, and proudly displayed in official portraits.[43] When he posed for the camera of Adrien Tournachon, Horace Vernet's chest was full of medals (Figure 7.4). The bourgeois black suit preferred by official and academic artists as well as *fonctionnaires* was an excellent foil for awards, but even artists who chose to signal their creativity with the aristocratic dress of a dandy paraded their awards in their portraits.[44] Nadar's photograph of Eugène Delacroix prominently displays the rosette of the Légion d'Honneur (Figure 7.5).

This competitive and hierarchical field was, however, inflected by distinctions of class and gender, especially at upper levels. In 1850 a worker was named to the Légion d'Honneur for the first time, when Jean Baptiste Pruvot was honoured for 50 years of agricultural labour. The first woman was named the following year, when Angelique Marie Duchemin was distinguished for her military exploits in the French Revolution. It is worth noting that Duchemin was distinguished for her contribution in an area strongly gendered masculine and that most women named in the following years were nuns, who, although honoured for a traditionally feminine role, were simultaneously removed from domestic femininity by their calling.[45] Rosa Bonheur finally was named to the Légion d'Honneur in 1865, while the Empress Eugénie was acting as regent; when Bonheur attended a state dinner along with other members, she was acutely uncomfortable to find herself the only person wearing a skirt.[46] The Légion d'Honneur functioned as a state mechanism for the institutionalization of a gender – as well as a class – order.[47]

I have argued that the *atelier charges,* the Ecole *concours* and the state-sponsored awards comprised an integrated system through which the profession of the artist in nineteenth-century France was gendered masculine. Through the ritual voyeurism of the *charges* and the official policies of the

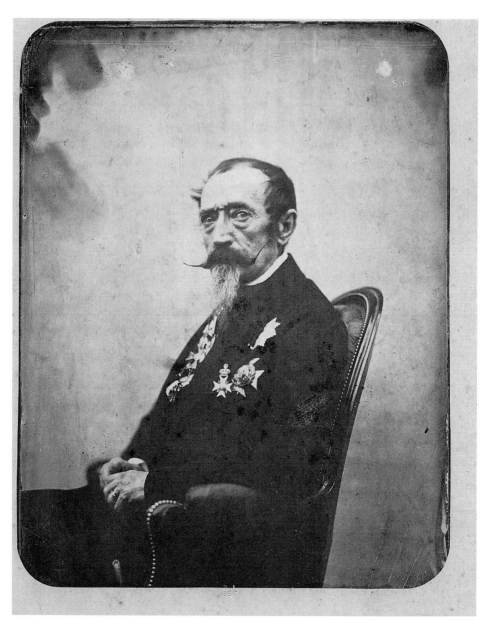

7.4 Adrien Tournachon, *Horace Vernet*, 1854

7.5 Nadar, *Eugène Delacroix*, 1858

Ecole, it excluded women; perpetuated within state-sponsored institutions, it can be considered, borrowing R. W. Connell's usage, hegemonic.[48] This formulation raises additional questions, which, while they cannot be addressed here, need, I think, to be signalled. Most important, what of the subordinate masculinities which, as R. W. Connell has suggested, are as significant as the feminine to the formation of hegemonic masculinity? What, for instance, of artists who did not study in Parisian *ateliers* or who, having studied in an *atelier*, did not progress to the Ecole des Beaux-Arts? It would seem that artists who did not pass through the *atelier*-Ecole award system were obliged to fashion a masculinity in other terms. Did independent artistic brotherhoods provide a site for contesting the dominant masculinity? And finally, was, the *atelier*-Ecole award system perhaps a factor in the 'crisis of masculinity' to which some feminist scholars have attributed the hyper-masculinism of modernist artists?[49]

Notes

Research for this essay, first presented at the College Art Association 1998 panel on Artistic Brotherhoods organized by Laura Morowitz and William Vaughan, was completed with support from the Social Science Research Council and the Samuel H. Kress Foundation. I have greatly benefited from comments on earlier drafts offered by Hollis Clayson, Lucie Arbuthnot, Sarah Betzer, Sheila Crane, Elizabeth Seaton and Margo Hobbs Thompson.

1. See Albert Boime, *The Academy and French Painting in the Nineteenth Century* (London: Phaidon, 1971); Monique Segré, *L'Art Comme Institution: L'Ecole des Beaux Arts* (Paris, 1990); Philippe Grunchec, *Les Concours de Prix de Rome, 1797–1863*, 2 vols (Paris: Ecole Nationale Superieur des Beaux-Arts, 1986) and *The Grand Prix de Rome: Paintings from the Ecole des Beaux-Arts, 1797–1863* (Washington, DC: International Exhibits Foundation, 1984–5).

2. Pierre Bourdieu, 'Manet and the Institutionalization of Anomie', in *The Field of Cultural Production: Essays on Art and Literature*, trans. Randal Johnson (New York: Columbia University Press, 1993), pp. 238–53.

3. On *juste milieu*, academic and official, see Boime, 1971, pp. 15–22. For a discussion of responses to Boime's formulation and its relevance to *fin de siècle* painting, see Robert Jensen, *Marketing Modernism in Fin-de-Siècle Europe* (Princeton: Princeton University Press, 1994), pp. 139–41.

4. I rely here on the model of homosociality developed by Eve Kosofsky Sedgwick in *Between Men: English Literature and Male Homosocial Desire* (New York: Columbia University Press, 1985), pp. 1–20.

5. Abigail Solomon-Godeau, *Male Trouble: A Crisis in Representation* (New York: Thames & Hudson, 1997), pp. 46–61, considers the homosociality of David's *atelier* in terms of masculinization of the public sphere. Tamar Garb in *Sisters of the Brush* (New Haven: Yale University Press, 1994), pp. 88–92, discusses the controversies generated by the campaign for women's admission to the Ecole des Beaux-Arts.

6. On Ingres' *atelier*, see Hippolyte Flandrin, *Lettres et Pensées d'Hippolyte Flandrin* (Paris: H. Plon, 1865), p. 113.

7. Archives Nationales: AJ/53/910, letter dated April 1866; 'La bienvenue est payée par les arrivants non seulement en argent mais encore en taquineries, en scies, en vexations et il faut le dire en mauvais traitements et en voies de fait.'

8. Quoted in Henri de Curzon, *Alfred de Curzon, peintre, sa vie et son oeuvre* (Paris: Librairie Renovard, 1914), vol. 1, p. 23: 'Les élèves me parurent d'une grossièreté ou d'une vulgarité dont j'avais naturellement pas eu l'idée jusqu'alors. Les quolibets et les rebuffades ne me manquèrent pas.' See also Boime, 1971, p. 53.

9. Val C. Prinsep, 'A Student's Life in Paris in 1859', *Magazine of Art*, ns. 2 (1904): 338.

10. Quoted in Gaston Poulain, *Bazille et ses Amis* (Paris: La Renaissance du Livre, 1932), p. 17: 'Mon entrée à l'atelier s'est effectuée sans trop d'encombre; On m'a fait chanter; on m'a fait tenir sur une jambe, etc., etc., toutes chose ennuyeuses, mais on va me laisser tranquille maintenant.'

11. Bibliothèque Nationale, Département des Estampes, microfilm KC 164 (f°), t. 6, R10852: 'Réception. Lecture du Règlement … Art. 5: le nouveau racontera l'histoire de sa vie et les circonstances qui l'ont déterminé à suivre la carrière des beaux arts; puis, dans un style moins élevé, il narrera l'histoire de ses premières amours!'

12. Etienne Delécluze, *Louis David: son école et son temps* (Paris: Editions Macula, 1983; reprint of Paris: Didier, 1855), pp. 52–3.

13. Alexis Lemaistre, *L'Ecole des Beaux-Arts dessinée et racontée par un élève* (Paris: Firmin-Didot, 1889), p. 15: 'a hail of jeers'.

14. Henry Monnier, *Mémoires de Monsieur Joseph Prudhomme* (Paris: Librairie Nouvelle, 1857), pp. 175–6: 'Rapin: qu'on le voie. Deuxième rapin: qu'on le déshabille. Troisième rapin: qu'on le rendre à sa famille. Et pourquoi? Riens dans sa physique ne décèle un homme appelé à de nobles destinées.'

15. Charles Moreau-Vauthier, *Gérôme, peintre et scupteur* (Paris, 1906), pp. 25–6: 'Je ne veux pas d'élève mal fait parce que les gens mal faits font la peinture mal faite', he would use a paint brush to mark the areas of the student's body that needed 'correction'. Gérôme studied in Delaroche's *atelier* in the same years as Cham.

16. John Shirley Fox, *An Art Student's Reminiscences of Paris in the Eighties* (London: Mills and Boon, 1909), pp. 115–17. A similar illustration by Edouard Cucuel appears in W. C. Morrow, *Bohemian Paris of Today*, 2nd edn (Philadelphia: J. P. Lippincott, 1900), p. 45.

17. Morrow, 1900, pp. 42–5.

18. Boime, 1971, p. 48, discusses the *atelier* system in terms of medieval precedents.

19. Shirley Fox, 1909, p. 119.

20. Boime, 1971, pp. 49–50. See also Boime, *Thomas Couture and the Eclectic Vision* (New Haven: Yale University Press, 1980), p. 445. Monique Segré, 1990, p. 132, calls the *charges* an occasion for the *anciens* to exercise their power sadistically, but doesn't ask to what end. William Hauptman, in 'Delaroche and Gleyre's Teaching Ateliers', *Studies in the History of Art* (Washington, DC: National Gallery of Art and University Press of New England, 1984–5), vol. 18, p. 80, dismisses the initiation as a 'mild embarrassment'.

21. John M. W. Whiting, Richard Kluckholn and Albert Anthony in 'The Function of Male Initiation Ceremonies at Puberty', in Eleanor E. Macoby, Theodore M. Newcome and Eugene Hartley, (eds), *Readings in Social Psychology*, 3rd edn (New York, 1958), pp. 359–70, suggest that initiation rites are harsher in cultures in which parenting practices lead to a closer mother–child attachment. Frank W. Young, however, suggests in 'The Function of Male Initiation Ceremonies: A Cross Cultural Test of An Alternative Hypothesis', *The American Journal of Sociology*, **68** (January 1962): 381–6, that initiations serve to dramatize and stabilize the male sex role in societies with a high degree of masculine solidarity. Lionel Tiger in *Men in Groups* (New York: Marion Boyars, 1969), pp. 126–55, likens initiations to courtship rituals.

22. Terry Shinn, *L'Ecole Polytechnique* (Paris: Presse de la Fondation nationale des sciences politiques, 1980), pp. 57–60. See also John H. Weiss, 'The French Engineering Profession, 1800–1850', in Gerald L. Gerson (ed.), *Professions and the French State* (Philadelphia: University of Pennsylvania Press, 1984), pp. 14–16.

23. This process is very similar to Michel Foucault's account of hierarchies of surveillance and corrective discipline in *Discipline and Punish*, trans. Alan Sheridan (New York, 1979), pp. 170–94.

24. Solomon-Godeau, 1997, pp. 178–9, discusses conventions governing the representation of male genitals in terms of the Lacanian distinction between the penis and the phallus.

25. Sigmund Freud, *Three Essays in the Theory of Sexuality*, trans. James Strachey (New York: Basic Books, 1962), p. 130, and 'Instincts and their Vicissitudes', *Standard Edition of the Complete Psychological Works*, James Strachey (ed.), (London: Hogarth Press, 1957), vol. 14, p. 23.

26. Tiger, 1969, p. 146. See also Elizabeth Badinger, *XY: On Masculine Identity*, trans. Lydia Davis, (New York: Columbia University Press, 1995), pp. 79–83; Badinger considers 'pedagogical homosexuality' a transitional practice necessary to achieving a normative heterosexual identity.

27. Sedgwick, 1985, pp. 2–3. On attitudes towards homosexuality in nineteenth-century France, see

Anthony Copley, *Sexual Moralities in France, 1780–1980* (London: Routledge, 1989), pp. 99–107, and Jeffrey Merrick and Bryant Ragan (eds), *Homosexuality in Modern France* (New York: Oxford University Press, 1996).

28. Robert Nye, *Masculinity and Male Codes of Honor in Modern France* (Oxford/New York: Oxford University Press, 1993), pp. 144–7.

29. Nina Maria Athanassoglou-Kallmyer, '*Imago Belli*: Horace Vernet's *L'Atelier* as an Image of Radical Militarism under the Restoration', *Art Bulletin*, **68** (2) (June 1986): 268–80, links the scene to Vernet's association with the military culture of Bonaparte. For Valentin's image, see *Magasin Pittoresque*, 1849, p. 381.

30. The most complete account of the event, referred to in several nineteenth-century sources, is in F. Ribeyre, *Cham, sa vie et son oeuvre* (Paris: H. Plon, 1884), pp. 66–71. For a summary, see Hauptman, 1984–5, p. 80.

31. The foundational analysis of the power dynamic of the gaze is Laura Mulvey 'Visual Pleasure and Narrative Cinema', *Screen*, **16** (3) (Autumn 1975): 6–18. Mulvey focuses on the female object of the masculine voyeuristic gaze. Of the many responses to her formulation, I have found the following especially helpful in considering the male object of the masculine gaze: Steve Neale, 'Masculinity as Spectacle', *Screen*, **24** (6) (Winter 1983): 2–16, and Norman Bryson, 'Géricault and Masculinity', in Norman Bryson, Michael Ann Holly and Keith Moxey (eds), *Visual Culture* (Hanover/London: University Press of New England and Weslyan University Press, 1994), pp. 228–59.

32. Solomon-Godeau, 1997, pp. 43–5.

33. Thomas Crow, *Emulation: Making Artists in Revolutionary France* (New Haven: Yale University Press, 1995), pp. 25–9.

34. David Gilmore, *Manhood in the Making* (New Haven: Yale University Press, 1990), pp. 26–8. Nancy Chodorow's argument, in *The Reproduction of Mothering* (Berkeley/Los Angeles: University of California Press, 1978), pp. 180–5, that the intense nature of modern mothering engenders the male child's need to separate from the mother and the feminine in order to effect a successful resolution of Oedipal tensions, suggests that a similar process may be at issue in modern, capitalist cultures.

35. On pre-nineteenth-century competitions, see Laura Olmstead Tonelli, 'Academic Practice in the Sixteenth and Seventeenth Centuries', in *Children of Mercury: The Education of Artists in the Sixteenth and Seventeenth Centuries* (Providence: Art Centre, Brown University, 1984), p. 104, and H. F. Schonweld-van Stoltz, 'Some Notes on the History of the Académie Royale de Peinture et de Sculpture in the Second Half of the Eighteenth Century', *Leids Kunsthistorisch Jaarboek* (Delft: Delftische Uitq Nij, 1986–7), vol. 5–6, p. 221.

36. For a general summary of Ecole *concours* before 1863, see Grunchec, 1984–5, pp. 23–8. On competitions in private *ateliers*, see Boime, 1971, p. 53. On the growing importance of competitions in the nineteenth-century Ecole, see Harrison C. and Cynthia A. White, *Canvases and Careers*, 2nd edn (Chicago: University of Chicago Press, 1993), pp. 18–20 and Segré, 1990, pp. 11, 93.

37. Boime, 1971, pp. 49, 50, 53.

38. Grunchec, 1984–5, p. 23.

39. Archives des Musées Nationaux (Louvre): 2HH7: Ottin, 'Souvenirs d'un jeune sculpteur, copiées par sa fille', 11.

40. On the award system see François Benoit, *L'Art Français sous la révolution et l'empire: Les doctrines, les idées, les genres* (Geneva, 1975; reprint of Paris: E. Baranger, 1879), pp. 233–4; Clara Stranahan, *History of French Painting* (New York: Charles Scribner and Sons, 1902), pp. 84, 275, 277; and White and White, 1993, pp. 31–2.

41. Bourdieu, 1993, p. 242. Bourdieu considers this career path as characteristic of academic rather than avant-garde artists and goes on to suggest that academic artists never completely 'escaped' from the Ecole, but internalized its values and carried them forward into their careers. While I agree that the connections between Ecole and state awards are critical, I argue that since these values were institutionalized within the entire state-sponsored medal and award system, they were not simply a 'holdover' from educational practices.

42. On collectors' attitudes, see Jules Claretie, *La Vie à Paris, 1881* (Paris: V. Havard, 1881), pp. 221–6.

43. Didot-Bottin, *Annuaire-Almanache du commerce et de l'industrie* (Paris: Didot-Bottin, 1838–1900).

44. On the preference for black suits among 'official' artists, see Françoise Heilbrun and Philippe

Néagre, *Portraits d'Artistes* (Paris: Réunion des musés nationaux, 1986), p. 10. Amelia Jones, in 'Clothes Make the Man: The Male Artist as a Performative Function', *Oxford Art Journal*, **18** (2) (1995), 18–32, presents a provocative analysis of the role of dress in constructing the masculine identity of the modern artist.

45. Louis Bonneville de Marsangy (1802–1900), *La Legion d'Honneur* (Paris: H. Laurens, 1907), pp. 174, 213–22.

46. Anna Klumpke, *Rosa Bonheur: sa vie, son oeuvre* (Paris: E. Flammarion, 1908), p. 309. Bonheur's experience was complicated by her customary transvestism; see Gretchen van Slyke, 'The Sexual and Textual Politics of Dress: Rosa Bonheur and Her Cross-Dressing Permits', *Nineteenth Century French Studies*, **26** (3/4) (Spring–Summer 1998): 321–35; Albert Boime, 'The Case of Rosa Bonheur: Why Should a Woman Want to Be More Like a Man?', *Art History*, **4** (4) (December 1981): 384–409. See also the next chapter in this volume, pp. 154–184.

47. On state regimes of gender, see R. W. Connell, *Gender and Power* (Stanford: Stanford University Press, 1987), pp. 120, 129–32.

48. Ibid., pp. 183–6.

49. Lisa Tickner, 'Men's Work? Masculinity and Modernism' in Bryson, Holly and Moxey (eds), 1994, pp. 42–82; Carol Duncan, 'Virility and Domination in Early Twentieth-Century Vanguard Painting', reprinted in *The Aesthetics of Power: Essays in Critical Art History* (Cambridge: Cambridge University Press, 1993), pp. 81–108.

Girls 'n' the 'hood: female artists in nineteenth-century France

Jane Mayo Roos

Flying home from Paris, just before writing this essay, I watched a TWA Movie Classic, 'How to Succeed in Business Without Really Trying' (1967). Toward the end of the film, a group of middle-management men-in-suits breaks into song about the need to bond together in the corporate world. The song is called 'The Brotherhood of Man' and celebrates the ways in which guys stick together when the going gets tough. Within the film's context, the lyrics are not 'intentionally' misogynist: the songsters have no overt animus toward women, and it is not toward excluding or demeaning women that their brotherly feelings are aimed. Rather, the absence of women is assumed to be part of the natural order of corporate life – it's a good example of Roland Barthes' concept of naturalized belief[1] – and the men dance and sing and bond in reaction to pressure from an alpha-male CEO and competition from the other would-be successful guys around them. Within this cinematic corporate environment, female executives did not exist.

Like the widget-making corporation in *How to Succeed in Business Without Really Trying*, the art world in mid-nineteenth-century France was a highly competitive, masculine sphere. With the emergence of a middle-class buying public, the production of art flourished, but only a small percentage of the country's artists received the support of the cultural establishment.[2] Women's work counted hardly at all, as if the exhibiting of art were a priapic struggle for survival, in which a female's biology left her poorly equipped. Ever since Linda Nochlin's essay 'Why Have There Been No Great Women Artists?' brought feminist analysis to a higher discursive plane, the ways in which females were prevented from full participation in the visual arts have been incisively delineated: denied access to the best training, they then faced a public – amateurs, buyers, and critics – that ignored or denigrated their works, and they were barred from admission to the professional organizations

8.1 Gavarni [Sulpice-Guillaume Chevalier], 'The Female Artist', 1839

that, for better or worse, validated an artist's works and increased their commercial value.[3]

And yet, despite the discrimination they faced, women in the nineteenth century did seek careers in the arts – as Gavarni's gentle and sympathetic caricature (Figure 8.1) indicates. They secured what training they could, worked seriously at establishing their careers, and in some cases achieved public recognition within that male-dominated milieu. This essay will examine the careers of three such anomalous women – Rosa Bonheur (1822–99), Berthe Morisot (1841–95), and Mary Cassatt (1844–1926) – and will consider how they shaped and composed their professional careers. Of greatest interest to me in this analysis are the questions of how these women – themselves the products of a society that devalued their accomplishments – emerged into adulthood with a sense of integrity, entitlement, and self-worth; and, having

accomplished that, how they navigated professionally in a world that was dominated by the brotherhoods of art.

These questions might seem to have simple, aesthetic solutions – since they are distanced now by time, culture, and the formality of academic discourse – but for much of the nineteenth century 'woman' and 'artist' were mutually exclusive terms, and when the former attempted to become the latter negotiating the issue of gender was professionally and socially imperative. A key argument in this essay concerns the way in which Bonheur, Morisot, and Cassatt formed deep, sustaining relationships with other women – sisterhoods, if you will – from which were drawn the support and validation so absent in the art world at large. In fact, if this essay had a starting point, a specific remark that altered my point of view, it was a reference to an entry by Morisot in one of her *carnets*: that 'the only true friendship a woman could have was with another woman'.[4] When I encountered that remark, I read it with some surprise, and it set me to wondering if the traditional emphasis on a woman's relation to a well-recognized male artist – in this case Morisot's to Edouard Manet – represented a subtle continuation into the late twentieth century of the gender biases of an earlier age. As will be seen, Manet's influence on Morisot was certainly a strong factor in the emergence of her mature painting, but her female alliances also carried high significance.

Overture: the brotherhoods of art

The art world in nineteenth-century France comprised a series of inter-connected institutions that regulated many aspects of professional practice.[5] For the training of its artists, the government funded a network of Ecoles des Beaux-Arts (Schools of Fine Arts) in the country's major cities, the most significant one being the Ecole des Beaux-Arts on the rue Bonaparte in the centre of Paris. Admission to the Ecole was achieved via competition, and acceptance into the programme gave the successful candidate a tuition-free education in the arts. Once admitted to the Ecole, students followed a rigorous, if rigid, curriculum, and outside their formal classes they worked in the *atelier* of one of the country's recognized 'masters'. During the course of their studies, students could compete for the prestigious Prix de Rome, the winners of which received a government-financed stay, several years long, at the Villa Medici in Rome and the near-priceless distinction of the award itself.

For the display and marketing of the fine arts, the government provided the Exhibition of the Works of Living Artists, popularly called 'the Salon', a block-buster, bazaar-like, mega-exhibition that brought artists into contact with the art-buying public. Held in the Louvre (till 1849) or the Palais de

8.2 After a sketch by M. Ryckebusch, *Painting Jury for the Salon of 1870*

l'Industrie (after 1855), the Salon included painting, sculpture, architectural drawings and prints and encompassed several thousand works each year.[6] The rules governing the Salon were set by the government, which determined such things as how many works could be submitted, who would compose the jury, and if the jury was elected who would be eligible to vote.

At the Salon, medals were awarded to the artists whose works were considered to be of highest merit. In many years, the awards came in several grades – first, second, or third class, plus honourable mention – and carried prize money as well. The recognition that a Salon medal brought greatly enhanced an artist's reputation and increased the economic value of the works. In some years, the receipt of a medal also enabled an artist to vote for the jury and/or freed that artist from the need to submit works for the jury's scrutiny. Other significant organizations included the Légion d'Honneur, whose members were named by the government and organized into the successive ranks of Chevalier (most common), Officer, Commander and Grand Officer (extremely rare). And the highly exclusive and prestigious Académie des Beaux-Arts, which chose its own members, the number being strictly limited to 40 places for artists and 10 for other professionals in the field.[7]

Within this organizational context, female artists had little, if any, professional place.[8] Until the very last years of the nineteenth century, women were excluded from the Ecole des Beaux-Arts, as faculty and students both; excluded from the *ateliers* of most of the country's best-regarded artists; and excluded from the competition for the Prix de Rome.[9] No woman artist was named to the Legion of Honour until the mid-1860s; no woman – artist or not – progressed beyond the level of Chevalier until the mid-1890s; no woman artist served on a Salon jury (Figure 8.2) until 1898; and it remains true today that no woman artist has ever been named as a full member of the Academy of Fine Arts.[10] As for Salon awards, a document in the Archives Nationales in Paris (Table 8.1) quantified, in precise, statistical terms, the status of women artists in the late 1860s.[11] Part of a study conducted by the administration of fine arts, these data

Table 8.1 Exhibitors at the Salon of 1869

Type [of work]	Hors concours	Exempt	Non-Exempt	Total
Male artists				
Painting	170 [13%]	140 [11%]	958 [76%]	1268 [100%]
Drawings etc.	47 [13%]	42 [12%]	264 [75%]	353 [100%]
Sculpture	64 [19%]	46 [13%]	233 [68%]	343 [100%]
Engraved medals	6 [24%]	5 [20%]	14 [56%]	25 [100%]
Architecture	7 [10%]	11 [15%]	55 [77%]	73 [100%]
Engraving	19 [11%]	21 [12%]	130 [77%]	170 [100%]
Lithography	4 [13%]	3 [10%]	23 [77%]	30 [100%]
Total	317 [14%]	268 [12%]	1677 [74%]	2262 [100%]
Female artists				
Painting	3 [2%]	6 [5%]	121 [93%]	130 [100%]
Drawings etc.	2 [1%]	10 [7%]	141 [92%]	153 [100%]
Sculpture	0 [0%]	1 [5%]	19 [95%]	20 [100%]
Engraved medals	0	0	0	0
Architecture	0	0	0	0
Engraving	0 [0%]	0 [0%]	14 [100%]	14 [100%]
Lithography	0	0	0	0
Total	5 [2%]	17 [5%]	295 [93%]	317 [100%]

Source: Archives Nationales, F[21] 531; data in brackets indicate percentages added by this author.

differentiated Salon exhibitors according to gender and tabulated the degree to which they had won medals at the Salon of 1869. Here, the designation 'hors concours' denotes those artists who had received the maximum number of Salon medals and were thus placed beyond further competition; 'exempt' indicates artists who had received at least one medal, but not enough to be considered 'hors concours'; and 'non-exempt' signifies Salon exhibitors who had not been given any medals at all.

As the table indicates, women fared poorly when it came to Salon medals. Whereas over a quarter of the male exhibitors (26%) had won some sort of Salon honour by the year 1869, only 7% of the female exhibitors had been so honoured, a mere 2% having received enough medals to qualify as 'hors concours'.

In delineating the art world of the period, 'brotherhood' is a useful construct, in that it catches both the associative and the gender elements of which the institutional network was comprised. As the making of art became an increasingly competitive and commercial enterprise, artists depended more and more heavily upon their professional affiliations, as a way of distinguishing themselves from the thousands of others who aspired to similar goals. Thus, groups like the Ecole, the Legion of Honour, the various medal-winning populations, or the Academy functioned as honorific fellowships – brotherhoods in the broader sense – membership in which gave an artist marketplace credibility. However, gender also came into play, in that the entry of women artists into the competition posed a further economic threat,[12] and one that could be dealt with easily by excluding them from the associations that carried currency. To this end, the making of art remained a masculine endeavour, and the official institutions – brotherhoods in a narrower sense – tolerated few exceptions to their natural order. From this perspective, 'brotherhood' is a subset of patriarchy and synonymous with discrimination against women artists.

At the awards ceremony for the Salon of 1864, Jean-Baptiste-Philibert, le maréchal Vaillant, opened the occasion with a brief speech in which he praised the assembly of medal-winners for their accomplishments. At the time, Vaillant held the position of minister of fine arts and thus headed nearly all of the institutions that comprised the official art world in France.[13] His remarks that day cast the practice of art as a quasi-religious vocation, in which brother united with brother, all sharing the same canonical faith:

Between the artists whose works have already caught the attention of the public and the young men who are entering into the career, there exists a community of feeling, a sort of sympathetic bond; because both groups, whatever their ages are, carry in their hearts the same belief, the same faith in art; and it is to fortify this union, it is to tighten this fraternal bond, that we have wanted to associate them with the same emotions and the same joys. Won't it be, besides, a gentle and touching satisfaction

8.3 Anonymous, *The Arts and Decency*

for the elders to salute the first steps of their brothers in the awards route along which they have already gone … ?[14]

Here, gender and economics are further allied, in that one response to the commercialization of the fine arts was an attempt to sanctify the profession by connecting it with monastic or priestly orders.[15]

Not to be overlooked is the way in which the flourishing of the brother-hoods, and their concomitant exclusion of women artists, were intimately related to the pervasive socio-sexual conditioning of the times. Geneviève Bréton, an intelligent, liberal woman of the 1860s, and a friend of several female artists, could write in her diary that '[i]t's most improper for a woman to have more talent than men'.[16] She meant the comment sympathetically, and while expressing her objection to it she gave voice to the widely held sentiments of the society around her. A similar connection between the woman artist and impropriety is expressed in an undated print in the Bibliothèque Nationale in Paris (Figure 8.3): here, as a young female artist attempts to draw from the male nude, a prudish figure in the background covers the model's genitals. The print's title, 'The Arts and Decency', suggests the moral depravity and loss of public standards that would, in the eyes of some people, result from a woman's freedom to look. However, the print is exceptionally broad-minded in its attitudes, and the woman who screens the genitals – using a fashionable female hat – bears a grim and malevolent visage. Thus, the suggestion is made that the need to censor the female gaze arose out of the dark recesses of a fearful and punitive collective unconscious.[17]

Scene 1: sisterhood as life choice

Rosa Bonheur was born in 1822, the eldest child of Sophie and Raymond Bonheur. She began to exhibit her paintings in 1841 at the age of 19, and her success was early and virtually instantaneous.[18] She had paintings accepted at the Salons all through the 1840s, and she received a third-class medal in 1845, when she was 23, and a gold medal for her works in 1848. These honours were followed by a first-class medal at the Universal Exposition in Paris in 1855, and by a second-class medal at the Universal Exposition of 1867, when 10 of her paintings were shown. In 1849 she was appointed by the government to serve as the director of a state-funded drawing school for women, a position that her father had held before her and that she retained until 1860.[19]

Early in her career, she was acclaimed 'a genius', and Victor Hugo, quintessential genius himself, wrote of her work: 'The boldness of her conceptions is sublime. As a creative Artist I place her first among women, living or dead. And if you ask me why she thus towers above her fellows, by

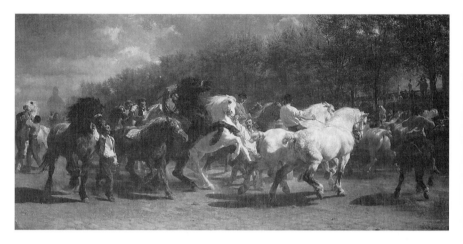

8.4 Rosa Bonheur, *The Horse Fair*, 1853/5

the majesty of her work silencing every detractor, I will say it is because she listens to God, and not to man. She is true to herself'.[20] Many critics compared her work to that of the English novelist George Sand, and Georges Bizet wrote a song in her *honour*.[21] Even the hard-to-please critic Théophile Thoré wrote: 'Mlle Rosa Bonheur, who, before the French revolution, would have been a member of the Academy of Fine Arts, has brought oxen under the yoke and has her sheep rest in the meadows of Cantal. Mlle Rosa paints almost like a man'.[22]

What painting 'like a man' meant was that she avoided the faint-hearted delicacy associated with so-called feminine art. She worked on an ambitiously large scale, and she depicted bold landscapes that presumed a command over her environment. At a time when the ideal of womanhood kept middle-class females close to home, innocent of the world around them and unblemished by its effects, it was highly unusual that a woman would assert power over her geography and produce large-scale scenes of the natural world.[23] Most often, Bonheur filled her landscapes with large and powerful animals – horses, livestock, deer, lions, and buffalos – which were not the sort of creatures that were associated with women or with women-who-paint.[24]

In addition, her works sold extremely well, *The Horse Fair* (Figure 8.4) going for the enormous sum of 40,000 francs (10,000 francs a year then being considered a solidly middle-class income). She was adept at managing her dealers, and at a time when few of her contemporaries (male or female) understood the complexities of the marketplace, she made good use of the benefits that a dealer and gallery offered.[25] Not one to shy from publicity, she had become an international celebrity by the 1860s, and her visage was widely reproduced (Figures 8.5 and 8.6). Such was the interest in her work

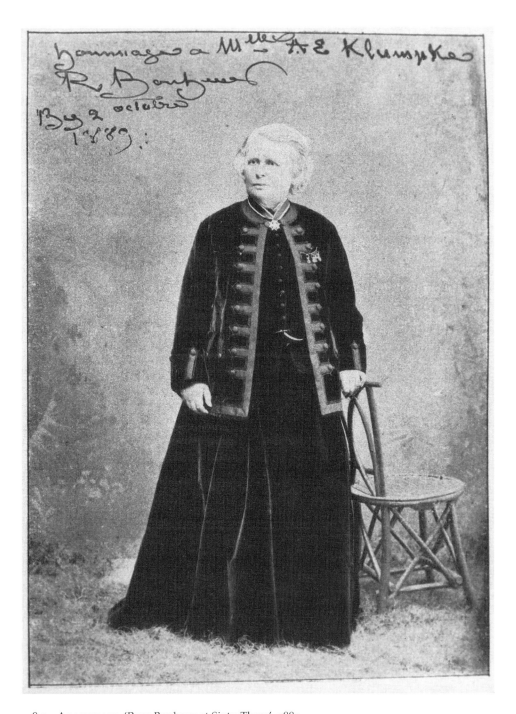

8.5 Anonymous, 'Rosa Bonheur at Sixty-Three', 1885

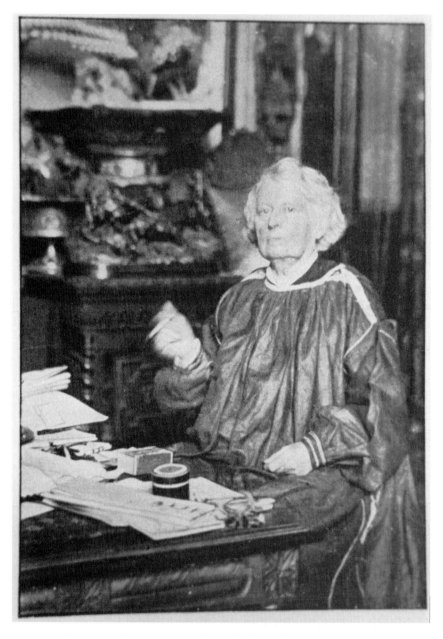

8.6 Anna Klumpke, 'The Cigarette', (Portrait of Rosa Bonheur), *c*. 1898

that the first book-length biography was published in 1856,[26] when she was 32, and many others followed. In 1865 she became the first woman artist in French history to receive the Legion of Honour. By then, she had purchased land and a house on the edge of the Fontainebleau forest, and it was in Bonheur's studio that the Empress Eugénie personally bestowed the honour. Legend has it that, pinning the Legion of Honour on Bonheur's jacket, the Empress remarked, 'genius had no sex'.[27] As of 1870, Bonheur was one of only five women to have their work enter the Musée du Luxembourg, the government's museum of contemporary art and the well-understood 'entrance room' to the Louvre.[28] The recipient of numerous international honours, she was made an Officer of the Legion of Honour in 1894, the first woman, artist or otherwise, ever to receive that award.[29]

Bonheur's upbringing and socialization were vastly different from those of the normative, bourgeois female. She grew up in an artistic household, where drawing and painting were part of her natural, familial environment. Her father, Raymond Bonheur, was a teacher and painter who encouraged all of his children to pursue careers in the visual arts. He gave special support to Rosa, whom he urged to outstrip the fame of Elisabeth Vigée-Lebrun and, also, to fulfil his own unsatisfied ambitions.[30] Rejecting the social conventions of the time, he embraced the radical ideas of Henri de Saint-Simon, which viewed men and women as equals and – in theory at least – valued the accomplishments of both.

Added to the philosophical influences of the Saint-Simonian sect was the grim economic situation in which Rosa was raised: while her father went off to live among the Saint-Simonian brotherhood, her mother was left to raise and support the couple's four very young children. As Rosa said of her charming, good-looking, and idealist father: 'He loved us impulsively, but his first priority was social reform. He never sacrificed noble ideals to personal matters'.[31] Sophie Bonheur died in 1833, at the age of 36, ground down by poverty and exhaustion, and the discrepancy between her parents' lives, and between the theory and practice of utopian belief, was not lost on their oldest child. Rosa loved and revered her mother – 'Poor mother! Such a saintly woman. I adored her and she died in wretched poverty'[32] – while of Raymond's relation to her mother she said that '[m]y father only knew how to make her sad'.[33] After her mother's death, Rosa (aged 11) was apprenticed to a dressmaker so that she could acquire a trade to support her younger siblings. She loathed learning how to sew, and after a brief and unsuccessful stint at a boarding school, she was educated by her father and taught to paint landscapes and animal subjects.

In Bonheur's case, then, conventional ideas of gender – and the social isolation and temperamental passivity of the 'feminine' ideal – were alien

concepts, and to some degree bourgeois luxuries, unknown to her in youth and adolescence. Raised to consider men and women as equals, she was forced to earn a living at an early age, and she knew at close range the crushing penalties to a woman's lack of power, both within the Saint-Simonian brotherhood and in a broader, more conventional world. As she remarked later in life, when she had explored the philosophy that her father had espoused: 'I understood what was noble about my father, but also my poor mother's anguish and pain, and I relived a moving drama whose ups and downs have had an incredible influence on my life.'[34] In view of the turbulence of her early life, it is not surprising that she rejected the idea of marriage and sought other alternatives to it:

… when a girl dons a crown of orange blossoms, she becomes subordinate, nothing but a pale reflection of what she was before. She's forever the leader's companion, not his equal, but his helpmate. No matter how worthy she is, she'll remain in obscurity.

My mother's wordless devotion reminds me that it's men's nature to speak their minds without worrying about what that may do to their mates.

Sure there are some fine husbands who are eager to make their wives' qualities stand out. … Yet I've never dared go stand before the mayor with a man.[35]

When Bonheur was 14, she formed a friendship with Nathalie Micas, who had come to the Bonheurs' to have her portrait painted. Bonheur soon settled into the Micas household – 'Life with my father was a mix of tragedy and farce'[36] – and became, as they all called her, Mme Micas' second daughter. From then on, the three women lived together, Nathalie's mother running the household and Nathalie working as Bonheur's studio assistant and amanuensis. In later years, Bonheur expressed repeatedly the important role that the relationship with the Micas family had had upon the direction of her life. Describing Nathalie as 'my childhood companion' who 'witnessed my trials and tribulations [and] shared my joys and sorrows', Bonheur exclaimed:

What would my life have been without her love and devotion! Yet people tried to give our love a bad name. They were flabbergasted that we pooled our money and left our earthly goods to each other.

Had I been a man, I would have married her, and nobody could have dreamed up all those silly stories. I would have had a family, with my children as heirs, and nobody would have had any right to complain.[37]

Living first in Paris and then at the Château of By, the women insulated themselves from the dominantly masculine society, forming an alternative social unit, a sisterhood and matriarchy, as female in its orientation as the society around them was male. Within this 'Domain of Perfect Affection',[38] the women could escape many of the gender constrictions around them, acting and dressing as they wished and creating an environment from which men were largely absent.[39] A strong feminist, Bonheur kept her hair cut

short, chain-smoked throughout her life (see Figure 8.6), and often wore what was considered to be masculine clothing: loose-fitting trousers and a loose fitting smock.[40] This was the attire that was most comfortable for work – 'Women's clothes', she said, 'were quite simply always in the way'[41] – and there were times when it proved useful beyond the boundaries of the studio. When she was young, men's clothing permitted her to travel widely without calling attention to her defiance of the gender norms; and in later life, when she had become famous, her trousers and short hair often protected her privacy. As she commented: 'Trousers have been my great protectors'.[42]

Bonheur's and Micas' sisterhood lasted until Nathalie's death in 1889, and in the last years of Bonheur's life, it was the American painter Anna Klumpke who sustained Bonheur's affections and who wrote the artist's official biography.[43] In inviting Klumpke to live at the Château de By, Bonheur held out the promise of a similarly familial relationship: 'I'm very fond of you, Anna, and this old friend of yours will be mother and sister to you'.[44] Bonheur delighted in the idea of a female biographer, remarking that 'I could never tell anyone of the male sex how the pieces of my life fit together'.[45] Though she had had good biographers before, she explained that 'When they asked me questions, I was always totally sincere. Yet I could never forget that I was talking to a man.'[46] Also, all of these biographies seem to have given her female relationships short shrift, and Bonheur felt that they neglected to give Nathalie any real voice and, worse yet, that they had ignored Bonheur's devotion to her 'poor dear mother's memory'.[47]

At the end of her life, Bonheur served as an honourary officer in the Society of Women Painters and Sculptors, an organization formed in 1881 to bring women artists together and further the exhibition of their works.[48] However, though Bonheur had earlier run a drawing school for young women, though she referred to her fellow female artists as 'sisters of the palette' and 'sisters of the brush',[49] and though she herself had become a role model for nascent women artists,[50] she was not in favour of professional organizations that would set women apart from men. As Klumpke wrote, Bonheur 'wanted an end to the practice of relegating women, in any domain where their intelligence or talent made them men's equals, to an inferior rank by the mere fact of sex'.[51] But she believed that 'there's no reason for them to form groups that shut men out. They'd do better to seize every opportunity to show that we women can be as good as men and sometimes even better.'[52]

Scene 2: sisterhood as image

Berthe Morisot's early life was relatively conventional, but it, too, showed the influence of liberal gender attitudes.[53] Born into a family of the upper-

middle class, Morisot enjoyed the privilege of private training in the visual arts. At her mother's instigation, Berthe and her sister Edma studied first with Geoffrey Alphonse Chocarne and then with Joseph-Benoît Guichard, the latter of whom recognized the girls' talent and took their education seriously.[54] Informally they worked with the naturalist landscape painter Camille Corot and followed the time-honoured practice of copying master-works in the Louvre.

Though the Morisot family was in many ways traditionally bourgeois, the girls' parents – Edmé Tiburce and Marie-Josephine Cornélie Morisot – provided their daughters with substantial moral and financial support. In the late 1850s it was their mother who chaperoned their sessions in the Louvre, she being the one who had arranged art classes for them, and in the mid-1860s it was their father who had a studio constructed for them in the garden of the family's home. Though the young women were relatively isolated in their study of the arts, their parents held regular Tuesday *soirées*, which brought an interesting mix of art-world figures into the Morisot household.

The Morisot sisters began to exhibit at the Salon in 1864, and they submitted further works all through the 1860s. In these years, their mother took an active role in their careers, as if through her daughters' success she might live out ambitions of her own. The family were avid letter-writers, and clear indications of her encouragement – and pressure – punctuate their corres-pondence. In 1867 we find Marie Cornélie describing to her daughters how she had just cleaned the 'great mess' in their studio, and it is clear from her remarks that she highly valued their work: 'It breaks my heart to see all the works of each season thrown into corners; some of them bring back to me impressions of the moments when you were doing them – all your efforts, your labours, a part of yourselves.'[55] That same summer, she wrote and urged them to keep painting, advice that she seems to have given quite frequently. After telling them – especially Edma – that they should take advantage of whatever scenes were available for their painting: 'The true science of life, in little as well as in great things, consists always in removing difficulties, in facilitating things, in adjusting yourself to them rather than in trying to make them adjust to you' – she seems to have realized how hard she had pushed: 'I know that you are shrugging your shoulders, and I can see Berthe's sneering and annoyed expression as she says to me: "Why don't you take [up] the brush yourself?".'[56] Eager for her daughters' success, she openly worried about what she saw as Berthe's lack of seriousness and lack of determination: 'She's always sure she could do such wonderful things in any place where she is not at the moment, and hardly ever makes an effort to use the resources at hand. ... Manet himself, even while heaping compliments on her, said: "Mlle B. has not wanted to do anything up to now [c. 1871]. She

has not really tried; when she wants to, she will succeed."'[57] At the same time, Marie Cornélie was quick to criticize those who did not take her daughters' work seriously, and throughout her life she followed their exhibitions avidly and wrote with interest and insight about how the works were installed and what the reactions to them were.

In addition to the encouragement from her mother, Morisot had a strong ally in her older sister Edma, the two young women shoring each other up through the years of studying, copying in the Louvre, and sending to the Salon. Given that the professional networks were closed to women artists in these years, and given that gender and class combined to keep the Morisot sisters apart from the studio groups and café life that were important features in the education of young males, the importance of such a close colleague – Morisot's 'working companion'[58] and 'the major relationship in her early life'[59] – cannot be underestimated. As I suggested at the beginning of this essay, female bonding seems to be a much-overlooked phenomenon in the development of serious women artists, and although male teachers and colleagues certainly provided encouragement and support, the presence of women allies could go a long way toward countering the gender prejudices of the period.

When Edma married in 1869, and gave up painting for the roles of wife and mother, both sisters very deeply felt the loss. They remained close and continued to support one another, however different their life choices had been. Several months after her marriage, Edma wrote to Berthe: 'I am often with you, my dear Berthe. In my thoughts I follow you about in your studio, and wish I could escape, were it only for a quarter of an hour, to breathe that air in which we lived for so many years.'[60] When Edma suspected that she was pregnant, Berthe sent her a letter full of encouragement – 'Adolphe [Edma's husband] would certainly be surprised to hear me talking in this way' – and went on to comment about her own feelings toward marriage: 'Men incline to believe that they fill all of one's life, but as for me, I think that no matter how much affection a woman has for her husband, it is not easy for her to break with a life of work.'[61] In Edma's case, Berthe thought that motherhood would fill the gap.

Once Edma stopped painting, she became her sister's favourite model, and a long series of images united the sisters as artist and subject, thus keeping them allied in painterly endeavours. In *Reading* (Figure 8.7), one of the most complex of these portrayals, Berthe depicted her sister and their mother, in an eloquent marking of the changes in their lives. Now in the last phase of pregnancy, Edma had returned home for her confinement, that period of transgenerational, female-centred nurturing that preceded the birth of a child. In this portrait, Marie Cornélie sits with a book in her hands – a large, solid figure, very much the sisters' bulwark – while Edma stares

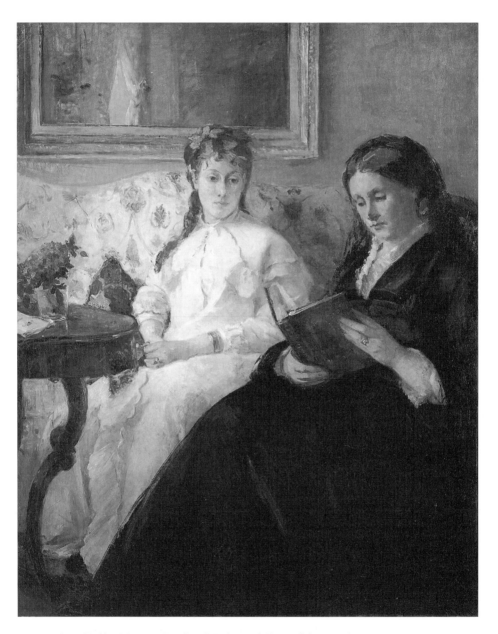

8.7 Berthe Morisot, *Reading (Mother and Sister of the Artist)*, 1869–70

downward in an attitude of precarious introspection. An intimate depiction of the enclosed world of mothers, daughters, and sisters, Morisot's image also represents the extremely rare case when a woman's pregnancy enters

into a work of visual art.[62] Also striking in this image is the way in which Berthe, an unmarried painter in her late twenties, depicted her sister, a woman now married and pregnant and without a career, and thus created a profound evocation of the existential dichotomy that governed so many women's lives.[63]

In fact, most of Morisot's art depicts an all-female world, in which women exist outside the aegis of men. In gardens or parlours or boudoirs, women sit or recline, read, sew or arrange their toilette; they amuse children, play instruments, or gather fruit or flowers in the sun. Sentient beings, these women possess a quietude and often solemnity that suggests the existence of a deeply flowing interior, cerebral life. In many of these images, as I have noted above, Edma served as Berthe's model, and their alliance in the art of sisterhood continued until Berthe's marriage at the end of 1874. In *Young Woman at Her Window (The Artist's Sister at a Window)* (Figure 8.8), dating to the same period as *Reading*, Edma sits thoughtfully in an armchair, isolated from the out-of-doors and contemplating the type of fan that had become a fashionable signifier of femininity. Among the other paintings for which Edma posed are *The Harbor at Lorient* (1869, National Gallery of Art, Washington, D.C.), *At the Edge of the Forest* (1871, Collection of Mr. and Mrs. Paul Mellon, Upperville, Virginia), *Mme Pontillon and Her Daughter, Jeanne* (1871, National Gallery of Art, Washington, D.C.), *Portrait of Mme E. P. [Edma Pontillon]* (1871, Cabinet des dessins, Musée du Louvre, Paris), *Woman and a Child in a Meadow* (1871, Gallery Hopkins and Thomas, Paris), *The Cradle* (1872, Musée d'Orsay, Paris), *Young Woman on a Bench* (1872, National Gallery of Art, Washington, D.C.), *Hide and Seek* (1873, Collection of Mrs. John Hay Whitney), *Reading* (1873, Cleveland Museum of Art), *The Butterfly Hunt* (1874, Musée d'Orsay, Paris), and *On the Grass* (1874, Musée du Petit Palais, Paris).[64]

Throughout her life, Morisot also formed close relationships with other women artists and placed a great premium on them. In the early years, one of her favourite friends was Adèle d'Affry (Duchess of Castiglione, Colonna), a sculptor who exhibited at the Salon under the pseudonym 'Marcello'. It was about Adèle d'Affry that Morisot remarked on the prime importance of friendships with women: citing a notebook by Morisot (now in a private collection), Charles Stuckey has observed that '[a]ccording to Morisot, the only true friendship a woman could have was with another woman, and none in her life equaled that with the Duchess of Colonna'.[65] When Adèle d'Affry died in 1879, Morisot was inconsolable, and though she found another female colleague in Mary Cassatt, their friendship seems to have lacked a similar spark.[66]

Morisot's professional reputation was secured when she joined the group that became known as 'the Impressionists'. In brief, all through the 1860s, attempts had been made to form alternative associations that would

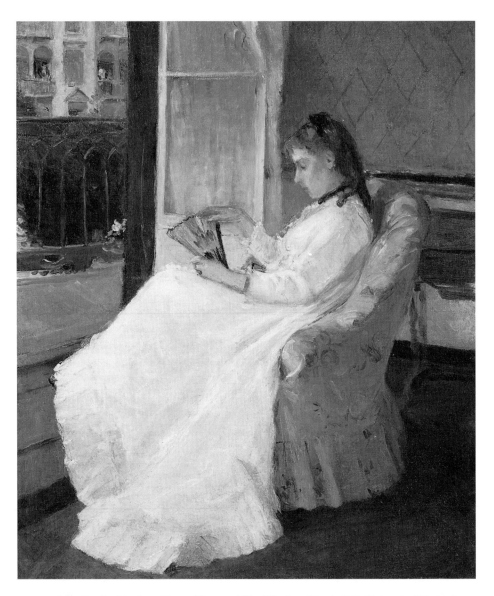

8.8 Berthe Morisot, *Young Woman at Her Window (The Artist's Sister at a Window)*, 1870

counterbalance the weight and power of the country's official organizations.[67] As the number of works sent to the Salon had increased, women artists were not the only ones who found difficulty working within the system, and many male artists, too, found that their works were devalued or ignored.

Modernist painters encountered special resistance, since their works clearly defied the Academy's standards, and in their stimulating embrace of contemporary life, and their disregard for the shared conventions on which so much acceptable art was based, these artists challenged the hegemony of an increasingly threatened cultural elite.[68] In a certain sense, the rejection of Modernist paintings from the Salon brought male and female artists together, both being relegated to the margins and in this case the difference of gender being overwhelmed by their distance from the establishment's centre.

When the group around Claude Monet, Camille Pissarro, and Edgar Degas formed the 'Société anonyme des artistes peintres, sculpteurs, graveurs, etc.' and held their first exhibition in 1874, they included works by two women – Morisot and Marie Bracquemond. Exceptionally liberal in the prominence and support they gave to their female colleagues, the Impressionists thus defied the notions of brotherhood on which so much of the art establishment was based. In later years, the group held seven further exhibitions, and Morisot participated in all but one of these shows. Though the *Figaro*'s art critic, Albert Wolff, could exclaim in horror that the group comprised 'five or six lunatics – among them a woman!'[69] – thus citing her gender as the epitome of a world gone mad – Morisot was one of the rare nineteenth-century women who seems to have circumvented the gender chasm of the times. While establishing and maintaining a serious career as a painter, she managed to integrate her professional and domestic lives, marrying in 1874 and giving birth to a daughter, Julie, in 1879. The man she chose to marry was Eugène Manet, brother of Edouard, and an exceptionally enlightened supporter of her career.

Scene 3: women apart from men

Mary Cassatt grew up in a well-to-do family in Pennsylvania. In her case, too, an economically privileged background provided access to training in the arts. In her early years, she studied at the Pennsylvania Academy of Fine Arts, in Philadelphia, which accepted female pupils and exhibited works by such women as Rosa Bonheur.[70] In the mid-1860s, feeling that she had outgrown the training and stimulation she could receive in the United States, Cassatt studied in France, working privately with a succession of painters who included Charles Chaplin, Jean-Léon Gérôme, and Thomas Couture.

Cassatt's parents, too, recognized her talent and supported it, despite the often-repeated comment that her father is supposed to have made – that he would rather see his daughter dead than see her become an artist.[71] Katherine Kelso Cassatt (Figure 8.9) encouraged her daughter's career from its earliest years, as is indicated in a letter from Cassatt to her friend and fellow art-

8.9 Mary Cassatt, *Portrait of a Lady*, 1878

student Eliza Haldeman; written when Cassatt was 19, the letter urged Eliza to come for a visit, with the remark that 'Mother thinks that it is likely your mother don't take as much interest in our pictures as we do and wishes you

would come here instead of my going to you.'[72] When Cassatt sailed to Paris in 1865, her mother went along to settle her in, and in later years her mother returned to Europe and the two women travelled together – to Rome in 1869, and to The Hague and Antwerp in 1873. After Cassatt settled permanently in Paris (1875), her parents joined her and remained in France until the end of their lives.

Despite the wealth and prominence of Cassatt's parents, they seem never to have desired a conventional, bourgeois life. Distancing themselves from their compatriots, they travelled constantly and always considered Europe as the most desirable place to live. By the time she was 11, Cassatt had spent four years in Europe, living in Paris, Heidelberg, and Darmstadt and becoming fluent in French and German.[73] Atypical and nomadic as her parents were, they encouraged their daughter's travel and placed few restrictions on her mobility. On her trip to Paris to study in 1865, she remained there for four years, and accompanied by her friend and fellow-art student Eliza Haldeman, she toured throughout France.[74] In the early 1870s she returned to Europe with another friend and artist, Emily Sartain; this time she settled in Italy, after which she took off for Spain, where she spent six months on her own. During her trips, she stayed in hotels or boarding houses, and through the friends she made along the way, she rented studios in which she could work. By the early 1870s she had realized that she need not even travel on first-class trains, but could go via second class in Spain and third class in France.[75]

Also unusual was the fact that Cassatt's parents insisted that she earn her living from her art and pressurized her to do so. Although upper-middle-class women often received a smattering of training in the fine arts, to enhance their lives as wives and mothers, they were usually discouraged from becoming too serious, much less earning a living from their work. Eliza Haldeman's father was typical in this regard, and in a letter to his daughter he expressed his dim view of her future career: 'You will get married and settle down into a good housekeeper like all married women & send off your paints to the garret! There is a prediction for you, and one founded upon almost universal experience.'[76] By contrast, Cassatt's parents encouraged and pushed their daughter, and as Mathews has written 'they were not inclined to indulge Mary's art as a pleasant hobby or a respectable feminine "accomplishment".'[77] Clear evidence of her parents' concerns come through in her father's letters, this one written in 1878:

Mame [his nickname for Mary], is working away as diligently as ever, but she has not sold anything lately & her studio expenses with models from 1 to 2 francs an hour! are heavy. Moreover I have said that the studio must at least support itself. This makes Mame very uneasy, as she must either make sale of the pictures she has on hand or else take to *pot boilers* as the artists say – a thing she never yet has done & and cannot bear the idea of being obliged to do.[78]

8.10 Mary Cassatt, *In the Garden (Lydia crocheting in the Garden)*, 1880

Her father continued the pressure, even after Cassatt's success at the Impressionist exhibition in 1879: '[E]veryone says now that in (the) future it don't matter what the papers say about her – She is now known to the Art world as well as to the general public in such a way as not to be forgotten again *so long as she continues to paint*!!' (my italics, her father's exclamation marks).[79] In Cassatt's case, her parents were concerned not that she took painting too seriously, but rather that she would not take it seriously enough.

Though Cassatt greatly disliked the United States, she seems to have been very much marked by the attitudes of the country of her birth. In terms of the customs of the nineteenth century, American women were more emancipated than women in France (though women of neither culture enjoyed such civil liberties as the right to vote); they had greater access to education and a greater freedom to move about. In her conversations with Klumpke, Bonheur praised the liberties available to American women, and in her estimation if 'Americans march at the forefront of modern civilization' it was 'because of the wonderfully intelligent way they rear their daughters and respect their wives'.[80] That Cassatt could travel so freely seems to partake of the American pioneer spirit, while the idea that she should support herself from her work

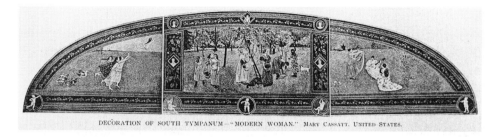

DECORATION OF SOUTH TYMPANUM—"MODERN WOMAN." MARY CASSATT. UNITED STATES.

8.11 Mary Cassatt, *Modern Woman*

seems rooted in American pragmatism and practicality. As a foreigner abroad, she was always something of an anomaly, her outsider status freeing her further from social constraints.

Cassatt settled permanently in France in 1875; several months later her sister, Lydia, joined her, and by 1877 the elder Cassatts had come to France for good. Whereas Eliza Haldeman and Emily Sartain had been Cassatt's companions and allies in earlier years, it was now Lydia to whom Cassatt most often turned. As had been the case with Edma and Berthe Morisot, Lydia now became one of her sister's favourite sitters, and until her death in 1882 she served as the model for numerous depictions of a modern woman's life. In *The Garden* (Figure 8.10), one of the paintings with which Lydia has traditionally been associated, Cassatt has placed her sister in the foreground, within a floral, plein-air environment that is both intimate and disturbing in the disposition of its space. Other works for which Cassatt used her sister as a model include *Reading* (1878, Joslyn Art Museum, Omaha), *Autumn* (1880, Musée du Petit Palais, Paris), *Lydia Seated in the Garden with a Dog in Her Lap* (c. 1880, Private Collection), *Tea* (1880–1881, Metropolitan Museum of Art, New York), *Lydia Seated at an Embroidery Frame* (1880–1881, Flint Institute of Arts, Flint, Michigan), *Driving* (1881, Philadelphia Museum of Art), and *Lydia Seated on a Terrace Crocheting* (1881, Collection Mr. and Mrs. Charles Hermanowski).[81]

Also like Morisot, Cassatt joined the Impressionist group, her affiliation with them becoming especially important after her work was rejected by the Salon. Though Edgar Degas is purported to have said, 'No woman has the right to draw like that',[82] he brought her into the group, which had a great influence on her turning toward genre subjects. For the rest of her life, she specialized in female themes and in paintings that suggested the quiet moments in the quotidian rhythms of a middle-class woman's life.

Cassatt's mural of *Modern Woman* (Figures 8.11 and 8.12), painted for the Woman's Building at the World's Columbian Exposition in Chicago (1893), encapsulates her ideas about the place of women in modern society and

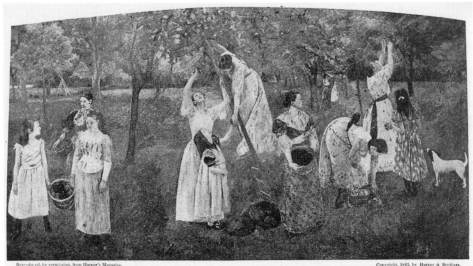

Reproduced, by permission, from Harper's Magazine. Copyright, 1893, by Harper & Brothers.

MODERN WOMAN (SECTION OF TYMPANUM). BY MARY CASSATT.

8.12 Mary Cassatt, detail from *Modern Woman*

illustrates many of the ideas argued in the present essay.[83] Tripartite in its composition, the mural depicts an exclusively female world, a sisterhood of women of various ages, who are shown in the out-of-doors. In the central panel, women and young girls are 'plucking the fruits of knowledge or science &', as Cassatt expressed the subject in a letter to Bertha Palmer, one of the organizer's of the women's pavilion.[84] On the left a trio of young girls pursues a figure of fame, while a gaggle of geese snaps at their heels. This group is visually balanced by another trio on the right-hand side, which is composed of older women – one dancing, another playing the banjo, and a third turning to observe them both.[85]

As an allegory of modern women, Cassatt's mural suggests the conditions under which they might succeed and flourish in their artistic and intellectual pursuits. First they must survive childhood with integrity and ambition intact and, ignoring those 'geese' who might snipe, reach upward and outward, aspiring toward the highest goals. Then, they must acquire the knowledge – the training, the education, the skills – that will enable them to prevail. In Cassatt's view, this would take place in a supportive and nurturing environment created by an extended female community. And finally, women need a space apart, where they can exist in tranquillity and put into practice the knowledge they have absorbed, whether it be music, dance, science, or the visual arts (the latter, it can be inferred, being signified by the mural itself).[86]

In other words, as opposed to the notions of self-effacement, ignorance, and inactivity in which middle-class females were stereotypically raised, the women in Cassatt's mural signify the aspirations, knowledge, and freedom to practice that would be available to women in an ideal modern society. And if her mural suggests an alternative to the buddy-systems of the late nineteenth century, it is that strength is to be found in sisterly alliances, in the formation of female relationships that nurture, inspire, and support.[87] Anticipating the uneasiness that her radical social ideas would provoke, Cassatt commented in the same letter to Palmer: 'An American friend asked me in rather a huffy tone the other day "Then this is woman apart from her relations to man!" I told him it was'.[88]

Finale: 'Our Rosa'

Carolyn Heilbrun once wrote that power is the ability to participate in whatever discourse one choosèÉ and to have one's participation count.[89] As the careers of all three of these artists indicate, their relationships with other women – their mothers, their sisters, their female friends – helped to nurture and develop their talent and to withstand the discrimination that was part of the century's naturalized belief. In their efforts to make their careers count, each of these artists created a slightly different solution to the problems posed by the brotherhoods, and whether they painted sisterhood or designed their lives according to radical feminist principles, all three of them drew heavily upon the power conferred by close female alliances. Having opened this essay with a musical reference to 'The Brotherhood of Man', I want to end with George Bizet's rousing *hommage* to Rosa Bonheur, composed in 1867 after she had received the red ribbon of the Legion of Honour:

> Our Rosa, never having been a coquette,
> With neither flowers nor ribbons concerned,
> The Empress wished, that for her toilette,
> She'd have the most brilliant one earned.

> When the honour, that noble recompense
> Made the gentle name of Bonheur illustrious:
> One could sign it with great confidence
> Because the ribbon wasn't gratuitous!

> Chorus: One could sign it with great confidence
> Because the ribbon wasn't gratuitous![90]

Notes

Kudos and thanks go to Laura Morowitz and William Vaughan for assembling this volume and keeping it on schedule; to Stephen Edidin and David Farmer (Dahesh Museum, New York) for bringing the recent exhibition of Bonheur's works to New York; to Sally Webster for her conversations about Mary Cassatt; to Valerie Mendelson Moylan for her assistance in obtaining photograph; and to Dan Favata for his careful proofreading. This essay is dedicated to my husband, Bill Griesar, my daughter, Katherine Roos, and my sisters, Susan Mayo Cornell, Trish Hargrave, Debbie Lazarus.

In using the word 'girls' in the title, I realize of course that the term has a demeaning connotation that is only too typical of a rhetoric of diminishment. However, given the context described in this essay, and given the significance of girlhood and the attention paid to it here, the term seemed both relevant and appropriate. Also animating this usage is the fact that by the end of the nineteenth century, Bonheur had come to represent a role model for young girls, as seen in such essays on her life as the one by Sarah K. Bolton, published in *Lives of Girls Who Became Famous* (New York: Thomas Y. Crowell, 1886), pp. 180–93.

1. See Roland Barthes, 'Myth Today', in *Mythologies*, trans. Annette Lavers (New York: Noonday Press, 1972), esp. pp. 129–30.

2. For a sociological analysis of the art world in France in this period, see Harrison C. White and Cynthia A. White, *Canvases and Careers: Institutional Change in the French Painting World* (Chicago: University of Chicago Press, 1993); first published 1965.

3. Linda Nochlin, 'Why Have There Been No Great Women Artists?' in *Women, Art, and Power and Other Essays* (New York: Harper & Row, 1988); originally published 1971.

4. Quoted in Charles F. Stuckey, William P. Scott, and Suzanne G. Lindsay, *Berthe Morisot, Impressionist*, exh. cat. (New York: Hudson Hills Press, 1987), n. 40, p. 178. The source for the remark is a notebook kept by Morisot and now in a private collection.

5. This analysis of the institutions and institutional practices of the period has been adapted from the present author's *Early Impressionism and the French State* (New York: Cambridge University Press, 1996), which includes a bibliography of many relevant primary and secondary sources. On the Ecole and the Atelier, see Chapter 7 in this volume.

6. Usually held annually in the nineteenth century, the Salon was biennial between 1857 and 1863.

7. The Academy of Fine Arts, a division of the Institut de France, comprised 14 painters, eight sculptors, eight architects, four engravers, six musicians and 10 'free' members (the latter usually arts' writers or curators). The classic history of the Academy is Henri Delaborde, *L'Académie des beaux-arts depuis la fondation de l'Institut de France* (Paris: Plon, 1891).

8 In their sociological study of painters in nineteenth-century France, White and White stated flatly that from the statistics '[i]t seemed clear that women were not accepted as professional painters' (1993, p. 51).

9. That the rules for the Prix de Rome stated not only that the candidates be male and under 30, but also that they be unmarried, barred women completely from staying at the Villa de Medici.

10. It was Rosa Bonheur who was the first woman artist named to the Legion of Honour and the first woman – ever – to reach the grade of Officer (see below); and it was Mme Léon Bertaux (born Hélène Pilate) who was the first woman elected to a Salon jury (see Tamar Garb, *Sisters of the Brush: Women's Artistic Culture in Late Nineteenth-Century France* (New Haven and London: Yale University Press, 1994), p. 32). It should be noted that women had belonged to the version of the Academy that existed before the revolution of 1789.

11. Report to the head of the division of fine arts, 20 October 1869; Archives Nationales, F^{21} 531.

12. On the idea that the threat women artists posed was economic, see Léon Lagrange 'Du rang des femmes', *Gazette des beaux-arts*, ser. 1, vol. 8 (October 1860): p. 39. Here, he argued that women should be allowed to practice as artists, but that 'male genius had nothing to fear from female taste' because women's talents equipped them only to work in minor fields.

13. Vaillant's full and official title was Ministre de la Maison de l'Empereur et des beaux arts (Minister of the Imperial House and of the Fine Arts).

14. Vaillant, speech at the Distribution des récompenses, extract from *Le Moniteur du soir*, 7 July 1864; reprinted in the catalogue for the Salon of 1865 (*Explication des ouvrages de peinture, sculpture, gravure, lithographie et architecture des artistes vivants* [Paris: Charles de Mourgues, 1865]), p. viii.

15. Several years later, Emile Zola would attack the arts establishment as having 'become a priesthood and a joke' and would interpret this situation as one of the root causes of the mediocrity of the Salon. His censuring of the idea of art as a sacred pursuit make clear how pervasive this type of rhetorical construction was (Emile Zola, 'Mon Salon', *L'Événement illustré*, 2 May 1868; reprinted in *Ecrits sur l'art*, ed. Jean-Pierre Leduc-Adine (Paris: Gallimard, 1991), p. 195).

16. Geneviève Bréton, *'In the Solitude of My Soul': The Diary of Geneviève Bréton (1867–1871)*, ed. James Smith Allen, trans. James Palmes (Carbondale, Illinois: Southern Illinois Press, 1994); diary entry for 12 December 1868, p. 63. I thank Caterina Pierre for bringing Bréton's diary to my attention.

17. Even at the end of the nineteenth century, when the Ecole des Beaux-Arts finally began to admit women on a restricted basis, there were men in power who railed against the immorality of a woman's viewing the male nude. As late as 1901, the painter and Academic Jean-Léon Gérôme expressed his views as follows: 'I have thought about this question of the nude model for men and for women … [at] the Ecole, and it seems impossible to me, *utterly impossible* [underlined in the original] that young women are to be placed in promiscuity with men, in front of the nude model. Were we to fall into a state of barbarity…that could be done, but in the state we are in now, no'. That the difficulty was especially pronounced when women looked at *men's* bodies is conveyed in his next sentence: 'Thus, I propose two solutions: the first is to place a pair of shorts on the male models …; the second is to use female models'. Gérôme's comment makes plain that the exclusionary policies governing the arts issued from deeply ingrained social attitudes, as Bréton's comment also stunningly reveals. See Marina Sauer, *L'Entrée des femmes à l'École des Beaux-Arts, 1880–1923* (Paris: École nationale supérieure des Beaux-Arts, 1990).

18. On Rosa Bonheur's life and career, see Dore Ashton, *Rosa Bonheur: A Life and Legend* (New York: Viking, 1981); Anna Klumpke, *Rosa Bonheur*, trans. Gretchen van Slyke (Ann Arbor: University of Michigan Press, 1997), originally published in 1908 and which includes an excellent bibliography; Francis Ribemont, ed. *Rosa Bonheur (1822–1899)*, exh. cat. (Bordeaux: Musée des Beaux-Arts de Bordeaux/William Blake 1997), also containing an extensive bibliography; and *Rosa Bonheur: All Nature's Children*, exh. cat. (New York: Dahesh Museum, 1998).

19. That her 'recent triumphs at the Salon' had played a role in her selection as the director and that she gave up the position because it took too much time from her painting are expressed in Klumpke 1997, p.146. On the history of the school, see Charlotte Yeldham, *Women Artists in Nineteenth-Century France and England* (New York: Garland, 1984), vol. I, pp. 40–48; and Garb 1994, pp. 76–78.

20. Quoted (in English) in *Little Journeys to the Homes of Famous Women* (New York: G. P. Putnam's Sons, 1897), p. 174.

21. For Bizet's song, see the conclusion of this chapter.

22. Thoré (1847), quoted in Ashton 1981, p. 51.

23. On the issue of women and spatial command, see Griselda Pollock, 'Modernity and the Spaces of Femininity', in *Vision and Difference: Femininity, Feminism and Histories of Art* (London and New York: Routledge, 1988): pp. 50–90.

24. As early as 1865, the art critic Arsène Houssaye had written about Bonheur's decision to become an *animalier*, and he had described it as a resolution to the problems – actual and metaphoric – that an ambitious artist faced when she wore 'female dress':

 From the moment she put her foot in the Louvre, do you know who her masters were? You believe perhaps that she went right to the Flemish naturalists? Not at all. She meditated in front of the severe masters of the French school, Poussin, Le Sueur, Claude Lorrain. That is why in her great paintings there is something magisterial, because great art has always dominated her soul, even when nature spoke to her face to face with all the eloquence of Truth. She began by dreaming of the grandeurs of Antiquity and the solemnities of History; but she was soon horrified by the abysses she would have to cross in her female dress.
 What to do? What would be the sacred road to art for the young woman? Along what route would she not encounter prejudice and hostility? She dreamt, she remembered, [and she took the Flemish painters Ruysdael and Paulus Potter for her guides] … . If nature is the master of the masters, one could say that Mlle Rosa Bonheur took nature for her studio. No one has understood more intimately, more profoundly, more poetically, the primal works of God: the tree, the prairie, and the beast. ('Le Chevalier Rosa Bonheur', *L'Artiste*, 15 June 1865: p. 270.)

 James Saslow has made a similar argument in his important and compelling analysis of Bonheur's art: that there was a significant benefit to her turning to paintings in which animals assumed great importance, in that this kind of art allowed her to sidestep the difficulties, and the more disturbing sexual coding, that depictions of the human form entailed. See Saslow, '"Disagreeably Hidden": Construction and Constriction of the Lesbian Body in Rosa Bonheur's

Horse Fair', in Norma Broude and Mary D. Garrard, ed. *The Expanding Discourse: Feminism and Art History* (New York: HarperCollins, 1992): pp. 187–205.

25. After her gold medal in 1848, the government commissioned the painting that became *Ploughing in the Nivernais* for the sum of 3,000 francs (at a time when 10,000 francs a year was considered to be a respectable, solidly middle-class income). *The Horse Fair*, her largest and probably best known work, was purchased by the entrepreneurial dealer Ernest Gambart, who paid Bonheur the then-enormous sum of 40,000 francs. He sent the painting on a highly successful international tour, and Bonheur then painted a reduced copy of the work and sold it for another 25,000 francs.

26. This was Eugène de Mirecourt's *Les Contemporains: Rosa Bonheur* (Paris: Havard, 1856).

27. See Klumpke 1997, pp. 172–73. An interesting historical gloss on the event is that the Empress made the award during a time when her husband was away – on a diplomatic mission to Algeria – and when she ruled as Regent in his absence. A supporter of women's achievement, the Empress apparently took advantage of her husband's absence to give one of France's pre-eminent painters the recognition she thought Bonheur deserved.

28. The other works by women honoured in the Musée du Luxembourg included a portrait by Louise Desnos, a miniature by Jeanne-Mathilde Herbelin, a still life of chrysanthemums by Eléonore Escallier, and a sculpture by Adèle d'Affry. As of 1870, the Luxembourg also included works by 239 male artists. See Philippe de Chennevières, *Notice des peintures, sculptures et dessins de l'école moderne exposés dans les galeries du Musée national du Luxembourg* (Paris: Charles de Mourgues, 1873).

29. For a list of her international awards, see Klumpke 1997, p. 196.

30. Ibid., pp. 109–112.

31. Ibid., p. 94.

32. Ibid., p. 64. Similar comments run throughout Bonheur's letters and conversations with Klumpke: 'I still have a loving heart, as did my adored mother whom I lost at age eleven' (ibid., p. 54); 'not a single biography about me even mentions how devoted I am to my poor mother's memory. In my eyes, that's the worst fault of all' (ibid., p. 67); 'I've never stopped thinking about her. Everything good and beautiful that I've done during my seventy-six years on this earth has been her inspiration' (ibid., p. 83); 'How often, in difficult moments, I've her protection! Oh! Yes, she'd been my guardian angel, the saint to whom I've raised my prayers and invocations' (p. 115).

33. Ibid., p. 55.

34. Ibid., p. 94.

35. Ibid., p. 206.

36. Ibid., p. 113.

37. Ibid., pp. 232–33.

38. Ibid., p. 234.

39. That they did not escape prejudice entirely is indicated by Bonheur's remark that '[m]ost people take a pretty dim view of women who live together … . I've been battling that prejudice all my life' (ibid., p. 72). In 1857 the Goncourt brothers, social snobs and sneering critics of anyone and anything not to their tastes, had encountered Bonheur at a dinner with mutual friends. She had, they wrote, 'the head of a little, Polish, hunchbacked Jew' (the epithet being phrased in the masculine gender). They went on to note that she was 'flanked by her eternal friend Nathalie, who has the head of a worn-out [and foolish old clown]'. See Edmond and Jules Goncourt, *Journal: Mémoires d'une vie littéraire*, vol. I (Paris: Robert Laffont, 1989), p. 241.

40. The gender-coding of clothes during the period was such that Bonheur had to obtain from the police a permit for 'transvestitism' in order to wear trousers in public. For an excellent summary of the issue, as well as a concise and useful bibliography, see van Slyke's introduction to Klumpke 1997, pp. xxx–xxxiv, and n. 10, pp. xxxvii–xxxviii.

41. Ibid., p. 204.

42. Ibid., p. 205.

43. This biography was issued in 1908 as *Rosa Bonheur: sa vie, son oeuvre*; as translated by van Slyke and published in 1997; it is the work quoted extensively in this chapter.

44. Klumpke 1994, 53.

45. Ibid., p. 67.

46. Ibid., p. 79.

47. Ibid., p. 67.

48. Ibid., pp. 239–40. On the Society, see Garb 1986; and J. Diane Radycki, 'The Life of Lady Art Students: Changing Art Education at the Turn of the Century', *Art Journal*, vol. 42, no. 1 (Spring 1982), pp. 9–13.

49. 'Sister of the brush' appears in a letter from Bonheur to Klumpke, written 5 January 1898, which bears the closing 'Goodbye, dear, sweet mademoiselle and worthy sister of the brush' (Klumpke 1994, p. 29); Bonheur used 'sisters of the palette' as a general term referring to women painters, in a conversation with Klumpke (ibid., p. 204).

50. To Bonheur's great delight, Klumpke had cited her (Bonheur's) influence at the Académie Julian: 'M. Julian … wanted to see his female students vie with the men for first prize in various competitions, … he insisted that we learn how to listen to our professors' critiques without bursting into tears … [and he urged that] we try and follow in the footsteps of our glorious predecessors, women like Mme Lebrun, Angelica Kauffmann, Rosa Bonheur' (ibid., p. 42).

51. Ibid., p. 204.

52. Ibid., p. 240.

53. On the life and career of Berthe Morisot, see Kathleen Adler and Tamar Garb, *Berthe Morisot* (London: Phaidon Press, 1995); T. J. Edelstein *Perspectives on Morisot* (New York: Hudson Hills Press, 1990); Anne Higonnet, *Berthe Morisot* (New York: Harper & Row, 1990); Denis Rouart, ed., *Berthe Morisot: The Correspondence with Her Family and Her Friends*, trans. Betty W. Hubbard, with introduction and notes by Kathleen Adler and Tamar Garb (London: Moyer Bell, 1987); and Stuckey, Scott, and Lindsay 1987.

54. Adler and Garb 1995, p. 13.

55. Rouart, ed. 1987, p. 26.

56. Ibid., p. 27.

57. Ibid., p. 83.

58. Ibid., p. 31.

59. Marni Reva Kessler, 'Reconstructing Relationships: Berthe Morisot's Edma Series', *Women's Art Journal* (Spring/Summer 1991): p. 24.

60. Ibid., p. 32.

61. Ibid., p. 34.

62. The subject of pregnancy is stunningly absent in nineteenth-century French painting. Though the woman as sex object formed a major theme in the art of the period, the results of sexuality seem a subject never to be mentioned, as if the dichotomy between woman as a sexual being and woman as mother and nurturer was hard and fast and absolute. On Morisot's images of her sister, see Kessler 1991, pp. 24–28; and Stuckey, Scott, and Lindsay 1987, passim.

63. Some of these ideas I have already expressed in Roos 1996, pp. 139–42.

64 For reproductions of these paintings, and discussions of them, see Stuckey, Scott, and Lindsay 1987, from which the foregoing information about these works has been adapted.

65. Ibid., n. 40, p. 178.

66 On Morisot's reaction to Adèle d'Affry's death, see ibid., pp. 115 and 117.

67. This is a history that the present author has followed in *Early Impressionists and the French State*.

68. See, for example, Stéphane Mallarmé's analysis of Manet's situation in relation to the conservative Salon juries; in Jane Mayo Roos (ed.), *A Painter's Poet: Stéphane Mallarmé and His Impressionist Circle*, exh. cat. (New York: The Art Galleries of Hunter College, 1999), pp. 32–44.

69. Wolff, 'Le Calendrier parisien', *Le Figaro*, 3 April 1876; reprinted in Ruth Berson, ed., *The New Painting: Impressionism 1874–1886*, vol. 1 (San Francisco: Fine Arts Museums of San Francisco, 1996), p. 110. This extremely useful volume reproduces a systematic and thorough compilation of reviews of Impressionist exhibitions.

70. On Cassatt's life and career, see Judith A. Barter et al. *Mary Cassatt: Modern Woman*, exh. cat. (Chicago: The Art Institute of Chicago, 1998), which includes an extensive bibliography; Nancy Mowll Mathews, *Mary Cassatt: A Life* (New York: Villard Books, 1994); Nancy Mowll Mathews,

ed., *Cassatt and Her Circle: Selected Letters* (New York: Abbeville Press, 1984); and Griselda Pollock, *Mary Cassatt: Painter of Modern Women* (London: Thames and Hudson, 1998). Concerning the exhibition of Bonheur's works at the Pennsylvania Academy, see Mathews 1994, p. 20.

71. The comment appeared in Achille Segard, *Mary Cassatt: Un Peintre des enfants et des mères* (Paris: Paul Ollendorf, 1913); quoted in Mathews 1994, p. 26 and n. 18, p. 337.

72. Cassatt to Eliza Haldeman (March 18 [1864]), Mathews, ed. 1984, p. 34.

73. The Cassatt family had planned to stay longer in Europe, but they left for the United States after the death of Mary's younger brother Robbie in 1855.

74. Less sanguine about her daughter's travel than the Cassatts, Haldeman's mother warned her: 'I fear that you with Miss Cassatt may venture too far, do not rely on her judgment as she has no religion to guide her and from the impulse of a moment you may rush with her into things that may injure you. So my dear child do be careful' (quoted in Mathews 1994, p. 36).

75. French trains in those years had compartments for 'dames seules', women travelling alone. Letter from Cassatt to Emily Sartain (October 13 [1872]), Mathews, ed. 1984, p. 107.

76. Samuel Haldeman to Eliza Haldeman (2 March 1863), quoted in Mathews 1994, p. 58.

77. Mathews, 1994, 73.

78. Robert Cassatt to Alexander Cassatt (13 December 1878), quoted in Mathews 1984, p. 143.

79. Robert Cassatt to Alexander Cassatt (21 May 1879), quoted in Mathews 1994, p. 117.

80. Klumpke 1997, p. 206; see also ibid., p. 94.

81. For reproductions of all of these works, see Barter, ed. 1998, from which the foregoing information about these paintings has been adapted.

82. Cassatt to Homer Saint-Gaudens, 28 December 1922, quoted in Mathews 1984, p. 335.

83. On the history of Cassatt's mural, see Carolyn Kinder Carr and Sally Webster, 'Mary Cassatt and Mary Fairchild MacMonnies: The Search for Their 1893 Murals', *American Art*, vol. 8, no. 1 (Winter 1994): pp. 53–69. Sally Webster is currently completing an in-depth monograph on the mural, tentatively entitled *Mary Cassatt's Mural of Modern Woman*.

84. Mathews, ed., 1984, p. 238.

85. A prototype for the format of Cassatt's mural, with its tripartite organization and its wide, enclosing border with large decorative rondels, is to be found in the mural programme for the Pantheon in Paris, which was inaugurated in 1874 and was still underway in the early 1890s. Though often forgotten today, the Pantheon programme was the most ambitious mural project of the early Third Republic. Begun under the conservative administration of those times, when the structure existed as the Church of Sainte-Geneviève, the programme continued when the building was secularized in 1885. That Cassatt adapted the format of her murals from this then-famous programme is logical, especially since Pierre Puvis de Chavannes' murals of the early life of Sainte-Geneviève formed part of the ensemble.

86. As to the third figure on the mural's right-hand side – the woman who sits and observes – she makes most sense within the context of the mural as less an audience for the dancer and musician, than as a representative of more contemplative, intellectual pursuits – the 'or science &' mentioned in Cassatt's letter.

87. In a letter to Eliza Haldeman, written in 1869, Cassatt gave her friend news of the Salon that year, who was accepted and who was not (Cassatt was not). All of the artists she mentioned were women, which suggests the way in which she tended to measure her own work not against that of the male artists around her, but against the work of other women.

88. Mathews, ed., 1984, p. 238.

89. Carol G. Heilbrun, *Writing a Woman's Life* (New York: Ballantine Books, 1989).

90. A copy of Bizet's music and lyrics was obtained from the Musée de l'Atelier de Rosa Bonheur, at the Château de By, Thomery, France: 'Notre Rosa, n'étant jamais coquette,/ Ne s'occupant de fleurs ni de rubans,/ L'Empératrice voulut, qu'à sa toilette,/ Elle en eût, et des plus éclatant./ Quand de l'honneur la noble récompense/Vint illustrer le doux nom de Bonheur:/ On pouvait bien signer de confiance,/ Car le ruban n'est pas une faveur!'

Anonymity, artistic brotherhoods and the art market in the *fin de siècle*

Laura Morowitz

In an 1891 letter written to a friend and fellow Symbolist painter, Emile Bernard described his dream of founding a communal brotherhood of artists.

> The goal of this group, called the Anonymous Ones, is thus art for art's sake. Not glory, not commerce, not reputation: the edification of an idea, of a work. Each member contributes his effort to the whole project. Each one could no more be taken away from the group than could a stone from a house, a beam from a wooden framework. Thus we aim for appreciation of the ensemble, and not the individual parts, which would falsify the goal of our efforts, and which would be the negation of our ideal. I thought that it would be interesting to refer to our group in formation by entitling this project to which I was destined, 'Les Anonymes'.[1]

In his glorification of artistic anonymity, Bernard was joined by many other Symbolists. Indeed, many Symbolist paintings of the early 1890s are marked by a strong similarity of style, which render them anonymous to the uninitiated viewer. Modelling themselves on the medieval monastery, artistic groups like the Nabis and the circle of Pont Aven lived and worked closely together, engaging in communal projects.[2] Drawing upon the same sources – medieval art, Japanese prints, images d'Epinal – and motifs, their finished works bear a sharp resemblance (Figures 9.1 and 9.2)

Their striving for anonymity, however, was not only the result of shared contact, but was also a deliberate strategy of resistance to developments within the art market. It is precisely in this period that dealers began to cultivate the powerful appeal of individual style. Instant recognizability, the possession of an unmistakable signature style, became a crucial marketing tool within the art network.[3] By fostering interest in anonymous art, the Symbolists signalled a lack of compliance with the new values of the art market-place. This essay explores one aspect of the Symbolists' attempt, and ultimate failure, to resist the inevitable commodification of art in the late nineteenth century.

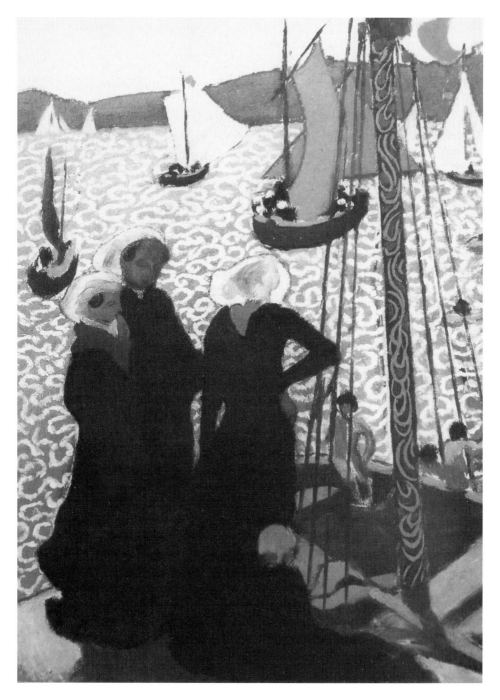

9.1 Maurice Denis, *Regatta at Perros-Guirec*, 1892

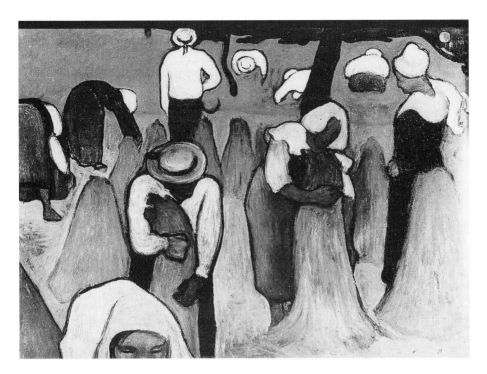

9.2 Emile Bernard, *Breton Peasants on a Wall*, 1892

As many recent studies have shown, by the *fin de siècle* the French art market had grown astonishingly complex and developed.[4] The rise of the individual dealer network wrought changes in the production, exhibition and consumption of all art created in the second half of the nineteenth century.[5] As the state abandoned its supportive function for artists,[6] painters were increasingly dependent upon attracting a bourgeois market. To appeal to buyers, artworks, like all other goods for sale, now had to possess the special attributes of the fetishized commodity.[7]

One such important attribute was exclusivity. In order to obscure the economic function of the work, it had to be presented as the unique, inspired product of genius. In opposition to the mass-produced or industrially created commodity, the 'fine' artwork embodied the skills and talents of a singular creator. These attributes were seen to be located in the formal style of the work. Dealers thus emphasized the unique style, the distinguishing 'touch' which characterized the artists in their stable.[8] This strategy naturally fostered competition among artists. Their work increased in (relative) value as it became more distinct from their competitors. The tendency of critics to single out and privilege one artist at the expense of others led to a divisive

attitude as various styles came to be 'pitted' against one another for material gain.[9]

While very much a part of the larger artistic network, the Symbolist artists attempted to deny the impact of such economic realities on their work, obfuscating their own contribution to this phenomenon. Their writings and declarations are rife with scorn for the art market, and for the artist who would sacrifice his 'ideal' mission for the sake of economic prosperity. At the 1891 opening of the Exposition des peintres Impressionnistes et Symbolistes at the gallery Barc de Bouteville, Gaston Leslaux claimed that the new generation of Symbolist painters would 'chase the money changers from the Temple of Art'.[10] 'The moment the artist thinks of money', claimed Maurice Denis, 'he loses the sentiment of beauty'.[11] Moreover, in his 1934 memoir the critic Francis Jourdain portrayed the Nabis as completely indifferent to the monetary worth of their paintings:

Never – I repeat – never did I hear at the Barc de Bouteville, these young artists discussing the price of their works, ratings, upward or downward trends, neither did the few buyers talk about good or bad investments. I do not claim that all these men were saints; but I can say the best painters of that generation were of no mean quality.[12]

In their illusive retreat from the market-place, the Symbolists turned to artistic sources 'untainted' by economic motivation. Medieval art, and the folk/popular art of French and non-Western cultures represented examples of pure, organically developed work. In their quest for ideal, symbolic art,[13] they were especially drawn to work of a spiritual nature.[14] (Ironically, by the second half of the nineteenth century, these very sources had been thoroughly exploited for bourgeois consumption.[15])

Of all the artistic 'sins' resulting from the fixation on profit, none was more heinous to the Symbolist than the corrupt appropriation of 'style'. For them, style was not an economic end-product, but was inseparable from the *meaning* (content) of the work.[16] Moreover, the competitive, divisive spirit encouraged by the focus on individuality was anathema to their notion of the artistic brotherhood. Groups within the Symbolist movement were characterized by such brotherhoods as the Nabis and the circle of Pont Aven, who often engaged in collaborative projects such as communal theatre productions, etc.

One tactic to thwart the increasing importance of individual style was to challenge its privileged status. If the 'bourgeois', 'entrepreneurial' artist aimed for absolute distinction, individual recognition, then certain Symbolists would glorify the opposite property: anonymity. These Symbolists would model themselves on the humble, anonymous artist who sacrificed recognition for the advancement of his community and the ennoblement of art. Idealization of the anonymous artist, and the desire to revive anonymous artistic societies became a frequent trope in Symbolist art and literature.

Emile Bernard believed his *Association des Anonymes* could serve as an antidote to the petty rivalries spawned by competition within the art market. In his list of rules for the society, Bernard insisted that there be 'no popularity, no jealousies, no dishonest plagiarisms'. Members would be sworn to 'incognito absolu' and forced to abstain from 'individual literary critique'.[17]All individual ego would be sacrificed to the needs of the group: members would 'renounce all personality in order to contribute to the total project, which would be the synthesis of all the combined efforts'.[18]

Furthermore, according to Jan Verkade, who joined the Nabi circle in 1890, a similar motivation lay behind the formation of this group: 'This would have been the goal of those whom I called Nabis. But the search for personality, the invention of a journalist, spoiled this beautiful force'.[19] By singling out and comparing the various Nabi artists, critics had shattered the harmony of the group.

In a letter to J. K. Huysmans, Bernard provided further indication that the Nabi group was intended to function as an anonymous brotherhood. He wrote of founding, along with Maurice Denis, Ker-Xavier Roussel, Pierre Bonnard, Edouard Vuillard, Paul Sérusier and Eugene Boch 'a mystical association of artists, who work only for art, renouncing the idea of making themselves well known and striving only for sincere production. The title of this association was: *Les Anonymes.*'[20]

The comments of Verkade and Bernard go a long way towards explaining the stylistic similarities shared by members of the Nabi circle, and other artists with whom they lived and worked. The paintings of Verkade and Charles Filiger (another artist within the Pont Aven circle), for example, share a precise neo-Byzantine stylization.[21] The early works of Gauguin's disciple, Paul Sérusier do not hide their stylistic derivation from the master (Figures 9.3 and 9.4). The development of styles such as cloisonism[22] functioned to obliterate distinctions of palette, form and texture in the work of different painters.

If the Symbolists admired a wide variety of anonymous artists, they privileged two paradigms in particular: the painter-monk and the communal cathedral builder. Both participated in anonymous groups dedicated solely to art produced out of spiritual devotion. In his novel *La Cathédrale* (1898), J. K. Huysmans *repeatedly* praised the simple 'workmen' who erected Chartres.[23] Bernard envisioned his 'Anonymes', 'like the glorious artists who made the cathedrals and loved only art … we call out to our group in this epoch of ambition'.[24]

The monastery served as the ideal model for the production of communal art. Living as a harmonious unit, the painter-monks (or so the Symbolists believed) produced works without the least concern for monetary profit.[25] Van Gogh wrote of his aim to found a community of artists in which Gauguin

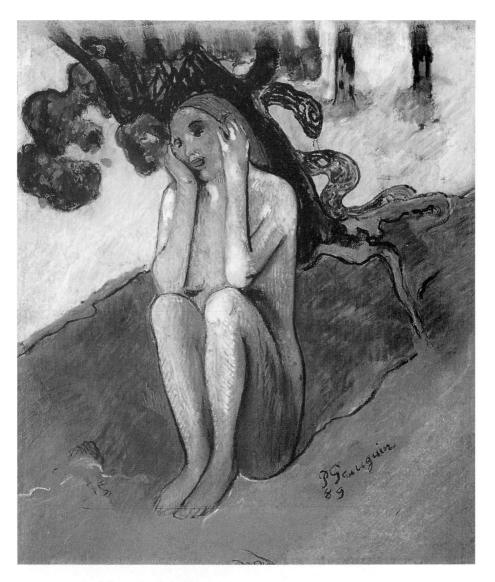

9.3 Paul Gauguin, *Eve*, 1889

would 'serve as the Abbot'.[26] Huysmans attempted unsuccessfully to establish an artistic community modelled on a monastery. He described to Bernard his hope of 'beginning a christian artists colony, benedictine lay brothers, in the shadow of the old cloister which exists there'.[27] Prior to the formation of the Nabis in late 1888, Maurice Denis recorded his dream of leading a group of religious artists who would participate in communal church decoration:

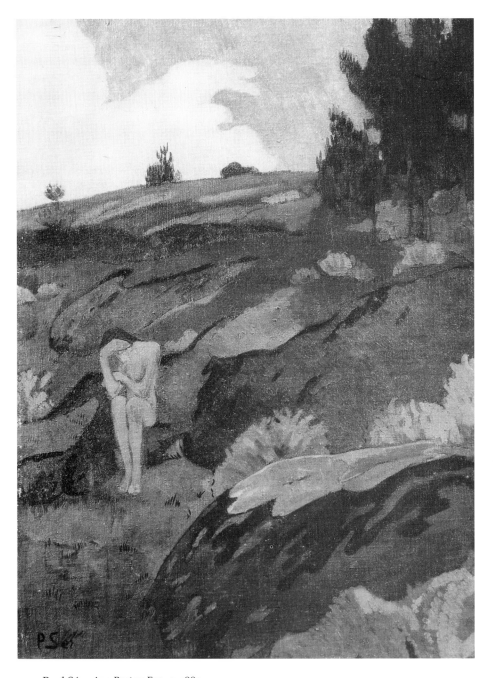

9.4 Paul Sérusier, *Breton Eve*, c. 1889

And then – oh it would be beautiful – I should erect in the middle of profane Paris a sumptuous chapel, where my brothers and I will dedicate ourselves to adorning paintings, frescos, panels, predellas, lunettes … And each year our artistic-religious society would come hear mass with their canvases held in their arms … the exhibition ends with a second mass in our church![28]

As an antithesis to the ambitious, worldly Salon artists, the painter-monk was deeply admired in the Symbolist milieu. Both Maurice Denis and Joséphin (Sâr) Péladan, founder of the Knights of the Rose+Croix, professed the most profound love for the art of the fifteenth-century Italian painter Fra Angelico.[29] Their attention was also drawn to the contemporary painter Charles Dulac, who had joined the Third Order of Saint Francis in 1890. Dulac, claimed Huysmans, 'was nothing like a man of our time; he cherished poverty, scorned fame, nourished himself like a hermit'.[30] Disgusted by the rampant materialism of the *fin de siècle*, many Symbolists were strongly drawn to monastery life. The Nabi Jan Verkade became a noviciate at the Beuron monastery in 1897, spending the rest of his life producing church frescos.[31] On several occasions Sérusier considered joining the monastery as well.[32] Huysmans's literary alter ego, Durtal, finds repose in the monastery of La Trappe. Even Symbolists who did not take monastic orders occasionally portrayed themselves in the guise of a monk.

In fact, many of the Symbolist 'brotherhoods' served as pseudo-monasteries, isolating their members from the cold values of the market-place. The paradigm of the painter-monk also functioned for artists who were not particularly religious but possessed a humility, a self-abnegating quality opposed to the self-aggrandizing nature of the Salon artist. It was precisely in such terms that Romain Coolus described his friend, the Nabi artist Edouard Vuillard.

Among painters of modern life, none is more sophisticated – more voluptuous, some would say: yet there is something paradoxically religious about him. It is not just that he has always lived in a way that is sober and dignified, almost to the point of austerity. The apartment in which he lives, the studio in which he works, have always had something monastic about them. One has only to watch him, as he prepares his colors *à la colle* on a little stove and in the humblest of sauce pans to realize that he is no more concerned with the outward surroundings in which his spiritual activity goes forward than were the artisans of the Middle Ages or the God-fearing painters of the Renaissance who worked in the service of the Church.[33]

While Vuillard's early work closely resembles that of his Nabi peers, his individual style quickly asserted itself, and his paintings can hardly be described as 'anonymous'. Indeed, this pattern is characteristic of many other Symbolist painters as well, whose distinct styles emerged in the course of the *fin de siècle*. Although they feared that participation in the market would 'falsify their goals and negate their ideals',[34] the Symbolists

had no choice but to comply; alternative systems of support did not yet (and still largely do not) exist through which the artist could financially survive.

While they detested the rivalry encouraged by market strategies, the Symbolist milieu was hardly free of internal jealousies and battles. Emile Bernard, who was determined to demand 'absolu incognito' of his '*Anonymes*', grew outraged when critics and artists failed to recognize his unique contributions to the Symbolist movement.[35] His jealousy of Gauguin is legendary. Symbolist history is full of other battles and excommunications.[36] Neither in their work, nor in their hearts, could the Symbolists extinguish their ego and thoroughly 'abdicate all vanity, all glory'.[37]

Nor would the genuine adoption of an anonymous style, even that of the humble 'painter-monk', have succeeded in locating Symbolist practice outside the market-place. For the 'primitif', the 'monk-artist', the 'painter-priest' had already been packaged for presentation to the public. Charles Dulac, the 'modern-day Angelico', was given a successful one-man show at Vollard's Gallery in 1899. The dealer described this 'monk-artist': 'following the example of Fra Angelico, before taking up his brushes he would kneel in prayer awaiting inspiration'.[38] The widely acclaimed 1904 Exposition des Primitifs Français, held at the Louvre museum, revealed the public taste – as well as the cunning creation of a market – for naïve, devout artists.[39] The very 'anonymous' sources beloved by the Symbolists – medieval woodcuts, Japanese prints, 'primitive' sculptures – had begun to find a successful and appreciative audience.[40]

In their very struggle to 'escape' the conditions of the art market, the Symbolists were deeply marked by them. Their insistence on form as a carrier of meaning can be seen as a response to the glorification of style-for-profit's sake. Indeed, their very formal language – 'pure' colours, simplified forms – may have been chosen, in part, for its accessibility to *all* artists, encouraging the spread of an anonymous style. Yet the variety of styles characterizing the Symbolist movement, indicates the limits of their project to remain anonymous. Such fluidity reveals the ambiguity that lay at the heart of the Symbolist project and the impossibility of 'escaping' an art network of which they were very much a part. As Robert Jensen has noted, the conception of the avant-garde as a continuing 'resistance to the commodification of art is fundamentally tautological. Until we live in a transformed society art is going to remain a commodity; it is just as much a part of its character as any designation for "art".'[41] Despite their dream of an isolated artistic cloister, the cash register had already begun to drown out the tolling of the church bell.

Notes

This essay first appeared in *Art Criticism*, **11** (2) (1996): 71–9. My thanks go to the editor, Donald Kuspit, for permission to reproduce the essay in full. It is adapted from my dissertation, 'Consuming the Past: The Nabis and French Medieval Art', New York University, 1996. For editorial comments on drafts of this essay I thank Susan Rosenberg, Maura M. Reilly and Françoise Lucbert. I also thank Robert S. Lubar, for encouraging me to develop the ideas in this essay.

1. 'Le but de ce group, dit des Anonymes, est donc l'art pour l'art. Pas de gloriole, pas de commerce, pas de réputation: l'édification d'une idée, d'une ouevre. Chaque membre y apporte ses efforts, concourt à l'édifice. On ne peut pas plus être enlevé du groupe qu'une pierre d'une maison, qu'une poutre d'une charpante. Donc c'est à l'appreciation d'ensemble que nous faisons appel et non à des distinctions individuelles qui fausseraient le but de nos efforts et qui serait la négation de notre idéal. J'ai pensé pourtant qu'il serait intéressant de parler de ce group en formation en intitulant le numéro qui m'etait destiné: Les Anonymes.' Letter from Emile Bernard to Emile Schuffenecker, 19 January 1891, Paris, Bibliothèque Nationale de France, n.a. fr.14277.

2. There was a great deal of interchange amongst various Symbolist sub-groups. Members of the Nabi circle travelled throughout Brittany with artists from the Pont Aven group, and contributed to journals and exhibitions led by members of the Rose+Croix Salons. See Wladyslawa Jaworska, *Gauguin and the School of Pont Aven* (New York: New York Graphic Society, 1972); Marie Amélie Anquetil, 'Le Sentiment religieux et l'art chez trois peintres du groupe de Pont Aven: Charles Filiger, Jan Verkade, Mogens Ballin', thèse, Paris, Sorbonne, 1976.

3. Henri Matisse, for example, caused his dealers a great deal of worry with his simultaneous appropriation of numerous styles. See Roger Benjamin, 'Fauves in the Landscape of Criticism', *The Fauve Landscape* (Los Angeles County Museum, 1990).

4. For the best studies on the French art market see Raymonde Moulin, *Le Marché de la peinture en France* (Paris: Les Éditions de Minuit, 1967); Robert Jensen, 'The Avant-Garde and the Trade in Art', *Art Journal* (Winter 1988); Nicholas Green, 'Dealing in Temperaments: Economic Transformations of the Artistic Field in France during the Second Half of the Nineteenth Century', *Art History* (March 1987); Malcolm Gee, *Dealers, Critics and Collectors of Modern Painting: Aspects of the Parisian Art Market between 1910 and 1930* (New York: Garland Press, 1981); Ambroise Vollard, *Recollections of a Picture Dealer*, trans. Violet MacDonald (New York: Dover Reprint, 1968); C. A. and H. C. White, *Canvases and Careers: Institutional Change in the French Painting World* (New York: Wiley, 1965). Also see Patricia Mainardi, *The End of the Salons: Art and the State in the Early Third Republic* (Cambridge: Cambridge University Press, 1993) and Sharon Adler Davis, 'Fine Cloths on the Altar; The Commodification of Late 19th Century France', *Art Journal*, **48** (Spring 1989).

5. This applies also to art produced for public display or sale to the state. As Mainardi 1993, has explored, the character of the national salons was irretrievably altered by developments within the private art market. For example, the Triennale (the government sponsored Salon), borrowed aspects of display and decor from the private commercial gallery.

6. On this see Mainardi, 1993.

7. The artwork functioned as fetish by focusing attention on its conditions of *production* (i.e. its heavy impasto assured the viewer it was handmade) while denying its conditions of distribution. By possessing such an object, the buyer both participated in, and concurrently seemed to reject, the dominating conditions of the capitalist art market.

8. On style as a marketing strategy see Moulin 1967; Gee 1981; Christopher Green, *Cubism and its Enemies: Modern Movements and Reaction in French Art 1916–1928* (London/New Haven: Yale University Press). Moulin notes that concentration on individual style also led to increased speculation in the art market during the late nineteenth century. On this practice, Robert Jenson notes that it 'migrated to the commercial gallery, where the dealers sought to make history through the artist's exclusive presence while confirming the value of the artist's work for the marketplace' (Jensen 1988, p. 361).

9. On this see the discussion of the marketing of the cubist school in Green, op. cit..

10. Gaston Leslaux, introduction to the first Exposition des Peintres Impressionnistes et Symbolistes, 1891, Galerie Barc de Bouteville. Reprinted in Theodore Reff (ed.), *Modern Art in Paris 1855–1900: Exhibitions of Symbolists and Nabis* (New York/London: Garland Press, 1981).

11. 'Au moment où l'artiste pense à l'argent il perd le sentiment du beau', Maurice Denis, *Journal*, vol. 1 (Paris: Editions du Colombier, 1957), 5 Sept 1885.

12. Francis Jourdain, *Bonnard et Son Epoque* (1943). Quoted and translated in Claire Frèches-Thory and Antoine Terrasse, *The Nabis: Bonnard, Vuillard and their Circle* (New York: Abrams, 1991), p. 24.

13. For a Symbolist definition of 'ideal art' see André Mellerio, *Le mouvement idéaliste en peinture* (Paris: H. Floury, 1896) and Albert Aurier, 'Le Symbolisme en peinture: Paul Gauguin', *Le Mercure de France* (March 1891).

14. For example, Byzantine icons or Breton crucifixes. For discussion of Symbolist sources see Julian Phillipe, *Dreamers of Decadence: The Symbolist Painters of the 1890s* (1971); Ursula Perruchi Petri, *Die Nabis und Japon: Die Frühwerke von Bonnard, Vuillard und Denis* (Munich: Prestal Verlag, 1976). Also see the bibliography in Claire Frèches-Thory and Ursula Perruchi-Petri (eds), *Nabis: 1888–1900*, exh. cat. (Zürich Kunsthaus/Paris, Musée d'Orsay, 1993).

15. On this see Abigail Solomon-Godeau, 'Gone Native: Savage Intellects, Modern Lives', *Art in America*, **79** (Feb. 1991); Griselda Pollock and Fred Orton, 'Les Données Bretonnantes: La Prairie de Représentation', *Art History*, **3** (Sept. 1980).

16. Denis, in particular, stressed the notion of formal style as the carrier of meaning: 'Ils ont préféré dans leurs oeuvres l'expression par le décor, par l'harmonie des formes et des couleurs, par la matière employée, à l'expression par le sujet'. 'Preface de la IX exposition des peintres Impressionistes et Symbolistes' (1895). Reprinted in Maurice Denis, *Théories 1890–1910: Du Symbolisme et de Gauguin vers un nouvel ordre classique*, 4th edn (Paris: L. Rouart et J. Watelin, Editeurs, 1921), p. 27.

17. 'Pas de popularité, pas de jalousies, pas plagiats malhonnêtes.' See Bernard's letter to Schuffenecker, 19 January 1891, op. cit. Bernard regretted that Schuffenecker had already disqualified himself from the group by his recognizable style: 'Je regrette que vous ne puissez être de notres, étant vous-même deja connu et ayant besoin de popularité pour vivre'.

18. 'Il renonce à l'ensemble d'un édifice qui sera la synthèse des efforts de chacun'. Letter to Schuffenecker, 19 January 1891.

19. 'Cela aurait été le devoir de ceux que je nommais … les Nabis. Mais la recherche de la personalité, l'invention d'une journaliste, a dispersé toute cette belle force', Letter quoted in Carolyn Boyle-Turner, *Jan Verkade, Disciple hollandais de Gauguin* (Quimper: Musée des Beaux-Arts, 1990), p. 38.

20. 'fonder une association mystique d'artistes ne travaillant que pour l'art, renonçant a se faire connaître et n'ambitionnant qu'une production sincère. Le titre de cette association était: Les Anonymes', Émile Bernard, unpublished letter to Huysmans, 9 January 1899, Bibliothèque de l'Arsenal, fonds Lambert.

21. Charles Filiger, a member of the Pont Aven circle, also exhibited works at the Salons de la Rose+Croix. On Filiger see Jaworska, 1972 and Anquetil, 1976.

22. First coined by the critic Edouard DuJardin, 'Aux XX et aux Indépendants', *La Revue indépendable* VI (17 March 1888), the cloisonist style, with its patches of pure colour outlined in black, was thought to have been inspired by medieval stained glass and cloisonné enamels. For the literature and bibliography on cloisonism see Bogomilia Welsh-Ovcharov, *Vincent Van Gogh and the Birth of Cloisonism* (Art Gallery of Toronto/Rijksmuseum Vincent Van Gogh, 1981).

23. 'Was there a guild, a brotherhood of image makers devoted to holy work, built for God, who went from place to place to be employed by the monks as helpers of the masons and laborers?', J. K. Huysmans, *The Cathedral*, trans. Clara Bell (Sawtry: Daedulus, 1989), p. 177.

24. 'comme des glorieux artistes qui firent les cathédrales et n'aiment que l'art … nous appelons à notre group en cette époque d'ambitions', Bernard letter to Schuffenecker, op. cit.

25. This belief is, of course, completely false. For the actual conditions/practices of the monk artists see J. J. G. Alexander, *Medieval Illuminators and their Methods of Work* (New Haven: Yale University Press, 1992).

26. Jaworska 1972, p. 59.

27. Letter from Huysmans to Emile Bernard, 3 January 1899, reproduced in *A Emile Bernard: Lettres de Vincent Van Gogh, Paul Gauguin …* (Belgium: Editions de la Nouvelle Revue Belgique, 1942).

28. Maurice Denis, *Journal* 12 August 1885. For original French, see p. 29, note 60.

29. On Péladan see Robert Pincus-Witten, 'Occult Symbolism in France: Joséphin Péladan and the Salons of the Rose & Croix', Ph.D. diss., University of Chicago, 1976 and Jean da Silva, *Salons de la Rose+Croix* (Paris: Syros Press, 1984). In 1884, Péladan published a laudatory article on Fra Angelico: 'Introduction à l'histoire des peintres de toutes les écoles depuis les origines jusqu'à la

Renaissance: l'Angelico', *L'Artiste* (March 1884). Drawing formal influence from the frescos of Fra Angelico, Denis repeatedly praised him in his writings. See, for example, 'Notes sur la peinture religieuse', *L'Art et la Vie* (Oct. 1896). Reprinted in Denis 1921, pp. 30–44.

30. 'Et la fait est que Dulac n'avait rien d'un homme de notre temps; il chérissait la pauvreté, méprisait la reclamé, se nourrissait de même qu'une ermite', J. K. Huysmans, *Marie-Charles Dulac 1865–1898* (Paris: Imprimerie Georges Petit, 1899), p. 8. Also see Henri Cochin, *Exposition Charles Dulac, Barc de Bouteville* (11May–4 June 1899). Huysmans devoted several pages to Dulac's lithographs in his novel *La Cathédrale*.

31. For Verkade's conversion to Catholicism and his entrance into the Beuron monastery see Dom (Jan) Willibrod Verkade, *Yesterdays of an Artist's Monk*, trans. John Stoddard (New York: P. J. Kennedy and Sons, 1930), p. 25.

32. For evidence of this see Carolyn Boyle-Turner, 'Paul Sérusier', Ph.D. diss., Columbia University, 1980.

33. Romain Coolus, 'Vuillard', *Le Mercure de France* (Jan. 1934). Translated in John Russel, *Edouard Vuillard 1868–1940* (Toronto: Art Gallery of Ontario, 1971–2).

34. See quote from Bernard, p. 187.

35. Bernard attempted everything possible to insure that history would recognize his primary role in Symbolism. In addition to 'pre-dating' his work, he was fond of quoting positive reviews which credited his achievements. For discussion of Bernard's career and personality see Mary Anne Stevens *et al.*, *Emile Bernard 1868–1941: A Pioneer of Modern Art*, exh. cat. (Mannheim: Stadtische Kunsthaus, 1991).

36. Péladan, in particular, was fond of banishing artists from his circle. See Pincus-Witten 1976.

37. 'abdique toute vanité, toute gloire'. Emile Bernard, letter to Schuffenecker, 19 January 1891.

38. Vollard 1968, p. 202.

39. On the exhibit see Henri Bouchot, *L'exposition des Primitifs Français: La peinture en France sous les Valois* (Paris: Librairie Centrale des Beaux-Arts, 1904).

40. For a discussion of the institutionalization of Gothic art in the *fin de siècle* see Morowitz 1996. On the reception of Japanese art see Gabriel Weisberg, *Japonisme: Japanese influence on French Art 1854–1910* (Cleveland Museum, 1975).

41. Jensen 1988, p. 366.

Bibliography

Andrews, K. (1964), *The Nazarenes*, Oxford: Oxford University Press.

Baker, A. R. H. (1999), *Fraternity Among the French Peasantry. Sociability and Voluntary Associations in the Loire Valley, 1815–1914*, Cambridge: Cambridge University Press.

Boime, A. (1971), *The Academy and French Painting in the Nineteenth Century*, London: Phaidon.

Bowlt, J. (1976), 'Patronage and the Neo-Nationalist Movement: Savva Mamontov and Princess Tenisheva', *Russian Art 1875–1975: A Collection of Essays*, Austen: University of Texas, 444–453.

Bürger, P. (1984), *Theory of the Avant-Garde*, trans. M. Shaw, Minneapolis: University of Minnesota Press.

Chadwick, W. (1996), *Women, Art and Society*, 2nd edn, London: Thames and Hudson.

Cherry, D. (1980), 'The Hogarth Club', *The Burlington Magazine*, **122**, April: 237–44.

—— and Pollock, G. (1984), 'Patriarchal Power and the Pre-Raphaelites', *Art History*, **7**, Dec.: 480–95.

Clawson, M. A. (1989), *Constructing Brotherhood: Class, Gender, and Fraternalism*, Princeton: Princeton University Press.

Crow, T. (1995), *Emulation: Making Artists in Revolutionary France*, New Haven and London: Yale University Press.

Crump, J. (1995), *Frederick Holland Day: Suffering the Ideal*, Twin Palms: Twelvetree Publishers.

Curtis, V. P. and van Nimmen, J. (eds) (1995), *F. Holland Day: Selected Texts and Bibliography*, New York: G. K. Hall.

Délécluze, E.-J. (1855), *Louis David, son école et son temps, souvenirs*, Paris: Didier (reprinted Paris: Editions Macula, 1983).

Driskell, M. (1982), *Representing Belief: Politics, Religion and Society in Nineteenth Century France*, Philadelphia: University of Pennsylvania Press.

Duncan, C. (1981), 'Fallen Fathers: Images of Authority in Pre-Revolutionary France', *Art History*, **IV**, June: 186–202.

Frèches-Thory, C. and A. Terrasse (1991), *The Nabis: Bonnard, Vuillard and their Circle*, New York: Abrams.

Garb, T. (1994), *Sisters of the Brush: Women's Artistic Culture in Late Nineteenth-Century Paris*, New Haven and London: Yale University Press.

Gallwitz, K. (ed.) (1977), *Die Nazarener*, exh. cat., Frankfurt am Main: Städtlisches Kunstinstitut.

Harding, B. (1897), *Brotherhood: Nature's Law*, New York: Theosophical Publishing Company.

Harding, E. (ed.) (1996), *Reframing the Pre-Raphaelites*, Aldershot: Scolar Press.

Hartley, K. *et al.* (eds) (1994), *The Romantic Spirit in German Art 1790–1990*, London: Thames and Hudson.

Honour, H. (1979), *Romanticism*, New York: Harper and Row.

Howitt, A. M. (1852), 'The Sisters in Art', *Illustrated Exhibitor and Magazine of Art*, pp. 211ff.

—— (1853), *An Art Student in Munich*, London: Longman.

Howitt, M. (1886), *Friedrich Overbeck: Sein Leben und sein Schaffen*, 2 vols, Freiburg: Herder'sche Verlagsbuchhandlung (reprinted Bern: Herbert Lang, 1971).

Hunt, W. H. (1905), *Pre-Raphaelitism and the Pre-Raphaelite Brotherhood*, 2 vols, London: Macmillan (reprinted New York: AMS Press, 1967).

Jensen, R. (1994), *Marketing Modernism in Fin-de-Siècle Europe*, Princeton: Princeton University Press.

Jussim, E. (1980), *Slave to Beauty: The Eccentric Life and Controversial Career of F. Holland Day*, Boston: D. R. Godine.

Kennedy, M. L. (1982), *The Jacobin Clubs in the French Revolution*, Princeton: Princeton University Press.

Landes, J. B. (1988), *Women and the Public Sphere in the Age of Revolution*, Ithaca: Cornell University Press.

Lankheit, K. (1952), *Das Freundschaftsbild der Romantik*, Heidelberg: Carl Winter.

Levitine, G. (1978), *The Dawn of Bohemianism: The 'Barbu' Rebellion and Primitivism in Neoclassical France*, University Park: Penn State University Press.

Lister, R. (ed.) (1974), *The Letters of Samuel Palmer*, Oxford: Clarendon Press.

MacCarthy, F. (1994), *William Morris*, London: Faber and Faber.

McLaren, Angus (1997), *The Trials of Masculinity* (Chicago: University of Chicago Press).

McVaugh, R. (1984), 'A Revised Reconstruction of the Casa Bartholdy Fresco Cycle', *Art Bulletin*, **66**: 442–52.

Marcel, D. (1987), *Fraternité et Révolution Française: 1789–1799*, Paris: Aubier.

Marsh, J. (1985), *The PreRaphaelite Sisterhood*, New York: St. Martin's Press.

—— and Nunn, P. G. (1997), *PreRaphaelite Women Artists*, Manchester: Manchester City Art Galleries.

Mosse, George (1985), *Nationalism and Sexuality*, New York: Howard Fertig.

Nodier, C. (1876), *Correspondances inédité de Charles Nodier*, Paris: Moniteur Universelle.

Nunn, P. G. (ed.) (1986), *Canvassing: Recollections of Six Victorian Women Artists*, London: Camden Press.

Pelles, G. (1963), *Art, Artists and Society: Origins of a Modern Dilemma*, Englewood Cliffs, NJ: Prentice-Hall.

Peters, U. (1991), 'Das Ideal der Gemeinschaft', in G. Bott and H. Spielmann (eds), *Künstlerleben in Rom: Berthel Thorwaldsen (1770–1844)*, Nürnberg: Germanisches Museum, pp. 157–87.

Pevsner, N. (1931), 'Gemeinschaftsideale unter den bildenen Kunstlern des 19. Jahrhunderts', *Deutsche Vierteljahrsschrift für Literaturwissenschaft und Geistesgeschichte*, **9**: 125–54.

Poggioli, R. (1968), *Theory of the Avant-Garde*, Cambridge, Mass.: Harvard University Press.

Rosenblum, R. and Janson, H. W. (1994), *Art of the Nineteenth Century: Painting and Sculpture*, London: Thames and Hudson.

Salmond, W. (1996), *Arts and Crafts in Late Imperial Russia: Reviving the Kustar Art Industries, 1870–1917*, Cambridge: Cambridge University Press.

Schindler, H. (1982), *Nazarener: Romantischer Geist und Christliche Kunst im 19th Jahrhundert*, Regensburg: F. Pustet.

Sedgwick, E. K. (1985), *Between Men: English Literature and Male Homosocial Desire*, New York: Columbia University Press.

Silberer, H. (1971), *Hidden Symbolism of Alchemy and the Occult Arts*, New York: Dover.

Solomon-Godeau, A. (1997), *Male Trouble: A Crisis in Representation*, London: Thames and Hudson.

Sussman, H. L. (1995), *Victorian Masculinities: Manhood and Masculine Poetics in early Victorian Literature and Art*, Cambridge: Cambridge University Press.

Tiger, L. (1969), *Men in Groups*, New York and London: Marion Boyars.

Tönnies, F. (1974), *Community and Association*, trans. C. P. Loomis, London: Routledge & Kegan Paul.

Tramm, P. M. (ed.) (1993), *Nazarenische Zeichenkunst*, exh. cat., Kunsthalle Mannheim, Berlin: Akademie Verlag.

Truant, C. M. (1994), *The Rites of Labor: Brotherhoods of Compagnonnage in Old and New Regime France*, Ithaca: Cornell University Press.

Vaughan, W. (1980), *German Romantic Painting*, New Haven and London: Yale University Press.

Wackenroder, W. (1971), *Confessions and Fantasies*, trans. M. H. Schubert, University Park: Penn State University Press.

Watson, M. F. (1997), *Collecting the Pre-Raphaelites: The Anglo-American Enchantment*, Aldershot: Ashgate Press.

White, C. A. and H. (1965), *Canvases and Careers: Institutional Change in the French Painting World*, New York: Wiley.

Index

Abbott, Jack 126
Abramtsevo 10, 11, 17, 26, 105–18
Aksakov, Ivan 112
Aksakov, Konstantin 112
Aksakov, Sergei 109, 111, 112
Aleksandrovich, Grand Duke Vladimir
 119
Ancients, The 12, 15, 17, 27, 70
Angelico, Fra 52, 53, 192, 193
Anonymes, les 185, 189, 192
Antokolsky, Mark 108, 109, 116, 117
Aron-Caen, Mme 24
Artel,The 118
Aven, Pont 195

Barbizon Community 118
Barbus 2, 3, 4, 5, 10, 12, 14, 15, 27, 32–47,
 68, 69, 70, 78
Barker, Alan 9
Barthold, Jakob Salomon 13, 59
Barry, James 74
Baudelaire, Charles 1, 13, 26
Bazille, Jean 140, 141
Belinsky, Vissarion 109, 112
Bellange, Jacques 138, 139, 140, 145
Benham, Jane 25
Berman, Patricia 19
Bernard, Emile 8, 185, 187, 190, 192, 193,
 195, 196
Bizet, Georges 162, 179
Blavatsky, Helena 126, 131, 132
Boch, Eugene 189
Bodichon, Barbara 24, 25, 26

Bogolyubov, Aleksi 108, 109, 118, 120
Bohemia 24
Boime, Albert 141
Bonheur, Raymond 161, 165
Bonheur, Rosa 147, 153, 155, 156, 161–7,
 173, 176, 179, 180, 181, 182
Bonheur, Sophie 161, 165
Bonnard, Pierre 189
Bourdieu 137, 138, 146
Bracquemond, Marie 173
Bréton, Geneviève 161
Broc, Jean 21, 37, 38, 40
Brotherhood of St. Luke 12, 45, 48, 49,
 50, 52, 53, 68, 70 (*see also* Nazarenes)
Brotherhood of the Linked Ring 15
Brothers, The 45
Brown, Alice 122, 125
Bulwer Lytton, Edward 76
Brücke, Die 78
Burden, Jane 89, 92
Burne-Jones, Edward 84, 86, 87, 91, 94,
 95, 97, 124
Burne-Jones, Georgiana 20, 91, 96, 97, 98,
 99
Büttner, Frank 52

Cameron, John 141, 143
Carman, Bliss 122, 125, 132, 134
Carpeaux, Jean-Baptiste 144
Carpenter, Edward 21
Catel, Franz 59
Cassat, Katherine Kelson 173
Cassat, Lydia 177

Cassat, Mary 155, 156, 171–9, 183, 184
Cham, 141, 143, 145
Chaplin, Charles 173
Chaucer 85
Chevalier, Suplice-Guillaum *see* Gavarni
Chicherin, Boris 111
Clawson, Mary Anne 8, 11, 41
Cless, Jean-Henri 137, 138
Codell, Julie 72
Collins, Charles Allston 74
Collinson, James 74, 79
Connell, R. W. 150
Coolus, Romain 196
Copeland, Herbert 21, 122, 124, 126, 131
Copeland & Day 124, 125, 131, 132
Cornelius, Peter 21, 30, 48, 55–61, 65, 66
Cornforth, Fanny 23
Corot, Camille 168
Correggio 51, 124
Courbet, Gustav 75
Couture, Thomas 173
Cram, Ralph Adams 122, 124, 126, 127, 131
Crow, Thomas 19, 21, 145

D'Abrantès, Duchess 41
D'Affry, Adèle 171
Dadd, Richard 70, 81
David, Jacques-Louis 2, 14, 19, 20, 21, 29, 32–40, 42, 44, 45, 68, 108, 137, 140, 144, 145
Day, F. Holland 9, 17, 21, 26, 29, 30, 122, 124, 127–34
dealer system 147
Degas, Edgar 173, 177
Delacroix, Eugène 147, 149
Delaroche, Paul 140, 143, 145, 146
Délécluze, Etienne 144, 151
Denis, Maurice 4, 17, 18, 21, 29, 186, 187, 189, 190, 191, 195
De Curzon, Alfred 140
De Saint-Simon, Henri 165
De Stael, Mme Germaine 42, 43
Deverell, Walter 74, 78
Diaghilev, Sergei 106
Didot-Bottin 147
Douglas, Mary 54
Drölling, Martin 140
Drouais, Jean-Germain 19, 33, 108
Duchemin, Angelique Mary 147

Dulac, Charles 192, 193
Duncan, Carol 20
Dürer, Albrecht 59
Dyce, William 26, 69

Ecole, The 143, 144, 146, 150
Egg, Augustus Leopold 70, 80
Elmore, Alfred 70
Eugénie, The Empress 147

Fantin-Latour, Henri 75
Faulkner, Charles 84, 91
Faulkner, Kate 99
Faulkner, Lucy 99
Fichte, Johann Gottlieb 56
Filiger, Charles 189
Flaxman, John 35
Fohr, Carl Philipp 61, 62
Förster, Ernst 56, 57
Fox, Eliza 25
Fox, John Shirley 141
Francia, Francesco 55
Franque, Jean-Pierre 14, 34, 38–43
Franque, Joseph 34, 38, 40
Freud, Sigmund 143, 152
Freundschaftsbild 74
Frith, William Powell 70
Froissart 85

Gambart, Ernest 182
Gartnov, Viktor 114
Gaugin, Paul 189, 190, 193
Gavarni, Paul 155
Gemeinschaft und Gesellschaft 48, 49, 50, 54, 55, 57, 58, 61, 62
Germ, The 6, 69
Gérôme, Jean-Léon 143, 144, 173, 181
Gilmore, David 145
Giotto 52, 59
Girodet-Trioson, Anne-Louis 43
Girtin, Thomas 45
Gleyre, Charles 140
Goethe, Johann Wolfgang 52
Gogol, Nilolai 109, 111
Golden Dawn, order of 122, 126, 127, 129, 131, 132, 134
Golovin, Aleksandr 116
Gombrich, Ernst 102
Goodhue, Bertram Grosvenor 122, 123, 124, 125, 126, 131–5

Görres, Joseph 56
Granovsky, Timofei 112
Guerrilla Girls 20
Guiney, Louise Imogen 122, 124, 125, 127, 134

Habermas, Jürgen 61
Haldeman, Eliza 174, 175, 177
Harding, Burcham 17
Harvey, Charles 84
Heilbrun, Carolyn 179
Herzen, Alexander Ivanovitch 109
Hogarth 45
Hogarth Club 71, 72
Hosmer, Harriet 24
Hottinger, Konrad 50, 52
Houssaye, Arsène 181
Hovey, Richard 122, 125
Howitt, Anna Mary 24, 25, 26
Hughes, Arthur 74, 75
Hugo, Victor 161
Hunt, William Holman 4, 5, 7, 13, 15, 18, 27, 69, 71–80
Huysmans, J.K. 17, 189, 190, 195, 196

Ingres 38, 140
Iordan, Fedor 106
Irigaray, Luce 103
Ivanov, Aleksandr 118
Ivanovich, Savva 106

Jauslin, Manfred 54
Jacobins 32, 33, 35, 38, 42, 45
Jensen, Robert 193
Jourdain, Francis 188
Julius II, Pope 59

Kant, Emanuel 54
Kauffmann, Angelica 30
Khomyakov, Aleksei 112
Kingsley, Charles 18
Kireevski, Ivan 112
Kireevski, Petr 112
Klosterbrüder, Die see Brotherhood of St Luke
Klumpke, Anna 164, 167, 176
Knight Errant, The 6
Kokorev, Vasily 112
Kosovsky Sedgewick, Eve 19
Kramskoi 118

Kuhn, Alfred 57

Lacombe, George 18
Landes, Joan 20
Leighton, Frederic 80
Lee, Francis Watts 132
Lemaistre, Alexis 141
Leo X, Pope 59
Leslaux, Gaston 188
Ludwig I, King of Bavaria 59
Lukasbund see Brotherhood of St Luke

MaCarthy, Fiona 84
Madox Brown, Emma 99
Madox Brown, Ford 69, 78, 84, 85, 111
Maikov, Apollon 111
Mallarmé, Stephane 183
Malory, Sir Thomas 68, 85, 113
Malyutin, Sergei 116
Mamontov, Ivan 106, 119
Mamontov, Savva 105–19
Mamontova, Elizaveta 116, 117
Manet, Eduard 137, 156, 168
Manet, Eugène 173
Mann, Thomas 61
Marcello 171
Marshall, Peter Paul 84
Marx, Karl 105
Masaccio 51
Mate, Vasily 120
Mathers, Mrs 127, 129
Mathers, McGregor S. L. 132
Matisse, Henri 194
Medici, Lorenzo de 59
Medievalism 142
meditateurs *see* Barbus
Mengs, Anton Raphael 50, 63
Messageot, Lucille 27, 35, 38, 41, 42
Meteyard, Thomas 122, 125
Micas, Nathalie 166, 167
Michelangelo 51, 57
Millais, John Everett 5, 7, 68, 70–74, 77, 78, 79
Miller, Annie 23
Monet, Claude 173
Monnier, Henry 141, 143, 151
Morisot, Berthe 155, 156, 167–73, 177, 183
Morisot, Edma 168, 169, 171, 177

Morisot, Marie-Josephine Cornélie 168, 169
Morris, Jane 20, 23, 41, 82, 84, 86, 91, 94, 95, 96, 99, 101, 102
Morris, William 26, 27, 82–102, 105, 124
Morris, Marshall, Faulkner & Co. 82, 84, 98, 111
Morris & Co. 98
Morrow, W. C. 141
Moser, Mary 30
Mosler, Karl 56
Mosse, George 53
Mulvey, Laura 152

Nabis 5, 10, 15, 17, 27, 185, 188, 189, 190, 192
Nadar (Gaspard-Felix Tournachon) 147, 149
Napoleon Bonaparte 41, 42, 43, 50
Nazarenes 3, 4, 5, 12, 15, 26, 27, 45, 48–62, 68, 69, 78, 108
Nesterov, Mikhail 117
Nevrev, Nikolai 115
Nochlin, Linda 154
Nodier, Charles 5, 16, 27, 37, 41–4
Norton, Charles Eliot 126
Novalis (Friedrich von Hardenberg), 49, 56
Nye, Robert 144

O'Neil, Henry Nelson 70
Ostrovsky, Alexander 111, 113
Ottin, Auguste 146
Overbeck, Friedrich 22, 30, 48, 50–66, 81

Palmer, Bertha 178, 179
Palmer, Samuel 4, 17, 18, 29, 70
Paret, Peter 55
Parkes, Bessie Rayner 25
Passavant, Johann David 53
Péladan, Joséphin 192
Peter I, Emperor of Russia (Peter the Great), 105
Pewter Mugs, The 122
Pforr, Franz 22, 48, 50–55, 59, 63, 64
Philbert, Jean-Baptiste 159
Phillip, John 70
Pinturicchio 59
Piper, Mrs 124
Pissarro, Camille 173

Pogodin, Mikhail 112
Polenov, Vasily 108, 109, 111, 113
Polenova, Elena 115, 116, 117
Poulain, Gaston 151
Prakhov, Adrian 108, 111
Prakhov, Mstislav 111
Pre-Raphaelite Brotherhood 3, 4, 15, 26, 27, 28, 67–85, 89, 94
Press, John 84
Primitifs see Barbus
Prinsep, Val 140
Pruvot, Baptiste, Jean 147
Puttfarken, Thomas 44

Quai, Maurice 4, 9, 14, 18, 35, 38, 40, 41, 42, 44
Quatremère de Quincy, Antoine-Chrysostome 38, 39

Ranson, Paul 17
Ranson-Bitker, Brigitte 28
Raphael 51, 53, 57, 59
Repin, Ilya 105, 108, 109, 112, 115, 117, 141
Revue Blanche, La 6, 27
Reynolds, Joshua 74
Rienzi 78
Riesener, Henri-François 35, 36
Roosevelt, Priscilla 109
Ropet, Ivan 115
Roqueplan, Camille 144
Rosicrucianism 134
Rossetti, Christina 72
Rossetti, Dante Gabriel 5, 7, 13, 23, 68, 71–9, 84, 85, 86, 89, 94, 95, 96, 98, 101
Rossetti, William Michael 71, 73, 74, 78, 79
Rousell, Ker-Xavier 189
Ruskin, Effie 20
Ruskin, John 13, 25, 69, 126
Ryckbusch, M. 157

Saint-Simonians 41
Salmond, W. 116
Samarin, Yuri 112
Sand, George 162
Sartain, Emily 175, 177
Savage, Philip 122
Savitsky, Konstantin 108
Schadow, Wilhelm 3, 56, 59

Schiller, Friedrich 54
Schlegel Friedrich 49, 53, 56, 63
Schleiermacher, Ernst Daniel 49
Schuffenecker, Emile 194
Schuré, Edouard 17
Scott, William Bell 80
secrecy 143
Sedgwick, Eve Kosofsky 73, 102, 144
Sepp, Johann 56
Serov, Valentin 105, 108, 110, 111, 117, 118
Serusier, Paul 9, 189, 190, 192
Shand-Tucci, Douglas 123, 124, 131
Shchepkin, Mikhail 109
Siddall, Elizabeth 26, 72, 86, 89, 91, 95, 99, 101, 102
Simmel, George 6, 49, 73
Slavophilia 10, 112
Society of St. Margaret 126, 135
Solomon, Simeon 30
Solomon-Godeau, Abigail 11, 19, 21, 143, 144
sororities 23
Staley, Allen 68
Stanislavsky, Konstantin 106
Stasov, Vladimir 109, 113
Stephens, Frederic George 69, 74, 78, 79
Stewart, Susan 99
Street, George Edmund 70, 71
Stuckey, Charles 171
Symonds, John Addington 21

Tenisheva, Princess Maria 116
Tennyson, Alfred Lord 8
Thoré, Théophile 162
Tiger, Lionel 73
Thackeray, William Makepeace 140
Tiburce, Edmé 168
Titian 51
Tönnies, Ferdinand 48, 49, 62, 63
Tournachon, Adrien 147, 148
Tretyakov, Pavel 112
Trutovsky, Konstantin 111

Turgenev, Ivan Sergeyevitch 109, 112

Valentin, Henry 144
Van Eyck, Jan 89
Van Gogh, Vincent 18, 189
Vasari, Giorgio 53
Vasnetsov, Appolinary 114, 121
Vasnetsov, Victor 106, 109, 111, 112, 114, 115, 117, 119
Vigée-Lebrun 165
Veit, Philipp 56, 59, 60, 61
Venetsianov, Aleksei 118
Vereshchagin, Vasily 108
Verkade, Jan 13, 21, 189, 192, 196
Vernet, Horace 144, 147, 148
Visionists 4, 5, 15, 17, 122, 124, 125, 126, 127, 131, 132
Vogel, Ludwig 50, 52
Vollard, Ambroise 193
Von Füger, Heinrich 50
Vrubel, Michael 106, 107, 108, 115, 116, 117
Vulliard, Eduard 189, 192

Wackenroder, Wilhelm 16, 29, 52, 53, 55
Ward, Edward Matthew 70
Wardle, George 97
Webb, Philip 84, 91, 92
Weber, Max 49
Weiss, Charles 37
Wescott, William Wynn 131, 132
Winckelmann, Johannes Jakob 38, 51
Wintergest, Joseph 50
Woolner, Thomas 74, 79
Wolff, Albert 173
Wollstonecraft, Mary 42

Yeats, William Butler 127

Zabelin, Ivan 115
Zhukovsky, Vasili Andreyevitch 111
Zola, Emile 180